Faces in the Forest
First Nations Art Created on Living Trees

In *Faces in the Forest* Michael Blackstock, a forester and artist, takes us into the sacred forest, revealing the mysteries of carvings, paintings, and writings done on living trees by First Nations people. Blackstock details this rare art form through oral histories related by the Elders, blending spiritual and academic perspectives on Native art, cultural geography, and traditional ecological knowledge.

Faces in the Forest begins with a review of First Nations cosmology and the historical references to tree art. Blackstock then takes us on a metaphorical journey along the remnants of trading and trapping trails to tree art sites in the Gitxsan, Nisga'a, Tlingit, Carrier, and Dene traditional territories, before concluding with reflections on the function and meaning of tree art, its role within First Nations cosmology, and the need for greater respect for all of our natural resources. This fascinating study of a haunting and little-known cultural phenomenon helps us to see our forests with new eyes.

MICHAEL D. BLACKSTOCK is Aboriginal affairs manager in the Ministry of Forests, British Columbia.

FACES
IN THE FOREST
FIRST NATIONS ART CREATED ON LIVING TREES

MICHAEL D. BLACKSTOCK

McGill-Queen's University Press
Montreal & Kingston • London • Ithaca

© McGill-Queen's University Press 2001
ISBN 0-7735-2256-5

Legal deposit fourth quarter 2001
Bibliothèque nationale du Québec

Printed in Canada on acid-free paper that is 100% ancient forest free (100%
post-consumer recycled), processed chlorine free, and printed with vegetable-
based, low VOC inks.

This book has been published with the help of a grant from the Humanities
and Social Sciences Federation of Canada, using funds provided by the Social
Sciences and Humanities Research Council of Canada.

McGill-Queen's University Press acknowledges the financial support of the
Government of Canada through the Book Publishing Industry Development
Program (BPIDP) for its activities. It also acknowledges the support of the
Canada Council for the Arts for its publishing program.

National Library of Canada Cataloguing in Publication Data

Blackstock, Michael D., 1961–
 Faces in the forest : First Nations art created on living trees

Includes bibliographical references and index.
ISBN 0-7735-2256-5

 1. Indian art–British Columbia. 2. Indian art–Yukon Territory. 3. Indians of
North America–British Columbia–Religion. 4. Indians of North America–Yukon
Territory–Religion. I. Title.

E98.A7B53 2001 704.03'970711 C2001-901060-5

This book was designed by David LeBlanc and typeset in 10/12 Sabon

To David and Matthew

Contents

Figures

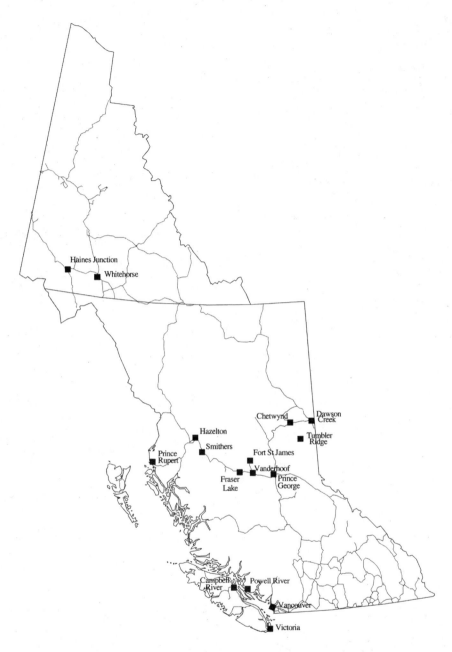

British Columbia and the Yukon Territory, showing major cities and places named in the text. Tree art locations are not indicated, out of respect for the First Nations communities who wish to protect and preserve these art forms and keep them in their natural setting. (Source: Government of Canada, reprinted with the permission of Natural Resources Canada.)

Prologue
Gitxsan Territorial Markers

Ha'gwil y'yeen, Ha'gwil y'yeen, Ha'gwil y'yeen
Lax hlanaahlx xsinaahlxwhl Ga' Nii ye'etxwm

Walk on, walk on, walk on,
On the breath of Our Grandfathers.

Guardian Spirits
of the Territories
You are the Stewards
of this land
Only the growth rings
of the Trees
Know how long this law
of stewardship is
Like the lens
of the camera
These markers have witnessed
and recorded
The changes that have
taken place
From the silent footsteps
of our ancestors
To the numbing sounds
of clear cut logging
Like the negatives
of a photograph
Transparent – yet full
of information
These images are

encoded histories
of a People

It is up to later
generations to develop
Showing the world
what has gone
The markers bear witness
to the fur trade
The blankets with small pox
the ravage on the people
One hundred and more
years later
We are strong and
continuing in the way
of our grandfathers

Like Ama Goodim Gyet
in his own way
Is making his marker

– Doreen Jensen (Hahl Yee)

Foreword

Antonia Mills

It is a privilege to write a foreword to Michael Blackstock's *Faces in the Forest: First Nations Art Created on Living Trees*. This book is an important guide to understanding how the First Nations experience the sacred forest and create art, and how their traditional knowledge can be respected and integrated into today's forest practices. I had the good fortune to witness the creation of the original manuscript from which this book has grown. Michael wrote his thesis as a requirement for a master's degree in First Nations Studies at the University of Northern British Columbia. This work continues the journey he embarked on to integrate his growing knowledge of the forest as a professional forester, as a Gitxsan person and artist, as a Gitxsan person working as an aboriginal forester in the Ministry of Forests in British Columbia, Canada, and as one of the first people to achieve a master's degree in First Nations Studies at the University of Northern British Columbia.

This book is a significant contribution to the scholarly endeavour to document the importance of culturally modified trees to First Nations peoples, an endeavour which may be of service in land claims and in negotiations over forestry practices on First Nations territories in the future. As a compendium of what is known about the carvings on living trees, it is vital for helping non-First Nations understand that these carvings are First Nations' messages that must be respected and preserved. The combination of academic research and fieldwork, and the reference to the appropriate First Nations authorities make this a fine example of research on indigenous matters.

Michael Blackstock came to the University of Northern British Columbia in the first contingent of graduate students in the First Nations Studies Master's Program when the university opened in its new campus in 1994. It was a program Michael had been waiting for: he knew it was time to explore more of his heritage so that he could integrate it with his

forestry work. While working as an aboriginal forester in Victoria, following his graduation from the Forestry program at the University of British Columbia in 1985, Michael had begun exploring this heritage through art. I first became aware of Michael as an artist in November of 1994. Until that time I had seen him mentoring students in courses such as statistics in the First Nations Center at the University of Northern British Columbia, and I had noted his patient teaching and competent mastery of these technical and mathematical disciplines. Then he gave a presentation using some of his Northwest Coast style silkscreen prints to the graduate seminar in First Nations Studies I was teaching that fall, and his work showed a depth of artistry I had not suspected. I suggested that he mount a show of his silkscreen prints at the university prior to Christmas; the exhibition was more impressive than I could have imagined. It is no wonder that master carver Walter Harris, his uncle, has done a combined silkscreen print with Michael. With no formal training at that time, he had integrated a vast understanding of the visual metaphor to illustrate both some of the Gitxsan oral traditions and his experience in the landscape. When it came time for Michael to undertake the internship required of all First Nations Studies master's degree candidates at the university, he went to the Gitxsan. Knowing his background in forestry, they assigned him the task of developing a five-year Gitxsan forestry plan. Michael's work exceeded Gitxsan expectations, and mine. He then proceeded to the thesis.

As you will see in reading the significantly expanded version here, Michael brings together what is known about carving on living trees in North America from written sources, and then explores this tradition from a Gitxsan base. He relates his experiences of traveling to the sites of these carvings and learning from the First Nations people knowledgeable about them, making this a voyage of shared personal discovery as he explores more and more leads, broadening his and therefore our experience, from the hop pole of the Stó:lö to the images in trees of the Gitxsan, the Carrier, and the Tahltan, Tsetsaut, Duneza, and Ojibway. Michael prepares us for this journey by presenting some of the oral traditions that reveal the sacred quality of the tree as an *axis mundi*, or means of transcending from this world to the spirit world and back again. The respect he accords these traditions, and the practices of the Gitxsan and other First Nations in trapping lynx and wolverine, plus his portrayal of the drama of finding the faces in the forest, convey much of the First Nations appreciation of the forest as a sacred space, a sacred place.

Michael's thesis defense – the second defense of a master's student in First Nations Studies at the University of Northern British Columbia – was a significant event. It took place in the Gitxsan village of Kispiox where the audience included not only his uncle Walter Harris, Chief Geel,

but also Alvin Weget and a host of other Gitxsan chiefs and leaders. Alvin Weget recounted the story of seeing Michael when he was first doing his internship, and not knowing who he was, since Michael did not grow up in the community. Because Michael's mother is European, he does not look obviously Gitxsan, and Alvin Weget said that he originally went into the office of the Gitxsan to ask why this white person had been hired to do this important work. Weget then laughed and said, "They explained who he was, and today, hearing him address us in Gitxsan, I know he is Gitxsan." Walter Harris positioned himself during the defense to demonstrate that he is the head chief of the house to which Michael belongs. Since that time Michael has been given a feast name, making official his position with this matrilineal society. Since that time, as Michael relates in this book, he has begun his training in carving in the Gitxsan tradition.

Michael responded to the questions in the defense excellently before this distinguished audience in Kispiox. The thesis had grown into a wonderful piece of work, and the whole community of Gitxsan could celebrate this achievement with Michael and his family. After the defense was over and its success an accomplished fact, Michael revealed to me that he bears on the underside of his left ear a pierced-ear birthmark. To the Gitxsan, such a mark is a sign that the person is of high or noble rank: his or her ears have been ritually pierced in a potlatch or feast, to "ear mark" him or her as one preparing to become a high or head chief; a child born with such a mark is a high chief returned. Michael had demonstrated through his life that he is such a person, confirmed it through the defense of his thesis, and confirmed it again by revealing the ear mark he has carried since birth.

Since completion of his master's degree, Michael's training has continued in the challenging arena of forestry where he works as an intermediator between the Ministry of Forests and the First Nations people in the area where he is stationed. The part of this book which has changed most since the thesis is the section where he proposes a means of reconciling First Nations concerns about the preservation of forest ecosystems with the forest industry's focus on cutting timber as a money-making venture. This section is essentially new, and shows his desire to build a bridge between First Nations concerns for the stewardship of the forests and the imperatives of the globalized economy which relies on exporting British Columbia forest products. This bridge is not easy to forge. While environmentalists such as David Suzuki recognize the importance of listening to the wisdom of the Elders (Knudtson and Suzuki 1992), some of the pioneers in recording and listening to First Nations Elders' traditional environmental/ecological knowledge such as Julie Cruickshank and Fikret Berkes note the gap between the presentation of this knowledge and the intentions of the government and private sector. Berkes notes (1999, 176)

that traditional ecological knowledge (TEK) provides a challenge to positivist-reductionist resource management practice, and that the new interest in TEK comes from the fact that Western scientific effort, based on the principle that resources are there to be exploited, has resulted in their serious depletion.

While consultation with First Nations is required in British Columbia before a timber licence can be issued on First Nations traditional territory, the desire to extract timber at the rate determined in the annual allowable cut all too often precludes the Crown's patience to stop and listen to First Nations concerns over the potential environmental impact. Not only forestry but also mining and pipe-line construction take place before archaeological assessment can be completed and First Nations have sufficient time to respond with their concerns about especially sensitive and sacred areas. Such concerns have resulted in numerous blockades of forestry, from Meares Island to Kispiox and other Gitxsan sites and beyond. Michael's proposal, which attempts to refine forestry policy to ensure that it listens more carefully to the First Nations voice, presents viable alternatives to present practice. Most importantly, he conveys over and over again the need to have and show respect for First Nations knowledge and appreciation of the sacred and spiritual nature of forests and the life forms that live within and from them, including human both Native and non-Native.

This book is well positioned to take us into the new millennium. As an integration of academic research and research with First Nations cultural and environmental experts, it provides a model for further cross-cultural scholarship, showing not only the fruits of bibliographic research but also the value of listening with attention and respect to the knowledge of First Nations Elders and the younger generation of First Nations people who have been taught and can articulate their cultural traditions. The use of oral traditions in *Faces in the Forest* represents one of the ways these rich traditions to inform us of the meaning of culturally modified trees. This is important now that the Supreme Court of Canada has stated in its Delgamuukw decision that, in the absence of written record, oral traditions will henceforth be recognized as valid history of First Nations. Their history is replete with experience of the sacred nature of trees, and of the intimate relation between practice and spirituality. In short, this book may be read for pleasure, but it may also be used in the academic study of forest use, First Nations or Native Studies, environmental studies, cultural geography, and history. My hope is that it will be so used, in order that others will hear what First Nations people have to say about the forest in the past, present, and future, and implement that knowledge that serves all peoples and the forests well.

Preface

Elders have warned me about creating meaning without knowing. They would not want me to create meaning for the sake of order where meaning may not exist, at least not in a profane sense. This book is a journey into the sacred forest; it is also an anthropological discourse from a First Nations point of view. While I was a graduate student in First Nation Studies at the University of Northern British Columbia, I was preoccupied with choosing a research methodology compatible with my cultural heritage. Anthropologists such as Paul Rabinow (1977), Vincent Crapanzano (1980), and Kevin Dwyer (1982) discuss their hesitancy to adopt accepted anthropological methods and their reasons for experimenting with new approaches. Essentially, their struggle is to choose between an artistic or a scientific representation of reality (Kloos 1990, 1). There is, however, a dearth of methods that can interpret First Nations reality without incorporating the colonial baggage shadowing Western anthropology, and so my own methodology evolved through the research process, crystallizing in the late stages of writing this book.

First Nations epistemology is commonly symbolized as a circular journey through the four stages of life. Each direction complements the other, culminating in the fourth stage, "the dawning place of wisdom" (Bopp et al. 1984, 62–3). Correspondingly, the first three chapters of this book complement each other to create a context for the secular and sacred interpretations presented in chapter 4. My approach to sharing the journey is similar to the modified phenomenological academic approach Rabinow undertook: "what you will read in this book is meant to be a whole, in which the meaning of each chapter depends on what comes after it. What the book and these experiences are about is themselves" (1977, 6). A discussion of methodology is necessary here to involve the reader in the research process. The discussion includes a definition of the problem; a description of my cultural stance; the derivation of an art research

methodology; and reasons for integrating oral history as evidence. The research problem addressed here is to give evidence credible from both an academic and a First Nations point of view that establishes the existence and possible interpretations of First Nations art created on living trees. A secondary problem is to develop a methodology for interpreting meaning.

I continue to struggle with the degree to which my personal journey is interwoven with academic discourse. Academia requires research to be unbiased, critical, and reproducible. Gitxsan Elders advised me to be respectful of their worldview, and to show an unquestioned acceptance of their oral history, the adaawk.[1] They also foresaw the importance of my research in their land claims struggle, however, and therefore wanted my research to be defensible. The two cultures blended and tugged to shape this book. I want both academia and the Gitxsan people to accept the validity of my research. The challenge is to share the journey in a manner which elucidates a credible level of critical detachment. I need to separate, for the reader, where possible, my personal and cultural perspective (Rabinow 1977, 5–6). Edward Said (1978, 25) introduced his book *Orientalism* by emphasizing how important it was for him to provide the reader with a cultural inventory of himself, as the "Oriental" author of *Orientalism*, before he entered into his critique of how Western historical traditions portrayed the "Orient." I follow suit with my own brief cultural inventory.

I was born in 1961 in Smithers, British Columbia. My father is Gitxsan, and my mother is of European descent. My Gitxsan name is *Ama Good-im Gyet*; I am a member of the House of Geel. My childhood years were spent growing up in small communities in British Columbia, and both my parents taught me to respect and enjoy nature. Now I am a professional forester and an artist. I began exploring my Native heritage in 1986 through painting, pen and ink portraits, and photography. The spirit of my art has always been with me, and it is inspired by my First Nations heritage and by Mother Earth. I always take the time to appreciate the plants, animals, light patterns, and water movements, and to listen to the Earth's messages when I am hiking.

First Nations culture is strong and has survived despite the oppressive effects of colonialism. On the other hand, the culture cannot return to the form it had prior to European contact. I have found a way to feel comfortable in the Western and Gitxsan cultures. My place is at the edge of both, where the two cultures interface; I have a foot in each world. I guide the reader through transitions in perspectives, just far enough to respect the other's perspective, because we can never be completely uprooted from our cultural stance.[2] *Ego-edgism,* defined here as *a personal perspective or worldview in which one's ego is equal to but different from others,* is a conceptual model I have developed to present a balance between First Nations and Western academic ways of knowing, and it characterizes my

stance as author. Although I am presenting this material, my own perspective is put aside as the Elders, as local experts, share their knowledge of tree art. There are many voices, academic and First Nations, in this book. My role is to create a context where differing interpretations can coexist. First Nations and academia must validate the research cooperatively; I defended my Master's thesis in the Kispiox community hall in front of my Elders and the university evaluators because I wanted feedback and approval from both groups. As we explore tree art from a variety of First Nations perspectives, you are encouraged to explore your own views, and then to support others' perspectives as being equally valid. Ego-edgism moves beyond deconstructing the centric qualities of Western academia, as Edward Said set out to do; it is a forum for sharing knowledge – a two-way exchange.

My research methodology was developed from those used to examine First Nations art, which have in turn been informed by both anthropology and art history. Key methodological elements from both disciplines are summarized in a table (see the appendix) to facilitate their comparison. Joan Vastokas was one of the first Canadian art historians to point out that "as a field of historical enquiry, native art of North America is relatively neglected and underdeveloped" (1986, 7), and she ascribes this void to the "inadequacy of current art historical theory and method in dealing with pre-historic and non-literate traditions" (13). She separates her analysis into three temporal categories: prehistoric, historic, and contemporary. Direct observations and descriptions of the artwork, such as the photographs and Elders' commentary used in this research, are the primary data. Secondary sources such as diaries, journals, narratives, and biographies of early explorers, traders, missionaries, Indian agents, and travelers are also useful, and are important sources for this study. Vastokas' goal is to reconstruct the meaning and chronology of artworks (1986, 20–3). Chronology can be determined through quantifiable data such radiocarbon dating or by analysing qualitative 'internal evidence' (23). Once chronology is established Vastokas begins the more difficult task of analysing "meaning," which is especially challenging for prehistoric works. She outlines three types of meaning, as shown in the appendix. The first is the function of the object. The second, implicit meaning, is inferred from the broader social context of the art, while the third, explicit meaning, can be derived from the subject matter directly. Vastokas points out the problems in trying to determine the meaning of prehistoric art by the "ethnographic analogy" approach, whereby functional and iconographic meaning is found by drawing analogies between the art of recent peoples and the art of prehistoric peoples. Vastokas advises caution in the use of this approach, and suggests that oral history, historical written accounts, and ethnographies are good sources of direct information.

In a later book, Vastokas adds a fourth type of meaning: "Given the conceptual paradigm of 'performance' as the tie that binds art, society, and environment together, and given the recognition that 'lived experience' is the crucial foundation for human communication and mutual understanding, even across cultures, what is needed is a total re-definition of what constitutes the dimensionally of the art object" (1992, 37). John Antoine Labadic (1992, 5) separates art history inquiry into two distinct modes, intrinsic and extrinsic. The intrinsic mode considers aspects such as style, function, and iconography, and is similar to Vastokas' implicit meaning. Labadic describes the extrinsic mode as focusing on the "examination and interpretation of the factors and conditions surrounding and shaping art objects" (6). A question is asked and qualified by identifying the art-historical mode, the aspect of inquiry (style, iconography, artistic biography), and the focus of the question (techniques and methods of painting). These two art history methodologies concentrate on dating the artwork and then determining meaning external to the culture. Anthropological methodologies, on the other hand, tend to analyse meaning within the cultural context.

Anthropological methodology overlaps with art history methods in a number of areas. For example, Evelyne Hatcher (1985) describes six categories of meaning that include all of Vastokas' categories. Aldona Jonaitis' methodology differs in that she focuses on the source of the meaning rather than on an interpretation of the meaning. Jonaitis analyses Tlingit art and structures her analysis on secular (ordinary) and shamanic (extraordinary) sources of power. Secular art enhanced the social life of the village, while shamanic art represents the array of objects that the shaman used to transcend the natural to the supernatural (1986, 13). The role of art in forming and maintaining relationships between the two sources of power in the culture was very important. As these relationships changed over time, the art also changed to accommodate new relationships between humans and the supernatural (149). Anthropologist Howard Morphy (1991) uses an art research methodology that closely resembles a mixture of Jonaitis' and Hatcher's methodologies, and some art history methods. Morphy conducted his field work over a ten-year period among the Yolngu people in Arnhem Land, Australia. He viewed contemporary Yolngu art as a system of knowledge, and his primary aim was "the explanation of form in relation to use" (1991, 5). Morphy focuses on the reasons why an artwork has a certain shape and why it was made in a certain way. In other words, he studies the art-making process, and the artwork in relation to culture. Vastokas is similarly interested in the art-making process and its ceremonial performance. Morphy's approach, like Vastokas', begins with a chronological study, followed by an analysis of meaning. As shown in the appendix, he has

three categories of meaning: An element of a painting has denotative meaning when it signifies a particular object, and connotative meaning when the observer has to understand the overall context to understand the meaning. Sociological meaning is a mixture of denotative and connotative meaning.

The scope of research for each of these methods spans a variety of aboriginal cultures. The similarities between methods outweigh the differences, however, and we can infer a core set of objectives and questions for a First Nations art research methodology. Morphy's methodology, since it includes most of the themes proposed by the others, provides a good starting point. He balances emphasis on chronology, function and meaning, and the power of the artwork. He also recognizes the significance of context, a factor which is stressed in the content and structure of this book. Morphy's model, however, does not explicitly distinguish between secular and shamanic sources of power, which is a strength in Jonaitis' treatment of First Nations art. His model could also be enhanced by incorporating Vastokas' notion that art is a "lived experience," and Hatcher's focus on the role of ambiguity and metaphors in determining meaning.

Morphy's research model, strengthened by these additions, informs my own interview questionnaires and field notes, and the focus of this book. While art history methods promote the classification and chronology of art, however, these are de-emphasized in this research, given the dangers inherent in using language to attach meaning to visual images such as tree art. Michel Foucault (1994, 10) believes the meaning of a visual image can emerge only from the "grey" ambiguity of anonymous language, rather than from the false clarity of a taxonomic description. He demonstrates the tension between language and the image in his description of a painting of a painter painting a painting of himself painting the painting (5–16). The painter is Velazquez, and the painting is *Las Meninas*. If one were to read Foucault's discussion on the painting of a painter at work without the benefit of seeing the painting, his words would only seem to spiral into an infinite abyss of confusion. On the other hand, the conjunction of his ambiguous discussion with the painting itself illuminates the painting *and* the text. In this book I avoid classifying tree art by form, style, or design because "it is in vain that we say what we see; what we never see resides in what we say" (Foucault 1994, 9). Foucault describes the relationship between language and the visual image infinite. I see greater value in encouraging a discourse on tree art than in attempting to satiate the curious with concrete answers. In the end, only one person can attach complete meaning to the art – the artist. Foucault describes the appearance of visible order as the "superficial glitter above the abyss" (251), and suggests that neither words nor the visible image can be reduced to the other's terms.

It is not that words are imperfect, or that, when confronted by the visible, they prove insuperably inadequate ... But if one wishes to keep the relation of language to vision open, if one wishes to treat their incompatibility as a starting point for speech instead of as an obstacle to be avoided, so as to stay as close as possible to both, then one must erase those proper names and preserve the infinity of the task. It is perhaps through the medium of this grey, anonymous language, always over-meticulous and repetitive because too broad, that painting may, little by little, release its illuminations (9–10).

In addition to the tension between tree carvings and their written description, French postmodern sociologist Pierre Bourdieu would point out a tension between the tree carving and the lived experience of seeing the faces in the forest. The reader's experience of reading this book would be quite different had he or she observed tree art within the context of a forest, or watched the artist carve the face in a tree centuries ago or today. Bourdieu (1977, 3) emphasizes the phenomenological experience, or lived experience, as a means to "make explicit the truth of primary experience of the social world." Interestingly, Bourdieu turns to art early in his attempt to identify the limits of objective observations by quoting Husserl.

To treat a work of plastic art as a discourse intended to be interpreted, decoded, by reference to a transcendent code analogous to Saussurian "*langue*" is to forget that artistic production is always ... pure practice without theory ... and it is also to forget that the work of art always contains something *ineffable*, not by excess, as hagiography would have it, but by default, something which communicates, so to speak, from body to body, i.e. on the hither side of words or concepts, and which pleases (or displeases) without concepts (1–2).

The modified Morphy approach recognizes a clear distinction between the intended viewing context and the actual viewing context of the art. So often the actual viewing context, such as a museum, is quite different from the artist's intended viewing context. The researcher can only truly "experience" the performance of an artwork in its intended viewing context. For example, carved wooden human-like figures which guard the shaman's grave can only be experienced within that context.

Finally, the researcher must recognize that art has power. Artistic mastery can give art its power, and make it a locus of supernatural power. The spiritual inspirations that motivate an artist must not be underestimated.

First Nations art research can be a focus unto itself, or it can complement oral history research projects. Art can check the validity of oral history interpretations, given that "[a]ll oral cultures are equipped with a rich store of visual symbols and images. These images, used in conjunction with social actions and 'performed words' – words spoken, sung or

danced – provide meaning and cultural identity to a community of users. Visual images supplement the performance of words to communicate more fully the flow of meaning between persons" (Daly 1993, 226–7). Oral history can in turn test the validity of art research results. The two are complementary, and interwoven. Oral sources are therefore integrated into this book to illuminate the written record and physical evidence discovered by research. After all, the initial purpose of writing was to enhance orality (Ong 1982, 5, 9). Writing was first used to capture speech, ancient Greek oration, for example, before eventually evolving into "strictly written compositions, designed for assimilation directly from the written surface" (Ong 1982, 10). Oral history, the adaawk, is a persuasive force in Gitxsan culture. This force is derived from the respect earned by an Elder telling the history, and the Elder's connection to the ancestors. Julie Cruickshank (1994, 408) defines oral tradition as a "coherent, open-ended system for constructing and transmitting knowledge." Ong focuses on a simple characteristic of oral cultures – "they have no knowledge at all of writing."[3] My Elders are quick to remind me that the adaawk is not a story, which Western culture interprets as fictional entertainment – it is our history.

First Nations epistemology is so highly integrated that it becomes difficult to draw clear boundaries around distinct packages of knowledge. The information included in this book has been marked by Elders as being relevant to the understanding of tree art, and it may provide clues for further study of the art form. There is no singular First Nations perspective, and thus Elders from many First Nations cultures share their knowledge through interviews and ethnographic transcription. Many oral histories were recorded by people such as Marius Barbeau, Franz Boas, William Benyon, and James Teit. Recorded oral history is valuable because it reflects the spiritual beliefs and values of Elders who lived in an earlier era. Claude Lévi-Strauss (1995, 84) has suggested that there is a link between mythology and ritual which "must be sought at a deeper level." There is also a link between verbal art (telling stories), and tree art. Each art form enriches meaning; a story is associated with tree art. Additionally, the context, or cultural and physical landscape where both art forms are performed, enhances the artwork's meaning and aesthetic power.

Two types of oral sources are used in this book: interview dialogue, which is a transcribed conversation between myself and an informant, and oral history, recorded in transcript form by another ethnographer. Interview dialogue has the informant's name attached to the transcription.[4] Transcribed oral history is integrated into the text in italics. This presentation of dialogue and transcription reminds the reader that the text was communicated orally; how oral sources are integrated into written text is crucial to ensure a context is set for its interpretation. I introduce

the oral source by describing the informant or translator, and my inter-
pretation of the dialogue or translated oral history immediately follows
the text. Framing is also achieved by situating the text within the book's
structure and theme.

Keith Basso (1983, 33–5) identified four major categories of Western
Apache oral history, which I have adapted for this book: myth (I prefer
"creation oral history"); historical tale (I prefer "pre-contact oral histo-
ry"); saga; and gossip. Creation oral history deals with creation themes,
and is usually told only by medicine men and women and Elders. Pre-con-
tact oral history deals with incidents prior to white contact and focuses on
telling of persons who suffer taboo-related misfortune. Sagas deal with
historical themes within recent times (sixty to seventy years). Gossip is a
report of recent events in the here and now. Basso also identifies a minor
category he calls coyote stories, which should be a major category called
transformer oral history: the coyote, raven, and rabbit are characters who
have the ability to transform into human form, and thus a more general
category is required. I introduce oral texts with references to these cate-
gories where such a context will aid the reader's comprehension.

I interviewed Elders who have garnered great respect in their commu-
nities for their ability to memorize and verbalize history. Their tellings are
not challenged in their communities. Some academics, however, still hold
the erroneous notion that Elders' recollections are fallible and should only
be used whenever "trustworthy" records are not available (Allen and
Montell 1981, 68). Our present-day literate culture assumes that written
records have more force than spoken words, especially in court (Ong
1982, 96). For example, in 1991 Chief Justice McEachern discounted
three years of oral testimony because he could not accept it as a reliable
evidence in the Delgamuukw land claims case (Cruickshank 1994, 412).[5]
Some of this testimony proved invaluable to my research. The difficulty
for a researcher is that oral traditions leave no residue, such as written
words, to be deciphered (Ong 1982, 11). Cruickshank (1994, 408) points
out that "ideas about what constitutes legitimate evidence may differ in
oral tradition and scholarly investigation." Allen and Montell (1980,
67–87) provide two practical kinds of tests for assessing the validity of
oral sources: internal tests, which evaluate the material in terms of its own
consistency, and external tests, which compare and contrast oral infor-
mation with written accounts and physical evidence.[6] Internal tests should
also recognize that errors may be made in the translation from spoken
indigenous language to English text. Subtle shades of meaning may be
lost: when my aunt tells her friends a joke in the Gitxsan language and
afterwards retells it to me in English, she will often say, "It is much fun-
nier when I tell the joke in my own language."[7] Readers may also be mis-
led by the translator's choice of words: for example, "god" may be taken

to mean the Christian God. Boas's book *Tsimshian Texts* (1902) is a valuable translation because he includes the Tsimshian text alongside the English text, allowing those readers who know the Tsimshian language to critique his translation of the oral history.

Mircea Eliade (1996, 6) suggests that a common mistake in ethnology is to reject evidence that was limited to one informant. A single person, whether an Elder, missionary, rabbi, or monk, can be a reliable source because they are entrusted by a community to be the caretaker of knowledge. However, I present tellings from culturally and geographically independent sources where possible, in order to satisfy the reproducibility tenet of the scientific method: does another independent oral history narrative support the claim of the first? This is an external test.

Ultimately, I want to present a perspective that is truthful to First Nations history and culture.[8] Truth should stand independent of the maker. Mario Valdes (1992, 17) describes truth as "our concept of how things are in the world as a valid representation; more often than not, most of us suspend judgment or give the maker the benefit of the doubt until enough evidence has been gathered to move us to make a judgment." The worldview of one First Nation will differ to varying degrees from that of other First Nations and non-First Nations cultures. These differences are fundamental to the different perceptions of truth. Every effort is made to highlight cultural differences and to avoid "universalisms" by linking specific beliefs, stories, oral sources, and Elders to a nation of origin.

The underlying challenge in adapting or creating an art research methodology which respects the First Nations worldview without minimizing well-established academic research methods is twofold: 1) First Nations are often functionally oral cultures; and 2) First Nations art is also a form of communication. Western academia, on other hand, is primarily a literate culture. A culturally appropriate art research methodology is one that reflects the subject culture's preferences for written, spoken, or visual communication. Walter Ong (1982, 98) advises us, as members of a literate culture, to respect oral cultures: "Persons whose worldview has been formed by high literacy need to remind themselves that in functionally oral cultures the past is not felt as an itemized terrain, peppered with verifiable and undisputed 'facts' or bits of information. It is the domain of the ancestors, a resonant source for renewing awareness of present existence, which itself is not an itemized terrain either. Orality knows no lists or charts."[9]

Acknowledgments

These acknowledgments not only express my thanks to the many people who helped me along my learning journey but also symbolize the nature of the research. The tree carvings were located with the selfless help of many people: it would have been an impossible task to find these profound art forms in the vast forests of British Columbia and the Yukon without their guidance. They helped me locate a friend of a friend "who may know something," or they would dig through their albums for old photographs, or introduce me to an Elder and reassure them of my intentions. I am most thankful to the Elders: without their knowledge, tree art would be only a historical curiosity. There is a great debate among Elders about whether they should share their knowledge or not. Some say they should protect the knowledge from the intrusive and uncaring eyes of the colonizer by holding it tight. Others believe that the younger generations and non-First Nations people can learn from their knowledge and that their culture will only survive if it is shared. I take advice from both arguments, but ultimately, tree art is a gift that should be carefully shared.

These acknowledgments list the people who helped me research tree art, and then those who helped me write this book. But first I would like to give special thanks to all my family and especially Charlene, David, and Matthew; Mom and Dad; Sheila and Cindy; John, Michael, and Scotty; Joan and Dave; Jacqui and Gordon; Walter and Sadie; Thelma and Bob; and Joey. Their love, support, and guidance is so helpful and very much appreciated. I would like to recognize and thank Roger Martin at McGill-Queen's University Press for his support and encouragement. Doreen, thank you for the beautiful poem. Dr Antonia Mills was my guide and mentor for my learning journey. Her quiet and powerful wisdom helped me see with new eyes, with a sacred gaze.

Research and Review: Charlene Levis, Joe Himmelspach, Gordon Harper, Del Blackstock, Don Ryan, Antonia Mills, Rhonda McAllister, Nick Prince, Mary Thomas, Mildred Michell, Mary Louie, Richard Daly, Thomas King, George F. MacDonald, Sarah Gaunt, Ron Chambers, Frederica de Laguna, Janet R. Klein, Frank Malloway, Thelma Blackstock, Doreen Jensen, Mike McFadden, Willie Smarch, Larry Fault, John Thiessen, W. Warn, Morley Eldridge, Craig Hooper, Bill Poser, Art Wilson, Walter Blackwater, Walter Harris, Darlene Veigh, Neil John Sterritt, Stewart Ray, Thor Peterson, Jack Foster, Bob Pollard, Terry Dixon, Sophia Mowatt, Norma Mowatt, Russell Collier, Norm Larson, Mike Murtha, David Riddle, Joan Levis, Mike Wyeth, Gail Fondahl, Margaret Gagnon, Sophie Thomas, George Desjarlais, John Bedell, Ron Hample, Brian Bagatto, Genette Reynolds, Flo French, Joyce Sam, Art Sam, Dave Nordquist, Francis Seymour, Marjorie Serack, Rita Winkler, Fred E. Coy Jr MD, Herb Manuel, Bob McDonald, Albert Joseph, Philip Janze, André Arsenault, Fraser Russell, and Dan Peterson.

Writing: Charlene Levis, Antonia Mills, Jean Wilson, Lesley Barry, Joan McGilvray, Jim McDonald, and Leslie King.

Funding: This book has been published with the help of a grant from the Humanities and Social Sciences Federation of Canada, using funds provided by the Social Sciences and Humanities Research Council of Canada. The research was partially funded by the Bill Reid Award Foundation.

Proceeds: A portion of the author's net proceeds resulting from the sale of this book will be donated to the Ksan Historical Society, Hazelton, British Columbia.

Faces in the Forest

CHAPTER ONE

The Long Way Around Is Closer to Home

Welcome to our journey into the sacred forest. As your guide, I share the mystery of First Nations art created on living trees. We traverse a difficult path through the First Nations and Western academic landscapes in search of ways to see and understand this sacred art. My foremost role is to set a context as we contemplate the meaning of a humble and powerful art form whose medium roots itself in Mother Earth. I also pause along the way to describe my search for a way to understand tree art. The story below was shared with me by Nick Prince, a Carrier writer and Elder; his guidance helped me choose a path for our journey.

Jimmy Burton and I went up north there, and it was cold. We snowshoed all day. We wanted to get to this cabin. And we had to go around this big swamp about four or five miles long, in the pine valley it was swamp, all of it. There was a space in between and we crossed that, and the cabin is way down that end. Geez, I wonder if we can just go across there? There's a place where there was a hole there [in the ice], it was melted you know. We go far enough around, he was doing all right ahead of me you know. I was walking about four feet from his trail. God dammed! I went down [through the ice]. Geez, son-of-a-bitch anyway. I was packing heavy too you know. He came, I said 'Don't get too close.' I said 'Just go and get a pole.' It was only a hundred yards from the bush. In the meantime I took my snowshoes off, I had to reach down and that stuff was warm. I untied my snowshoes, and leave that there. He got me out. And we went in the bush and made a shelter, and camp there all night. I changed my clothes, and it stink. 'Well,' he says, 'we learned a lesson, we got to listen to the old people' [Nick laughs]. Yeah, they used to say 'the long way around is closer to home.' That's a saying of the old people, they used to say that, you know. Yeah, there is a lot of things that we learn. Every day was a learning process. We didn't just go out there to trap, we went out there to learn. They were always teaching us (Prince 1995).

Nick said he had learned an important lesson that day when he took the short cut across the swamp and fell through the ice. He was reminded of his Elders' advice: "the long way around is closer to home."[1] Conscious of this lesson, I avoid the temptation to immediately explore the meaning of tree art; in the absence of a proper context, I might convey an incorrect impression. In other words, our path avoids the swamp's thin ice, or else I may muddy the waters of First Nations history. Many Elders said they would "only tell me what they knew about tree art," and nothing more. They were not comfortable in guessing or telling me second-hand knowledge. The Elders respect their history. The Elders are also reluctant to discuss other cultures, out of respect for the different lived experiences of their neighbours. I respect this wisdom by identifying the cultural perspective of people who have shared their knowledge, because their perspective may differ from that of other cultures.

My desire to avoid short cuts in developing an understanding of tree art and to respect First Nation's history was reinforced when I saw a carved face in the forest for the first time (figure 1). The face, sculpted on an old hemlock tree, stared at me down the old Gitxsan trail from another era, and stopped me dead in my tracks. I had never felt this power before, and there was no doubt in my mind that I was looking at a living spirit. I wanted to learn more, and simultaneously I felt the burden of responsibility associated with this encounter. At the end of my learning journey I came to understand who the spiritual power was that guided me to the faces in the forest.

Only a few tree carvings and paintings, lying hidden in inaccessible pockets of the landscape, have escaped the effects of industrial development. Consequently, there is a paucity of traditional knowledge regarding these old and wondrous creations: only a few Elders can now recall their meaning and history. This investigation into the history, meaning, and significance of tree art will ensure that First Nations people can pass on this knowledge about their land and art to the next generation. Equally important is the objective to increase the awareness of this art form for non-First Nations people so they can learn about and respect its meaning and beauty.

My journey was inspired by two events. The first occurred in the summer of 1994 while reading a paper on Tsimshian culture by George F. MacDonald (1993, 78). In his discussion of Gitxsan territories, significant bridges, and main trading trails, MacDonald notes, "Trails and property boundaries were marked with clan carvings on trees." I had never heard of carvings on trees before that moment, and as a professional forester and an artist, I was intrigued. The second inspiration came later in the fall when I asked my uncle, Walter Harris (Chief Geel), if he knew of tree carvings. Walter, who is a gifted master carver, told me that a forestry

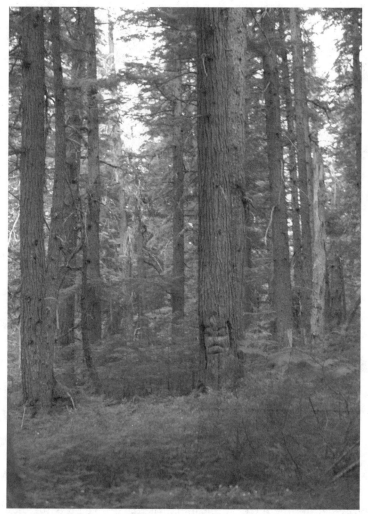

Figure 1. The first Gyetim Gan discovered by the author on the Anspayax-Kuldo trail.

crew found a tree on his territory a few years ago with a human form painted on the blaze, (the wood exposed by removing the bark), and he showed me the painting that had been cut out of the tree (see figure 2). I was fascinated. I had heard of petroglyphs and pictographs on rocks, but never of tree carvings and paintings. Why hadn't I heard of tree carvings? This question was as intriguing as the tree images themselves.

The ensuing journey, which I share with you here, was rich with spiritual and cultural experiences.[2] We will listen to Elders talk about tree

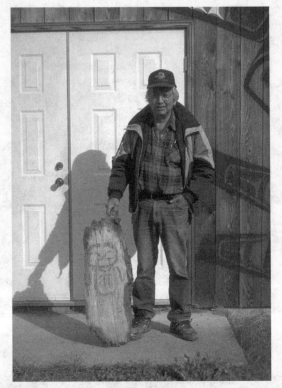

Figure 2. Chief Geel, Walter Harris, holding an
example of a Gitxsan arborograph.

carvings and paintings as markers of their history and culture. We will
search the First Nations landscape for an art form which has lain hidden
from the intrusive eyes of the colonizer for over a century in British Colum-
bia. We also seek answers to questions like: is tree art a First Nations art
form? What are the intended meanings of tree art? Who is the intended
audience for tree art? Why is tree art a mystery to the colonizer? Why are
faces common images? What is a "living tree" from a First Nations per-
spective? And how do we describe the First Nations landscape?

Our travels across the First Nations landscape follow the remnants of trad-
ing and trapping trails. They wind through old-growth forests, connecting
villages to food sources, spiritual sites, and each other. The trails were
known to connect the Coastal Tsimshian with the Carrier, and the Carrier
with other Dene nations such as the Navajo. The First Nations landscape
is a place where the sacred and the profane worlds are in balance and har-
mony, and this spirit of place, *genius loci*, is the inspiration and viewing

context for tree art. The destination of our journey is a shared experience and knowledge regarding the First Nations landscape and tree art. The journey has four stages: planning in chapter 1, preparations in chapter 2, travelling in chapter 3, and reflecting on the journey around a campfire in chapter 4.

I was inspired by Nick Prince's eloquent style, and I asked him how he chose a style when he wrote his manuscript on the history of Carrier people. He said, "There is always a story, it is the Indian way of telling things. They don't just say 'Oh, I met so-and-so over there,' they tell a story. It sticks with you that way." You will hear many stories about tree art and the sacred tree on this journey, such as how a Nisga'a chief was shot for not obeying the strict law regarding the exact length of his crest pole; why the Kitsumkalum people did not eat snow to quench their thirst; how a chief burned his regalia after he was converted to Christianity; how the Secwepemc respect the birch tree, and how the Dene sacred regard for the lynx came about. These stories reinforce the richness and interconnectedness of First Nations culture. Hugh Brody (1988, xxiii) introduced his book *Maps and Dreams* as a book of anecdotes and a research report which grew out of a resistance to colonialism. Here, the anecdotal evidence on the visual art form, tree art, is shared by the verbal artists, the Elders, and background research complements the Elders' evidence.

The Elders' oral tradition is a verbal art form where symbols are created from breath, speech, and memory (Ruoff 1990, 6–7). It is connected to visual art which can act as a reminder or symbol for stories. Jane Young refers to metonymic images "that evoke parts of tales and myths and the emotions associated with these vitally important 'texts.'" Rock art and tree art can be "metonyms of narrative" where the image "stands for and calls forth the verbal recitation" (1988, 122). For example, the recorded Iroquois oral history about tree spirits is a verbal art form which creates the context for the visual art form of the Iroquois false face mask. Navajo sacred chants or "Ways" are a combination of chants, sand paintings, and the ceremonial performance (Hausman 1993, 15–16). The sand paintings are visual expressions of the healing chant. The verbal, visual, and performance arts are one. The Elders' stories and commentary along our journey are an essential part of the visual experience of tree art. Verbal art enriches the viewing context of tree art, and tree art adds light, colour, and form to verbal art.

Paula Gunn Allen (1992, 241) compares "tribal literature" to a forest "in which all elements coexist, where each is integral to the being of others." All the characters have spirits, and none are purely heroic or evil. She explains that tribal stories have numerous points and elements that may come in and out of focus as your perspective changes. Allen warns the reader of tribal literature and oral histories to be aware that "as the old

tales are translated and rendered in English, the Western notion of proper fictional form takes over the tribal narrative." The imposition of "western tastes in story crafting" results in "a western story with Indian characters." Marius Barbeau's great unsung Canadian classic *The Downfall of Temla-ham* is a good example of a Shakespearean-like presentation of his carefully researched and translated oral histories.[3] Barbeau (1973, 247–53) heard many stories from Gitxsan Elders in the period 1920–24, and he translated and shaped these stories into a book. The book accurately presents Gitxsan history and culture but is wrapped in a flamboyant Western style which at times masks important elements of Gitxsan culture.

To extend Paula Gunn Allen's metaphor, an oral history is analogous to a tree in the forest. The roots and branches of each tree intertwine in a forest of greater cultural meaning. This forest is derived from a set of related stories, rather than from a single story. Here lies the enormous challenge of interpreting oral history, because there are no fast-food-like or take-out packages of knowledge.[4] The forest is created over time, by Elders telling a story each night to children, and patiently offering teachings by relating them to the previous night's story. Elders sometimes recount a story told to them by their Elders, and they will end by saying something like, "For years I think about what they say, and now it makes sense. They know what they were talkin' about." Some stories are planted in you by the Elders. The meaning will lie idle until you have matured enough to "know what they were talkin' about." The complexity of oral history forbids quick interpretation. The oral history presented in this book is as simple as my respect for its complexity will allow; furthermore, it is absolutely necessary to include, if I want to present a sense of tree art's spiritual context. I face a dilemma when presenting oral history since it is a highly interconnected art form, and it cannot be presented as snippets, or modern sound bites. The stories are meant to be understood, in context, as part of a whole.

Nick's lesson of crossing the ice motivated me to make careful preparations. We will be taking "the long way around" by preparing ourselves to see with new eyes, eyes that can see new meaning in the First Nations landscape and art forms. A discussion on the interpretation of First Nations art is the first of four preparatory discussions presented in chapter 2.[5] First Nations art has been overlooked as a sophisticated art form and communication medium. This preparation addresses the question of who is the audience for First Nations art.

The second preparation reviews the background literature on tree art, and consequently draws attention to how little we know about it. There is no in-depth research on tree carvings and paintings on living trees; there are only a few scattered accounts of these trees by ethnographers such as James Teit, and by explorers. The third preparation discusses examples of crest

poles, masks, and dolls, as art forms inspired by the spirits of the forest.

The fourth and final preparatory concept examines the role of the sacred tree in First Nations spirituality, and how it relates to tree art. The sacred tree is the artistic medium for tree art.[6] Throughout this preparation I address the question "what is a spirit?" I also investigate why trees are important cultural symbols, why trees have living spirits, why the supernatural tree plays a strong role in oral history, and why there is a sacred relation between man and trees in rituals of both life and death. Physically and spiritually, the forest and trees are the intended viewing context for tree art, and accentuate its intended meaning.

With preparations complete I guide you, in chapter 3, to a number of tree art sites. We will make about a dozen stops in British Columbia and the Yukon, and one in Manitoba. We will spend most of the time around Hazelton, B.C., but will also visit Chilliwack, Phillips River, which is north of Powell River, and sites near Fraser Lake, Tumbler Ridge, White-horse, and Haines Junction in the Yukon.[7] Our discussion at each site includes how the tree was found, my first impressions, some important characteristics of the artwork, and then, with the help of some Elders, its possible meanings. Each stop concludes with a look at the "second journey of meaning": tree art can take on a second meaning as the intended viewing context is transformed by the effects of colonialism and industrial development. George, who we meet at the first stop, will help us understand the second journey of meaning.

At the end of the journey, in chapter 4, please join me around the campfire. The campfire is a place for most cultures to tell stories, reflect on the journey, and ponder the future. A Tsimshian oral history will help focus our thoughts about the spiritual aspect of what we have learned. I also provide other reflections: as your guide, on the commentary given by the Elders, and the questions presented earlier; as a forester, on the lessons of the journey, with practical solutions to address our disrespect for the forest; and as an artist, on tree art and the role of the art form and the artist in helping us see the forest with new eyes.

The focus of this book is on carvings, etchings, paintings, drawings, or writings done on the wood or bark of living trees by First Nations people. The phrase "tree art" describes the general practice, and "tree carving" describes the specific practice of incising. The term *arborograph* (Eldridge 1991, 7) has been used to describe a painting on a tree, and *dendro-glyph* (Etheridge 1918, 1 and MacDonald 1993, 78) has been used to describe a carving on a tree. I standardize the terminology as follows:

- arborograph: a drawing or painting on the exposed wood of a tree
- arboroglyph: a carved image on the bark or exposed wood of a tree
- arboroscript: written or printed text on the bark or exposed wood of a tree.

"Tree art" covers all three types. The Gitxsan refer to carvings of a human-like face in trees as "Gyetim Gan," which means "person in the tree or wood." I occasionally use the Gitxsan term when I talk about arboroglyphs which are human-like faces.

I also want to distinguish between crest poles and tree art. ("Crest pole" is preferable over "totem pole" because First Nations people do not "pray" to a crest pole as a totemic god.) Although the crest pole is created from a tree, the village is the intended viewing context. The intended viewing context of tree art is the forest. Consequently, crest poles are familiar, easy to find, and well studied by ethnographers; tree art is unfamiliar, hard to find, and scarcely studied.

Rock art, petroglyphs, and pictographs are not discussed on our journey except in one story that is relevant to a possible meaning of tree art, about a pictograph commissioned by a Tsimshian chief named Legaix in the nineteenth century. The literature is voluminous regarding painting, writing, and incising on rock, but less so for geoglyphs, images created on the ground using boulders or scraping away the earth (see Kehoe 1965 and Aveni 2000 for examples of Plains Cree, Blackfoot, and Andean geoglyphs). Other unique types of rock art, such as the images inscribed on a rock by scraping away the lichen, which are called lichenglyphs, have yet to be studied (MacDonald 1995).[8] Since, as we have noted, literature on tree art is almost non-existent, Marie Battiste's summary of Algonquian rock art will suffice as useful background information for our journey:

For practical functions, Algonquian Indians used petroglyphs, pictographs, and notched sticks to communicate information and messages to friends and relatives of one's whereabouts or of routes and directions taken or to be taken, to relate stories of the hunt, of battle or of individuals or heroes of ancient times, to enlist warriors into battle, or to record historical events ... Algonquian Indians were known to have used pictographs and petroglyphs for communicating with the spirit world or for conveying individual visions and experiences with the spirit world. In effect, the Native texts represented a Native theory of knowledge, predicated on the existence of spirits, power, or medicine. Plants, animals, humans, and spirits of the universe communicated in the spirit world as one. Thus many Micmac petroglyphs illustrate the journeys of Micmacs to the world beyond. (1985, 9–10).

Communication with the spirit world and its relation to the trees and forestry will be an important theme for this book.

Preparing for the Journey

The real voyage of discovery consists not in seeking
new landscapes but in having new eyes
MARCEL PROUST

Tree art is a mystery to most people, even though it has existed for centuries. Explorers, ethnographers, archaeologists, and forestry professionals have traversed a landscape where tree art was unimagined, and consequently it remained unseen. On the other hand, some First Nations Elders are keenly aware of tree art and its meaning. To see the unseen, one must have "new eyes." Hyemeyohsts Storm (1972, 78–80) tells a Plains Indian story of how Jumping Mouse gave one of his tiny eyes to the ailing Buffalo. The Buffalo recovered because of Jumping Mouse's gift, and then became a great gift for the Plains people. Hawk heard this story and he asked the chief why the mouse gave away one of his eyes, and the chief responded, "This Mouse must give up one of his Mouse ways of seeing things in order that he may grow" (Storm 1972, 80). The little mouse woman is called Kwulanskisat, or Second-sight, by the Tsimshian. She has the ability to see the unseen and acts as a guide to travelers. You are lucky to have her help.

A magical walk I enjoyed in a Tolkien-like forest near Terrace reminded me of the importance of seeing with new eyes.[1] Joan Levis, my mother-in-law, told her hairdresser, Flo French, about my quest, and it so happened that Flo's daughter had seen some tree carvings near Terrace. I phoned her daughter, Gennette Reynolds, and she kindly arranged to meet me at Ferry Island. She told me how her children had shown her the carvings on the cottonwood (*Populus trichocarpa*) trees. We walked along the river edge trail, admiring beautiful little carvings that looked like elves playing in a forest. The carver was a mystery to us both, but the carvings looked very recent. I later learned of an article in the 8 November 1995 Terrace *Standard* newspaper, which revealed the mystery carver. He is Rick Goyette, and he estimated that he had carved over twenty-seven faces in the forest. He makes an interesting observation: "Adults don't tend to see them (the carvings) very often – it is usually the kids who

spot them." Rick is not a First Nations person, but his remark on how children relate to his faces is common to many cultures.[2] Some Gitxsan people believe that children are particularly aware of the spirit world, especially up to the age of three. They have the ability to see the unseen. I hope to help you see the unseen by introducing the artistic, historical, and cultural viewing context for tree art, and to help prepare your spirit by introducing you to First Nations spirituality. Such preparations focus light on the layers of meaning imparted by the Elders. The unprepared observer would be oblivious to the journey's richness in verbal and visual experience.

Four preparatory discussions follow. The first preparation examines First Nations perspectives on First Nations art. The second preparation reviews the limited academic knowledge of tree art. Beliefs in tree spirits and how they manifest in First Nations art is the topic of the third preparation. The fourth and most important preparation encourages an appreciation for the First Nations perspective on the sacred qualities of trees and the forest. The adaawk, or oral history, is a vital container of First Nations epistemology or ways of knowing, and passes on knowledge of how the sacred and secular worlds exist and coexist.

These preparations provide a cultural stance for viewing tree art that was lacking for early European explorers and researchers of First Nations life. The visual image is a poignant quality of tree art, but the meaning of the image is equally important and it is deeply rooted in First Nations philosophy, which was unclear or unknown to most Europeans. Remember, as you gaze upon the faces in the forest, that the visual stimulation will trigger meaning based on the culture that informs your gaze.

PREPARATION ONE: INTERPRETING
FIRST NATIONS ART

Tree paintings and carvings are a First Nations art form. "Art" has defied universal definition by the most able art historians, philosophers, critics, collectors, and theorists of aesthetics. The Gitxsan people, on the other hand, do not have a word in their language for art.[3] Doreen Jensen, a Gitxsan cultural leader, elaborates by saying, "This is not because we are devoid of art, but because art is so powerfully integrated with all aspects of life, we are replete with it ... When the Europeans arrived, they found aboriginal Artists creating beauty, culture, and historical memory. Art built bridges between human life and the natural world. Art mediated between material and spiritual concerns. Art stimulated our individuality, making us alert and alive. It affirmed our cultural identities" (Jensen 1992, 17–18).

"Art" is not defined in this study because creativity thrives on freedom, and this ambiguity stimulates creative discourse. Artists redefine art by

pushing the boundaries of culture; they avoid being constricted by an imposed social construct. Art transforms itself into new meaning and shape just when it seems to be defined. Bill Holm (Holm and Reid 1975, 108) describes the interpretation of Northwest Coast art as "the most dangerous game." He warns that "[e]arly anthropologists tried and tried to get interpretations from the artists themselves, but got widely differing interpretations from everybody. That's all right." Joan Vastokas (1986, 7) points out that, "[a]s a field of art historical inquiry, native art of North America is relatively neglected and underdeveloped." Often art historians have dismissed Native art because they view it as a craft or a primitive expression. However, according to Vastokas, "there is growing evidence that style transmits information about culture, and that form and imagery conspire together to communicate latent cultural meaning, even without the aid of written texts" (30). Thus art can reflect latent cultural meaning and/or an artist's desire to push the boundaries of culture. Art should be evaluated first on its own aesthetic terms and then cautiously for its anthropological value.

Art was first created at least 30,000 years ago in the limestone caves of what is now France and Spain. In the beginning there was a strong connection between art and spiritual practice: "By combining the mystery of prayer with the miracle of graphic depiction man came to terms with his environment" (Bowers 1987, 426). Antonia Mills (1996a) suggests that "[t]he dialogue was not between the artist's creation and a secular audience but between the object and the spirit world and its human and animal viewers. 'Art' and music had their goals to connect the human and the spirit worlds in a sacred manner." Although Bowers (1987, 430) goes on to say that the specific purpose of connecting the sacred and the human through art has dissipated over the centuries, especially in Western society, Doreen Jensen confirms that this sacred connection is still strong in Gitxsan art.

Until quite recently, First Nations art has been viewed as "primitive art" rather than "high art" by the Church, anthropologists, and art historians. For instance, Reverend William Henry Pierce, a respected missionary in Kispiox who was half-Tsimshian in descent, tells a sad story in his book *From ... Potlatch to Pulpit* of how a Bella Coola chief burnt ceremonial regalia soon after his conversion to Christianity.

Because of Tom's (Chief Tom) kindness to the missionary, he was greatly persecuted by all the other chiefs. While the young people were anxious to have a missionary and learn the new way, the chiefs and older people were strongly opposed to having any change whatever. This opposition made him all the more determined to become a Christian. After his conversion he became very anxious to burn all his idols which he said he had been serving for thirty years. Accordingly, one Saturday he informed me privately that it was his intention to destroy them all

that night after everybody had gone to bed ... At midnight two boxes were brought in, both filled with heathen treasures of all kinds, such as the secret whistle which belonged to the man-eater dances, dog whistles, wild dance whistles, aprons, head dresses, leggings, etc. These boxes he told me, had been handed down for several generations ... At two o'clock in the morning everything had perished in the flames (1933, 45–6).

Apparently some churches, such as the one in the Nisga'a village of Gitwunsil, were built using crest poles as floor beams.

Authors such as Larry Shiner (1994), Marianna Torgovnick (1989), Joan Vastokas (1986, 1992), and H. Gene Blocker (1991) have all contributed to deconstructing the latent evolutionist view that First Nations art is "primitive." Blocker describes a fundamental problem: "[t]he very term 'primitive art' indicates the problem involved in any cross-cultural study – that is, the problem of using 'our' concepts to study 'their' culture. It is a Western cultural perspective to suppose there is an evolution of cultures from 'primitive' to 'advanced,' and the concept of 'art' in the sense of 'fine art' is equally a Western designation and concept" (88). First Nations art is inspired by the sacred and secular worlds, just as Western art can be.

Perception proceeds from one's position as an observer, and this position ultimately creates the context for discourse.[4] The gaze affects the interpretation of art. "What [art] communicates depends not only on its own innate qualities, but also on the interaction with the viewer" (Mills 1996b). An observer from one culture examining the art from another should try to understand the perceptions of that other culture. Doreen Jensen eloquently reinforces this point. "If we pay attention, First Nations Art will remind us of this basic rule for being a human being: When I diminish others' "belongingness" in the universe, my own 'belongingness' becomes uncertain" (1992, 20). Vastokas (1992, 17) describes art-making thus: "The artist is a performer. Art-making is thus a process of performance, an engagement among self, product, and socio-environmental setting in all its dimensions. Art in any culture is not an artifact." Vastokas builds upon the work of the American philosopher John Dewey when she investigates the concept of art being an aesthetic experience "rooted in the sensate human body and its interactions with the natural and social environment." Art is a "lived experience." Vastokas says "the very experience of a visual art-work is in itself 'performance': the art-work and the observer engage in an active dialogue, even, a dance" (33). First Nations art, like First Nations culture, has too often been portrayed as primitive, while at the same time its obvious affective power is felt by most viewers even when they are unaware of the spiritual meaning or that it may be a visual communication system.

INTERPRETING FIRST NATIONS ART AS A VISUAL COMMUNICATION SYSTEM

A common assumption about First Nations cultures is that knowledge is passed on only through oral traditions. Non-Native researchers and First Nations peoples voice frustration because "there is no written record." But Fred Coy (1999, n.p.) suggests that messages on trees were a universal communication medium for First Nations in North America, and they were "apparently understood by all linguistic groups." The Ojibway recorded portions of their Grand Medicine rituals as pictographic symbols on birch bark scrolls (Ruoff 1990, 11), while John Adams (1986, 1) contends that the Gitxsan crest pole "is a form of writing system based on a ritual language," and "every pole tells a story." A figure on the pole may represent the story of the acquisition of a nox nox (spirit) crest, a clan crest, or house crest, and its placement on the pole is just as important as the selection of the form, style, and design. Adams calls the integrated system of crests and associated stories a language that represents a "magical geography" (10). Magical geography is the First Nations landscape.[5]

The lingering notion that First Nations art is "primitive" has, perhaps, forestalled the identification of First Nations art as a communication system. Garrick Mallery collected and described pictographs and petroglyphs found throughout the Americas in his two volumes entitled *Picture Writing of the American Indians* (1972). Being unable to understand what he had collected, Mallery assumed that American Indians, specifically the Maya, had only approached the use of "an alphabet or syllabary" and "had proceeded no further." He exclaims that only "[t]opers of the mysterious may delight in such dazing infusions of perverted fancy, but they are repulsive to the sober student" (773). Michael Coe (1993, 280) has recently disproven Mallery's conclusions by describing the Maya writing system as "a mix of logograms and syllabic signs; with the latter, they could and often did write words purely phonetically"; Mallery's brash statement stands as a warning to researchers to avoid ethnocentric assumptions about First Nations art. A good example of Carrier tree art which functions as a visual communication system (reported by Father A.G. Morice) is discussed in an upcoming section.

Interpreting First Nations art in terms of a visual communication system can be a dubious process without an appropriate theoretical framework. Authors such as Elizabeth Boone (1994), Michael Coe (1993), Howard Morphy (1991), and Robert Layton (1991) use Saussurian semiotics and the notion of semasiographics as a basis for interpreting picture or visual writing systems. Morphy's 1991 analysis of Australian Yolngu paintings highlights two important points. First, he stresses that the meaning of the paintings is dependent on the ceremonial context, the people, past ceremonies, and on "the set of iconographic and sociological meanings encod-

ed in them" (140). Second, he suggests that the spiritual power of a paint-
ing can be enhanced by aesthetics. For instance, he describes the shim-
mering effect of finely cross-hatched lines on paintings as representative of
the bright lights of the ancestors (138). Artists can enhance the spiritual
power of their work through their artistic finesse. Consequently, talented
artists were recruited to create important tree art, masks, and poles.

The following discussion provides an overview of how these authors
interpret the use of signs and particularly semasiographic signs, rather
than an in-depth discussion of the theories. Morphy gives the most useful
description of Saussurian semiotics and its application to the study of
meaning in aboriginal art.

The central idea behind the Saussurian sign is that it consists of two components,
the signifier and the signified, each of which has an independent existence in its
respective system of similarity and difference. The sign is the coming together of
the elements from these two systems of difference; it is not the representation of
an object that exists in the world outside. From a Saussurian perspective, the
object comes into being through its encoding in a sign system and can then be used
in communication by others who know the code. There is, of course, no limit to
the number of codes that an object may be encoded in, but in each case it involves
a conjunction between two different systems of similarity and difference ... The
importance of this Saussurian perspective to the anthropology of art is twofold.
The first is that it does not give priority to verbal language over other systems of
communication, but allows other systems an equally independent role in the
encoding and transmission of objects and ideas. Second, it allows for the fact that
different sign systems, by encoding things in different ways, may encode different
things (or the same thing with different values) and may have different commu-
nicative potentials ... The search for a medium to communicate a message, for a
new conjunction of a set of signifiers with a set of signified, lies at the heart of
much artistic and technological creativity – the discovery of ways to say what had
previously been unsayable (1991, 143–4).

The goal of an artist is to creatively imagine ways of communicating the
unsayable (encoding) and seeing the unseen (decoding). The art (or sign)
has two aspects: the signifier (sound-shape: form, style, and design) is cre-
ated by the artist (encoder) to communicate a concept, feeling, dream, or
vision (the signified) to an intended audience (decoder) familiar with the
conventions of the art (writing system) and the viewing context (forest or
ceremony). For example, a stop sign only has an agreed-upon meaning
when it is placed at the intersection of roads. But how would it be inter-
preted if it were placed in an elevator?

Boone (1994) examines visual systems of recording and communicating
information in pre-Columbian America. She defines writing as "the com-

munication of relatively specific ideas in a conventional manner by means of permanent visible marks" (15), and places Sampson's (1985, 26, 17) glottographic and semasiographic systems of writing within this defini-tion. Glottographic systems represent speech that includes phonetic and syllabic systems. Semasiographic systems "convey ideas independently from language and on the same logical level as spoken language rather than being parasitic on them as ordinary scripts are" (Boone 1994, 15): for example, the international road-sign convention communicates with drivers independent of their native language (Coe 1993, 19). The sema-siographic system includes a set of signs, or visual marks, in which mean-ings are suggested, independent of words or sounds, which have been pre-viously agreed to by the encoder and decoder (Coe 1993, 19 and Boone 1994, 14). Boone describes two kinds of semasiographic systems: 1) con-ventional: meaning is indicated by the interrelationship of arbitrary (non-intuitive) symbols such as mathematical notation; and 2) iconic: an intu-itive logical system of symbols such as road signs (16).

The semasiographic system does not constitute a written language since it functions independently of language.[6] However, Coe (1993, 20) does give an example of a semasiographic system devised by an Apache shaman called Silas John whereby a series of signs were painted on buck-skin and "read" in Apache without transmitting phonetic data. Hertha Wong (1989, 295) also describes a symbolic language that may be a type of semasiographic system, used by Plains Indians in the late nineteenth century to "read" autobiographies painted on robes, tipis, and shields. Wong suggests that pictographic communication was commonly practised by the Plains people. She describes the pre-contact pictographs as follows: "Such 'picture writing' was meant to record and to communicate rather than to please aesthetically. Before 1830 these pictographic narratives were a type of shorthand ... One well-known example is the pictograph-ic robe of Mah-to-toh-pa (The Four Bears), a Mandan chief. In 1832 George Catlin visited the Mandans and reported that Mah-to-toh-pa wore a robe with 'the history of all battles on it, which would fill a book'" (297–8). Wong focuses on the historic accounts and descriptions of pic-tographs rather than on interpretation methodologies, and therefore, although the Plains pictographs appear to be semasiographic, it is not pos-sible to analyse the visual communication from her accounts. For exam-ple, it is not clear whether the pictographs can be interpreted independ-ently of the Plains language. Richard Daly summarizes his approach to understanding the meaning of prehistoric Stein Valley pictographs as a visual communication system or "non-alphabetic literacy" as follows:

As in art, the rock writing imagery is mnemonic and acts as a prompt to human expression, both in the writer and the reader. Indeed, it is argued that early

writing in Ancient Greece – as it had developed by 700 B.C. – supplemented traditional oral recitation, and only much later did it transform oral culture to 'literate' culture (Havelock, 1986). The units of such writings are pictures and notations that often possess common referents that pay little heed to linguistic boundaries. These images can unite people from different languages by means of visual cultural commonality, but unlike alphabetic writing, they do not unite a population linguistically (1993, 223–4).

Daly suggests that rock art is a common visual communication system that can unite different language groups, since a decoder does not necessarily need to know the language of the encoder to interpret a semasiographic system (Boone 1994, 17). Nevertheless, Coe (1994, 43) suggests that knowledge of language is a prerequisite to deciphering a writing system. In *They Write Their Dreams on the Rock Forever*, Salish Elder Annie York refers to the Stein rock art and a writing on a tree as "writings" (Arnett et al. 1993, 3). Her descriptions of dreams portrayed in the rock paintings give essential information on the meaning of the art; without the cultural insight she supplies, the art would provide a visual and artistic experience for the viewer but the artist's meaning would not be clear. Much of the cultural meaning would be "unreadable" by outsiders, those not "fluent" in the symbolic language of the paintings.

The trans-linguistic semasiographic system is the most likely visual communication system a First Nations art researcher would encounter. Bill Holm (1990, 602) groups the art of First Nations in the Northwest into three major stylistic and conceptual divisions that were expressed in the nineteenth century:

1) Northern province: Tlingit, Haida, Tsimshian, Haisla, Haihais, and Bella Bella
2) Central province: Kwakiutl and Nootkans
3) Southern province: Coast Salish, Chinnookans, and people of the Oregon Coast.

The languages within these groups are quite different. However, consistent stylistic art forms may have functioned on a rudimentary level as a visual communication system for marking and establishing territory for trade and for brokering power relationships. Holm confirms that Northwest Coast artists had "a highly developed system for the organization of form and space in two-dimensional design as adjunct to the well-known symbolism" (1985, 92). "As in all art it remained for the imagination and sensitivity of some of the most imaginative and sensitive men to give life to a list of rules and principles and produce the wonderful compositions that came from the northern coast" (93). "The conventions of the art were so strong, or the Indian artists so conservative, that the introduction of trade paints did not materially affect the selection and use of color" (26).

For example, crest symbols are understood by groups across linguistic boundaries as it is crucial for clans and tribes to understand and recognize the power associated with a crest pole or house front clan symbol.

Tree art's primary function is as a communication system. The question is to whom does it communicate, what does it communicate, and for what purpose? Saussure's anthrocentric assumption was that humans were the only audience for writing systems. However, the audience of tree art could be animal spirits or spirits of the ancestors, as we see on our journey in chapter 3, as well as human and secular, seeking territorial boundaries. Additionally, the meaning inherent within tree art as a communication system is highly dependent on the intended viewing context. Illustration of this can be seen in Altman's description of a form of tree art created in a ceremonial context by the Arikara First Nations people of South Dakota.

The Arikara ceremonially honoured the cedar toward the time of the winter solstice. A suitable tree would be taken from the Badlands (a mountainous area in what is today western South Dakota), and brought to the center of the village. First, gifts were offered to the tree spirit. Later on, the tree would be "attacked" by members of the different secret societies who made up the priesthood of the tribe. The bottom of the tree was painted red, and hawk feathers were attached to its top. Then the tree was taken to another spot and set erect on a sacred stone pillar, considered by the people to symbolize the foundation of the world. Grandmother cedar would remain there until the spring thaw, when the mothers of the tribe would fasten their childrens' moccasions to its branches. The cedar tree was then consigned to the nearest river. The Arikara believed that the spirits of their ancestors dwelled downstream, where they would see the childrens' moccasions tied to the tree as it came into view. It would be a message to the ancestors that future generations of the tribe were alive and well (1994, 95).

Here the audience is the spirits of the ancestors and the intended viewing context a ceremony of renewal.

Joan Cardinal-Schubert (1992, 19), a Canadian First Nations artist, tells a story that reflects the infancy of our understanding of First Nations art as a communication system: "When I was a child, my father showed me the signs on the trees, old messages emblazoned in the bark and grown out of sight. Out of reach ... There was a preciousness in these hidden messages, available only to those who knew they were there." A First Nations perspective helps us find and understand the messages. In the second preparation we learn how little was the information available for the Western world about tree art and its hidden meaning as a communication system.

PREPARATION TWO: RECORD OF TREE ART

As we have seen, Western discourse on First Nations art is practically barren of any accounts, analysis, or even mention of tree art. I suggest that since early ethnographers and explorers did not view the marks on trees from a First Nations perspective, their significance and meaning remained unseen. Logistics also played a role: early explorers of the west like Simon Fraser, Samuel Black, and Alexander Mackenzie traveled primarily by river and not along the forest trails, and therefore there were few early observations to spark interest. The following accounts were recorded as curiosities rather than as serious inquiries.

Before reviewing the written record regarding tree art, however, I would like to briefly explore tree art created by the Widadjuri and Kamilaroi people in New South Wales, Australia (Altman 1994, 81–2), the Moriori people of Chatham Island (King, 1990), and the Māori of New Zealand (National Museum 2000, 1–5).[7] Robert Etheridge Jr published the essential work on Australian Aborigine tree art entitled *The Dendroglyphs, or "Carved Trees" of New South Wales* (1918). He classified seventy-seven sites of interest into two types of dendroglyphs (see figures 3 and 4 for examples): 1) *taphoglyphs,* or grave or internment markers, and 2) *teleteglyphs,* or trees carved with sacred totems or symbols, located on initiation sites, commonly called Bora grounds. Etheridge was careful to point out that a casual observer may incorrectly assume that taphoglyphs were imitations, developed after European contact, of a wooden tablet to mark a grave (34). His discussion on antiquity carefully argues that taphoglyphs were created long before European contact, and therefore their purpose should not be equated with that of European gravestones. Etheridge recognized the difficult task of unraveling meaning, but he did establish possible patterns. For example, he suspected that taphoglyphs were marked with "family marks" or *mombari* (29). Bora grounds,[8] the site of initiation ceremonies in Eastern Australia, are surrounded and marked with tele-

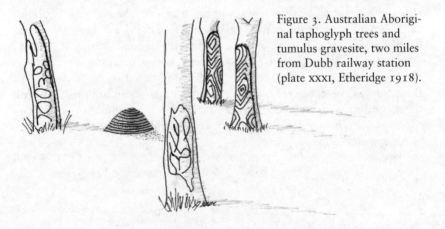

Figure 3. Australian Aboriginal taphoglyph trees and tumulus gravesite, two miles from Dubb railway station (plate XXXI, Etheridge 1918).

teglyphs. The purposes of teleteglyphs include 1) totemic representations of supernatural beings such as the giant serpent; 2) notches or spirals carved in the tree to allow spirits, such as Daramulan,[9] to descend from the sky during the tooth extraction ritual; or 3) instructions on food related taboos (61, 72–5).

Etheridge's study has a taxonomic research approach: it provides detailed descriptions of the tree's location, descriptions and diagrams of the designs, and settlers' impressions of the meaning. The study does not, however, include the Aboriginal point of view, although there are hints of tree art's sacred nature. One account describes grave sites in Kamilaroi country without bodies and surrounded by carved trees which were meant to cheat or trick a malevolent or evil spirit by misdirecting it from the real grave. There is one quote which may be a window, within the book, into the Aboriginal purpose of taphoglyphs: "The carving on other trees which I have found in aboriginal cemeteries has described the initiatory, tribal, and clan merits of the deceased, and intimated that not only had he been favoured by many good and evil spirits during his life, but that his own power for good and harm was now extended" (33). The concept of transferring the spirit of the deceased into or through a tree is examined later, but seems to be a possibility expressed by Etheridge. The Aboriginals of New South Wales, I am sure, can offer sacred and secular meanings unseen by Etheridge.

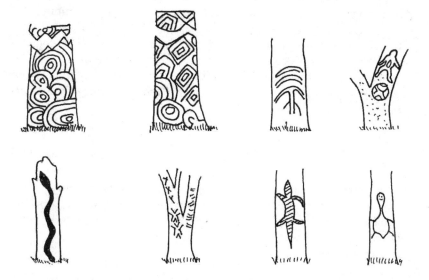

Figure 4. Samples of Australian Aboriginal teleteglyph tree art designs (plates VI and XV, Etheridge 1918).

Michael King (1990) describes the tree carvings on Chatham Island created by the Moriori people. Like the New Zealand Māori, these people are Polynesian, and in fact they sailed from New Zealand around 900 AD (King 1990, 11). The Moriori created dendroglyphs on kopi tree trunks. King reports that most of the images were of human figures that may be associated with death ritual. The number of carvings has been reduced, through clearing of the forests and wind damage, from thousands to dozens. Some of the remaining carvings are about 200 years old (11–13). The Museum of New Zealand Te Papa Tongarewa reports in their on-screen visitor service that

The soft bark of the karaka (*Corynocarpus laevigatus*) trees attracted the attention of Māori and Moriori artists who carved images resembling the human form on their trunks, both in the Wairapapa and Rekohu (the Chatham Islands). To the Moriori of Rekohu these tree carvings are *rākau momori*. To archaeologists, they are dendroglyphs and some fine examples can be seen in the *Mana Whenua* exhibition. As the bark on these trees continues to grow most of the old carvings have now disappeared. Fortunately many of the dendroglyphs were photographed in the early 1900s by Augustus Hamilton, a former director of the national Museum (National Museum of New Zealand).

There is no comprehensive research, such as Etheridge's book, which addresses the topic of tree art in North America. The tree art described in this section represents those occurrences mentioned in the literature, and in most cases the art no longer exists. I present these references by starting with the earliest records in eastern North America and then progressing to more recent accounts in British Columbia. One of the earliest accounts of "trees bearing marks" was originally recorded by John Cabot in 1497 (Batistte 1985, 9). Garrick Mallery's *Picture Writing of the American Indians* also has a historical reference:

The Living Tree, of the use of which for pictographic purposes there are many descriptions and illustrations in this paper. In addition to them may be noted the remark made by Bishop DeSweinitz(a) in *The Life and Times of Zeisberger*, that in 1750 there were numerous tree carvings at a place on the eastern Shore of Cayuga Lake, the meaning of which was known to and interpreted by the Cayuga Indians ... The Abnaki and Ojibwa have been and yet continue to be in the habit of incising pictographic characters and mnemonic marks upon birch bark (1972, 213).

Despite his many "descriptions and illustrations," it is difficult to discern from Mallery's catalogue which pictographs were on living trees rather than on rock. He does imply, however, that tree art was common.

Most of Mallery's references to tree art occur in his section on notices of direction, maps, and health of a traveler (1972, 329–57). He describes three human characters cut upon large jack pines, created by Ojibway people near Red Lake, Minnesota (see figure 5) (337). These figures indicate the direction a traveler took when leaving the trail. According to Mallery, a Micmac scout would warn of an approaching Passamaquoddy war party by drawing a notice on a tree which mapped the war party's direction of approach and indicated their number (see figure 6) (341). He also reports that the Abnaki people would blaze a tree near the butt to indicate the health of a traveler. A blaze on one side of the tree meant that they had poor luck in gathering food, and blazes on four sides meant they were starving (347).

It has been suggested that tree art was more common, within the United States, east of the Mississippi River (Coy, 1999, n.p.). The tree was the preferred medium in the eastern woodland, as compared to rock in Arizona. Bishop Loskiel recorded his observations of tree art in states such as Pennsylvania.

Their hieroglyphics are characteristic figures, which are more frequently painted upon trees than cut in stone. They are intended, either to caution against danger, to mark a place of safety, to direct the wanderer into the right path, to record a remarkable transaction, or to commemorate the deeds and achievements of their celebrated heroes, and are as intelligible to them as a written account is to us. For

Top: Figure 5. Ojibway figures drawn on jack pine trees (Mallery 1972, 337).
Bottom: Figure 6. Micmac map drawn on a tree (Mallery 1972, 337).

this purpose, they generally choose a tall well-grown tree, standing upon an eminence, and peeling the bark on one side, scrape the wood until it becomes white and clean. They then draw with ruddle, the figure of the hero whose exploits they wish to celebrate, clad in his armor, and at his feet as many men with heads or arms as fell by his own hands. These drawings last above fifty years, and it is great consolation to the dying warrior that his glorious deeds will be preserved so long ... (1794, 25).

Paul Wallace (1952, 18–19) describes the "Painted Line" or Towanda Path in Pennsylvania: "It received this curious appellation ... because of the many examples found along this path of picture writing. The Indians stripped a ring of bark from the tree and painted on the exposed surface with red ochre and charcoal, the news of the day." Coy (1999, n.p.) concludes that "it appears from the pens of the early recorders of history and keepers of journals that pictures on trees were universally used by the Native American for communication ... The carved or painted trees were usually found on or near trails or paths, at campsites or village sites, near salt licks, in general conspicuous areas germane to the occasion."

De Schweinitz's 1870 account of David Zeisberger's trip to Cayuga Lake, New York, in 1750 says:

Advancing now along the eastern shore of the lake, they forded numerous creeks, and came to a spot which their guide approached with proud steps and glowing eyes. It was the rude, but to him glorious, monument of the warlike deeds of his nation. The trees [oak and ash] all around were full of figures and curious symbols carved on the bark, – telling of battles fought and won, of scalps brought home, and of prisoners taken. He [a Cayuga Chief] led them to one tree in particular, and pointed out the history of his own exploits ... Man, in every age, and in all states of civilization, is swayed by the same desire to leave to posterity the tokens of his renown ... So in the remote wilderness, by the waters of Cayuga Lake, the trees of a primeval forest published the fame of its children. But while Egypt, Greece, and Rome still live in their memorials, broken though many of them be, and while the monuments of our times are viewed by admiring thousands, the oak and the ash, which recorded Cayuga greatness, have long since bowed under the white man's axe, and the history which their bark unfolded, like the race that it concerned, is well-nigh extinct (160–2).

Alongside De Schweinitz's egocentric use of words such as "rude" and "children," and his premature declaration of a race "well-nigh extinct," this passage provides an early record of tree carvings and a possible meaning of the carvings.

There are very few descriptions of tree art located between eastern North America and British Columbia. Oregon Hastings captured the

earliest photograph of a Kwakwaka'wakw tree carving in June, 1898. Hastings was a professional photographer who had accompanied Dr I.W. Powell's tour of British Columbia as Indian Commissioner in 1879. The photograph (see figure 7) shows a man or frog carved on a tree one mile west of Fort Rupert (near Port Hardy).

James Alexander Teit, an ethnographer, provided some useful descriptions of tree art while travelling through Lillooet, Shuswap, and Chilcotin territories in the late nineteenth century as a member of the Jessup North Pacific Expedition.[10] He describes carved figures on trees in the Lillooet territory, carved by adolescent boys and girls as the "record of their observances" (1906, 282). He is presumably referring to the visions they experienced during their initiation to adulthood. He also cites two more types of tree carvings and paintings:

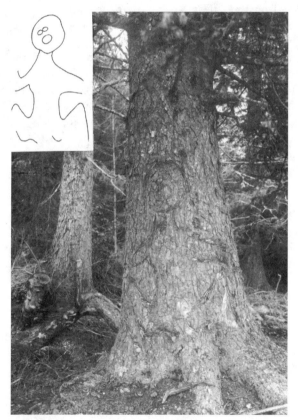

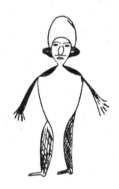

Figure 8. Teit's fig. 98 of a Lilloet carving of a human on the bark of a tree (1906, 283).

Figure 7. Frog or man carved on tree near Fort Rupert (Neg. no. 42996, courtesy of Department Library Services, American Museum of Natural History).

- In some places persons "passing for the first time" would paint orcarve figures on trees instead of rocks (see figure 8). When a tree was to be painted, the bark was removed (282).
- Trees by graves were sometimes stripped and painted by the Lillooet (273).

In the first description, the carved trees appear to be markers. The second description seems to suggest that the Lillooet carved or painted images as burial markers. Teit does not describe these images or their meaning.

Teit gave his second account of tree art in his 1909 ethnography on the Shuswap (Secwepemc) people. He shows one example of a Shuswap carving on the bark of a cottonwood tree (591) (see figure 9). He also writes about the Chilcotin people in a later chapter of this book, and he refers to seeing tree art in both the Shuswap and Chilcotin territories. I reproduce Teit's figure 281 here in figure 10, which shows two human-like images that were carved on trees near Anahem (Anaheim) Lake, B.C.: "Rock paintings (fig. 280) appear to be very scarce in the Chilcotin country, but carvings on the bark of trees may frequently be seen (fig. 281). Those which I have seen differ a good deal in style from those of the Shuswap" (789).

Teit's most detailed account of tree art (Teit and Boas 1973) is in his 1927–28 Salishan ethnography, where he reproduces a significant number of the tree art images in his figure 25, shown here in figure 11. He describes paintings on the trees alongside those on rocks, which suggests that the reasons for using the two mediums were probably similar. The account here refers to the Thompson peoples:

In connection with the training period, adolescents of both sexes made records of remarkable dreams, pictures of what they desired or what they had seen, and events connected with their training. These records were made with red paint on boulders or cliffs, wherever the surface was suitable ... Rock paintings in their territory are plentiful; but I heard of no petroglyphs, except that sometimes figures of various kinds were incised in hard clay. Rock paintings were made also by adults as records of notable dreams, and more rarely of incidents in their lives. Pictures were also cut into the bark of trees, and some were burned into the wood of trees (Teit and Boas 1973, 283–4).

The most significant point to be gleaned from Teit's various ethnographies is that he usually describes tree art in the present tense. Tree art was a current practice when he observed it in the Lillooet, Shuswap, Chilcotin, and Thompson territories.

Another account of tree drawings or arborographs was observed by Teit (1956, 140–1) in the Tahltan and Kaska territories as markers of dreams by youth on vision quests: "Pubescents only rarely made paintings of any

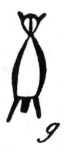

Figure 9. Teit's image of a Shuswap carving on a cottonwood tree (1909, 591).

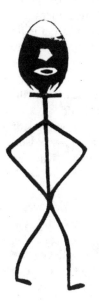

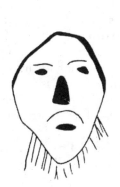

Left: Figure 10. Teit's fig. 281 of Chilcotin carvings on trees in Anahem Lake (1909, 789). Left: height about 160 cm. Right: height about 60 cm.

Bottom: Figure 11. Teit's fig. 25 showing Okanagan images incised in the bark of trees: a) girl, b) man, c) perhaps ribs, d) woman, e) perhaps an animal, f) perhaps a woman's cap (1973, 288).

kind. A few of both sexes made rude figures of animals etc., on blazed or peeled trunks. These had little meaning and were made for show much in the same way as whites do who cut their initials, etc., on trees. A few of such pictures were representations of things seen in dreams, which the boy or girl took a fancy to illustrate in this way." Teit attaches the images' meaning to adolescents going through the initiation process.

Dana Lepofsky (1988, 71–2) describes an arborograph located in the Stein Valley in April, 1988. There are two scars on the tree: one has an illegible design created by shallow cut marks, and the second has three charcoal drawings and a recent pencil drawing. The drawings include a two-headed creature with deer antlers indicated on the right head, a male human figure facing forward with prominent ears or horns, and a large drawing of a single human arm. The scars and older, intelligible image were probably created between 1875 and 1907.

Marianne Ignace et al. (1995, 11) describe a knotted tree located northwest of Lillooet, B.C., which is a "way marker in a physical and spiritual sense." Knotted trees serve as directional markers or vision quest trees. If you take a bearing on the horizontal leader of the knotted tree, it will lead you to another similarly altered tree, usually within 500 metres. Knotted trees have a cavity at the intersection of the knot (figure 44b), in which sacred objects are placed when the tree is used for vision questing (Franck 1997).[11] McClellan (1975, 294) reported a Tagish trail sign which was a "small spruce tree which had been twisted as a trail marker and had grown that way" (1975, 294).

Hamlin Garland, a novelist and poet, traveled to Alaska during the Gold Rush and wrote a book about his adventures. The 1898 Gold Rush Route or "Poor Man's Route" snaked its way overland from the southern interior of British Columbia to the Klondike (Barbeau 1958, 185–6). Garland (1899, 82) gives a relatively detailed account of tree carvings he saw as he traveled west through the Bulkley Valley between Burns Lake and Hazelton.

All along the trail were tree trunks whereon some loitering youth Siwash had delineated a human face by a few deft and powerful strokes of the axe, the sculptural planes of cheeks, brow, and chin being indicated broadly but with truth and decision. Often by some old camp a tree would bear on a planed surface the rude pictographs, so that those coming after could read the number, size, sex and success at hunting of those who had gone before. There is something Japanese, it seems to me, in this natural taste for carving among all the Northwest people.

Garland was quite impressed by these carvings. The journals of other explorers who passed through the same area, such as George Dawson and Peter Skene Ogden, make no mention of seeing the carvings, nor, for that

matter, do they comment much about First Nations culture. Garland, as a writer and adventurer, was probably more curious than a prospector or surveyor, and consequently may have paid more attention to tree art.

Father A.G. Morice established himself in the Fort St James area, which is relatively close to the Bulkley Valley, in the late nineteenth century. He had a strong influence on the Carrier culture of the day: for example, he introduced a modified form of the Cree syllabics writing system for the Carrier language. He also observed tree drawings, and his full description of them is given below, including a reproduction of his figure 197 here in figure 12.

Fig 197 presents us with graphic signs used as means of communication between different hunting parties. They alone might be pointed to as the elements of native 'writing.' The two last are taken from rock inscriptions. They are now unintelligible to the Carriers. Here is the meaning of the others: a, bird; b, lizard; c, beaver; d, bear; e, lynx; f, cariboo; g, marten; h, canoe; i, woman; j, man; k, snake.

These are generally drawn in charcoal on trees or, by exception stones, and as such it must be confessed that they afford but very restricted medium of expression to the native mind. It has therefore to call into requisition any other material means which may be at hand, and it must be said that the use made of them is sometimes wonderful. I was lately traveling in the forest at a time when the yearly reappearance of the salmon was eagerly looked for. At a certain spot not very far from a stream we came upon one of those aboriginal drawings made by an old man who had no knowledge of the syllabic signs now used to write the Dene language. The drawing represented a man with a woman, a horse with a burden, the emblem of a bear with three marks underneath and a cariboo. Above the whole and hanging

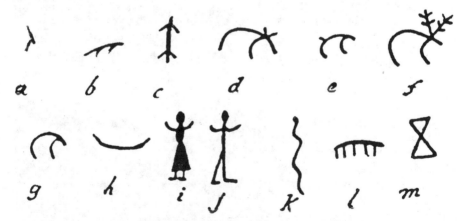

Figure 12. Morice's fig. 197 showing images drawn on trees with charcoal or stone.

from a broken branch were four pieces of young bark cut out in conventional form of the fish. Now the message was instantly read by my companions and it ran thus: 'Such a one (whom they named) has passed here with his wife, and a good load of furs, after having killed three bears and one cariboo; and furthermore he captured four salmon *two days ago*. He is now gone in the direction that we follow ourselves.' This date could evidently not have been told had the Indian marked with charcoal the sign of the salmon. He was so well aware of this and was so much intent upon fixing the time of the first appearance of the fish that he had recourse to the pieces of bark, the relative degree of freshness of which he knew could be easily be determined by the experienced eye of his fellow Carrier (1893, 210).

Here is confirmation that images were carved on trees rather than on stones, as a means of written communications between hunters. The Carrier hunter created the image in the forest to announce a catch of salmon: the first catch marked the end of the winter, and often of the scarcity of food. The hunter also made "wonderful" use of the material at hand to indicate the passage of time in a way that would be comprehensible to others who shared the same familiarity with the natural world, a way that required no reference to artificial designations of time, such as the days of the week or month. Morice's account is significant because it clearly puts doubt on the common perception that First Nations would only communicate orally rather than through a symbol or writing system.

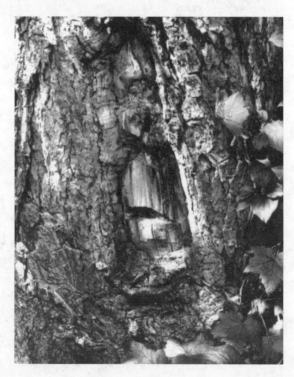

Figure 13. Harland I. Smith's 1920 photograph of eyes and mouth carved in a tree, south of Bella Coola, which has since been cut (courtesy of MCC/CMC photograph no. 50151).

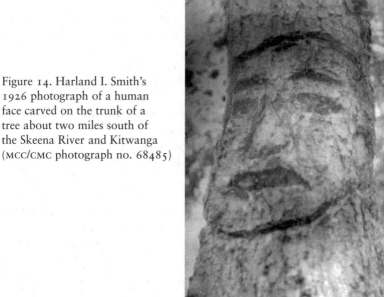

Figure 14. Harland I. Smith's
1926 photograph of a human
face carved on the trunk of a
tree about two miles south of
the Skeena River and Kitwanga
(MCC/CMC photograph no. 68485)

Marius Barbeau also recorded a description of Indian signals, through
the native informant Arthur Hankin in 1923 (Hankin 1923, n.p.). Hankin
described how the Babine Lake Indians, whom he called the "Sekanis,"
used smoke signals "to join [their] family or partners" and "to join [them]
at a certain place," or to signal for more provisions. Hankin concludes his
description of Indian signals with a brief allusion to tree paintings: "They
also leave signs on trees by means of Indian paint." Hankin said, "[t]hey
readily understand the signals, with crests as signatures." He does not elab-
orate whether the crests were associated with the smoke signals or signs on
trees, but the latter is more likely. In any case, this is additional evidence
that some First Nations had developed non-oral communication systems.

Harland I. Smith, a Canadian ethnographer, photographed two tree
carvings, in Bella Coola in 1920 (figure 13) and in Kitwanga in 1926 (fig-
ure 14). The archival description of the tree in Bella Coola is "Eyes and
mouth carved in a tree, south of Bella Coola that has since been cut." This
photograph is remarkably similar to a Gitxsan tree carving I photo-
graphed near Hazelton, shown in figure 26. Smith's archival description
of the Kitwanga tree is "Human face carved on the trunk of a tree, about
two miles south of Skeena River and Kitwanga, British Columbia."

John McMurdo (1975, 12), an archaeologist, found a grave site on the Stewart Pack Trail near Van Dyke Island, north of Kitwancool (Gitanyow), in 1975. There were two poplar trees with inscriptions of names and dates that said that the child of Chief Wee-lezqu of Kitwancool had been buried there in 1891. Other names were of Wolf house members. This account is the only arboroscript account which confirms its function as a burial marker. The child was buried along the trail.

The previous descriptions are from the nineteenth century, and from southern and central B.C. The accounts of Garland, Morice, and Hankin are closely related within the area between Prince George and Hazelton. In the Peace River area, a historian named Dorthea Calverley willed her voluminous collection of interviews and papers to the Dawson Creek Public Library. It was there that I discovered the following account.

The late Mr. Allen Robinson of Bear Flat traveled with surveyors far up several of our Peace River tributaries. Far up the Halfway he made his way to a conspicuous clump of tall spruce in an area that had otherwise been burnt over, and covered with lower second-growth forest. In the centre, one ancient tree had been cut off sixty or seventy feet from the ground – far higher than any snowfall could have given a man footing to stand on. The top of the tree bole had been carved into an enormous totem-like face. It was weathered as if it had stood for many decades. Mr. Robinson could discover no tradition whatsoever – it had 'always been there.' Somehow it had escaped the fire ... Mr. Robinson became crippled due to his World War I service, he could never go to these interesting finds ... he continued to think about them for many years – wondering 'Who got up to that incredible height to carve that totem-like countenance, and how and why? What unknown people inhabited our outer fringes? Where did they go? (Calverley, n.d., 7–8).

The Halfway River is northwest of Fort St John, in Beaver territory, and Mr Robinson would have seen this tree carving which "had always been there" before 1914–18. The intriguing element in Dorthea's record is that the carved face is high up, as if it were meant to be seen from a distance. The carver would presumably have had to make a great effort to carve the face and prepare the tree, and therefore it was likely an important marker. And yet, in the end, we are still left with the poignant questions closing Dorthea's record.

Hugh Brody's 1988 *Maps and Dreams* also documents how the Beaver used trees for symbolic communication and ceremony. Brody mentions the medicine cross occasionally throughout the book, and it becomes a touchstone, a place of constant meaning on the changing landscape. Joseph Patsah is the pseudonym of a Beaver Elder who lived on the Halfway Reserve, and he relates in *Maps and Dreams* what he saw as a fourteen-year-old boy, when his father created a medicine cross near

Midden River. The family was searching for new hunting territory "after several years of struggle and near starvation" (7).

Yet Joseph's Daddy, along with the others, sought a confirmation of the new area's potential. This was done by means of dream prophecy and the erection of a medicine cross. They stripped a tall straight pine of all its bark and affixed a crosspiece about four-fifths of the way along its length, then attached smaller crosses to the crosspiece – one at each end. They nailed a panel, also in cross formation, close to the base of the pole. Even when its base was sunk into the ground, this cross, or set of crosses, was twice the height of a tall man. When it was in place, Patsah and others hung skin clothing and medicine bundles from the main crosspiece, and on the panel near the base they inscribed 'all kinds of fancy" – drawings of animals that had figured in the people's dreams, animals of the place that would make themselves available for the hunt.

The night the cross was completed, an augury came to one of the elders in a dream. A young cow moose, moving to the Patsah Camp from the Bluestone Creek area, circled the base of the cross, then went off in the direction from which she had come from [*sic*]. Two days after this dream, hunters discovered the tracks of a young cow moose, and, following these, recognized them to be the tracks of the dream animal ... The dream prediction had been auspiciously fulfilled. The new area would provide abundantly (8–9).

The medicine cross is made from a living tree, and the panel is inscribed with "all kinds of fancy" or drawings. Based on the information in the book, the cross was created about or sometime after 1914, when Joseph's father arrived in the area. The cross's meaning clearly originates from his spirit, and his desire for good luck as a hunter; this belief system is defined here as good luck epistemology. He makes an offering to the new land they wish to hunt; consequently, the spirits give him permission to use the land by means of a dream.

American frontiersman Addison M. Powell wrote a book about his ten years' experience in Alaska beginning in 1898 (Powell 1909). He observed cache posts or trees that had maps drawn on them with charcoal or lead pencil. Powell refers to the Indians who drew these maps as the Sticks or Ahtnas along the Copper River.[12] He explains the meaning of one such map (figure 15 reproduces his diagram): "This would mean that a man with a gun, a squaw, a little girl and a dog had left the bank of the river, when the moon was half full; that their first day's travel will terminate on the bank of a creek, where they will camp on the near shore; that their next day's travel will terminate on the bank of another creek where they will camp on the opposite shore; and that at noon of the next day, they will make their final camp at the foot of the mountain" (287). Like

Morice's Carrier message and Mallery's Micmac map example, Powell's map functions as a visual communication system along the trail.

I close this review of the ethnographic written record with an account of a tree painting which was observed near Tok, Alaska, in the 1950s. The research on the Tok arborograph, by anthropologists Olson and Vitt, is the most detailed research on any arborograph or arboroglyph. It was found in Tanana territory: "Mr. Sterling True, while lumbering at mile 93.2 Tok cut-off on the Glenn Highway, noticed a tree which had been blazed or the bark peeled off and the open area painted with pictographic type figures ... The left half of the small human figure on the left, and the left end of the animal figure have been covered over not only with pitch and bark, but the new growth of the tree seems to have spread over and covered them partially" (Olson and Vitt 1969, 77, 80). They estimated the paintings were 122 years old – in other words, they were made in 1847 (80). The researchers consulted the Tanana Elders for possible explanations for the origin and meaning of the images. This is what they learned:

- "He [Mr Charlie David, Native informant] said that such paintings could be a message to other band members to let them know people were moving somewhere" (81).

- "Mrs. David said that she thought that the animal figure might indicate a dog packing a load. The two curved vertical lines arising from the neck region may symbolize a pack. Secondly, it was asked if the sign might have been made by a medicine person. Mr. David was sure that a medicine person would not leave his 'mark' on a tree. Both of the informants seemed sure that it was not done as a shamanistic practice by the medicine person" (81).

- "He [Mr David Paul, Native informant] mentioned that in former times a painting of a human figure was made on a tree to indicate that someone had died. He said that the work could be interpreted either way" (81).

Figure 15. Powell's reproduction of a map drawn on a tree (1909, 287).

The Elders gave a variety of possible meanings for the tree painting, suggesting that the images could be communications between band members or a burial marker. These possibilities expand our awareness of the possible meanings of tree art. Traditional science may judge this study as "inconclusive," but I see great value in the researchers' results because they consulted the Elders.

It is clear that tree art existed across Canada and Alaska. It seems to have had a variety of purposes, including:

- records of vision quests or dreamings of new territory for family settlement;
- records of war exploits;
- traveler's messages along trails; and
- burial markers.

The purpose of the practice seems to differ from nation to nation. Finally, a review of the ethnographic record shows that tree art was created in British Columbia at least up until 1910 or 1920. Nonetheless, while in chapter 3 we see more recent examples, the twentieth century is relatively barren of accounts of tree art. This void, or lack of awareness of tree art by the First Nations and non-First Nations community is an effect of colonialism. I discuss these effects in more detail later on in chapter 4.

PREPARATION THREE: POLES, MASKS, AND DOLLS

First Nations poles, masks, and dolls are art forms that are manifested from spiritual beliefs regarding trees and the forest. These beliefs are important to understand as background for viewing tree art. We will examine the crest pole, Tsimshian guardian pole, Iroquois medicine mask, and Dakota tree dweller doll; these art forms are closely related to tree art. Not all tribal groups practice their creation, but most are common in Canada.

The term "totem pole" used by non-First Nations actually covers many types of poles, such as the welcome pole, house front pole, house portal (entrance) pole, mortuary pole, shame or ridicule pole, house (corner) post, guardian (watchmen), and memorial (crest) pole. Barbeau (1950), Duff (1959), and Stewart (1990) are three good sources on poles.

The Gitxsan call the crest pole xwts'aan. It encodes the history of wilnat'hl, a group of people with common kinship whose shared history is kept alive by the carved crests. Mrs Cox, a member of the Gitxsan community, recorded and translated the histories of the Gitanyow (Kitwancool) crest poles (Duff 1959). Each history tells of how the wilnat'hl came to their territory "leaving their power and mark which made this country theirs" (Duff 1959, 24). The crests embody the adaawk, moving from the current chief at the bottom up and back into

time. Reverend Pierce (1933, 125–6) relates the meaning and importance of the Tsimshian crest pole:

A totem pole is a tall cedar post or tree, sometimes 50 feet high or more, according to the rank of the person for whom it is intended. A totem pole is in reality a monument erected to the memory of a dead chief ... The carvings on the totem show the descent and intermarriages of these families. Whatever figure is carved at the top of the pole represents the name of the crest to which that pole belongs ... It was law among the Northern Indians that the totem to be erected should be the exact length. If the law was violated, due punishment was meted out. An instance of this happened on the Nass River where one of the chiefs had a totem pole complete and raised. During the ceremony it was discovered that the length exceeded the allowance. When the chief was informed that the pole was too long, he refused to listen, therefore he was shot right on the spot.

The crest pole simultaneously connects the people to the sky world, thereby giving them access to the spirit power, or dax̱gyet, and to the land or territory, since its roots are planted into earth. The pole is a living spirit which is treated with care as it is moved from the forest to its new resting place in the village (Marsden 1987, 19–20).

The chief calls upon his father's side of the family (gutxa'oo) to select, cut, and carve the tree. The x̱mass (bark is off) ceremony relates to the cutting of the tree and removal of the bark. The Tlingit scattered eagle down around the tree as a sign of peace before they cut it down, to ensure the falling tree would not injure its neighbours. As a sign of respect, they also threw oil or food on a fire to feed the indwelling-spirits of surrounding trees (Emmonds 1991, 305). The hlim giin didhl gan (welcoming/prefeeding the tree) ceremony is practiced when the tree is brought to the village to show respect to the living tree spirit (Johnson 1981, 6–9). The Tlingit also have a "feeding the tree" feast, where berries and oil are fed to crest poles and to house posts (Emmonds 1991, 305). The intent of these ceremonies is to recognize and protect the spirit of the tree as it is transformed into a connection with the spirit world (*axis mundi*). The intent of the pole-raising feast is to gather witnesses to observe and recognize the power of the new chief about one year after the death of the previous chief. Hanamuxs told the court in the Delgamuukw case that "[i]t's a way of telling the other chiefs that the house is as strong as it was before, and that will continue to exist because we have a fair number of people in our house who will continue the activities within the house of Hanamuxw who will ensure that it will continue in the future. It's also a way of releasing spirits of those who have passed on. It's a way of acknowledging to our creator too the privilege of having them share their lives with you. It's a way of saying that they have added dimension to our

lives ... that we respect them, and we are saying that they were important to us. That's it" (J. Ryan n.d., 5026). The connection to spirit or sky world enables an intermingling between earth and the sky world, and then the spirits of the deceased return to the sky world and da<u>x</u>gyet is transferred to the wilnat'hl.

Neil J. Sterrit (1995) told me a story of how an Elder taught some young people about the crest pole and the ceremonies in about 1925. Charlie Sampson (born circa 1875) and a number of hunters were at a camp at the mouth of Panorama Creek and the Nass River when he cut a balsam tree for a crest pole. He carved a crest pole ten to twelve feet high. When he was finished he got everyone up early, he had a big pot of moose stew, and they celebrated and raised the pole by tying it to a tree. Neil stressed the purpose of this pole was to teach and entertain, and not to establish territory.

The guardian or watchmen pole has a different function. Figure 16 shows one located on Princess Royal Island, near Kitamat, photographed in the spring of 1989 by Brian Bagattto, a Kitamat photographer. The pole is about six feet in height and is located just above the high tide mark. It faces the entrance to Laredo Inlet. The human figure watches over the bay, guarding against intrusion. Hilary Stewart (1990, 37) describes the more common form of watchmen figures: "Elaborately carved Haida house frontal poles often carry at the top one to four (generally three) small, crouched human figures, wearing high-crowned hats. Known as Watchmen, they have supernatural powers, and from their lofty positions atop the pole, they look out in several directions to keep watch over the village and out to sea. They protect those within the dwelling by warning the chief of the house of any approaching danger, alerting him to canoes arriving or anything else he should know. The high-crowned hats worn by the Watchmen symbolize the status of the chief whose house they guard." This beautiful moss-topped pole is similar in form and design to tree carvings, and, as we will shortly learn, its purpose may also be similar. It stands diligently watching, a witness to change; its spirit strength will live on when the wood rejoins Mother Earth.

The Iroquois medicine mask is also known as the false face mask, but I prefer the term medicine mask as it is truer to their meaning. There has been exhaustive academic study of these masks, most notably by William Fenton (1987) and Arthur C. Parker (1923). The Iroquois of the Haudenosaunee Confederacy have forbidden public exhibition of the masks (Haudenosaunee 1995, 39), and I therefore do not include images of these beautiful masks here. The masks are very expressive, with exaggerated mouths, chins, and noses. Each mask is different in character, the mouth being the most variable form (Fenton 1987, 30).

Parker has documented the practice of carving the mask on a living tree,

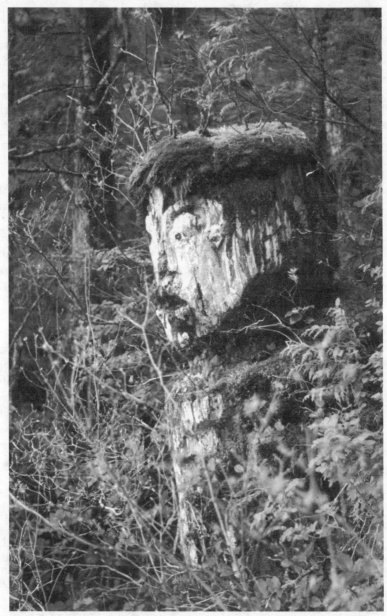

Figure 16. Watchman pole on Princess Royal Island, near Kitamat (courtesy of Brian Baggato).

and then removing it from the tree after a ceremony so that it becomes a mask rather than an *in situ* tree carving. The earliest photograph of a person carving a medicine mask on a living tree was taken in 1905 by Arthur Parker (Fenton 1987, 206). The more modern practice is to carve from seasoned wood (209). The masks were carved in living trees so that they would be imbued with the tree's life spirit; consequently, they were considered to be more powerful than masks carved from seasoned wood (206–9). The basswood tree was typically the tree of choice because "[t]he absorbent quality of basswood for drawing out diseases and for healing wounds is well known in Iroquois medicine" (206). The carvers would offer the tree tobacco as part of a three-day ritual of selecting and carving a mask from the living basswood tree (206–9). The Iroquois also carved the masks from hardwood trees such as elm, cucumber, and maple trees (128).

The adaawk of the medicine mask's origin, eloquently described by Parker, provides the spiritual context for the medium, the tree:

Unfolding from the trunk of the basswood, the great face stared out at the spellbound hunter and opening wide its wide protruding lips began to speak. He told of his wonderful eyesight, its blazing eyes could see behind the moon and stars. His power could summon the storms or push aside the clouds for the sunshine. He knew all the virtues of roots and herbs, he knew all the diseases and knew how to apply the remedies of herbs and roots. He was familiar with all the poisons and could send them through the air and cure the sick. He could breathe health or sickness. His power was mighty and could bring luck in battles. Evil and poison and death fled when he looked, and good health and life came in its stead. He told of the basswood and said that its soft wood was filled with medicine and life. It contained the life of the wind and the life of the sunshine, and thus being good, was the wood for the false-faces that the hunter must carve.

Long the hunter listened to the words of the giant false-face and then he wandered far into the forest until the trees began to speak. Then he knew that there were trees there in which the spirits of the beings of which he had dreamed and that the Genonsgwa was speaking. He knew that now his task of carving must begin and that the dream-beings, the voices, the birds and the animals that he saw must be represented in the basswood masks that he must make (1923, 399).

Fenton (1987, 128) points out that "Not only are False Faces derived from trees, but they can disappear into trees." The hunter's spiritual encounter occurs in the forest, where the supernatural being or false face unfolds before him on a tree. The face explains a medicine ritual, and having learned the tree spirit's healing power, the hunter begins to carve the medicine mask from the tree. Fenton explains the healing tradition that developed from this original encounter:

The faces of the forest have also claimed to possess the power to control sickness. They have instructed dreamers to carve likeness in the form of masks, promising that whenever anyone makes ready the feast, invokes their help while burning tobacco, and sings the curing songs, supernatural power to cure disease will be conferred on human beings who wear the masks ... Sick persons often dream of a particular kind of mask, and the range of variation reflects artistic license of individual carvers who sculpt the masks from single blocks of living basswood, or some seasoned substitute (1987, 27).

A secret society called the False Face Company was responsible for protecting and helping all living things. In return, the spirits of the Genonsgwa gave healing powers to the medicine persons (Parker 1923, 400).

There are many similarities between the Iroquois face that unfolds in the tree and the Dakota tree dweller. The tree dweller belief manifests itself as an art form in the tree dweller dolls, which have a much more haunting quality to them than do medicine masks. James Howard (1955, 169) says that the tree dweller appears in the form of a very small man, an animal, or a bird.

He dwells in the forest or in lonely places and is sometimes encountered by solitary hunters or travelers. He is usually malevolent and often 'loses' people in the woods or hills. He sometimes appears to people in visions, however, and if he is secured by a person as a spirit helper in this manner he can be summoned to work for the good of the visionary by performing the proper ceremony. Shamans with tree dweller power usually made a small wooden image of him which they kept along with their other medicines and paraphernalia (170).

Like the tree face spirit, the tree dweller has the ability to grant "favored mortals the power to cure certain diseases, the gift of clairvoyancy, and luck in hunting" (Howard 1955, 169). Iroquois hunters would leave offerings of tobacco to the faces in the forest because the spirits were feared if they were not shown respect, as is the case with the Dakota tree dwellers. These spirits were both friend and foe.

The Nootka people, more properly known as the Nuu-Chah-Nulth, also manifested their belief in tree and forest spirits in art forms like masks. David Penney (1981) did a detailed review of the Nootkan "Wild Man" forest spirit and its role in a winter ceremonial called Tlokwalle. He suggests that the forest "functions as the common ground between human and spirit, a zone where the mythic and social worlds overlap" (95). It is within this zone that anthropomorphic spirit beings live or come from their home in the mountains. There are two spirit beings: Almequo, who can be dangerous to man and transfer power during their encounter; and puqmis, who are former humans who became lost in the woods and died,

subsequently becoming ghosts who cannot transfer power to humans (95). Almequo is a supernatural being who partially enters the human world through the forest and puqmis are humans who partially enter the realm of the supernatural. Penney describes how a Nootkan person could anticipate two types of encounters in the forest: "The human, when entering the forest, was aware of two possible consequences: that he would encounter a supernatural being, and, if he was spiritually prepared, he would return to the village strengthened with supernatural power – or that he would behave carelessly, be led astray by a puqmis, and lose his human identity" (97). Penney also describes some human-like masks which are common manifestations of these forest spirits. For example, he discusses the Makah (Neah Bay) mask called Qualu bo quth (giant wild man of the woods), the Kwakiutl Bookwus mask (wild man of the woods), Ts'onoqua (cannibal woman) masks, and the Nootkan cedar bark ogre mask.

Poles, medicine masks, tree dweller carvings, and Nootkan masks have all originated from spiritual beliefs about the tree and forest. These examples add to the realm of possible meanings for tree art. They also contribute to our understanding of the intended viewing context of tree art by illustrating the spiritual nature of trees and the forest. A common theme in these examples is the spiritual encounters with supernatural beings who appear near "great trees" in the forest and either empower the human character of the story or bring bad luck in hunting.

PREPARATION FOUR: THE SACRED TREE

The tree in a forest, the medium for tree art, profoundly symbolizes a spiritual attachment to the earth.[13] The tree, as the medium of expression, and the forest, as the intended viewing context, are fundamental elements of the artist's intended creation. First Nations art can convey power through its aesthetics, especially when it is viewed in the intended viewing context. As explained in the preface, the intended viewing context is simply where the artist envisions the artwork to be viewed: a dance mask takes on meaning only in the dance; a museum goer cannot appreciate the full meaning of this mask when it is viewed in a glass case. An artist can enhance spiritual power by paying attention to the aesthetics of form and style. The master carver, for example, has the ability to bring life to artwork, and so a shaman enlists the best carver to convey the spiritual power of his or her visions or travels between worlds.

The forest, as well as being tree art's intended setting, is also a context from which inspiration arises. Thus it is part of both the physical and spiritual worlds that together make up the First Nations landscape. Boas (1955, 349) concluded that art arises from the expression of emotion and

thought; by extension, I suggest the spirit is the source of that emotion and thought, and that emotion and thought are profoundly stimulated and inspired by physical and spiritual experiences within the forest.

The sacred tree is a symbol omnipresent in cultures throughout the world. The "sacred" use their power to manifest themselves in the profane world in the form of natural objects such as rocks or trees (Eliade 1963, 30). In his study of world religions, Mircea Eliade refers to the sacred tree as the "Tree of Life" or the "Cosmic Tree" (298–300). He says, "The myths and legends which relate to the Tree of Life there often include the idea that it stands at the centre of the universe, binding together earth, heaven and hell."[14] For instance, he refers to the Chinese miraculous tree at the centre of the universe called "Kien-Mou," or standing-wood: "[T]hey say that at midday nothing upright standing near it can cast a shadow" (299–300). Sen Gupta (1980, 10) tells a story about Adam and the "tree of life." The ailing Adam, the first man, sent his son Seth to ask the angel for a branch from the tree of life. The branch was planted on Adam's grave and it grew into a tree. Eventually the wood from this tree was used to make the Holy Cross. Gupta also tells an old Celtic legend about the trembling aspen: "It is said that during Christ's agony in the garden of Gethse [Gethsemane], he was overshadowed by an aspen tree, which burst the fibers of its leaves on witnessing the supernatural agony of its creator, and from that time, in memoriam, it trembles when even a breath of wind is not stirring" (23). The Druids held particular sacred regard for the oak tree, and held ceremonies such as the worship of Baal, the god of fire, under the sacred oak. The Greeks believed that every tree had its own dryad, who came into life with the purpose of being its guardian, and died when the tree died (Altman 1994, 48). The dryad is also known as hamadryad. A traditional belief of the people of India is that Lord Vishnu and other deities reside on the top of the most sacred tree called Peepal. The Japanese believe that the pine is a symbol of longevity (Gupta 1980, 10, 32). Eliade (1963, 281) says that sap-filled trees symbolize motherhood in Africa and India, "and are therefore venerated by women, as well as sought out by the spirits of the dead who want to return to life." Altman (1994, 9–19) says there are ten determining reasons why cultures may consider a tree to be sacred: 1) it provides an essential service or product; 2) it is located near a sacred site; 3) it is connected with a sacred animal; 4) it is associated with a particular sacred event; 5) it is associated with the appearance of a nature spirit such as a dryad; 6) it has healing, purification, or enlightenment powers; 7) it is located at a ceremonial site; 8) it is unique among its species, like the Golden Spruce on Haida Gwaii; 9) it is associated with an unusual event such as communication from the spirit world; or 10) it is a symbol of fertility and growth.

Beliefs about sacred trees abound amongst First Nations. The Dene believe they are protected against dangerous spirits if they sleep beneath a

large spruce tree (Dene Wodih Society 1990, 30). The Seneca creation sto-
ries tell of a great tree beside the great illustrious chief's lodge in the Sky
World or Heaven that bore corn for food (Thompson 1967, 14). There
are many First Nations sacred tree symbols, such as the Five Nations Tree
of Peace, which symbolizes a "Great Peace" between the Five Nations.
Colden (1866, 58) quotes a Mohawk Chief as saying: "We now plant a
tree who's [sic] tops will reach the sun, and its branches spread far abroad,
so that it shall be seen afar off; & we shall shelter ourselves under it, and
live in peace, without molestation." This Five Nations symbol of peace
and law has endured since its creation in 1684 (Parker 1923, 431). The
sacred tree is also a power symbol for Gitxsan people, because it repre-
sents the law. Gitxsan Chief Gwisqyen described how each successive
generation draws its strength from the land as a tree's roots sink deeper
and deeper into the ground: "This is like an ancient tree that has grown
the roots right deep ... into the ground. It's ... sunk. This big tree's roots
are sunk deep into the ground and that's how ... our law is ... The
strength of our law is passed on from generation to generation and each
generation makes it stronger right to this day where I am now" (Rush et
al. 1990, 1–2). Many First Nations, including the Carrier, believe that ani-
mals and trees talked to man, as demonstrated in recorded oral tradition,
and that they still converse during vision quest experiences.[15]

The tree is a source of nourishment and power, a source of life (Bopp et
al. 1985, 7). I will explore the meaning of the sacred tree by examining
the spirit of trees, to better understand their inspiration for tree art.

SPIRIT OF TREES
*All things are interrelated. Everything in the universe is a part of the single
whole. Everything is connected in some way to everything else.*
(Bopp et al. 1985, 26)

I am humbled by their presence, always, whether I am among the wise old
Douglas firs that edge the ridge paralleling the Blackwater River in Carri-
er country, or the misty hemlock forests that protect Kuldo Creek in
Gitxsan territory. Their spirits pulse through the old-growth forests. Trees
seem immortal to us, whose lifetimes span at best only a few centimetres
of their ringed history. The oldest known tree was a bristlecone pine (*Pinus
longeva & aristata*) in California that was 4,950 years old. A professional
forester, trained to liquidate the negative mean annual increment of the
decaying British Columbia old-growth forests, I was drawn to forestry, as
were many others, because being in the forest gives me spiritual pleasure.
Unfortunately, this reverence can be trained or persuaded away.

Another poignant story by Nick Prince emphasizes a Carrier perspec-
tive. Nick wrote a story from a tree's perspective entitled *How I Became*

a Dugout Canoe (Prince, n.d.), based in part on his experience of making his first dugout canoe when he was a teenager (Prince 1995). I reproduce only those excerpts related to the tree spirit.

I came into being in the forests on the south side of what is known as Great Beaver Lake. This is an area with some hills, but no mountains; a region ideally suited for my friends and I to grow up in. I began my life as a tiny seed, and took root in the damp dark soil of the land ... As I grew taller, I grew stronger. The wind and storms provided the exercise I needed to give my body the resiliency to bend and sway with my brothers. We enjoyed life with the moose, grouse and bear that fed around us. These animals, we also recognized as brothers and sisters (1).

Nick has been a trapper, carpenter, head sawyer, and tribal chief. His range of lived experience gives him a variety of perspectives, but he chose the perspective of a living spirit. The story proceeds to the point where the Carrier choose the cottonwood tree for their dugout canoe.

They pointed out the tree for the young boy who was with them, and told him the funny tree was called T'soo, (spruce) and they pointed at me and called me Ts'i tel, (cottonwood). The young boy came over to me and spoke these words as he tapped on my trunk with his hand; Nyun atahat'sun yudantan, (You, we have chosen) ... The men returned [the following spring] at this same time, only there were more of them than before. They all crowded around me and talked, and I was proud to be so tall and straight. They made a fire, and camped away from us. We noticed there were two families this time, and their children played in the woods around us. Each day, the fathers of these two families would bring some water to throw on me, and they would say some words to me. Somehow the water seemed different from what I had grown up knowing! They did this for four sunrises, and each day they faced in a different direction after they had thrown water on me (5–6).

When Nick tells this story to a group of people, at this point in the story, he will ask why the characters are putting water on the tree. The next passage answers this question. On the fifth day they cut *Ts'i tel* down.

The following morning they came early. One old man walked up to me, threw water on me, and said; Ts'i tanleh. Ndi too buhol'eh, (You are going to become a canoe. Become accustomed to this water) ... Every day they worked on me, they put some water on me, and now I could sense the water had come from this lake. I no longer felt strange! It seemed I was to become a part of the water in this lake (7, 9).

They are introducing the spirit of the lake to the spirit of the tree. Nick's beautiful story is an example of what it means to have respect for the spirit of the tree.

The Gitxsan word for spirit or soul is ootsxen, which also means a shadow. The soul or spirit has also been referred to as a shade, manitou, means of life, man's mask, means of healing, and a bird. A Kwakwaka'wakw Elder explains the difference between a spirit and a ghost: "the ghost is not a soul, for it is only seen when it gives notice to those who are going to die, those who see him; for he has the whole body of a man, and his bones are those of people who have long been dead. It is not the same as a soul for they have no bones in their bodies, and they have no blood, for the souls are just like smoke or shadows" (Boas 1913, 727–8). A house group or an individual can have spirit power, but the spirit leaves you when you die (Marsden 1987, 154–5). Gitxsan Elders tell me they do not leave offerings to a tree when they harvest its bark or choose it to make a canoe, house, or crest pole. Instead they talk to the tree and explain why they need its help. Mary Thomas explained a similar belief of the Secwepemc (Shuswap):

I do a lot of silent prayer in my heart. I don't understand the tobacco. A lot of people say you give back tobacco to Mother Earth. When I go to somebody's territory I acknowledge and thank them for accepting me to walk on their territorial ground. I respect it. So when I go out in the woods to collect any plant or medicines or whatever, I always say a silent prayer within me. Thanking Mother Nature for your wonderful gift. This is what my mother taught me. She used to stand there just before taking the bark off the birch [paper birch, also known as white birch (*Betula papyrifera*)] tree. She would look like she was petting a human being, she would go like that [Mary acts out her mother's stroking motion] to the tree. She says, "Mother Nature put you on earth to help me to survive, and I want to thank you for the medicine you are allowing me to take off of you." And I listen to her as she is saying this in Shuswap. And then she would start taking the bark. When she was finished she would pat the tree, and say "thank you, thank you, thank you" and then she would walk away. That's all I know. And I do that. When I go to dig roots or collect birch bark, I look at the tree and in silent prayer, "I am not here to hurt you, I am here because I need a part of you to survive and I acknowledge the trees." As far as offering, tobacco was never a part of it. Tobacco was introduced (Thomas 1997).

Mary's mother treated the birch tree as another human, thanking it for the bark which would help her in many ways. They would part as friends, with a gentle pat, since the mother was careful not to damage the inside bark, as will be described later by Mary. This Shuswap spiritual belief ensured a balance and harmony with other spirits.

Marius Barbeau (1973, 198) presented four precepts that the Gitxsan observe. The first shows how strongly the Gitxsan, like the Shuswap, believe in the "spirit-selves" of all beings: "Do not abuse animals or ridicule them. Their lives are not unlike yours. Their spirit-selves, unless propitiated, stand over them in readiness for the deed of retaliation. Do not waste their flesh or scatter their bones. Above all, spare their broods, lest they visit wrath upon you and migrate from your hunting territories, leaving them barren and desolate for your own ruin."

Reincarnation is an important characteristic of Gitxsan spiritual beliefs. Antonia Mills (1988, 45–6) suggests that Gitxsan and other shamanistic peoples believe that the soul or spirit can survive physical death and reanimate into another body through numerous cycles. Mills queried a Tsimshian Elder, "Reincarnation must give you a different sense of self," to which the Elder replied, "It gives us a different sense to be in tune with *spirit*" (49).

The Gitxsan and Witsuwit'en spiritual belief is described in the opening statement of their Delgamuukw *vs.* the Queen land claims case.

The Gitxsan and Witsuwit'en believe that both humans and animals, when they die, have the potential to be reincarnated. But only if the spirit is treated with the appropriate respect. If the bones of animals and fish are not treated with that respect, thereby preventing their reincarnation, then they will not return to give themselves up to humans. In this way, a person's actions not only interact with those of the animals and the spirits, but also have repercussions for future generations, deprived of the food that will ensure their survival (1987, 18–19).

Stanley Walens (1981, 116–17) suggested a similar Kwakiutl perspective on the reincarnation of the tree sprits. Both the beaver and humans have the ability to cut down trees, and they have a responsibility to treat the tree with respect in order that the spirit of the tree is properly released and reborn into another being. He said that "[t]he Kwakiutl see trees, especially cedars, as living beings with faces, arms, legs, and souls" (116), and concludes that the beaver and human share an important destiny "because they alone can ensure the survival of the forest" (117).[16]

THE SUSTAINER OF LIFE
The ancient ones taught us that the life of the Tree is the life of the people.
(Bopp et al. 1985, 7)

The tree sustains life. Spiritually, trees are guardians and protectors from birth, and can exhibit supernatural power. Physically, the tree is a source of food, for example the inner bark of some species, and of material, for baskets, canoes, crest poles, houses, and fuel, to name only a few of its

uses. The tree was and is a great provider. The Stó:lö people, in the Fraser Valley, have a song about Hopai, the Cedar:

There was one good man.
To him K'HHalls said:
'You shall be a tree;
You shall be Ho-pai, the cedar;
You shall be houses, beds, ropes;
You shall be baskets and blankets;
You shall be a strong boat
In the flood that I shall send
To show this Tsee-o-hil
That there is One other than he
In Schwail, the earth' (Street 1974, 72).

The Stó:lö people still live by this ancient song. In a story about cedar bark, a young Coast Salish girl tells of her experience collecting cedar bark with her granny, and of how her granny chose a tree: "Then she spoke to the tree, 'We have come to honour you, mother cedar. We need your help. We need your bark to make our clothing. We thank you for the many gifts you give our people. We ask your help in the work ahead of us.' Then she lay down a small weaving she had made, her gift to the cedar tree" (Stó:lö Sitel 1983, 15). Boas (1913, 619) also describes a Kwakwaka'wakw "prayer to young cedar" which is said while collecting cedar bark.

The inner bark of the lodgepole pine (*Pinus contorta*) and hemlock trees was an important food in the spring. Alexander Mackenzie (1970, 352) observed some "interior Indians" in 1793 eating a delicacy of the inner tegument of the bark of trees. A thin piece of bone was used to strip the bark. He also describes the Bella Coola people eating the inner bark of the hemlock tree: "The dish is considered by these people [Bella Coola] as a great delicacy; and on examination, I discovered it to consist of the inner rind of the hemlock tree, taken off early in summer, put into a frame, which shapes it into cakes of fifteen inches long, ten broad, and half an inch thick; and in this form I should suppose it may be preserved for a great length of time. This discovery satisfied me respecting the many hemlock trees which I had observed stripped of their bark" (366).

Hamlin Garland (1899, 82) observed the same practice in June of 1898 when he traveled through Carrier territory:

Like the *Jicarilla* Apaches, these people have discovered the virtues of the inner bark of the black pine. All along the trail were trees from which wayfarers had lunched, leaving a great strip of white inner wood exposed.

'Man heap dry – this muck-a-muck heap good,' said the young fellow, as he handed me a long strip to taste. It was cool and sweet to the tongue, and on a hot day would undoubtedly quench thirst. The boy took it from the tree by means of a chisel-shaped iron after the heavy outer bark has been hewed away by the axe.

There is also a description of Carrier women harvesting shavings of the inner bark of the pine in a Carrier myth recorded by Morice (1896, 22).

I have seen western hemlock (*Tsuga heterophylla*) in the Kuldo area and lodgepole pine (*Pinus contorta*) near Fraser Lake that have rectangles of bark removed for about one-third of the circumference of the tree. I have also observed scars about one to two metres from the ground, and the scarred trees usually occur in groups. Anne Eldridge (1982) wrote an extensive paper on the topic of First Nations people harvesting the inner bark, or cambium, of a tree. She supports the assertion that "[s]tripping for cambium is a logical interpretation of rectangular wounds on hemlock, spruce, pines, aspens, and cottonwood" (26), and suggests that the cambium was a source of sugar, for energy while traveling, and that the hemlock cambium could be a source of calcium for children and pregnant women (24). Harvesting occurred in the spring when the bark is easily peeled due to the increased flow of sap in the tree. Secwepemc people harvested sugar crystals from the branches of very old Douglas fir trees. They hit the branch with a stick and the crystals would fall from the branch into a basket or blanket.

There are more uses for trees. Hilary Stewart (1984) has described many uses of the cedar tree, and Nancy Turner (1979) has published books of plant use, including trees, by British Columbian First Nations people.[17] George Dawson (1891, 18) observed that the Secwepemc people used ponderosa pine (yellow pine [*Pinus ponderosa*]) chips as a source of fuel. The bark did not smoulder for long; consequently, a pursuing war party would find "it is difficult to tell by an inspection of the embers how long ago the fire was made." I have observed some Douglas fir (*Pseudotsuga menziesii*) trees at the archaeological site between North and South Pender Islands that have had the bark chipped off. This site may have been a layover spot where it was strategic to leave little trace. The Okanagan peoples would blaze a yellow pine and then set the oozing pitch on fire to create heat. This would be a meeting place and a warming tree in the fall or winter (Manuel 1999).

Dawson (1891, 14) reported another use the Secwepemc people had for the bark of the western white pine – to make small canoes. He explained that "[t]he inner side of the bark, stripped from the tree in one piece becomes the outer side of the canoe" This case is unique because the canoe is made from white pine bark rather than birch bark. The Okanagan

people are well known for their birch bark canoes (Turner 1979, 199).

Mary Thomas, the Secwepemc Elder mentioned earlier, told me how they relied on the paper birch tree in the following excerpt of our interview. She carefully explains how the bark is collected and how the birch tree is connected to the forest ecosystem. Her story interweaves related information in the skilful manner only an Elder like Mary can create; every word is interesting. There are many lessons in her story.

The birch tree is a really special tree to our people. Number one, you have to know when to get the birch bark. It only lasts so long. I think there is a reason for that. My mother used to say there is always a reason for things, and Mother Nature is a good teacher. If you are lazy you will keep putting it off, putting it off. By the time you go up to get your birch bark it is stuck, then you are out of luck. You cannot get it all year long, it is only a certain time of the year you can get it. It only lasts about three to four weeks in the spring when the sap starts to go up. It releases [the bark], you can hear it when you get your knife and just cut, you can hear it, it's cracking. You touch [the bark] and it just flops off. You have to know how to roll it, to preserve it for your winter use. And if you cut it too deep the sap's going to start to ooze. I am not saying that, the little birds and insects bore into the pulp in between, they feed on the sap which has a lot of sugar content. There is a lot of sugar in the birch. When the woodpeckers, hummingbirds, or insects bore holes, Mother Nature has such a way that it eventually closes it, it mends itself and leaves little bumps on itself. This basket I have chose, see these little bumps on the bark, that is where little insects were boring into the bark, right through to the pulp that is between this and the tree. This bark is growing on the birch tree, around the tree, it stretched. The inside of the tree is wood, and it is growing. Like cedar and fir they have fibres this way and it just expands. But the birch bark goes this way and it gets tighter and tighter as the wood grows. In a cold winter you can hear it, a loud bang in the forest, that is the birch giving, usually on the north side. The outer bark splits, and you get those little curly bits along the one side. That's the thin side of your bark. If you cut on the opposite side, you're going to have that thin side on the bottom of your basket. So when you cut on the thin side you are going to double it where you sew the seams of the basket anyways, to put it together, and you have the thick part on the bottom. If you penetrate through the pulp, it will mend itself, but rot will start to fill in, and there is a fungi that grows on that tree [the fungi is a rusty colour inside with a blackish outside]. I had a hard time finding this. Nancy Turner from UVIC [University of Victoria] gave me this. It grows right in the injured part of the tree. That's the one I was telling you they put in the fresh water clam shell to keep the fire embers while they traveled. There is another one that looks like a little horse hoof, that's not the one. There is also another one that grows on hemlock that is red inside that they used for painting rock paintings. I learned about the birch tree, I learned that when the

old people say that the sap goes up I often wondered how much sap is going up that tree? So last spring, Tom and Agnes, who have that little store here, have some birch trees on their property. It was one about that big [three feet in diameter at the base] and then it grew into three. They tapped one little cut in one side, just the one fork of the tree. And every morning we were getting a gallon, and a gallon at night. For a whole week we were getting two gallons every day, and there was some dripping down the trunk too. It started to heal itself so we left it. But we proved it, that the old people did collect the sap. I boiled it and boiled it, until it started to sizzle. That is when the syrup is ready. I poured it into a jar. It took me a whole week to get a pint. You could not ask for anything sweeter [Mary gave me some to taste and it was wonderfully good]. The question I have is, fourteen gallons in one week that we got out of that one little fork. How many gallons went up the three forks. That's what the old people used to talk about. The sap stays in ground and it feeds other plants, and then in the spring it goes back up. The wind, the sun is collecting the solar energy. Then when it goes down it feeds the other trees, the leaves drop and creates a compost. If you take a look at the fir, the pine and the evergreens. All they drop is turpentine. You never see anything growing under a pine tree especially, the ground is burnt solid. What do they do for Mother Nature? If you cut out all these leafy trees, there is nothing in the ground to feed these so-called money maker trees. You are depriving them of their food. That's why I could not believe it when I seen all these birch trees where I collect my birch bark, everyone of them were dead up there where I collect my bark. Somebody in the forestry had cut the bark on the trees all the way around [the forestry crew was brushing out the birch to release the conifers from competition]. And Bob told me that day, in all the books I have studied I have never heard a story like you told me. [He apologized to Mary for cutting her birch trees and she later forgave him by giving him a small gift] (Thomas 1997).

Mary described a fungi, known as *Inonotus obliquus,* which grows on the paper birch tree and was used to carry fire embers. Mary also explained how it was used to cure arthritis: a hot ember was placed on the affected part, water dripped on the ember, and it would pop off, leaving a burn mark. The burn would suck out the arthritis.

My Great Aunt Sophia Mowatt told me a humorous story about a fungi that grows on the birch tree.

SOPHIA [as translated by Norma Mowatt]: The birch tree, they have them round things on there, you look up at it, and when you look at it and when you find it you laugh and laugh and then you climb up there and cut it off. You are lucky person to get that. Not very many people find it [she says]. You see up in the trees. You lucky to see up on that birch. You lucky to find it. You laugh all the way up and

when you take them down. And the person to find it is lucky! Not very many people find them in the bushes. You got to laugh as hard as you can when you are doing it. And you get a fire and heat the rocks, and and you put it in there, but you are laughing all the time you are doing it. You never stop laughing, when you are doing it, when you pick up the stones you are still laughing. You be tired of laughing by the time you did it. When you quit laughing it does not work. 'Mas,' you got to be a lucky person to find one. You got to be laughing all the way to get and bring it down. That's what they use for paint. That thing you took from the birch you use as a powder and you use it on your face. After you put it the rock, in between the hot rocks and it becomes powder (Mowatt 1995).

Sophia suggests you are very lucky to find this fungi (which may be *Pitoporus betulinus*), and you have to behave in a certain way or it will not work for you. First Nations people have many uses for the birch and its parasitic organisms.

Foresters and archaeologists refer to trees that show evidence of being used by First Nations people as "Culturally Modified Trees" or CMT's. For instance, a cedar tree that still shows the scars caused by bark stripping is a CMT. I prefer the term "Trees of Aboriginal Interest" or TAI's, because a tree does not have to be modified to be of interest. Trees of aboriginal interest can include bark-stripped trees, trees of sacred significance, or trees from which cambium, planks, sugar, or roots were selectively harvested. CMT's are part of the broader category of TAI's. For example, Mary Thomas explained how the Secwepemc collected sugar crystals from Douglas fir branches, a process that does not modify the tree:

We looked through the archives in Victoria, and found an old, old picture of a Douglas fir branch with sugar crystals on it. And that is what my grandmother used to gather. They come up on the branches and they are really really sweet. And if you ate too much of it, it gave you the runs and pitch does clean you out. My grandma used to have a big birch basket, and she would put it under the branch she would hit it with a stick and it would drop into the basket. Like little sugar crystals. We used to just love that! We would gather and put it in our mouths and eat. But we could not find any of that stuff anymore. And this women that was at that workshop told me that there is one place in Merritt, one of the mountains, they call it Sugarloaf mountain. She said they still have it there, I hope they preserve it. Even the jack pine, at a certain time of the year when the boughs are covered with yellow pollen, if you go to a second-growth tree and take a strip of the outer bark off and under it you scrape that pulp and put it in your mouth it is sweet. That proves that everything has a certain amount of sugar content which fed our bodies (Thomas 1997).

Mary Thomas also points out that trees of interest are not necessarily the "money makers" that are commercially harvested by the forest industry. Bark is harvested from mountain alder (*Alnus icana*) for its cancer curing properties, cascara (*Rhamnus pushiana*) for its laxative properties, and pin cherry (*Prunus pensylvanica*) to decorate baskets. Additionally, the plants, fungi, or animals living in the tree may also be of interest. For example, the black lichen that hangs from tree branches is used by Mary to make "Indian bannock." Mary also says sucking on black lichen (*Bryoria fuscescens*) will quench your thirst and provide some food value.

Sophie Thomas, a Carrier Elder and healer, told me that the British Columbia Forest Service used to prohibit their practice of harvesting the inner bark of pine trees as a source of food (Thomas 1995). This is an example of the clash of cultures and the impact of colonialism on the traditional lifestyle of First Nations people.

Trees sustain life not only physically but also spiritually, and in this sense the tree is important to many First Nations throughout the cycle of their life. In fact, the tree is believed to be a "protector" of newborn children in many religions around the world. Eliade (1963, 306) says the tree can make the birth easy, and can also act as a guardian over the newborn; "direct contact with embodiments of power and life can be nothing but favourable to the newborn child" (307). The Ainu, the First Nations people who reside on the islands of Hokkaido and Sakhalin, planted a tree to celebrate the birth of each child. From that point on it was believed that the health of the child would depend upon the health of the tree (Altman 1994, 4). Many First Nations in Canada practiced a ritual where a woman or a man, the mother, father, aunt, or uncle of the newborn, would place the afterbirth in a tree or bury it at the foot of a tree. This practice is documented for the Sekani (Jenness 1937, 54), Tahltan and Kaska (Teit 1956, 101), Kwakiutl (Walens 1981, 110), Delaware (Altman 1994, 85), Alkatcho Carrier (Goldman 1940, 273) and the Bulkley Carrier (Jenness 1943, 530). Teit gave a detailed description of a Tahltan or Kaska ritual associated with a male newborn.

There was a custom if the infant was male for the father to repair to the confinement lodge shortly after the afterbirth had come. He took with him a miniature bow and arrows, the latter about five inches long. These he made as soon as he had learned his child was a boy.

Holding them in the infant's hands, he made motions as if the infant was shooting the afterbirth with an arrow. Sometimes the arrow was actually shot at the afterbirth. At the same time the father prayed aloud, saying "May my boy be a good hunter and a good shot in after years." He then wrapped up the bow and arrow and going to some tree in a secluded place (or any place near by, according

to some) hung the package up in the tree or hid it in the branches of foliage ... It was believed the conducting of this ceremony helped to make the boy become an expert and lucky hunter ... (1956, 104–5).

Walens describes the Kwakiutl ritual:

Normally the afterbirth of a child, which is considered a part of its living flesh, is ritually treated to prevent sorcerers from using it to bewitch the child. It is then buried at the foot of a live cedar tree, where its substance is absorbed into the tree. This ritual is believed to ensure the longevity of the child in three ways: first, the tree becomes the guardian of the child; second, just as the tree lives a long time, so too will the child; and third, since children are considered to have a very tenuous link to this world until they have been given their first name (at ten months), the absorption of their living substance into that tree helps establish a firmer link to life (1981, 110).

Goldman (1940, 273) suggests that the practice ensured easier childbirth in the future, while Jenness (1943, 530) says it ensured fertility. Regardless of the particular reason, the tree spirit has the power to bring good luck in future activities such as conceiving, birthing, survival, and hunting. Great Aunt Sophia Mowatt told me that the Gitxsan would put the afterbirth of a boy in a tree to bring good luck in hunting and that of a girl in a berry bush to bring good luck in berry picking (Mowatt 1995).

Simon Fraser (1960, 85–6) observed "many piles of sapin [fir branches] near the road," and was informed by his guides that "they were birth places." This observation was made at a place where the Thompson and Lillooet people mixed. Altman (1994, 85) describes an interesting ritual practised by the Nuxalk, whereby they carefully select and prepare a piece of wood to rub over a newborn's body. They believe the strength of the wood will protect the baby from all dangers, including sorcery.

It is common in cultures the world over to believe that the souls of their ancestors have returned to trees after their death. Altman (1994, 80–1) reports that early Europeans, and First Nations people in Australia (especially on Adaman Island) and North America practiced tree burials. Many cultures including the Kwagulth (Dawson 1887, 348–9 and Walens 1981, 60), the Sioux (Altman 1994, 81) and the Bella Coola or Nuxalk people (Mackenzie 1970, 387) placed their dead in trees, on poles or scaffolds.[18] George Dawson gave a detailed account of the Kwakiutl practice.

The graves of the kwakiool are of two principal kinds: little scaffolds to which the coffin-box is lashed, high upon the branches of fir trees, and known as tuh-pe-kh; and tombs built of slabs of wood on the ground ... The trees used for the deposit of the dead are often quite close to the village, but when a tomb is placed upon

the ground, it is generally on some rocky islet or insular rock ... Graves in trees are generally festooned with blankets or streamers of cloth and similar appendages are affixed to poles in the vicinity of the graves on the ground. Roughly carved human figures in the wood are also often added. These sometimes hold in their hands wooden models of copper plates which are so much valued by these northern tribes of the coast (1887, 348–9).

It is not entirely clear, based on this description, whether the human figures were carved into the slabs of wood, onto the trees, or on separate pieces of wood. Dawson's description of carved figures at Shuswap burial sites is similarly vague: "Some years ago, carved or painted figures, generally representing men, were commonly to be found about the graves along the Fraser and Thompson. The posts of the enclosure were also not infrequently rudely carved and painted while kettles and other articles of property were hung about the grave or in its vicinity. Horses were in some cases killed, and the skins hung near the graves; but most of these objects have now disappeared, and crosses are frequently substituted for the old carvings" (1891, 10). It is important to note that carvings of human figures or animals on posts or trees were used by some First Nations such as the Shuswap to mark burial sites.

Alexander Mackenzie (1970, 387) observed "the remains of bones" near or beneath large old cedar trees that sometimes measured "twenty-four feet in girth, and of a proportionate height." Mackenzie surmised that the Bella Coola "natives may have occasionally burned their dead in this wood." Walens (1981, 60) attaches the following meaning to the Kwakiutl practice: "A person who dies and is buried in a tree still resides in the world of humans; as his body decomposes or is devoured by scavengers, his material existence disappears, but his soul travels to other places in the world." It seems from this that the tree is a medium of travel for the spirit of the dead person.

All First Nations believe the spirit can travel to the spirit world. Great Aunt Sophia (Mowatt 1995) told me that the missionaries persuaded the Gitxsan to stop their cremation practices and bury their dead in the ground. She said that there was a short transition period where the dead were wrapped in birch bark and placed in a fetal position in bent boxes, rather than in coffins, and then buried in a grave. I think the Gitxsan originally placed the dead, wrapped in cedar or birch bark, on the branches of trees before both tree and body were burnt. Teit observed that some First Nations removed the organs from the body before it was cremated, and "the body was preserved for some time before being deposited in the gravebox, which was placed on a tree." Burial posts or trees were commonly used as resting places for the body. Boas (1970, 534) felt that Teit's version of the burial practice "seems more plausible, because it agrees with the

statement contained in traditions." A story recorded by William Benyon reporting Tsimshian burial practices supports Boas's claim: "He placed her [the Chief's daughter] in a burial box which was the way people disposed of their dead in olden times. They did not bury them in the ground but put them on burial posts. Often guards were placed there to prevent the remains being tampered with" (MacDonald and Cove 1987, 7).

People of higher status may have been placed on burial posts and people of lower status may have been placed on trees. Perhaps lower status people did not warrant the effort of making a pole. The carvings and cloth on the burial box and nearby posts or trees may act as guardians to ensure the spirit is not disturbed while on its journey to the spirit world. For example, Jonaitis describes carved figures placed against the trees surrounding a Tlingit shaman's grave house.[19] She attributes to these carvings the purpose of "protect[ing] the shaman's remains from evil forces" because the "power lived ever after his remains" (Jonaitis 1986, 26–7). Barbeau's third precept of Gitx̲san beliefs explains the need for tree burials, as the *axis mundi* to the spirit world in the soul's journey after death: "For the dead survive as ghosts, dwelling for a time in the air above their former habitations, and they may cause injury to the living. Mourn their loss, however lightly, cremate their remains and lay them on trees, that their souls may journey abroad and cross the river of sighs in the end" (1973, 198–9).

There is a close association of the tree with the life and death cycle. The genesis of First Nations peoples' sacred regard for all trees may originate with their association with birth and rebirth, the trees' ability to sustain life, and with power endowed to certain trees by supernatural beings. Any tree can have one or all of these characteristics, and thus some First Nations people respect each and every tree.

SUPERNATURAL TREE
The Sacred Tree represents the Great Spirit
as the center pole of creation ...
The physical world is real. The spiritual world is real.
These two are aspects of one reality.
(Bopp et al. 1985, 23, 27)

Many First Nations people believe that all trees have spirits. Additionally, a sacred tree or cosmic tree may also act as the *axis mundi*, or "axis of the universe," which enables human communication with the sky world. Consequently, according to Eliade (1963, 300), encounters with supernatural beings happen near the *axis mundi* or "by means of it." The *axis mundi* theme as it relates to ceremonial poles is discussed in Joseph Jorgensen's classic study of the Ute and Shoshone Sun Dance. He describes

the cottonwood tree centre pole in the Sun Dance corral: "The center pole and the other ritual items of the [Sun Dance] corral have several meanings for the dancers. At base, however, is the belief that the center pole is the medium through which supernatural power is channeled. The center pole is also believed to have supernatural power of its own. Power comes in the form of sun's rays, but need not come only in this form. Power can also be channeled through the pole at night, either through the moon or through the sacred fire" (1974, 182).

The *axis mundi* concept also informs the Gitxsan crest pole's function: "[The pole] re-creates, by reaching upwards, the link with the spirit forces that give the people their power, while at the same time it is planted in the ground, where its roots spread out in to the land, thereby linking man, spirit power and the land so they form a living whole" (Delgamuukw *vs.* the Queen 1987, 24).

The sacred tree symbolizes the *axis mundi* or connection between the physical world and the spiritual world. For instance, spirals or notches cut into the heartwood of trees adjacent to the Eastern Australian aboriginal Bora ground allowed spirits from beyond the sky to descend down the tree to visit an initiate (Etheridge 1918, 61–73).[20] George Weisel gives a very interesting account of the Flathead people's practice of making offerings at a medicine tree called the Ram's Horn tree. The ponderosa pine (yellow pine) tree is located on the east bank of the East Fork of the Bitter Root River, beside Highway 93 in Montana (Weisel 1951, 5). Weisel provides an account from a fur trader, Warren A. Ferris, in 1833: "The tree is unusually large and flourishing, and the horn is in it some seven feet above the ground. It appears to be very ancient, and is gradually decomposing on the outside, which has assumed a reddish cast ... The oldest Indians can give no other account of it, than it was there precisely as at present, before their father's great-grandfathers were born. They seldom pass it without leaving some trifling offering, as beads, shells, or other ornaments" (6). Weisel tells of Ellen Big Sam's yearly visits to leave some of her hair on the tree to ensure her a long life (9). The oral history tells how Ram got one of his horns stuck in the tree while being chased by Coyote (7). Trees can be offering sites or connections to the sky world. I examine this theme in detail through oral history stories of the Gitxsan, Tsimshian, and many other peoples.

The following creation oral history, recorded by Franz Boas in his book *Tsimshian Texts*, demonstrates the Tsimshian belief that the sacred tree can connect the earth world and the supernatural sources of power who dwell in the sky world. Barbeau (1973, 185) describes how the sky world, or sky country, "rests on the blue vault a very short distance above the mountain peaks."[21]

The story also presents the Gitxsan teaching of respect for all beings,

and the relationship between the tree and the shaman's training. The entire story is presented below.

There were four children who were always shooting squirrels. They killed them all the time. Then they dried their skins and put away their meat. They did so at the foot of a large spruce tree – they did so for a long time all the year round. Then they had killed all the squirrels. Only the chief of the squirrels and his daughter were left. She was very white. Now, a boy went out and came to the foot of the great spruce tree. He looked upward, and saw a little white squirrel running round the tree. When it had gotten to the other side of the tree, behold, he saw that she was a young woman. The boy saw her. The woman called him. Then the boy placed his bow at the foot of the great tree.

The woman entered the house of her father, who was the chief of the squirrels. He was much troubled, as all his people were dead. Therefore he had sent his child to call the boy. The chief questioned his daughter, and she replied, 'The boy is standing outside.' Then the chief said, 'Come in, my dear, if it is you who killed my people.' The prince entered and sat down. They gave him something to eat. After he had finished, the chief said, 'Why did you kill all my people?' The prince replied, 'I did not know that they were your people, therefore I did so.' 'Take pity on me,' said the chief to the prince. 'When you return home, burn the meat and the skins of all the squirrels. I will make you a shaman.' The chief did so; he made the prince a shaman. Now he was a great shaman. 'Your name as a shaman shall be Squirrel,' said the chief.

The prince lay down. Then the chief rose and put on his dancing apron. He painted his body red, and put on a crown of bear claws. From his neck hung the skins of squirrels. He held a rattle in his hand and sang, 'Ia haa, ia nigua iahae! I become accustomed to this side, I become accustomed to the other side.' Then the prince became a great shaman. The chief of the squirrels did so a whole year. Then he sent the prince home.

The chief, who had lost his son, had almost forgotten him. Then one of his other sons went to shoot squirrels, and came to the place where his brother had been. He came to the great spruce tree. he looked up, and, behold, the skeleton of a man was hanging in the branches. The bones were held together by skin only. His flesh was all gone.

The boy returned. He entered the house and told his father about it. The father sent the young men, who saw where the body was hanging. Then

one young man climbed the tree, took the body down, and they carried it home. They entered the house. Now the chief's wife took a mat. She spread it out and laid the body down on it. She laid it down very nicely. The young men placed his hands, his feet, and his head in the way they belonged, and laid the head down face upward. There were only bones. Then they covered the mat with another mat. They painted it red and covered it with bird down. Then they sacrificed. For four nights and days his father and mother did not stay in the home. They had gone to another place, to another house. Only four men, his most intimate friends, watched him. Then they sang 'Ae!' accompanying their song with batons. Then they spoke, singing. Then the body came to life again. The bones were covered with flesh. Then he sang. He invited the tribe of his father in and the people came. Then the prince said, 'Burn the meat of all the squirrels that I shot during the past years, and burn their bones and the skins, which I am keeping in many boxes.' The people did so. They burnt it all.

Then the great master of the squirrels was glad, because his tribe had come to life again. Then the prince sang, "Ia heiaha a, heia'aya negwa iaha!' I become accustomed to this side; I become accustomed to the other side.' He stood there, and was a great shaman. Then he stopped. His name as a shaman was Squirrel. That is the end (1902, 211–16).

This story tells of a young boy who did not respect squirrels and his resulting encounter with the Chief of the Squirrels, from the other side (the spirit world), at "the foot of the great spruce tree." It is common for a supernatural being to be a white animal, like the white squirrel that enticed the boy into the tree and then transformed into the Chief's daughter. Gitxsan, Tsimshian, and many other First Nations stories have examples of characters encountering supernatural beings at or through the medium of a "great tree." Goldman recorded a similar Southern Carrier creation oral history about respecting squirrels, where the boy entered the sky world or spirit world by climbing a tree.

Tsax'kaps sister liked him. Tsax'kap used to shoot squirrel all the time. His sister told him, 'If you shoot at that squirrel and you miss your arrow will go way up.' Tsax'kap shot at a squirrel and missed. The arrow started to go up. He climbed a tree to catch the arrow which appeared always a little bit ahead of him. The tree grew up higher and higher. In a short time Tsax'kap looked down. He saw like a smoke. Above he could see a hole in the sky. The tree was just a bit short so Tsax' Kap climbed in [where the sky God lived] (1940, 356–7).

Morice (1896, 22) translated a Carrier oral history about a jealous husband who followed his wife to a dead tree. She struck the trunk with a stick and "[s]oon a beautiful young man, white as daylight, came out of the top of the tree and played with her." The theme of a white, supernatural being appearing from a tree is replicated in this myth.

Charlie Mack, a Lillooet Elder, tells a Coyote story where Coyote tricks his son into travelling into the "upper world." Coyote used his power to put dirt on a stump and then he called it an eagle's nest. His son Yikw-OOSH-hin began to climb the stump to get the nest, and "Coyote made the tree grow a little higher" (Mack 1977, 20).

Boas's squirrel story also depicts the training of a shaman, and explains how he lives in both worlds: "I become accustomed to this side; I become accustomed to the other side." This phrase is one of the most beautiful and expressive explanations of First Nations cosmology. It describes the shaman's ability to let his spirit travel between the two worlds. The youth's shriveled body was hung on a tree by the supernatural Chief, and the youth came back as a shaman after the squirrel meat and bones were burned. Having received respect, the squirrel spirits were properly released and could then reincarnate back into squirrel people.

Diamond Jenness (1986, 65–70) recorded a similar story of Old Pierre, a Coast Salish medicine man. The creation oral history explains how Pierre was chosen to be a medicine man during his encounter with "the father of all trees."

My mind returned to my body and I awoke, but now in my hands and wrists I felt power. I rose up and danced until I fell exhausted again and my mind left me once more. Now I traveled to a huge tree – the father of all trees, invisible to mortal eyes; and always behind me moved the same being as before, though I could not see him. As I stood before the mighty trunk, he said: 'Listen, the tree will speak to you.'

For a long time I stood there waiting. Finally the tree spoke: 'O poor boy. No living soul has ever seen me before. Here I stand, watching all the trees and all the people throughout this world, and no one knows me. One power and one only I shall grant you. When you are treating the sick, you shall see over the whole world; when the mind of your patient is lost you shall see and recapture it. Remain here for awhile till someone comes with a noise like the rushing of a great wind – someone who always rests on the top of this tree. Do not look until I bid you.'

I waited. There came a sound as of a great wind at the top of the tree. 'Now look,' said the tree. I looked. On its summit stood a great white horse. Its hoofs were red, and two persons sat on its back. 'That horse

flies all over the world,' said the tree. 'I shall not give you its power, for you would not live long.'

This was a supernatural tree, used by spirits to connect the spirit world and earth. The spirits used the tree as a connection.

The Tsimshian pre-contact oral history called "Guell Hast" is very similar to the Beaver Indian story about a medicine cross in Hugh Brody's *Maps and Dreams*, described earlier. In both stories a man sets out to find new territory because his people are starving; both stories talk of a spiritual marker. In the Beaver story, Joseph's father carved a medicine cross in a living tree, whereas in the Tsimshian oral history a single fireweed (*Epilobium angustifolium*) is placed by a supernatural tree that makes a sudden mysterious appearance. In both cases the "great tree" serves as a messenger from the spirit world to confirm the right for the new family to use the discovered territory. Joseph's father sought spiritual support by erecting the medicine cross on the new-found territory; the Tsimshian chief also seeks support.

Here he set his mark and claimed the land. 'This country,' he said, 'I take for the hunting grounds of my people, the men of Medeek. I take it that it may be used not wastefully nor with wanton destruction of the animals and the birds and the fish that dwell therein' ... Here for the night he stayed. His long ordeal was over. The time of self-denial was past. Taking such wood as came to his hand he prepared to light a fire and cook a little food. From under his blanket coat he drew a little pouch. In it he had finely shredded cedar bark mixed with powdered resin of the pine. Taking his firesticks of cottonwood roots he twirled until a spark appeared. With this spark he lit the mixture from his pouch and a fire sprang up.

Fed and warmed, he made his bed beneath a close-limbed spruce and slept until the break of day. Again he lit the fire. As he ate he looked around. Close by stood a giant tree. Strange! The night before it had not been there. And at the foot of that tree grew a single haast, a fireweed. Tall and slender it stood, its leaves trembling in the breeze. A haast growing out of the snow? Surely some magic. Such a plant was far ahead of the season of its kind.

His curiosity was aroused. He left his food and moved closer to the plant. It was fresh and green. It still stirred with the breeze. Still closer and closer he came to it. At last his hand reached out to touch the foliage and as his hand came close the haast vanished.

Guell Haast, the single fireweed, he called that place. To this day Guell Haast is the southern boundary of the hunting grounds of the Bear people. From that day Guell Haast, the single fireweed, has had its place on the totems to tell of the time of famine and how the people were saved from starvation (Robinson and Wright 1962, 35–6).

Mary Mackenzie presented the following story to the court during the Gitxsan – Witsuwit'en land claims case known as Delgamuukw *vs.* the Queen. William Benyon (Williams 1952) and Isaac Tens (Tens 1952) have recorded other versions of this story. This pre-contact oral history is important to the northern clans in Gitxsan territory. A significant number of the tree carvings discussed along our journey are located in this area near the old village of Kuldo (Qualdo). Therefore the story provides context for our journey as well as insights into crests, trees, and spirits. I chose to present Mary's version because she offers important interpretations about crests as she tells the story. The court's interspersed questions and recording of administrative matters are not included.

The adaawk of Gyluuget starts at Gitan gasx. It's a village, and to translate, the Gitan gasx is the village of wild rice. It's been the oldest village up north. The location is near Bear Lake. In the House of Gyoluugyat and Gitan gasx we have a warrior, and the name of our warrior in our House, Gyoluugyat's House, is Suuwiigos.

There is another group of native people. They're called Tsi tsa wit, and they're further up north. They came down to Gitan gasx, and they had seen that the people of Gitan gasx had quite a bit of land, so they decided to raid the village of Gitan gasx to get more of their land. Suuwiigos had a brother by the name of Tsawaas.

While he was on the trapline, and after he discovered that somebody had killed him, and this made Suuwiigos furious, so he started a group. He asked for a group of people to go with him, to go to the Tsi tsa wit territory.

They raided – they came upon a place where they only seen smoke coming out from the ground, and these were the people we call in Gitxsan, Luu Tsobim Tsim yibit, and it means the people underground.

They had a very good idea of their location of this village that they came upon, so they returned, and Suuwiigos prepared himself to declare war with these people, so he – they killed a grizzly bear and they took the hide, almost a whole hide with the head and paws and everything on it.

Now, they prepared this grizzly hide, they cleaned it, scraped all the fat off it. Now, they went and got pitch from the jack pine trees, and they rubbed it on this fur part of the hide, and they covered it with sand. Now, they had this – had this hide out, and the people had bow and arrows. They shot at this hide. If the arrow goes through they have to put more pitch and more sand to it for it to be arrow proof, you would say. Now, when this was ready, Gyoluugyat knew that this armour was ready for him, so they set off again and they went to where this village of the people that lived underground. Now, he advised his army that he – they'll sneak up to this place while he himself draped in this grizzly bear skin, and he walked down the opposite of the village, the adaawk goes like there was a gulley, a deep gulley, and this is where the grizzly bear with Suuwiigos in it walked, and then the people of the underground seen this grizzly bear, and they went out, they want to kill it, so they did. Now, they took, all their arrows, they shot at the bear and they didn't penetrate at all, so all their arrows were used up. This is when the force came and went into dug up the people, they killed them all. Now, this is how Suuwiigos led this group of people to fight off these Tsi tsa wit. Now, when this was over Suuwiigos returned to Gitan gasx.

He returned to Gitan gasx. Now, he knew that he had to have someone with him to – to help – to aid him or to – he was to have a brave person too, so that they would do more raiding, because they – he knew that there were still more Tsi tsa wit in other places. He had – now, this is not clarified to me, but I'll say it both. It's either Suuwiigos had a lovely daughter or lovely sister, so he sent word out that he had a beautiful sister or beautiful daughter, and the men of the – of other places, villages other than outside of the Gitan gasx came, and quite a few came. Suuwiigos didn't think that there were – he wasn't the man for his sister, so one day this man came, he heard about Suuwiigos and he heard that he had this lovely lady. So he went – he went into Gyoluugyat's House, and Gyoluugyat never turned, and this man by the name of Kuutkunuxws came, and he seen Gyoluugyat alongside the fire, so he went over to the fire, of course he was – Suuwiigos was laying alongside the fire putting the heat on his back.

Now Kuutkunuxws went and ruffled this fire, and there were sparks come out, and it fell on Suuwiigos' back. He never turned, and again [Kuutkunuxws] made the fire flare up, more sparks. Suuwiigos never moved. So Kuutkunuxws stepped back towards the door and he stood there. This is when Suuwiigos got up with a club and he went to Kuutkunuxws and asked him what he was doing, and Kuutkunuxws never said anything. He said 'If you don't tell me what you're doing

here,' he said, 'I'll club you.' He raised his club, Kuutkunuxws never blinked, and that showed that he was very brave, and Suuwiigos knew too that Kuutkunuxws was a very brave man. Right there he said to Kuutkunuxws that he was a brave man and that if he wanted to marry his sister or daughter he would let her marry him. Now, so the two, Suuwiigos and Kuutkunuxws, traveled together, after he married, Kuutkunxws married Suuwiigos' lady. Now, they traveled together, and this is when our crests came. While going out looking for the Tsi tsa wit they came across a big tree, and they made their camp underneath this tree, and during the night they heard noises, and it was coming out from the tree that they were under. Now Kuutkunuxws went up and to get – to see what he – what was making this noise on this tree, and he seen this thing, it was a human being, but it was a giant human being. Now, he came down and told Suuwiigos about it. Now Suuwiigos went up to see this big human being. Now, this is when Suuwiigos got to this figure, this human figure, the giant one. He took it and knocked it down and swung it to the ground. So they left, so when Suuwiigos, before he left, he tell Kuutkunuxws (currently William Morrison of Kispiox) 'I will have that figure for my crest.' Now, this is why we have that figure for Gyolu-ugyat's house of Gyadim Lax ganit (the man of the tree) is our crest.

They knew that they were on the heels of some – another group maybe, and they knew that they were near the place where they'll meet with other group of people, that there were going to have – we say in Gitxsan wil digitxw (when a group of people meet together and they have a war, or they have a fight amongst the two groups).

Now, again at nighttime they – well, at dawn they go, Kuutkunuxws and Suuwiigos and the people that are doing battle, they camped again near a lake. Now, they – Suuwiigos didn't know just how far ahead these people were from where they were, so anyway, he went down to the lake to get some water. Now, just when he got to the lake he seen shadows on the surface of this lake, and he looked, he stopped, and he watched, and he seen this movement, so he knew that the people they were after were up in the trees just above them, so he went back to his – to Kuutkunuxws and to the other people and told them 'Our enemies are just above us,' so this is how they went, and of course they fought the battle. Now then again, this is how Gyoluugyat received the crest of these shadows. Now, on our blankets and on our – painting of our Houses we have these figures. They're a group of people, and they come in a zig zag way on our blankets. Now, this is 'Nii tsabim lax gan. The first one was Gyadim Lax ganit. Now there is 'Nii tsabim lax gan, when there's a group of people. And this is how we got our crest

again. Now, this is the way that the Gitxsan people get their crests, is anything unique that they come across or they've seen they've taken it as their crests. Now, the people that travel, any more unique things happening you will find that in other House, Chief's Houses. Our Chief has more crests than the other House because they go out to look for these things so they will have a crest, and who has the more crests are the people it shows that they work together, and they make it very strong. And this is how these crest mean so much to us, is by looking for it, and to keep it as ourselves in our House. Now, in . another House a Chief would have a crest. Now, we can't borrow crest from other Houses. What House belongs, their crest belongs to one House, is their property. Now, these are how strong these crests stand in the House of a Chief. No one can use other Houses, Chief's Houses' what crests they have. If they do they – there's embarrassment of the Chief. There has to be punishment. We go to the House of that whoever took another person's crest. So this is very firm in our laws even today, that we – no one will use another Chief's crest. That's their title for that (Mackenzie n.d., 222–8).

Mary describes how the braves encountered a large naked human in a tree and the spirits (shades) walking along the canopy. The warriors claimed these beings as crests because of these encounters. Williams (1952), in his version of Mary's story, describes the shadows that were encountered as follows: "They now went on, and arrived at a great lake. Gutkwinuhrs' [Kuutkunuxws'] father-in-law, Tsilaerentk from Kiskagas, was also with them, and he was a brave warrior too. As they looked into this lake, the wind was blowing and they saw the shades of the trees in the lake. And they took these shadows of trees as a crest and called them Qanhautsenrht, 'Tree-shadow-of,' and they gave this crest to the Larhkibu (Wolf) ... " Emmonds (1991, 102) explains the Tlingit view on tree shadows as "the shadow cast by the tree in the sunshine [was its spirit]."

These spirits are called nox nox by the Gitxsan and other Tsimshian groups. Marius Barbeau (1973, 71) describes nox nox as "the spirits of nature, and the shades of our forebears." He says they are "unseen in daylight but ever present beyond sight" in places such as the sky and forest (179). Frances Robinson describes nox nox as follows:

Nochnochs were also real entities with tremendous powers. Boas call them nExno'x, helpers from Heaven, and points out that the term designates anything mysterious. As well as being supernatural helpers, they are also the whistles used in dances and the sleight-of-hand tricks of the dancer. Ken Harris says that they are either persons or animals possessed by known spirits and used by the Heavenly Father to punish or reward. The nochnoch, therefore, wields a large influence

in the Northwest Coast people's lives. Any action of a nochnoch is interpreted as either punishment or reward (1976, xvii).

I like Robinson's explanation because she illuminates the point that nox nox can also be beings that are "possessed by known spirits." Sacred trees are beings which have the potential, at any time, to be possessed by the supernatural. Every being on earth has its spirit quality and the potential to be nox nox.

Echoing Mary Mackenzie's account, Marsden (1987, 45) explains that one of the ways nox nox and crests are acquired is while on a journey into battle: "Tests of strength on the journey allow the warriors to experience their own power before it is put to the greater test. They can precipitate an encounter with a supernatural being. This spirit or being may be the ancestral power of the wilnat'ahl already embodied in a crest or it may be a new one. In either case it presents itself to the warriors before the battle as a promise of the supernatural assistance he can draw upon in the war itself." The nox nox usually represents negative human qualities such as pride or greed that work against the fulfillment of Gitxsan law. The chief has the power to control nox nox and ensure balance and harmony (158–9). Kuutkunuxws and Suuwiigos acquired their crests when they encountered the "man in the tree" and "shadows" nox nox while on their way to do battle with the Tsetsaut people.

The next set of stories are good examples of the relationship between the supernatural tree and purification. The Gitxsan call purification Si'setxw, which can increase a person's daxgyet or spiritual power. The stories "Am'ala, Very Dirty" (Boas 1970) and "Person of the Trees" (Menisk and Benyon 1987) share the same theme: a young boy who has unclean habits is purified by an encounter with a supernatural tree and he gains great power. The boy Am'ala has such great power that he now holds the world up on a pole. The other boy, Guxla, becomes rich by supplying his people with scarce firewood. I will present portions of the creation oral history about Am'ala and then of Guxla.

The young man [Am'ala, (Very Dirty)] went to the bay south of their house, where a brook was running down. He was full of sorrow while going up the brook. Then he met a young man whose skin shone bright. He asked him, 'Why are you so sad this morning, my dear!' The young man answered, 'O supernatural one! my three older brothers make fun of me and laugh at me, and they call me Very Dirty!' Then the supernatural being replied, 'What do you wish of me? I will grant you your wish.' Then the young man said, You see that my skin is not clean. I want to be clean, and I want to be stronger than any living being in the country.' The supernatural being replied, 'Go over there and gather the

*leaves of the supernatural tree and bring them to me.' So Dirty went to
the great valley and tried to find the leaves, but he could not do it. He
brought leaves of all kinds, but the supernatural being refused them.
Then the supernatural being went himself and brought a bunch of leaves
of the supernatural tree. He said, 'Let us go down to that pool yonder!'
They went, and behold! there was a good pond, and the supernatural
being washed Dirty in the pool four times. He washed him with the
leaves of the supernatural tree, and he became very clean, and was a
fine-looking man, tall, and broad of chest ... Now, all the animals heard
that this young man was the strongest person that ever lived ... When
all the animals had failed, the strong trees came. First the Crabapple
Tree [Malus fusca] came to his door and called him out to fight with
him. He came out and pulled it out with the roots as one plucks out
grass; and thus all the strongest and greatest trees came. He pulled them
out and broke them to pieces ... (117).*

Dirty, with the aid of his slave, defeated all the living beings and the strong
mountain. The slave would rub the oil of wild ducks on Dirty's sore back
to rejuvenate his power. Finally he won the right to replace the ailing chief
who was supporting the world on his chest with a pole.

*Dirty is still holding the world on his chest, and his slave is also there.
The oil of wild ducks is nearly gone now; and as soon as Dirty dies, the
world will come to an end (121).*

 The creation oral history about the boy named Guxla who has unclean
habits also describes his encounter with a supernatural tree and his result-
ing gain of daxgyet.

*There was a Chief who had a grandson. The boy used to emit noises
through his hands that annoyed the chief. The chief thought that he was
making a mess all the time. The boy developed that habit until he actu-
ally defecated without a stop. They chased him out of the house, and
built a house for themselves at the end of the village. Both he and his
grandmother stayed together. They had a little chopping axe.*

*He was now pretty well grown up, and strong. One night, a stranger
came into the house. They did not know who he was. They placed a
mat at the back of the house for him to sit on. The grandmother took a
spring salmon and began to roast it. After that, she crushed some berries
in a bowl. After she had finished giving the berries, she gave him high-
bush cranberries and soapberries.*

When the man had finished eating, he asked the boy, 'Have you not a chopping axe?' The boy replied, 'Yes, I have one.' The man said, 'Let me see it!' The boy brought the axe, which was made of stone. The stranger looked at it. He took it, put it in his mouth, and pulled it out. They saw that the axe was sharpened. In the path which the people used to pack their wood was a great spruce tree. They had nothing to cut the spruce tree with. The man then said to the boy, 'You will cut the big spruce tree, in the morning.' He added, 'Just before the tree falls, you must shout, 'Amlan, wiliamlan!' meaning that the tree will split itself in small fragments.' The man said, 'Do not leave a particle of this tree. Take it all, even if it requires all day taking it. My name is Giskyila. You must not leave a particle of that tree. Immediately after the tree falls, you must run to the top of it to the very end.' After he had told the boy his name, the stranger went away. It was the tree itself that had come to him after taking the form of a man.

In the morning, the young boy got up and began to chop the tree. While he was doing this, the men of the village saw him and made fun of him, saying, 'Does this boy who was always defecating think that he can chop down this big tree?' The boy kept up chopping away, the axe not penetrating very deep into the wood. While he was chopping this tree to pack it away, the women saw him and laughed at him, 'The young boy who was always defecating thinks that he can chop this tree down?' All those that came by did the same thing, especially the women; he was the butt of ridicule, because he messed himself and wanted to show off. The boy kept chopping and he was getting very discouraged. He was about to give up. Then the axe went right into the wood. It was rapidly chopping through the side of the tree. What was coming out of the tree was black, and different from what it should have been. Then the tree began to fall, and, as it was falling, the boy shouted, 'Amlan, wiliamlan!' just as he had been directed the night before. As it came down, it fell into pieces, as if they had been cut into fire lengths. He then ran along the top of the tree to the end. There he picked up a box. When he opened the box he saw that there was a garment in it. It was very red, and it was called Garment-of-Bright-Red on account of the colour. There was also another garment in there, which was the Garment-of-White-Hairs.

The boy Guxla, took these garments into the house where his grandmother was awaiting him. They began to pack the wood he had cut. They did not leave a branch, as they had been instructed. Now they had a big pile of wood in the house. During the night, a huge snow storm came upon the country and buried all the houses. The snow was very heavy, and the people were unable to go and get their wood, because of

the deep snow. The chiefs of the diverse Houses began to buy wood, paying with moose skins. This, from the boy and his grandmother. They had many moose skins, because of their selling of the wood. They were wealthy now, and he was becoming a chief.

He was now grown up, a young man, and the grandmother retained all the moose skins. After the snow was all gone, the young man said that he would have a feast. After his guests had arrived, he began to give them all presents. During this ceremony, he announced that he wanted to assume the name of Guxla, the name that had been applied to him in ridicule. He also assumed the name of the man that had been in to see him, Giskyila. At the same time, he exhibited the Garment-of-Bright-Red and the big box People-of-Tongues (315–16).

In these stories, the supernatural tree, or nox nox, gave Am'ala great power that manifested itself into strength and Guxla great power that manifested itself into wealth. Their metamorphoses were initiated by the tree's ability to purify and bestow da<u>x</u>gyet. Again, I think a supernatural being passed on power through the sacred tree; in these oral traditions the tree symbolizes purification.

There is a Tsimshian story called "The Widow and Her Daughter" (Boas 1970) which reinforces this symbolism: it describes the origin of the use of devil's club (*Oplopanax horridus*) as a purifier. Tsimshian hunters and trappers use devil's club to purify themselves before they go hunting. A young boy met his supernatural father in the forest one day, and the father said, "I will teach you to obtain valuable animals by trapping them without shooting them." The father showed the boy how to make traps and snares. The father then said, "And you shall eat the bark of devil's club," and taught him purification rituals. Devil's club was used in purification baths, as a treatment for diabetes and stomach ulcers, as an emetic, and as a laxative. Interestingly, devil's club is a member of the ginseng plant family. A year passed and the boy's luck turned for the worse – he could not catch any animal. His supernatural father appeared again.

Early the next morning he went into the woods, looking for devil's-club, but he did not find any. Late in the evening he came back home; and after he had washed his body, he went up a little hill, and behold! there was a large tree. He went toward it; and before he reached the foot of the large tree, a supernatural being came around to meet him. When he saw him, he said, "Is that you my son? Tomorrow you shall cut down this large tree, which will last you throughout your lifetime." After he said this he disappeared. The young man went home, and early the next morning he went and found the large tree. He went toward it, and

behold! there was a devil's-club tree larger than any other tree in the whole world. He took a stone axe and felled the great devil's-club tree ... Then he started to wash his body with the bark of the devil's club and its sap, and he ate some to purify himself (Boas 1970, 174–5).

The supernatural father appears from behind a "great tree" to pass on the power of the devil's club. The boy became very wealthy because of his renewed trapping success, and "[h]e remained an expert hunter."

The final extract is about the family of Tsauda, a supernatural being. The extract comes from a Tsimshian pre-contact oral history story, recorded by Henry W. Tate and edited by Boas, about Tsauda and his slave Halus. The initial passages describe how Halus tricks Tsauda, who is the son of a supernatural Chief-in-the-skies. Halus was to arrange a marriage between a beautiful girl on earth and Tsauda, but Halus married her instead. Tsauda was very angry and he cursed Halus. Tsauda said, "Everything that you do in the future will turn out badly, and you will be disappointed with your wife!" Tsauda then married the princess's lame sister and exclaimed, "She will have good fortune." In the ensuing events Halus met with misfortune at every turn, when gathering firewood, fishing, or hunting. Tsauda's wife gave birth to two daughters. Supernatural beings such as Tsauda have the ability to prevent a person from being able to succeed at hunting, fishing, and providing for their family. Supernatural beings' ability to affect luck is discussed later when we look at some of the reasons why tree art was created. Here is a passage relating how Tsauda's son-in-law had an encounter with a supernatural tree.

When the elder girl was married, she told her husband that her father, Tsauda, told her of a good copper in the Copper Creek at the head of the Skeena River. Therefore the prince called his three young men to go with him to see the good copper at the head of that creek; and when they were going in their canoes up the river, they smelled sweet-smelling scents; and when they went farther up, they smelled still more fragrant odors; and they went on and on, and the odor was sweeter than ever. Before evening they camped, and the prince went into the woods; and as he went through the valley, he saw something standing in the middle of a nice plain, moving and waving. He went near it, and he saw that it was a live tree of odors. So he ran to it and embraced it, and all the branches of the tree also embraced him, and the living tree pressed him hard and squeezed him; and before he lost consciousness, he shouted, to call his men to come to his help. They ran quickly, and saw the prince and the living tree of odors embracing each other. The prince said to his men, 'Dig away the earth from the roots quickly.' The men dug away the earth quickly; and when all the roots were out of the ground and the

*branches were dead, the prince was released from the branches. All the
branches let go of his body.*

This is the tree of odors, or the live tree.

*This prince was very successful, because he was married to the daughter
of a supernatural being. He cut the tree into short pieces, and he also
cut the branches and the roots, and he gave to each of his men one root;
and his men filled their bags with the soil from the place where the tree
of odors had been, and when they came back home, they sold them for
a high price. Then all the chiefs from all the tribes came to buy one of
the short pieces at a high price, and the princes and the princesses came
and bought pieces of the tree of odors, and the prince became a great
chief (297–306).*

The husband of Tsauda's eldest daughter became powerful as a result of
his embracing encounter with the "tree of odors," as did Guxla when he
encountered the supernatural tree that provided firewood. The "tree of
odors" may be the the rocky mountain juniper (*Juniperous scopulorum*)
which is an aromatic tree still found in places near Hazelton. There is, for
example, a small stand on the southern edge of Telkwa, B.C.

These oral histories demonstrate how the sacred tree can act as the *axis
mundi*, whereby the tree becomes a locus of supernatural power. Human
encounters with supernatural trees or nox nox result in the acquisition of
daxgyet, manifested through a crest, purification and strength, medicine,
or good luck. All trees, therefore, are to be treated as sacred.

PREPARATIONS COMPLETED

Our preparations should enable you to view tree art as more than a stat-
ic artifact. Tree art may appear as a *tableau vivant* – silent and motionless
spirits arranged on the First Nations landscape, as actors stand frozen on
a stage. The story and context created in the frozen moment becomes the
snapshot of history that is the source for the story of each tree along the
way. But although the faces in the forest may in the physical landscape
seem frozen, in the spiritual landscape they are alive: they age as the tree
ages, they gain power as the tree gains its power through Mother Earth,
they embody the artist's spirit, and they embody the spirit of the forest.
This alternate perspective may help you to see the unseen.[22]

The Journey

Langdon Kihn was an American artist who traveled to Hazelton, B.C., in the early twentieth century. He painted landscapes and portraits of Gitxsan chiefs.[1] He wrote a short article in 1926 about his experiences with the Gitxsan, in which he offered a beguiling invitation: "I am neither a historian nor an ethnologist, just an artist pure and simple, and want to take my reader into an artist's paradise. Not necessarily an artist's paradise but any one's paradise" (Kihn 1926, 170). As your guide I offer you a similar invitation to discover tree art and its impressions upon your spirit. Upon completing the journey I hope we will share a sense of tree art, the forest context, and the realm of possible interpretations. This textual and visual journey across the First Nations landscape begins in southern British Columbia and continues northward to Hazelton, Fraser Lake, Tumbler Ridge, and then to the Yukon. A trip to Manitoba completes the journey.

The knowledge imparted at each stop adds meaning to the realm of possible interpretations for tree art. There is a story or history for each tree and tree art image along the way, constructed from my perspective, the perspective of local Elders – the verbal artists – along with background research and photographs of the visual art. These stories encapsulate our knowledge of tree art at a moment in history, knowledge that will evolve and change with time.

Through our preparations you have been introduced to the artistic, historical, and spiritual context of tree art. Now we begin our journey in the Lower Mainland of British Columbia with George. George was also my first introduction to tree art. George changed my perspectives regarding living trees, spirits, art, and artists.

LOWER MAINLAND

GEORGE

George lives in the reception area of the Coqualeetza Cultural Centre, Sardis, B.C. Richard Daly, co-author of *They Write Their Dreams on the Rocks Forever*, told me where to find George, and so I traveled to Sardis in the spring of 1995. There I met Frank Malloway, a cultural adviser and a hereditary chief in the Stó:lö nation. Frank is a humble and knowledge-able person, with strong spiritual beliefs. I spent a memorable day with Frank talking about George and his history.

George is very powerful in appearance. He was carved on a cedar hop pole around 1920 (see figure 17). Frank begins by telling me about the hop poles and hop picking history, and then he describes George's genesis.

MICHAEL: If you could just recount the history of George for me ... He was on the Hulbert farm on a hop pole?

FRANK: Yeah, maybe I could take you down to the hop yard later. They are like a bean, you know a lot of people [who] are picking beans say 'are these hops?' They stand them up and string wires, the strings are attached to the wires down to the plant and grow up to the top of the string. And the hops are hanging down there. And now they cut them down and they lower the wires, or they used to, when they picked them by hand, they lower the wires. But now they picked them by machine, they cut them down and lower them into the wagon and take them to the kiln. There's no hand picking any more.

MICHAEL: So they pick seasonally?

FRANK: Yeah, Usually the second week in August until the end of September, anywhere from four to six weeks. We were just talking about that the other day. About the migration of people, they used to pick strawberries, they start picking strawberries, they go to raspberries and then go to hops, and after hop picking they would go to the Okanagan to pick apples. Some even went as far as California to pick grapes.

MICHAEL: So was this the Stó:lö people?

FRANK: Yeah, it was the Stó:lö people, and all the people on the coast. You know. It was sort of the fun part of it, not everyone wanted to make a million, they wanted to socialize. A lot of marriages occurred. A place to meet people, beginning a new life with somebody. Just the other day we were talking with the Elders. I guess what brought it up, was that there are so many of our young people marrying their cousins. They say, well, we don't get to travel anymore. A long time ago we used to travel to the States, we'd pick berries and then we'd come and pick hops, then we'd pick apples you know. Meet people

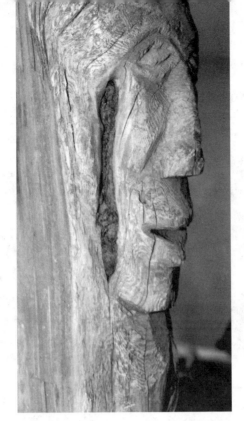

Figure 17. Left: George, a carving on a hop pole, Sardis, B.C. On the right, Frank Malloway is shown standing beside George.

from a long ways away from your village, you know, and you brought a woman home that was not related to you, but now our people don't do that anymore, you know. Now we're finding out that a lot of our young people are marrying their cousins. It got really bad up in the Shuswap area. We have a girl working for us, she married one of our boys across the river, she told me that the Elders got all the young people together several years ago, too many of you are marrying your cousins. We want all you girls to go to school somewhere else. When they entered high school in different areas in B.C., you know, a lot of them went to Victoria, Duncan, Campbell River, she said 'I came to Mission.' And met her husband there, or Abbotsford. I am not too sure which. She said the Elders put their foot down, too many people inter-marrying. What brought it up was our longhouse you know. She never ever was to our longhouse dances you know, one of my cousins told me about it.

Figure 18 depicts the hop picking era, showing the First Nations hop pickers, Stó:lö and many others, who traveled on the seasonal round. The history of the hop picking era in the Chilliwack valley is part of George's historical context.

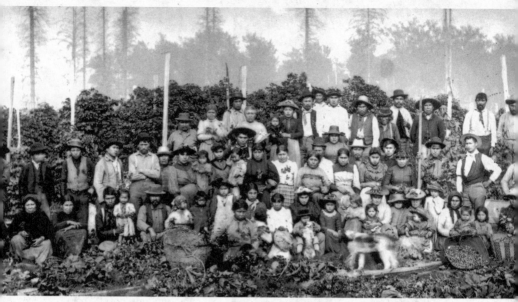

Figure 18. Native hop pickers, Chilliwack, B.C. (Chilliwack Archives: photograph no. 3564).

FRANK: But, uh, going back to George, this hop pole, I guess it is about fifteen feet long you know. He [the artist and hop-picker] used to see this big knot in the pole and he could see a face in there, and he used to talk to it you know. Nobody else could see that face so he decided to get his little hatchet out and break the face out so everyone could see it. So after that pole needed to be replaced, the Hulbert family who owned that hop yard, they took it down and planted it in their garden. When the hop yard was sold, I guess they got attached to it, the totem pole, it's not really a totem pole, the face. They took it with them when they moved to Vancouver and put it in their garden. I guess the lady who Reuben Ware interviewed about the hop yard, she said she was worried it would deteriorate, she was very careful with it, she gave, when she showed it and told him to take it back to Chilliwack. She gave him a quart of preservative, 'You brush this on George, and make sure you brush this on George.' Then we gave him a quart of that every year. George came home, he wasn't christened George until Reuben Ware in the history he got from this lady, was that George Yutslick was the one that carved the face in this pole. So we just dubbed him George because we didn't have any other name, and that was about, gee I must be getting old, it was twenty years ago. George came back, I think it was in '76, or '77. You know and it

is '95 right now. So, it's quite a few years now, but he doesn't really have a permanent place to sit. That's why the Elders were really upset by it, he was laying in the longhouse, nobody really respected him, there was so much change in staff here. The cultural centre was the one looking after him and they put him in the longhouse. He was removed from there when we had the opening for the new building. The Elder said we had to have a permanent place for him so. That the only history I know of George. George Yutslick carved the face so everyone could see it.

MICHAEL: When you said you blessed it at the ceremony [opening the Coqualeetza building, in spring 1995], what was the process?

FRANK: Well we have among the Coast Salish people, the Coast Salish people we only have one mask, the swaihwe mask, at the ceremony we use the swaihwe mask for a lot of marriages, uh, funerals just before the burial they brush the casket, they wave the spirit into the other world. Naming ceremonies, bless longhouses. So when we opened the new building. We call it the new building but it was reno-vated from the old [tuberculosis] hospital, we bless it in our own way, so there was no other way we could have done it, though our swaih-we mask. We had thought it would do two jobs. And that was to name two children, with the name Stó:lö, they were supposed to be living markers of that day. So we just changed the ending of their names, it was the female and this is the male, Stak:lia for the female and Stak:alak for the boy. Stak:alak verifies that person being the male, and Stalak:lia or, something like that, I can't remember. See that picture up there, up there it's my wife's aunt, she has the name Sta ...
... my wife carries the name ... So her children. While they were bless-ing the children, Stephen Horn was saying we should get George up here, he needs to be blessed too. So three things took place at once. We blessed the building, we blessed the children, we blessed George. We had a lot of mask dancers. They were all lined up, they did three jobs at once. It is a great honour to be a mask dancer. It is strict. Not everybody can use it. You have to belong to the mask family. We lost it for 150 years. And it just came back. But that's the early missionar-ies, they made you burn your masks, burn everything. They gave them up. One we know of, we burned it, the others gave them up, or the others hid them away. We just lost one a few years ago, one of our Elders was moving from Laidlaw to Boston Bar to his daughter's home. And they had it in the back of the station wagon. It was so hot that day, they had the tailgate open. And the mask was just inside there, they stopped at a restaurant and they went inside to eat and they came out and the mask was gone. Someone reached in and took it. It was one of the old carvings, the old masks were not really fancy

the way you see the carvers doing the face masks now, it was what George looked like. They have protruding eyes, a crooked nose and a protruding tongue. That's what really identified the swaihwe mask, the protruding tongue. In our area they didn't have the bird as the nose. They had a great big nose. I didn't see that mask, but Mark seen it, he said that's the old mask.

MICHAEL: What do you think of George becoming so important to the Elders, what do you think it represents to them?

FRANK: I think it represents part of their history, as the hop yards, and keeps them attached to the past. Like what we were doing with the children, like I mentioned, we christened them, they are living markers. It's their job to tell other people what happened that day. I think George was representing the hopyard and when you talk about the hopyard it brings a lot of memories back for the old people, they start remembering things that happened. Like 'Oh that's where I got my wife.' Brings back happy memories. It's just like something that happened, you respect it, also you take something that's your own way. Like the man I was asking he said 'that's our history, we've got to have George up here, we got to show respect to him, we've got to put him in a place that everybody can look at him.' And then when people ask about it, like you coming along and asked about George, and saying 'well what are the hopyards?' You don't know anything about the hopyards. Our kids here are like that here. They don't know anything about the hopyards. Because the last time they picked hops by hand here was in 1953. So that's forty-two years. We've got kids that are eighteen that never hear about it. So that's why I think it's so important to our Elders, it's just like a book you know. Oral history, you ask questions about it, and a whole bunch of stories comes out. It's like I was saying earlier that you respect things that you make, you don't just cast it aside. It has a certain life to it, then you return it to nature. George is not ready yet to return to nature. He has still got a long life ahead of him.

MICHAEL: Important work ahead of him?

FRANK: Yeah, I think a lot of Elders are attached to things like that, it reminds them of the past and the stories that come out of it you know. Like George Yutslick, there are no Yutslicks left in this area, they have all died away. You talk about, well who made that, 'George Yutslick,' well who are the Yutslicks? So that where it will come out. There are descendants of the Yutslicks, but they do not carry that name.

MICHAEL: When you talk about markers, what are the markers?

FRANK: Well, that's the term that Steven Point first brought out, that was Arnold Richie, he was the one who reminded me, you got to have a living marker. A marker could be translated as an informant, some-

body who remembers that day, usually we call witnesses and they have to remember what took place, but we refer to these children as living markers, they began their life as Stal:lak and Stalak:lia on that day. You can't take that away, as their new life. That's the only way I can translate it as what Arnold and Stephen referred to them as living markers.

MICHAEL: Do you think George is a living marker?

FRANK: I think he would be also, it's the second journey that he's taken, the first journey was just coming back home. By waking up those stories, it came at a time when a lot of our Elders knew the carver. A lot of the Elders in our area knew the carver so they started telling stories about George Yutslick. But today even our sixty-year-olds don't remember George Yutslick.

MICHAEL: So it sounds like it would be an important part of this research to get a picture of George Yutslick?

FRANK: Yeah, maybe I could take you over to look for one ... The Yutslicks originated in the Cultus Lake reserve. And some of them were living on this property when they surveyed the reserves. There was a village here along Lukakuk creek. One of the ladies at Nuksack, just passed away, she was the last one born here. Mamy Cooper, she was from this reserve. Harry Yutslick, I think he was the son of George Yutslick. He [was] the last Yutslick that I knew of. His grandson and wife's grandson I believe they raised him and put him through high school. He married a lady from Shuswap, she's the only one that carries the name Yutslick, through marriage. Mary Yutslick. She teaches a lot of her culture, the sweat lodge. She was working for the prisons for quite awhile. Medicine woman, putting them through their fasts. She was busy over the weekend. I went to see her.

George has become a historical marker, an informant who wakes up stories for the Elders and connects them to their past. He was created by George Yutslick in the 1920s, and remained on the Hulbert hop farm functioning as a hop pole and garden marker until the Hulbert family sold their farm.[2] They moved to Vancouver and took George with them. George returned to his rightful home in Sardis where he was blessed with cedar boughs and given the name "George" in the spring of 1995. This was, as Frank points out, his first journey. George Yutslick's intention was to unfold the spirit of the tree in the knot of the hop pole. He wanted to share his insight with the other hop pickers. George was a very good carver, and his carving reminds me of a False Face mask because of the exaggerated facial features. The intended viewing context for George was the hopyard, as shown in the old archival photographs. But George traveled, sat in gardens and basements, and finally in the reception area. Frank calls

George's new journey as a historical marker in the reception area the "second journey" of meaning. George has awakened faded memories, and the Elders are now passing them on in the oral tradition.

MICHAEL: George is interesting, I guess as an artist it is interesting to see how a, how a piece of art goes through history, and picks up its own history and how people relate to it. George is coming back on a new journey. It's a powerful carving, George Yutslick is a very good carver. It's powerful.

FRANK: I think it takes artists to appreciate it too you know, the ordinary people they come and look at it. You have to be an artist or have that feeling to appreciate it. I was walking by there the first week he was put there – 'Hi George.' The receptionist was looking around, she thought somebody got by her.

I developed the notion of the "intended meaning" of the first journey, and the "second journey of meaning" from my conversation with Frank. Both Frank and George taught me the importance of history and how the meaning of an artwork changes. The artist creates the intended meaning within the intended viewing context. The "second journey of meaning" develops over time through changing circumstances or changes to the intended viewing context. The hopyard was George's intended viewing context, and the intended meaning was artistic and spiritual. Now the viewing context is the reception area of the Coqualeetza Cultural Centre, and the second journey of meaning is as a historical marker. George's role is the same as the two young children who were blessed along with George – to witness and preserve Stó:lö history.

George is an excellent example of the interconnected nature between verbal art and visual art. In George's second journey of meaning, he awakens old stories through his presence. George symbolizes an era and all its associated people: he helped the Stó:lö Elders recapture and pass on important history through their storytelling.

I learned another important lesson from George and Frank regarding how to define the living tree as a medium for tree art. Frank mentioned that he said "Hi" to George as he walked by, as he would to an old friend in passing. The following discussion helped me define "living" trees.

MICHAEL: If you were to write a history of George, what things do you think would be important?

FRANK: The important things about, at the beginning is the spirit of the tree itself, how it comes out, and how the old man seen this and want everyone else to share it.

MICHAEL: The interesting thing about this one is, that from a Western

perspective, that the tree is dead, it's just a board standing there, a piece of dead tree standing in the field. But George saw it as alive.

FRANK: Yeah. Well one of our teachings is anything that you make out of a living thing like a tree, like the canoe, you start using it, that piece of wood comes alive, even the paddles come alive. Maybe it's a teaching that was given to our people so they respect everything they own. I don't know, to the old people everything was alive. I was telling you earlier I went back to school in the 70s to get my grade twelve, and while I was in my biology class my instructor said you know this desk here is made of atoms, and you know those atoms constitute wood. It could be bullshit. Well that's the same thing that if someone says you know this log here is a canoe. Well that's the same thing that the biology teacher told me, you got to believe it.

MICHAEL: When I look at George I believe that he is alive. George Yutslick did a very good job.

FRANK: We lost a young boy a few years ago, we had a burning for him. We burned his belongings, his clothes and stuff you know. His grandmother had a paddle, one of those bent paddles. She had it up on the wall. She said, 'He made that for me, I want him to take it with him.' So he [a friend of the boy's] went outside. During the ceremony, there was a fire you know. He turned around, and the whole pile that was on there flipped over and the paddle came flying off. You know, and he picked it up, and then he said, 'You know everything that we use has a spirit, and you know when we offered the paddle he took the spirit of the paddle, and kicked the paddle out, he took the spirit of the paddle, that's all he needed.'

The hop pole, like the canoe paddle, is a living spirit; it may not have water or sugar coursing through its veins, but nevertheless George Yutslick unmasked the living spirit by carving George. Frank responded to my statement that George is alive with the paddle story. The paddle, as a wooden utilitarian tool, had a spirit. The deceased young boy took the spirit from the paddle as he began his second journey. Frank emphasized the respect the Elders show for their belongings, because they were made from the Earth's gifts, such as the sacred Hopai, the Stó:lö cedar spirit. They cared for their baskets, paddles, and canoes until these things were ready to return to nature. Their belongings had a spirit, "you got to believe it," says Frank.

DISCOVERY PASSAGE AND PHILLIPS RIVER

Phillips River flows into Phillips Arm along the west coast of British Columbia, north of Powell River. Somewhere along Phillips River are tree carvings such as the one shown in figure 19. It took almost a year to track down this

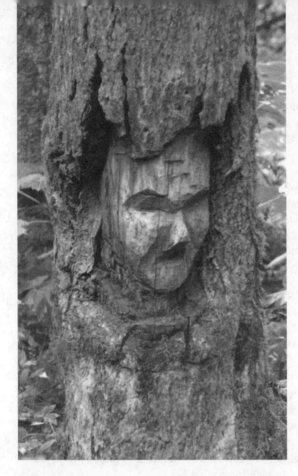

Figure 19. Carving of
a face on a tree along
the Phillips River taken
in 1973 (courtesy of
T. Dixon).

photograph. I had been trying to locate the author of an archaeological
report of another tree carving, on Vancouver Island in Discovery Passage
(Borden number: EbSi-9).[3] A Mr T. Peterson filed a report in 1973 of a tree
carving that "appears to be Indian," of a human face. I took a chance and
decided to call the T. Petersons listed in the Campbell River phone book,
and luckily the author, Thor Peterson, was the first person I called.

Thor originally thought I was referring to the Phillips River tree carv-
ings. He had submitted an archaeological report on these trees as well, but
the report was lost somehow. Once we cleared up the confusion over the
two sites we began to discuss each one and how he discovered them. I
spent a few days in May of 1995 looking for the Discovery Passage tree
carving based on Thor's recollection, but to no avail. I did, however, find
a scar, created by human activity some time ago, on a large cedar tree. Bob
Pollard of the Campbell River band assisted me with the search.

Thor also told me about the Phillips River site, which he visited in 1973
as well. He had flown in by helicopter with an old prospector named Bob
Hart, who has since passed away. They were looking for an old Indian

copper smelting site that Bob Hart had discovered along the Phillips River, near some big flat rocks. Thor remembers eight to twelve carved faces in the trees around the old smelting site. Apparently Bob Hart cut into old scars and found the faces under the wood still in good condition, and there was a mirror image on the cut pieces. Thor said that Bob Hart had a theory about the tree carvings, that they marked copper deposits or old smelting sites, and therefore he followed a hunch, as this was his successful prospecting style. Another extract from the Tsimshian oral history about Tsauda's son-in-law, described in the fourth preparation of the last chapter, offers some insight to the Tsimshian perspective on copper as a salmon spirit, and how the smelting process could produce dangerous fumes. The Tsimshian are close northern neighbours of the Kwaikah people of Phillips River.

Then the younger daughter of Tsauda said to her husband, 'My dear, my father has told me that there is a good copper at the head of a creek'; and the husband of the younger one called his young men to go with him up there. The following day they set out and went up that creek, and night after night they camped. That young prince went walking along the bank of a River, searching for smooth copper pebbles; but he could not find any, because the time had not come yet. They traveled on many days, until they reached a place way up the River, and toward evening they camped there. There was not much water in the River, and they could not travel on by canoe, because three small brooks joined where they camped, and at this place the deep water ended. The young prince walked along the bank of the River. Then he saw many salmon. He hastened back to his men, and told them that many salmon were in the deep water there. Therefore he took his salmon-spear and went down again, while his men started to light a fire in the camp. He went down, and stood there ready. When he saw a large salmon come up, he struck it and took hold of it. He dragged it up the shore and clubbed it. Then he took out his dart and threw the salmon backward. So the salmon struck the smooth stones of the River bank. It sounded like copper. Then the young prince went to the place where he had thrown the salmon. He took it up again to see if anything was under it and behold! the salmon was transformed into copper. So he took it up to the camp of his men and showed it to them, and they were all very happy. In the night they got ready for the next morning. They spent the whole night making a new pole and new darts to be used the next day. Before daylight they all went to sleep, and the prince took his copper and put it under his head as his pillow. Late on the following morning, when the sun was high in the sky, the steersman woke up and aroused his fellows; and when the breakfast was ready they called the prince. Then they

found that he was dead. They wept over him; but the wise man said to his fellows, 'He died because the live coppers killed him. Let us burn it!' Thus said the steersman.

They threw the copper into the fire to be burned, took the bark of a dried spruce tree, and started a large fire, and the live copper was melting; and when the fire had gone out, the pure copper remained in the ashes like a pole. They saw that the copper was very good and soft. They took it and put it into a bark bag, took the prince's body down to the canoe, wrapped him in a new cedar-bark mat, and carried him in their canoe down the River.

When they arrived at home, and the prince's wife saw him dead and saw the melted copper, she felt very sad. She went into the woods weeping for her husband.

While she was sitting at the foot of a large white-pine tree, she heard a noise on the tree above, and saw a shining light. There was a man who came down from the top of the white-pine tree and smiled at her, and said, 'My dear daughter, what ails you?' She said, 'My beloved husband is dead.' And Tsauda replied, 'Don't feel sorry for him! If you want him alive again, I will resuscitate him, my dear daughter!'

Now, Moon knew that her father had come down to visit her. Therefore she stopped crying, and said, 'Bring him back to life for my sake!' Tsauda said, 'Call out all the people, and I will bring him back to life.' So she went into the house. She sent out all the people. Tsauda came in and took the cold water of life from the spring and sprinkled his face with the water. He slapped the dead man on both cheeks with the palms of his hands, and said, 'Come back to life from death, son-in-law!' and the prince sat up, and his wife came to him and embraced him.

Then Tsauda said, when the young man was alive again, and when all the people had come into the house, 'Be careful of the living copper of that River! Let nobody go there, but my son-in-law and his descendants! I shall teach them how to kill the live copper and how to make costly coppers. Then he shall teach his children as I taught him!' thus spoke Tsauda to the people; and when his speech was at an end, he called his son-in-law aside, and also his youngest daughter, and told them how to kill the live copper. He said, 'As soon as you catch the salmon coppers or live coppers, make a large fire and throw the salmon coppers into it, as many as you caught in one evening at your camp. You must throw

them all into the fire, and the fumes will not hurt you, but it will make you richer than any chief in the whole world; but if you tell these high commands to some of your relatives or friends or to your tribe, you shall become poorer than ever, and those to whom you have told my secret shall become rich. Let nobody go with you to that River!– only you two, you and my dear daughter. She shall take them with you; and whoever goes there without your consent, he shall die by the fume of the live coppers.'

After Tsauda had given this advice to them, he said to his favorite daughter, 'Now, my dear, go with me to the foot of that white-pine tree!' and when they reached there, he told his daughter, 'You shall eat the pitch that covers this white-pine bark as a medicine against the influence of your copper-work. You shall rub it over your hands and face before you take the live copper.' As soon as Tsauda said this, he flew up to his supernatural home.

Then the prince and his wife went up for the coppers. He did all that his father-in-law had commanded him to do, and he was the first copper-worker among the natives. He became richer than any chief around about, and his fame spread all over the country. Chiefs from all different tribes came to buy his costly coppers with many thousands of costly animal skins, and canoes, slaves, boxes of grease, costly abalone shells, and all kinds of things. So this prince was great among all the chiefs. He gave away many times costly coppers, male and female slaves, elk skins, and all kinds of goods. At his last great feast he invited the chiefs of all the tribes, and they proclaimed that he should take his great grandfather's name, Around The Heavens, and all the chiefs said that he should be the head chief (Boas 1970, 303–6).

Tsauda's youngest daughter and her husband became powerful because Tsauda gave them the protection of the white pine sap when they were smelting the live coppers, thus enabling them to make copper. I have presented the entire reference to live coppers because it helps in understanding the intended meaning of the Phillips River tree carvings. John Meares (1790, 247) made this observation regarding native copper mining along the Northwest Coast: "The pure malleable lumps of copper ore seen in possession of the natives convince us that there are mines of this metal in the vicinity of this part of the western Coast. We once saw a piece of it which appeared to weigh about a pound, through which a hole had been perforated."

There was once a village at the mouth of the Phillips River where the Kwaikah (mainland Coast Salish) people lived (Assu 1989, 14). They

moved to Campbell River late in the nineteenth century or early twentieth century, and joined the We-Wai-Kum people (16). The Kwaikah people were known to be warriors (16). I suspect it was the Kwaikah people who carved the Phillips River arboroglyphs.

Even though I did not have the financial resources to look for the carvings on Phillips River, I have located photographs of the tree carvings. Additionally, two people were interviewed who have seen the carvings. Bob Hart's theory of a connection between the tree carvings and the copper smelting process, of which very little is known, is certainly possible. As the oral history illustrates, copper was an extremely important metal to most Northwest Coast people, and therefore knowing the location of deposits and the copper smelting sites would have been vital from a secular and spiritual point of view. Enough so to warrant tree carving markers, but for precisely what reason may never be known. Two possible reasons are to denote ownership of the site by a house or family group, or to invoke supernatural protection while smelting copper. This site is significant because it could reveal not only the hidden secrets of the beautiful tree carvings but also more information about the mining and smelting of copper prior to contact. This site warrants a serious investment in time and money to unlock its precious history.

Before we move on to visit the face in the forest carved by Art Wilson in 1988, I will describe how a tree grows so that we can interpret scars and carvings on trees. Thor Peterson mentioned that Bob Hart cut away old scars and found carvings underneath. Understanding how a tree grows and how a scar is formed helps us search for carvings hidden by the tree's scar.

Once a seedling is established, whether coniferous (evergreen) or deciduous, it grows from the tips and adds girth (circumference) starting in the spring and finishing up in the late summer. The growth then slows to a point where only the roots grow in the winter months. There are three kinds of buds on a tree: the lateral, flower, and terminal buds. The lateral bud produces the extensions to branches, and the flower bud produces male or female flowers called cones. The terminal bud bursts into a leader and grows from the previous year's stem. Therefore, it produces an additional segment for the stem or trunk. This bud is responsible for the increase of height in the tree or the lengthening of branches. A professor in my first year forestry class put a cartoon up on his overhead projector of a cowboy sitting under a tree, with a noose tied from around his neck to a branch on the tree. He then asked, "How many years of growth will it take to hang the cowboy?" The answer, now that you know how a tree grows, is that the cowboy will not hang. The tree only grows from the tips. If you put a chalk line on the trunk of a tree one metre above the ground this year it will still be one metre above the ground twenty-five years later.

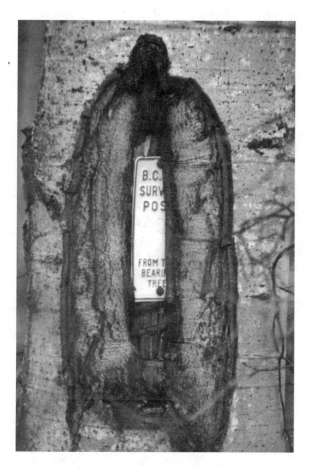

Figure 20. Example
of how a scar
progresses over
a wound on a
trembling aspen.

The tree increases in circumference because of the work of a small but important layer called the cambium. Energy created through photosynthesis and liquids containing minerals gathered by the roots travel up and down the cambium and inner bark, and this is why it was harvested as a food source. If we could travel from the outside of a tree to the centre we would go through the outer bark, the inner bark, the cambium, the sapwood, and the heartwood. Note that softwood or conifers are the only species that differentiate between sapwood and heartwood, the heartwood being darker. The cambium produces inner bark on the outside and sapwood on the inside. You can kill a tree by girdling it or, in other words, by removing the cambium layer from the complete circumference of the tree. However, if you were to remove a portion of the cambium while harvesting it for food, what would happen? The remaining cambium layer would start to grow over the wound from the edges, producing sapwood

and inner bark. Each year the scar becomes smaller and the girth increases. Many years later the "exposed" scar will be smaller in width and deeper because the tree grew in circumference while the bare inner wood of the scar did not until it was covered by new cambium. When the scar is completely covered by new wood and bark it is commonly known as a "cat face." Figure 20 illustrates the progressive growth over a survey tag that was nailed to a blaze on an aspen tree. The scar is roughly twenty to twenty-five years old. The scar closed over the sign as if someone slowly pulled a drawstring around the edge of the blaze.

HAZELTON

Hazelton, B.C., rests in the shadow of the great mountain Stekyawden (Painted Goat Mountain) at the junction of the Skeena and Bulkley rivers. I will guide you to a number of tree art sites in the Gitxsan territory surrounding Hazelton. The first stop will be at a carved tree where Sam Greene Creek flows into the Skeena River.

ART WILSON'S TREE CARVING

Don Ryan, Chief Maas Gak and the chief negotiator for the Gitxsan, suggested that I contact Art Wilson about his tree carving. I called Art, whose hereditary chief's name is 'Wii Muk'wilixw, in July of 1995 to ask him if he would guide me to the site of his tree carving. He graciously offered his services, and we arranged to drive to the site on 16 July 1995. As I drove, Art explained the history of the tree carving and how it relates to a blockade that was established by the Gitxsan in 1988 to stop logging in the Sam Greene Creek area. Westar, a forest company, applied for an injunction to stop the blockade, but the court upheld the legitimacy of the chief's request to suspend logging until the question of aboriginal ownership was addressed. Art is a Gitxsan artist and leader among his people. He created a print called *Precedence* that tells the story of the Sam Greene blockade, and he also carved a face in a tree at the blockade camp (see figure 21). The on-site interview with Art begins with his description of why he carved the face in the tree.

MICHAEL: Maybe you could start out by saying why you did the
 carving.
ART: I was mainly thinking about the sacrifice that we were doing at
 that time, and I was thinking like anything else, it has to be something
 that reminds us of what happened. I very reluctantly carved the face
 in this tree, the chances of killing the tree. I stood here and talked
 awhile, just letting the trees know I was very reluctantly doing it. We
 were brought up, we were taught that everything is alive, I guess it

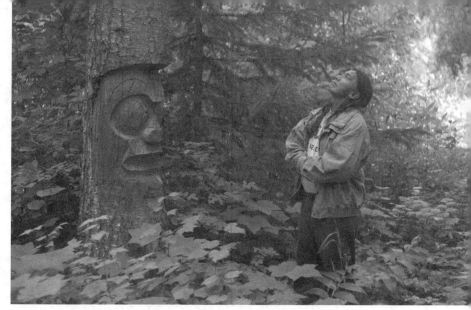

Figure 21. Art Wilson looking at his carving of a face on a hemlock tree at the Sam Greene blockade camp.

was part of the sacrifice. What I tried to signify was tears here, an expression of sadness of what was going on. Just like this tree, it sacrificed its life for all the trees across the road. So I guess between us and the tree, we have a sad story to tell. Anytime anyone comes along, they ask themselves, why is this face here, and find out who did it, and why it was done? I feel badly that the tree dies. Maybe it had a purpose I guess.

MICHAEL: Why did you choose a face?

ART: I chose a face because when people see a face it just naturally draws their attention. If I had to do this all over again I think I would have done a smaller face. The main reason I did a big face is because it would be hard to miss. This tree has made a very big contribution to educating people, just by surviving these last years.

MICHAEL: Have you ever done any other tree carvings?

ART: No.

MICHAEL: Have you ever seen any others?

ART: I saw one in the last *Daxgyet* [a Gitxsan nation newsletter], I heard about the ones at Kuldo, but I have not seen them first-hand. But I have been told about these carvings and why people do them. Most of the reasons are because it is like a memorial, remembering. There are probably other reasons, I don't know. This was the particular reason I did this one. People would ask me about it and why did I do it. Basically it, I thought at the time when the sap was starting to flow, put an expression on the face.

MICHAEL: Why were you here at the Sam Greene blockade?

ART: I was here to support the actions of the chiefs across the river there, save the land, sacrificed a lot of time in different fights about the land. It takes a lot of time to live it down and I think the public has forgotten now. It is a good thing that people have short memories.

MICHAEL: You say that this is a memorial for the sacrifice that people made here, what do you mean by sacrifice?

ART: Sacrifice, this tree basically, from my view, sacrificed its life to pass on the message on behalf of other trees. This situation is a sad situation, it deserves the attention of people so they can do something about it. That is partly what I was thinking.

MICHAEL: Why did you pick this tree?

ART: Well, I thought it was a tree that was in a place where everybody who came by would not miss it.

MICHAEL: How many people were at the blockade?

ART: It went down to three of us, and at the height probably about fifty. It was really amazing at that time, the people that were here heard some singing up in the bush there. Singing and drums. We ask at the time, what do you think that was? The ancestors in the spirit world were happy with what we were doing.

MICHAEL: Do you think they asked you to do this carving?

ART: I don't know, I just felt compelled to do it. People will see it and ask questions.

MICHAEL: You heard people talking about other tree carvings and the idea of memorial, what do you mean?

ART: It is similar to the whole idea of totem poles, I guess. I think some of the tree carvings from what I understand are significant to the other house groups. I think just seeing the actual carving will tell you something about it. This for example, it looks like a tear.

MICHAEL: It is a beautiful carving.

ART: For some reason I quit over here, for some reason I must've got distracted.

MICHAEL: How many years ago did you carve this tree?

ART: Eight years ago maybe, it might be that long, time goes so darn fast.

MICHAEL: I think it does its job, you notice it right away.

ART: I guess the other thing with this is the scars of the chainsaw. I wanted to do something that says something.

MICHAEL: To mark the period of history?

ART: To remind us that this kind of equipment causes a lot of destruction. Especially down the middle of his eyebrows. Just to say it is a cause of a lot of pain. It is getting there now. The Forest Practices Code. The forestry and mines. I actually went to forestry class at

UBC, and told them what was happening and it's time they practice what they learn, and things would be different. I don't know. At least I hope to hell they will be different.

MICHAEL: This was a successful blockade, wasn't it?

ART: Oh yeah, yeah. I did a print on it called *Precedence*. Fireweed [clan] on that side [Wolf on the other side of the Skeena].

MICHAEL: Are you happy with this when you look at it eight years later?

ART: Oh yeah, I am surprised it is kind of … .

MICHAEL: Do you think it has taken on a different life?

ART: I think so, there is a better expression in his face. The weathering has done the final touches.

MICHAEL: Have you heard about people who talk about the living spirit of the tree?

ART: Oh yeah, anytime you go to get trees you have to talk to them first, and tell them why you are doing what you are doing. If it means that your life depends on it, and you have to stay warm. It is a good thing to let the trees know why you are doing it for whatever reason.

MICHAEL: Are there any ceremonies or offerings?

ART: The only thing that I know is that people say you make sure you talk to the trees. I think other tribal groups they do that, they go that one step further. It is possible we may have done that, I don't know. Be respectful that we are possibly killing a tree. That tree is not quite dead, it looks like there is some green on top. It makes me feel a little bit better.

Art Wilson created a historical marker for the successful blockade. The tree carving marks the location, and also acts as a memorial, to help people remember, or to spark questions from following generations. It was with great reluctance that Art cut into the tree to create his marker because it went against his nature. He chose to carve a face, as a natural attention-grabber to passers-by, and he chose to carve tears to express sadness. Art lives in Kispiox almost in the shadow of Mary Johnson's pole, which shows a sister holding a grouse too late to nourish her brother who has just died of starvation. Tears stream down her face and the pole.

Art's commentary on his tree carving provides useful insight to the reasons why an artist creates tree art, because there are few examples of recent tree art. Most carvings are like those in Phillips River, where the intended meaning is much more difficult to determine since the artist is unknown. Both of the recent carvings, by Art Wilson and George Yutslick, are memorials or historical markers. Art Wilson's tree carving is *in situ*, in the intended viewing context. The intended meaning which Art attributes to his carving is highly dependent on the viewing context. Art's

tree carving is still on the first and intended journey of meaning, but he says the face has weathered and aged so it is less sad. The sacrifices made by the tree and the Gitxsan highlight the need to involve First Nations in land use planning.

TREE PAINTING ON GEEL'S TERRITORY

I was convinced that tree art still exists on the First Nations landscape when Walter Harris, Chief Geel, told me of the tree painting that was found on his territory during the winter of 1988–89 (described in chapter 1). We looked at the cut-out image from the decayed tree (see figures 2 and 22). Walter knew little about the tree painting or its history. Morley Eldridge, an archaeologist, summarized his impressions of the tree.

The tree painting or 'arborograph' was located on a 1-m-diameter dead hemlock tree that leaned heavily to one side. The base of the tree was hollow, with only a thin shell of wood remaining behind the bark. The tree had been blazed on four sides, but three of the scars were completely overgrown. Tool marks in the bark indicated that, probably, a metal axe or adze had been used to remove the bark. The fourth side has a 70-cm-long open scar-face near the base of the tree with a 46-cm-long painting, in black, on the exposed wood. The pigment may be charcoal mixed with grease, although this has not been confirmed by laboratory tests (1991, 7).

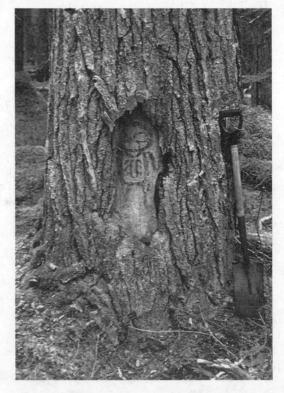

Figure 22. Geel's arborograph *in situ* (courtesy of M. Eldridge).

The scar and the associated painting were made between 1826 and 1836 (8), dates determined using dendrochronology (tree ring dating). This was the approximate time of the arrival of the Hudson's Bay Company in the area, and Eldridge speculates that the arborograph may be an ownership marker for a trading trail (8). I asked my Great Aunt Sophia Mowatt (age ninety-five) whether she knew of the tree. She said she did, and thought it was a territorial marker (Mowatt 1995).

The Tsimshian and Gitxsan geopolitical system, or house and clan territorial system, which was and still is governed through the feast, was in great turmoil from 1787 onwards (Marsden and Galois 1995, 169–70). The early fur trade economy had created imbalances of power: Chief Legaix of the coastal Tsimshian took advantage of his access to the European fur traders via the west coast by monopolizing the access to interior fur supply areas such as the Gitxsan territory. James McDonald (1985, 42) suggests that the Gitxsan were "already trading at inland markets with the Coastal Tsimshian for European commodities from American sailing ships when the Hudson's Bay Company trader explorers reached them, arriving from the East in 1826." Interior house chiefs realigned their connections with the more powerful coastal chiefs through marriage and conflict to establish trade relations. One possible outcome of the flux in power was that house chiefs found it necessary to reaffirm their territorial boundaries or control over trading trails by using markers such as tree art. I will examine the geopolitical dynamic again at the Kholkux tree carving stop in the Yukon.

Little is known about Geel's tree painting except that it is unique. Arborographs are rare because they are more sensitive to weathering than arboroglyphs. Sophia attributes possible territorial significance to the tree painting, but in the end, little will ever be known about this creation. The very fact that it exists, however, and was created in the early nineteenth century, adds to the chronicle of Gitxsan history.

ANSPAYAXW – KULDO TRAIL TREE CARVINGS

The next leg of our journey is along the trail which connects Kispiox (Anspayaxw) and the now deserted village of Kuldo. Kuldo was a thriving and important northern village in Gitxsan territory, and it was still inhabited when goldseekers rushed by in 1898. But the flu, the influences of the Church, and the establishment of reserves all depleted the village until it was abandoned. However, it is still used in the summers when the Gitxsan go there to fish. The trail between the two villages was used by Klondike goldseekers to access the Yukon along the overland route that Barbeau (1958, 185–6) calls the "Poor Man's Route." Cattle were driven along the trail north to feed the goldseekers. Adventurers such as Hamlin Garland passed along the trail in the Gold Rush, and he wrote about the

village of Kuldo: "There was a fork in the trail here [about three miles north of Kuldo Creek], and another notice informed us that the trail to the right ran to the Indian village of Kuldo ... Turning to the right down a tremendously steep path (the horses sliding on their haunches), we came to an old Indian fishing village built on a green shelf high above the roaring water of the Skeena ... There were some eight or ten families in the canon ..." (1899, 121).

Barbeau (1958, 191) describes how the Gitxsan people were enlisted to widen the trail to meet the needs of the goldseekers: "Jimmy Deacon, a wild and woolly woodsman, arrived at Hazelton from the south in the spring, with the news that the trails to the north must be cleared at once. He hired many Indians for the work. 'We started from our village here and improved the old Indian trail.' Gamanut [the Outlaw Simon Gunanoot], one of his Skeena men, still remembered well many years later at Hazelton." The Dominion Telegraph Trail was established in 1899 along the widened Anspayaxw-Kuldo trail. In 1961 the Forest Service constructed a forest road following the trail up the valley. Old survey markers can still be found beside the forest road. This trail is layered with history, but the surviving tree art creations act as reminders of the trail's original purpose – to connect Gitxsan villages.

We begin our journey at Deadhorse Lake, our southernmost stop along the trail. We then travel along the trail to Deep Canoe Creek and view a number of examples of tree art. Finally, we continue across Kuldo Creek where a few tree carvings mark the main and side trails.

DEADHORSE LAKE

Walter Blackwater, a Gitxsan Elder, told me of tree carvings at the camp along Deadhorse Lake (Blackwater 1995). The camp is about fifty metres from the lakeshore, and about thirty metres off the Anspayaxw-Kuldo trail along a spur trail. There are numerous initials and messages carved and written on the surrounding trees. The dates on some of the tree writings were 1929, 1944, 1955, and 1977. The three carvings (figure 23) are on two hemlock trees at the trail junction. They are rough carvings of faces and the single carving looks to be newer and done with an axe. There are a few old leg-hold traps still hanging from the trees in the area. I know nothing more about this particular site.

DEEP CANOE CREEK

The Deep Canoe site is about five kilometres north of Deadhorse Lake along the trail. During my initial research I discovered an archaeological site report (Borden number: Gk Ta-1) which Doug Anweiller had filed with the Archaeology Branch in 1991. The report described nine trees, each with a "face" carved on the trunk. My first trip to this site was on

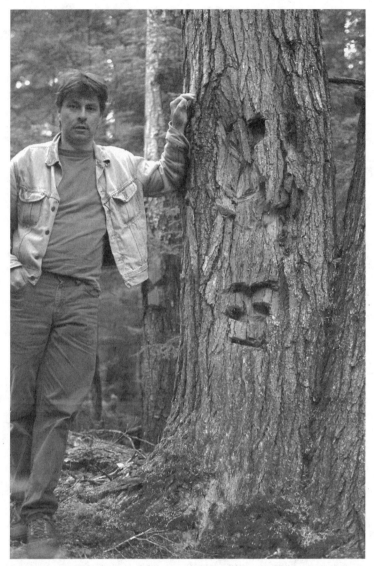

Figure 23. Tree carvings of faces at the Deadhorse Lake camp, two in the foreground and one behind the author on a separate tree.

22 June 1995, accompanied by Darlene Veigh and Russell Collier from the Gitxsan Treaty Office. We split up into two groups and started to look for the trail and the carvings. I worked my way up to the steep ridge along Deep Canoe Creek, and found the old trail. The trail is worn to a thirty-centimetre depth in places, and it appeared and disappeared through the windfall like a breaching killer whale. There were signs of the old telegraph wire, a telegraph cabin, blazed trees, old cavity traps in stumps, and kindling trees along the trail. I felt the trodden history beneath my feet as I anxiously followed the trail.

I ducked under a windfall and started off again, and then I glimpsed a face. I was so excited I could hardly breathe. I walked a few more steps and there it was, a face carved in the trunk of a hemlock tree. I rushed back to find Russell and Darlene. They had found the trail and were making their way to my location. As they arrived I pointed to the carving. It was deceiving in appearance because it looked like a rough carving on the bark, but it was actually carved on the overgrown scar of another carving. Someone had recarved an old carving once the scar had grown over the original.

After viewing and recording our first find, we made our way further along the trail. Then came the experience I recounted in chapter 1: we all stopped dead in our tracks, halted by a powerful face staring at us from

Figure 24. Powerful arboroglyph carved in hemlock tree at the Deep Canoe site.

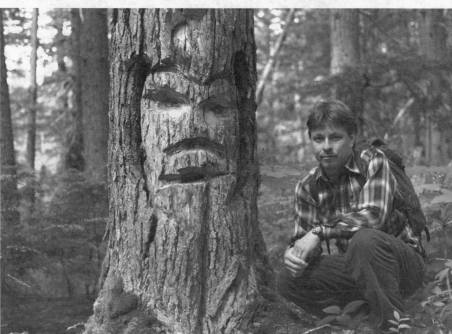

the trunk of an old-growth hemlock tree (figure 24). Its charcoal eyes fixed upon our arrival, as they had with goldseekers, telegraph workers, and generations of Gitxsan. It is easily seen as you walk up the trail, and was obviously placed for maximum impact. We reacted with "Wow." I had not seen tree art *in situ* until that memorable day.

I showed a photograph of this tree to Walter Blackwater, a Gitxsan and Elder trapper now in his seventies. He was born in Kuldo and he has traveled most of the Northern Gitxsan trails as trapper. Walter begins the interview (Blackwater 1995) by describing some of the locations where he has seen tree carvings.

WALTER: I know where this one is. This one here is where the telegraph trail is. I have seen this one. It is right on the telegraph trail. But the one that's up in the mountain, the Kuldo people, that's marking their trapline that goes up in the mountain. That's way up there. But the telegraph line that's down on the Skeena River – you see the flats right there, that's where the trail is, that trail. I will show you the pack trail. That's where they camped right there. They let the horses feed on the flats there. That's how I know this one here. I know it's right on top of the hill, that's this one here. I know exactly where it is.

When you first asked me about this one [figure 24], I could not figure it out. I thought you were talking about real totem poles. This is a different one. This is totem pole, what do they call them, it's more like a Gyetim Gan, that's what it is. I forgot what it is. This one, you could see all the way. The other side Kuldo. What do you call that creek on the other side of Kuldo? You can see a whole bunch of them alongside the telegraph trail, maybe about twenty of them. The creek runs this way and it goes up the hill. Right on top of the hill that's where they are. They call that place ... Smak la hant. And the other side, and you got that flat over there, they got a camp there. There's another one there. Full of them there. All over the place. And you go to Poison Mountain. You can see them there. The last time I was up there was 1958. The trail was still really good. The last time the government used that trail was 1936. That's the last time the government used that trail. You know that trail they call it the Telegraph Trail. They take the horses up there and take the winter supplies up there for the lineman they call it. They drop the winter supplies at every main cabin. There is two, three, four, five, six, seven, eight, nine cabin. Telegraph Creek supplies the other side. That's why I know this one. From the sixth cabin is our trapline to the ninth cabin about thirty miles. Like my own trapline goes up to twenty to thirty miles after this trail. Another creek goes running that way. They call it ... There's no trees in there. Just once in a while you can see trees over there.

That's where they camp. If you miss that one there is not another one for fifteen miles. That's where they went to trap beavers in the winter time. You can see the Gyetim Gan in there.

MICHAEL: So why did they carve those?

WALTER: Just like in the olden days, you know. While just like the totem pole over there [he pointed to the Kispiox village crest poles]. The earlier people they gonna ask the other people 'what does that mean?', the Gyetim Gan, you know the totem pole, they gonna say 'what does that mean?' This one [pointing to tree carving in the photograph] is only the Gyetim Gan, the face of the man, they say that, Gyetim Gan. The totem pole is different. You can see all kinds of them in the village here. There are different meanings on each one of them.

Walter uses the Gitxsan name for these faces in the forest, "Gyetim Gan." He told me the trappers would occasionally carve tree art for something to do and that they were not territorial markers. Walter implies that the location of a Gyetim Gan is often associated with a camp. He explains that Gyetim Gan can be similar to crest poles (totem poles) because people will ask "what does that mean?" and there will be a story for each one. John Adams (1986, 2) quoted a Gitxsan Elder as saying that "Totem poles are the Indian's book about traplines." The crest pole in many ways represents the house territory, while the word "trapline" also refers to territory. Some tree carvings were meant to act as a marker for a story, similar to the crest acquisition and ancestral journey stories associated with crest poles. Walter told me of a specific example of a tree carving which was recently carved to mark a trapline.

WALTER: Past old Kuldo, there is really lots of [tree carvings] there, especially up on top of the hill there, talkin' about that little creek on the other side of Kuldo. There's a big creek coming down there, not the deep one. The deep one is a small little one, the other one got a flat, on one side the other side is flat. The [carving] I am talkin' about there is a whole bunch of them. There is a whole bunch of those. I know one they making one of them, related to Steve Morrison. They went with Pete Muldoe ...

MICHAEL: Why did Steve Morrison carve that one?

WALTER: He was with Pete, they say that's his trapline. I know it's Giskasst territory ... That lady's name Lay gum Slaks, Indian name hey, chief. That's the one that owned that place. After that lady died, Pete went up there with Steve Morrison. Steve got nothing to do, you know they just carving them. That's the funny-looking one, funny-looking Gyetim Gan. 'My mother is related to the old people,' it's written on the bottom, that's his picture.

MICHAEL: That's what it says?

WALTER: Yeah that's what it says. Oh, it's a really bad one, I told them you know.

MICHAEL: They carved right on the tree?

WALTER: Yeah, they carve right on the tree. Written with whose picture is there. The other one they call him 'my mum's 'u siwiks' [or wilxsa'witxw]. They related to you guys, I guess, Walter Harris. That's mum's, that why they do that. That's mum's 'u siwiks' hey, they come out, they mark it right there, they put a name there. It had a big pipe in there. You know the old people had a pipe there. That's how they draw, just like that, they carve a pipe right in there.

MICHAEL: Why did they carve his face in there?

WALTER: They make a mark, they cut in there, they had a limb like a pipe.

MICHAEL: That's supposed to be Jay Powell [a linguist working on the Gitxsan language in the 1980s]?

Walter described how Steve Morrison carved a Gyetim Gan to mark a trapline after a chief had died. He said it represented a linguist called Jay Powell, his mother's relative. The carving has a pipe in its mouth and writing below it explaining its purpose. Walter characterized the carving as a "really funny picture."

Walter turns his attention to the tree carving at our earlier stop (see figure 24) and begins to explain how old he thinks the carving is, based on a feather-like form above the forehead of the face. Just as Art Wilson said that "just seeing the actual carving will tell you something about it," and then explained the significance of the tears on his carving, the form above the forehead in this carving is also significant.

WALTER: This one here, you know the old Indians had a feather on their head. That's what it is, this one here, it's a feather, like that. Before that, they would make cuts in feather [in the wood] to make it look, but you won't see that now because it is really old. That's a Indian with a feather in its head.

WALTER: Why do you think they did that?

MICHAEL: It's a, Indian styles you know. In the olden days, that one there, they had no clothing there. When they go up in the mountain they got their hides. They cover themselves. That's before the clothing came around. That's when this one, just imagine the people they are thinking back in the olden days. They say in the pictures in the olden days, like in the book there, that how I find out, this one. But this one here he just look like Am Halait (carving on headdress), but it is an Indian feather. This one here [see figure 25], it like a totem pole, but

we still call it Gyetim Gan. That's the older people that make it like it, but it is not dressed like an Indian.

Walter believes the carved form on top centre of the forehead represents a feather, and therefore the carving must be quite old since it was only the "Old People" who wore the head feather. Walter said this carving was done "way before the white man." The second tree carving that Walter is referring to is just up the trail a few metres. He feels that its carving style is also like that of the older people, even though it has no feather. Walter is quite sure there is a story behind this carving.

WALTER: Some of them are meaning something. Like this one, it looks like horns. This Gyetim Gan they make horns over here. The older people can tell the stories as soon as they see the pictures. As soon as they see pictures of Gyetim Gan, they know all about the stories, and their meanings. But me, I can't tell you anything, but I just say I don't know anything. I did see this one, really good. I know this one. But now I don't even know where the trail is now.

Figure 25. Darlene Veigh standing beside "totem-like" tree carving at Deep Canoe site.

MICHAEL: So that's important, they are not boundary markers, and they are not like totem poles, but some of them have stories.

WALTER: Yeah, some of them have stories.

MICHAEL: And the thing at the top that looks like a Am Halait, is actually a feather.

WALTER: Yeah, that's a feather, yeah, it's more like Am Halait, in Indian it's ... This is not an Am Halait. They call it 'gu<u>x</u>stuu' [the feather], now I remember.

MICHAEL: All the people did Gyetim Gan, [people of] Kuldo, Blackwater?

WALTER: Yeah, Kisagas too. You can see on top of the hill above the village there. You can see them all, maybe they [the trees] fell down, or whatever. There's lots over there. I don't know if you are going to find a trail anymore.

MICHAEL: What village are you talking about?

WALTER: Kisagas. Now right across from Kisagas village. Old village. You ever see that village? Eighteen kilometres from here, up the Salmon River road.

MICHAEL: Would people down here in Gitannmax and Gitanyow do carvings?

WALTER: Yeah, they do it on their own territory. They call that river towards Smithers, that trail that goes across the Bulkley, there is a creek running down that way. You can see those carvings there too. That's the Hazelton territory. Not only us, it's all over. Gitsugukla do the same thing, but we don't know where they are. We don't know where the trapline is.

MICHAEL: Now I am trying to summarize this. Trappers would do this, right?

WALTER: Yeah, some of them, and people traveling along them.

MICHAEL: Could you tell the difference between the ones done in Kuldo compared to Hazelton?

WALTER: No, they look the same.

MICHAEL: I have a theory that this is like the spirit of the tree, this is alive, this Gyetim Gan?

WALTER: Yeah this is alive, that's what it means, that's alive. That's living, you know what I mean, it's a spirit. That's not only Kuldo that does that. I went up to take my Grandfather to Skidims Lake, I seen some of them like that, but they were small ones. They are all logged off now, you can't find any now. It is in Kispiox territory.

According to Walter Blackwater, the Gyetim Gan were common throughout the Git<u>x</u>san territory, and the style was similar enough that one could not discern any regional differences. He also suggested that a person

would only carve trees in their own territory, probably on a trapline trail.

I also interviewed Sophia Mowatt about these tree carvings, and she called them Gyetim Gan as well.

MICHAEL: These are carvings, Sophia [showing photographs].
SOPHIA: [as translated by Norma Mowatt]: They carved trees and get the lynx to go over there so they could trap them.
MICHAEL: Some of them have a human face. Was that part of it?
SOPHIA: They carved it right in there, yeah. They carved the tree and it attracts the lynx. You can use a deck of cards too [to attract the lynx], Queen, Jack, and King, [that's what she said.] They like the colour. It attracts them to the colour.
MICHAEL: Does the face attract?
SOPHIA: [Yeah, that's what she called,] it attracted them there, they scare off easy. They will stand and watch you.
MICHAEL: So they were not boundary markers?
SOPHIA: No, they are not boundary markers. It is to attract lynx if you want to trap them.

Sophia is respected in the Gitxsan community for her memory of the old times and people. She says that Gyetim Gan were meant to attract lynx because lynx are curious. I was surprised by this explanation because it had not occurred to me that the intended audience for some Gyetim Gans might be animals rather than humans. I asked Walter Blackwater about this practice.

MICHAEL: Do you know about trapping lynx?
WALTER: That's a nice story for that one. They not going to make a Gyetim Gan, they make baby pictures, very beautiful and you put it in the back of the deadfall [trap]. And that's where the lynx get after it, they go around it and around it, before they get there, hey. And finally they get into the trap and they going to bite that thing. They got him. They want to get that, they don't eat it. He just going to take it away, like a pack rat. He just like the way the picture is. The people making the hair, on a doll. They paint it, they call it Mas. Like hemlock they got a big thing on the trees [fungus], the old people knock it off and put it in the fire. Burns all around and cooks right inside. They scrape it and comes out like a powder. There's no paint. Like a powder. And that's what they use to make the doll, it's pretty, they dye the hair. The old people make basket for berries, they dye that, they use that for dye. Not only the red. They make a dyed mud and mix it with this one.
MICHAEL: These dolls, would they carve them on trees?
WALTER: No, they carve it out of wood and put it in the trap. The lynx

is going to get that thing, they going to get it. They step on that thing and, that trap, they got it. They did not sold the furs, they eat it.

MICHAEL: They eat the lynx?

WALTER: They eat it, lynx.

MICHAEL: So they trap lynx before white man came?

WALTER: Oh, they trap the lynx because they say that lynx, "weex," in Indian language. It taste like rabbit they say. They don't sell that fur, they make a hat. That's why they do that. That's before the white man came along.

Walter had not heard of carvings on the trees to attract the lynx, but he did explain the practice of carving little "doll" heads and placing them in the deadfall trap to attract the lynx into the trap. Sophia, who is about twenty years older than Walter, says the carvings were done on the tree to attract the lynx to the trap. These methods were practised by other First Nations as well. Robert Sullivan (1942, 99) interviewed a Tena Elder about lynx trapping methods: "'That's why,' concluded Ambrose, 'when they put out snares for lynx in the 'old times,' they make a little house and put bait in the middle, and then make some kind of doll cut out of rotten wood and put it on each side of the bait. They represent the two wives. Everytime they put snares, they do that.'" Richard Nelson (1983, 155) describes how Koyukon trappers from the village of Koyukuk, Alaska, draw faces on blazed trees to attract the curious lynx to their trap, and he made a similar observation for the Huslia Koyukon practice: "The Huslia Koyukon rely almost exclusively on visual attractants. Most commonly they draw a little face on a blazed tree behind the trap, or on a piece of wood that is put in the set" (1986, 228). The lynx was central to the meaning of some Carrier tree art; I will discuss the Carrier practice and the spiritual significance of the lynx in detail at the Hallett Lake stop.

Figure 26 shows another nearby tree carving. Note how the scar tissue has grown over, so that only the mouth can still be seen. This tree carving shows the dynamic nature of the art form due to weathering and the growth of scar tissue. The journey for this tree carving is almost complete as nature has all but refolded over the image.

Walter Blackwater recognized the carving in figure 26. He said, "I know this one, it was made a long time ago. Is this tree still standing?" I told him the tree was completely dead now, and he said that it was dead when he saw it last. This example is similar to the one photographed in Bella Coola by Harland I. Smith (figure 13).

KULDO ROADSIDE

Norm Larson, an employee of the Ministry of Forests and a long-time resident of Hazelton, guided me to two more tree carvings along the Kuldo

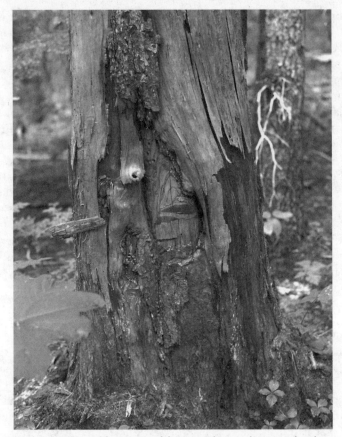

Figure 26. Very old carving of face, similar to photograph taken
by Harland I. Smith (fig.13). Deep Canoe site.

forest road. My wife and I followed Norm up the busy logging road that
follows the trail. The first tree was in the forest just across the Kuldo
bridge at about the thirty-four-kilometre mark of the Kuldo forest road
(figure 27). It is carved on a hemlock tree, and it is right beside the trail
overlooking the logging road and the Skeena River. Norm was born and
raised in the area, and he shows great concern for protecting the trees
since they are an important part of his heritage. As a non-First Nations
person he shares the pride and concern of the Gitxsan people. The first
journey of meaning of this carving remains unknown, but its second jour-
ney has been to help the groups of young Gitxsan children who travel to
see it to learn about their heritage.

The next stop is up the road about five kilometres. Norm showed me
this tree as well, and he said it had been found when the forest road was

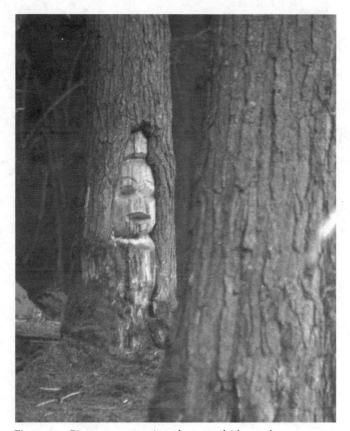

Figure 27. Gitxsan tree carving along roadside north
of Kuldo Creek.

being constructed. The tree is about five metres from the roadside. This
Gyetim Gan has lived – first in quiet isolation and then amidst the diesel
roar of industrial development – as a witness to change (see figure 28). It
was carved with the same finesse a master carver would show carving a
ceremonial mask or crest pole. The nose, only millimetres thick at its
finest point, has been finely sculpted. This carving taught me two impor-
tant lessons. The first lesson was again to be mindful of Art's advice, "just
seeing the actual carving will tell you something about it." I visited this
tree four times, and I did not notice the cross carved above the head (see
figure 29) until my uncle, Walter Harris, pointed it out to me. This cross
"tells something about it." Walter suggested this carving might be a bur-
ial marker. Since the carving was created with great attention by a person
with the abilities of a master carver, its aesthetic power could signify a

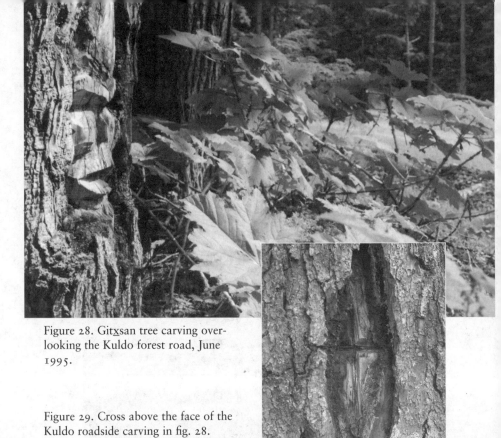

Figure 28. Gitxsan tree carving over-
looking the Kuldo forest road, June
1995.

Figure 29. Cross above the face of the
Kuldo roadside carving in fig. 28.

headstone marker of an important person. If this is a burial marker, it was
probably done shortly after the initial influence of the Church in the nine-
teenth century. As was related earlier, my Great Aunt Sophia described a
short transition period after the Church forbade cremation, when the
Gitxsan buried their dead by sitting them in a bent box. The subtle cross,
carved above the powerful face, hints at the beginnings of Church influ-
ence in this remote valley north of Kispiox.

I learned my second lesson when I brought Walter to see the carving; a
new era in the tree carving's history was marked by the visit. During pre-
vious visits, I noticed an old-growth hemlock forest on the opposite side
of the road from the carving. But, as figure 30 shows, the forest had been
logged. The face on the tree seemed lonely. The forest and trees it had
faced for so long had disappeared in a few short weeks. This Gyetim Gan
had just embarked on its second journey of meaning. It is a witness to the
disrespect being shown to the spirit of the forest and to Gitxsan history
and territory, and for that matter the history of all British Columbians.

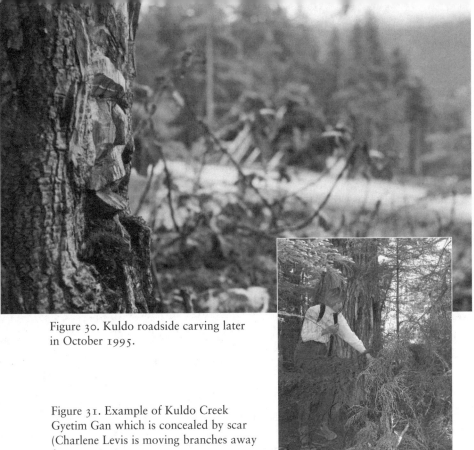

Figure 30. Kuldo roadside carving later in October 1995.

Figure 31. Example of Kuldo Creek Gyetim Gan which is concealed by scar (Charlene Levis is moving branches away from carving).

The first journey of meaning may have been as a memorial to an important Gitxsan, and the second journey, like the intended meaning of Art Wilson's tree carving, is a memorial to the sacrifice of the forest.

There is another Gyetim Gan about one hundred metres south along the trail (see figure 31). The scar has all but covered this carving, and it was concealed by the thick brush around the base of the tree. I found it because I was carefully checking every tree in the vicinity of the carving shown in figure 27; it is *easy* to walk by these hidden carvings.

GITXSAN COMPENSATION TREE CARVING

We are now travelling up to the headwaters of the Kispiox River, along the Xsi Wis An Skit tributary. Mary Johnson was a Gitxsan hereditary chief of the house of Antgulilbix, Giskaast (Fireweed) clan. She testified as a witness in the Delgamuukw land claims case, and she retold a oral history about the murder of Yal and a compensation tree carving. The murder was resolved through the feast system by awarding compensation ter-

ritory to the victim's house by the offender's house. The new territory boundary was marked by a crest on a tree. Excerpts from her testimony are shown below.

MARY: At the end of the Xsi Wis An Skit (Kispiox River) grandmother told me, and great, both of them, and at the end they climb the – where the ridge is, and the ridge is their boundary, but the other side of the ridge is given to – to the – to both Antgulilbix and Tsibassaa as a compensation because Yal is murdered on the ice where – where Xsagangaxda runs into Skeena River, that's where it happened ... And I wouldn't say it was in my grandmother's time or great-grandmother, it happened thousands of years ago ... And they climb after the end of Xsi Wis An Skit [Kispiox River] ... And there was a ridge and on that – the other side the ridge, they said there was a tree standing there and they – *they smear this tree with blood that's their own paint, and there was a crest on the tree, a sun* ...[4] Because it belongs to the Giskaast, that's the crest. That's the Giskaast crest, yeah, and that tree represents compensation that's in exchange of blood and it won't be taken back from us until the end of the world. It will be there. [emphasis added]

LAWYER: Now, did your grandmother or your aunt see this tree?

MARY: She said she sees it, that's why she told me ... I mean great-great-grandmother [saw this tree] (Johnson, 13:800–1).

The lawyers asked Mary for some clarification about this compensation tree a short time later.

LAWYER: So the murder of Yal took place outside your territory?

MARY: Yes.

LAWYER: Now, can you tell me whether there is anything more mentioned in the adaawk of your House for the northern territory?

MARY: Yes, grandmother told me and great-great grandmother that at the end of Xsi Wis An Skit there is a hill and they climb the hill, and there is a ridge there, and on – that's a boundary they said is the ridge. And on the other side the ridge, that's the land that they gave our ancestors compensation for murdering Yal. *And grandmother said there is a tree standing there, and it's smeared with blood. And there is a sun on the tree, and that's what Giskaast crest, is the sun. So that shows the exchange of blood. And they won't take it back from the family crest until the end of the world ... They just say he was murdered and they give the land as an exchange for blood. If they don't do that, they will return the blood* ... [emphasis added].

LAWYER: So before the territory was given to Antgulilbix as compensation for the murder of Yal, it belonged to somebody in the Village of Kuldo?

MARY: Yes.

LAWYER: Because your territory marked the boundary between Kispiox and Kuldo?

MARY: Yes, yes (Johnson, 14:872–3).

Mary's testimony links the Antgulilbix's adaawk to the creation of tree art. She testified that the murder of Yal happened thousands of years ago, thereby demonstrating that tree art is a very old art form. In this case, the tree art is a boundary marker "till the end of the world." If this were the case, it is conceivable that the image would be recarved as the original tree carving rotted. The tree was also described as smeared with blood or "blood that's their own paint." This may have been real blood, or perhaps "Mas," which, as Walter Blackwater explained, was a powder from a tree fungus or red ochre mud.

I will now explain the Gitxsan house system and how house territories are marked and governed, as this helps to understand the practice of compensation.[5] The house or "wilp" is the primary biological, political, geographic, and economic unit of Gitxsan society. There are about forty-two houses within the Gitxsan territory, and each house belongs to one of four clans: Giskaast (Fireweed), Lax Skiik (Eagle), Lax Ganada or Ganeda (Frog), and Lax Gibuu (Wolf).

Each house is lead by a hereditary head chief and one or more assistants or wing chiefs. The house name is usually based on the hereditary chief's Gitxsan name. However, traditionally the chief's name and house name were different. Each house is responsible for one or more territories that are defined by boundaries such as lakes, creeks, mountains, rivers, and trails, which are recorded and reaffirmed in the adaawk. Each territory has its own Gitxsan name. A house will also have access to specific fishing sites (Delgamuukw *vs.* the Queen 1991, 127–9).

Specific and strict laws govern the use of house territories. Olive Mulwain, a Gitxsan Elder, explained some of these laws to a land claims researcher:

All these people knew which territory is theirs. They turned off at the proper trail, they didn't trespass on each others territory. They don't camp on someone's territory just because it is a good place, they go on ... Our people of old days had a law, if a thoughtless person went to another territory and trapped/hunted it is considered stealing. He didn't get permission from the owner. The law of the ancient people is that they kill that thoughtless person, his blood is spilled on the ground. The reason they enforced the law is so that the thoughtless person doesn't set a

precedent of trespassing, it also enable the owner to show his strength and discourage others from trespassing on his territory if they know the law will be enforced. Then follows another law, the law of 'Shiisw' (territory settlement) the white people call it peacemaking (1982a, 1–2).

 She also explains that a person from another house "can pass through, but they don't camp on it, they just pass through to get to their own territory." Everyone knows each other's boundaries and she says they are called "'Anliit'iisxw' (blazing mark or post marking boundary of a territory)" (Mulwain 1982b, 1). For example, Stanley Williams (1983, 2), a Gitxsan Elder, talks about a pole with a rock on top of it which marked the boundary between the Gitxsan and Nisga'a people near Blackwater Lake. Richard Benson (n.d., 2) gave evidence of red blazes on trees which marked a boundary between two houses: "This Lake [Dam ansa Angwas] is a boundary, and only the east half of it is owned by the House of Gylogyet. Two trees, on either side of the Lake, were marked with Mas (red ochre) to show this was a boundary." The lake is very near the compensation tree site that Mary talked of in her testimony. Olive Ryan testified in the Delgamuukw case that the Gitxsan marked trees for boundary markers and they were called "an lay tix" (Ryan, 1131). Some tree carvings and blazes are a type of boundary marker, or corner post called "an lay tix." However, I caution against assuming that all tree art marks boundaries because, as we have seen in Gyetim Gan along the Anspayaxw-Kuldo trail, there are a wide variety of intended meanings.

 The intended meaning of the carving on the compensation tree was to mark a change in territory agreed to at a "Shiisw" feast thousands of years ago. The tree was last seen in Mary's great-grandmother's time, and I hope it will be found again in mine. If I find the tree, its carvings will not only mark a boundary but also – in a new journey of meaning – be evidence that the adaawk can be linked to the existence of and persistence of house territory boundaries. Chief Justice Allan McEachern gave his opinion that the Gitxsan did not have house boundaries: "The weight of evidence is overwhelmingly against the validity of these internal boundaries as definitions of discreet areas used just by the ancestors of the present members of the various Houses" (McEachern 1991, 277). The previous example of the compensation tree can be used to refute McEachern's view.

WIIMINOOSIK LAKE TREE CARVING
Neil John Sterritt, Madeegam Gyamk, has traveled across most of the Gitxsan territory conducting Gitxsan place-name research with the Elders. In our interview on 21 July 1995 he told me about two interesting

Gyetim Gan. The first is at a camp along the Telegraph Trail on the east side of Wiiminoosik Lake, in the northern reaches of Gitxsan territory, north of the Kuldo village site.

NEIL: The most recent one I saw was on the trail six miles east of Blackwater Lake. Was there about a month ago, our camp was there. We had a camp there, it was a former camp. Someone else had camped there, it was a very old tree carving. It was a stump, somebody had cut the tree down. The stump had a face on it. It was about a three-foot stump, perhaps fifteen to twenty inches in diameter. Years ago in the early fifties, there was one just this side of first cabin, right alongside the road. It was actually called Green's campsite, it appeared to have been created in the twenty to thirty years prior to then. I don't think it is there anymore, I see a gravel pit in that area there now. And the creation of gravel pit may have led to its destruction. That was quite a good one actually. That's about it.

The people we were with [were] Blackwater: on the question of whether there is any significance to these [carvings], were they declarations of land, and they were born at Blackwater, these two individuals. Their name is Blackwater. They said no, not to their knowledge [is there any significance to the carvings].

I am trying to remember if I took one [photograph] last month at Blackwater ... I wanted to get a photograph of that stump. I can't remember if I took one or not. I took one of the one [carving] my son did, with the Blackwaters standing around it ...

There is another one [carving] right beside it [the one at Blackwater Lake]. My son carved it, Gyetim Gan, Wood man. Gan is wood or tree, Gyed is man. Gyedim Gan, eh. Man of wood or tree.

Neil later sent me a copy of the photograph showing the new carving his son, Gordon, had carved at the east end of Wiiminoosik Lake in June 1995.[6] There is an old carving on a stump about fifteen feet from Gordon's new one. Neil told me that he is not aware of any territorial significance to this old Gyetim Gan. He felt the carvings were more like an art form and people would just carve them for something to do at camp, as Neil's son had done on their trip.

NEIL: The tree carvings that I have seen were along trails. Mainly a trail from Hazelton to Blackwater, and generally called the Telegraph Trail today, and also the Kispiox trail, the trail from Kispiox to Hazelton. I seen others on trails farther in the bush. They are called Gyetim Gan. What they are at a campsite, what I have been told, by people who were there, is that they were made by people who were whiling away

their time. Any of those along that trail, they do not have any spiritual or territorial significance. And I have been advised that by several people who walk the trails and were there as much as sixty years ago.

The new Gyetim Gan carved by Gordon and by Art Wilson demonstrate that some Gitxsan still create tree art. I did not get a chance to interview Gordon about his reasons for carving Gyetim Gan. Neil mentioned a second tree carving along the Kispiox main forest road. I searched for it, but, as Neil suggests, it was cut down when the gravel pit was constructed.

I would like to move on to the last stop in Gitxsan territory, at the northern border of Gitxsan territory. Here Neil tells us about a tree with "Chinese-like" symbols written on the trunk.

LONG GRASS AND NISGA'A BOUNDARY MARKERS

Neil describes a tree marker which is in the middle of a swamp just north of Panorama Creek. This tree could provide significant information on inter-tribal boundaries, and on late nineteenth-century writing systems.

NEIL: Somewhere up here, there's a big swamp, I think you can see it on the 1:2,500,000 [map]. Somewhere in the middle of that swamp there's a tree with a blaze, fairly large. And it had almost like Chinese writing on it, all over it. And my uncle was told by his uncle that was kind [of] a marker between the Tahltan and the Gitxsan. It was on a tree that was leaning, it was like in the middle of this swamp. Percy [Sterritt] and his cousin [George Brown] were walking across the swamp and the ice was crunchy. It was almost like the whole swamp was moving, the water moved under the ice. They stopped under this big balsam and this was on it, it just like Chinese writing, like hieroglyphics. Walter Blackwater referred to the same tree.

MICHAEL: He said it was a marker between the Tahltan?

NEIL: Well [they] [Percy Sterritt and George Brown] told [their] uncle about it, and [their] uncle said it was a boundary marker. It's not a face, just Chinese-like writing.

MICHAEL: It might be syllabics used by the Dene and Father Morice in the interior. How old was the tree when he [Percy] saw it?

NEIL: It was about 1930 when he saw it, he thought it was pretty old, but I do not know. Could have been syllabics.

MICHAEL: It would have been interesting to know if the Tahltan used syllabics.

NEIL: I don't think it would have been the Tahltan, as you are going to find this out at my presentation. We think that the head of the Nass, the whole area here was occupied by the Long Grass band or people. And the Tahltan were down here. This group of people were here

from 1830 and 1890. And there was tremendous battles during that period between us and them. And they moved to Fort Ware in about 1890. And then to Telegraph Creek after 1900 and in particular in about 1940, and then some of them went to Iskut. They are collectively called Bear Lakers, some of them were, and some of them from Kispiox. So the Long Grass people, in this period, these people came from Fort St James, they came from, could have been by marriage, or could have been back and forth to Peace River. So you don't have to look to the Tahltan to see if they were into syllabics. This was a mixed group, they were Gitxsan, Tahltan, people from the east, it is called the Long Grass people. It is a long helicopter ride from here. It is a complex area there.

MICHAEL: It definitely sounds like syllabics.

NEIL: I never thought of that angle that people came from that way. Cause I was always thinking this way. And they were connected some of those people came this way. Fort St James way, I never thought of that. And if that's the case, there was a whole bunch of things that happened there. There was killing and compensation going on from about 1840 on. Some in Walter Harris's house, some that Walter doesn't even know about, and I told him about. I have no doubt that the territory came into our hands at the same time. They were part of the same incident. This is in Wolf side, Fireweed on the Skeena, Wolf on the Nass.

Neil is referring to the Long Grass people who occupied the land north of Gitxsan territory in the mid to late nineteenth century. The Long Grass people are a sub-group of the Sekanis (who are neighbours to the northeast of the Gitxsan) (Sterritt 1995). Neil describes a lot of fighting between the house of Geel and the Long Grass people during this period. The tree in the swamp may mark territory, or specifically compensation territory, to the benefit of the houses of Geel and Xhliiyeemlaxhan. I suggested to Neil that the Chinese-like writing on the tree may be syllabics. As mentioned earlier, Father Morice introduced a modified form of syllabics to the Carrier in the Fort St James area in the later nineteenth century (Suttill 1994, 4). Neil thought this was quite probable because some Carrier from the Fort St James area did join the Long Grass people. Neil Sterritt authored *Tribal Boundaries in the Nass Watershed* (1996) in which he discusses the history of the interaction between the Long Grass and Gitxsan people. Again, it would be helpful for the Gitxsan if the tree could be located because it may mark important boundaries.

The Nisga'a First Nation territory is west of the Gitxsan, and southwest of the Long Grass territory. The Nisga'a marked their boundary with the Gitxsan near Blackwater Lake by erecting a short pole and placing a rock

on top (Williams, 1983, 2). Reverend Pierce (1933, 174–5) tells an interesting story about a boulder that demarks the boundary between the Nisga'a and Kitsumkalum people.

When going on one of those winter journeys they [Kitsumkalum people] made it a rule never to eat any snow or ice to quench their thirst. They believed that if they indulged in this, their constitution would be weakened and they would be unable to stand any fatigue or hardship, or to keep up the pursuit of any animals ... As a substitute for snow or ice, when their thirst needed to be quenched, they selected a small nice round pebble the size of a marble, which was kept in their mouth as they journeyed on through the snow on their snowshoes. This pebble was handed down and passed on to different generations, at the same time gradually increasing in size, until at last it became too large to be placed in the mouth. It was then laid aside and placed at the back part of the house where Neas-yok lived. As this pebble increased to a considerable size and became solid enough to be stationary, Neas-yok, when tired would go and rest his back by this stone. Today that stone still stands. It has been examined and measured by prospectors, and is ten feet high and eight feet thru. One side faces the Nass and the other side, the Kit-sum-kalum river, thus forming a dividing line between the Naas people and those of Kit-sum-kalum (1933, 174–5).

I discovered another story about Nisga'a territory markers in the spring of 1995 when a young Nisga'a man suggested that I contact Hubert Dooland, a seventy-seven-year-old Nisga'a Elder and fisherman, to learn about the Nisga'a practice of creating tree carvings. I set out to locate him during that summer's fishing season. Hubert's wife directed me to Prince Rupert, where Hubert moored his boat, the PE 92. I drove to Prince Rupert from Hazelton on 20 July 1995. An exhaustive search through the Vietnamese Canadian and First Nations boat city ended with recommendations to check the Prince Rupert marina – "we saw him there earlier in the month." The day was getting hotter and I was getting more tired, but I set out to thoroughly search the Prince Rupert marina. The infectious energy of the fishermen preparing for the upcoming opening of the salmon season motivated me to continue, and I soon saw a boat with the weathered name PE ??, flying the Canadian First Nations flag. I decided to hang around, since my search was looking fruitless anyway. So I stood at the ramp and looked at the boat – waiting. A taxi soon pulled up to the ramp and an elderly First Nations man, loaded down with groceries, got out of the cab. He walked by and one of the bags dropped and spilled in front of me. I helped him gather up his grub. It was Hubert, he was rushing to prepare for the opening at Kincolith. I had five minutes to talk to him as he waited for his tardy son – I felt that this short meeting was meant to be.

With Hubert's permission I quickly took notes on what he knew of tree carvings. He said the Nisga'a did carve in living trees, and some of the images were faces. He told me that his grandfather said they were meant to signify ownership of territory. He was aware of some in the headlands of the Meziadin drainage. Many trails met at the Meziadin Lake area. For example, site Gk Tf - 002, which is an arboroglyph associated with a prehistoric human burial, is located here along the Nass River.[7] A young Nisga'a man told me that a great Nisga'a chief, who had territory in the Meziadin area, commissioned an artist to carve an image of the chief's face on a living tree to mark ownership. The chief wanted to keep his spirit alive so it could watch over his territory after he passed away. The tree became a living marker and an eternal witness of the chief's power. The tree is called a "living tree."

This stop completes our journey through Gitxsan territory. We will now travel into Carrier territory to the Fraser Lake area, where Nick Prince provides commentary on a tree carving near Hallett Lake and Carrier syllabics written on a tree near Klez Lake.

FRASER LAKE

HALLETT LAKE

The story of how I found the carving at Hallett Lake is typical of how I relied on a combination of luck, persistence, and, most importantly, the help of other people to locate examples of these rare art forms. It begins with a conversation about my research topic with Dr Bill Poser, then a professor at the University of Northern British Columbia. He suggested I talk to Craig Hooper of the Ministry of Forests in Vanderhoof about a message tree at Klez Lake, which we will see at our next stop. During my discussion with Craig about the Klez Lake tree he said someone had told him there was a face carved in a tree at Hallett Lake. My father and I went to Hallett Lake in the fall of 1995 to look for the carving. All we found was a dilapidated cabin that was used by hunting guides. The hunters wrote, on the plywood walls, about their success: "One bull moose, November 1958, E. Fudd, guided by Ray's." I mentioned our search to my brother-in-law, John Thiessen, and he said that he would ask his friend Leonard if he knew who the Rays were. A couple of weeks later John called and said that Leonard suggested that I call Stewart Ray, a retired hunting guide. I called Stewart right away, and he knew exactly where the tree was, describing its location in great detail. The following weekend I set out for Hallett Lake accompanied by my friend Joey Himmelspach. We followed Stewart's directions and walked through the forest along Hallett Lake for about an hour. We stopped for a moment to re-check the directions and at that moment Joey called out "Here it is!" (figure 32). We

were both shocked at the ease with which we had found this tree.

I interviewed the Carrier Elder named Nicholas Prince, who I introduced at the very beginning of our journey, about Carrier tree carvings at his island home on Stuart Lake on 6 November 1995. He is a spiritual person who has walked, snowshoed, canoed, and trapped throughout the Fort St James area. He has also interviewed many Carrier Elders in the process of writing his book on Carrier history prior to 1793, when Simon Fraser "discovered" Carrier territory. Nick connects two worlds, like the footbridge that connects his island to the shore of Stuart Lake. He lives a traditional Carrier lifestyle as a trapper and hunter for his family, and he has also been successful in the modern world as a carpenter, a tribal leader, and a writer.

I showed him the photograph of the Hallett Lake carving, and he said he did not know why that particular carving was carved, but he did know about other Carrier tree carvings. The interview with him begins with a description of how the Carrier would inscribe a burial marker on trees using syllabics. He then discusses other purposes such as marking "meeting place" camps and carvings as apologies to the lynx spirit. I present our entire interview.

NICK: When you see carvings out there on the traplines, while you are out on the traplines, someone will put a small carving like this, of a face, you know. It is a message left that somebody died, you know,

Figure 32. Hallett Lake carving shown in the intended viewing context.

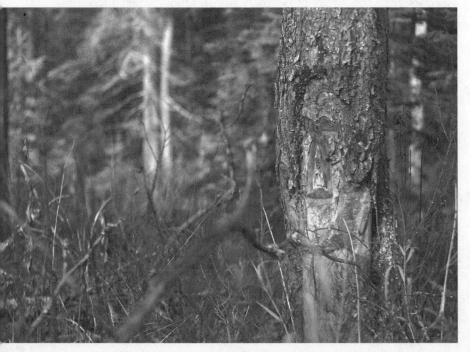

usually there is a name written in syllabics. Sometimes when the owner of a trapline dies, they carve, you see they have what they call a meeting place. Different areas of the country, for the traplines, one family here, one family there. And one place where the invisible place is they call that the meeting place, ... , And that's the boundary you know, each camp you see north, south, east, west around it eh, in some points of that trapline they have these meeting places which is an invisible boundary eh, and each one of them has a carved face on it. See that's supposed to be the guardian of your boundary eh, and everybody respected that. And the different marks that they put on there eh, you know like they left messages it meant a lot of things, they left sticks. They can put axe marks and drive a small wedge into the bottom part of it and leave a piece of birch bark with something written in syllabics about who died or what's happening. It's like passing on news to each other. You know and they used to be thought of as being sacred by all the people, not in a religious sense, but it is something done by the people with sincerity and people look as it being sacred in that respect.

MICHAEL: Who would carve that?

NICK: Well, it would be one of the relatives, or whoever traplines that was left, one of his sons or uncle who was part owner of that trapline, like a company. Maybe two brothers would own a trapline.

MICHAEL: Was it a traditional practice?

NICK: Yeah, it's been in practice for many years. Like when I started up west of here near Sutherland River that goes right to Babine Lake, between here and Fort Fraser there is a river, that Sutherland River, that goes right to Lake Babine. That used to be a boundary of a guy who I used to trap with. We used to trap right along that river and there is two places that I know. One on the south end of his boundary and the north end you know, he has carvings there he said his grandfather made it.

MICHAEL: Would you be able to find them today, do you think?

NICK: I don't know if they are even still standing, there has been so much logging you know. I go through that area you know, of course I flew over that area in a helicopter one time I could not even find any landmarks. Everything is just about gone, even the meadows you know, meadows are drained out. Like in the spring they used to be flooded, but they are just meadows now, trees are starting to grow because they are not flooded. How are you going to find them forty years later?

MICHAEL: Some were carved at meeting places as boundaries of traplines. When we are talking traplines, does this mean the before-fur-trade traplines as well?

NICK: Yeah, they were not called traplines, they were called, like they say "Khe yoh," his country, Khe yoh. They use that word quite a bit, they would say that's the end of your grandfather's country. That's what use, it means they use that land for hunting, they use that land for trapping, they use that land for fishing. Anyway you look at it is part of their livelihood.

MICHAEL: Maybe I will get you to write that word "Khe yoh" so that I get it right.

NICK: See like they talk about that. See down the river, my grandfather's trapline is under Chief Quaw's trapline. It has been in our family for all these years. Now we have it. They call it "sii anu Khe yoh," your grandfather's trapline. They express it like that. It takes many years for them to say, in the Indian way of talking, you really say right out, even if your grandfather has been dead for twenty years. They still say that is your grandfather's land. And it takes many years when you get older, now that I am getting older they starting to tell me 'your Khe yoh down there,' your country. They always said to me your grandfather's country. The way I look at it you have to earn the right for it to be called your country for so many years before they actually say your country. They will tell my grandchildren "that's your grandfather's country," for years.

MICHAEL: To be an Elder you have to earn the right for it to be called your country.

NICK: You see how it is, lands were given out by years ago by people like Chief Quaw, Gwes was his name. That's a form of self-government. They have the clan system, beaver, frogs, whatever. Each one had a head person, maybe one or two, if they were a smaller clan they would have one. Each one is traditionally handed down to the next generation. You see Gwes was what you called the 'Ne za cho,' the head of all the clans, leader of all the 'ne za,' clan leaders. He was like a prime minister and the 'ne za' were like ministers. You see the form of government system that they actually had was copied. The same thing in the United States, they copied the league of nations.

Gwes, or somebody high up, allotted the land to different clans. Like east of here belongs to the beaver clan, and west it belongs to the grouse and caribou, and north it belongs to the frog. Different areas are bear and wolf. Each area was allotted to different clans. You know like boundaries were defined by the size of the family, like the Prince family have good strong generations following, eh. They get traplines, Khe yoh. They acquire that line through the ne za.

MICHAEL: These meeting places would be meeting places of families between clans or within clans?

NICK: It does not matter, they could be right next door to another clan

eh. But still it is their meeting place, they respect each other's invisible boundary. Even if they had a camp where they meet, and their trapline is divided like this, but if they have a dinner camp here, that's supposed to be in their boundary. These people respect their dinner camp. And maybe these other guys, and they can cross trails and go to their dinner camp.

MICHAEL: What do you mean by dinner camp?

NICK: Each camp that was put in there was given a name. There was a place where you sleep, camps where they have lunch, camps where they stop at night. Each camp was a half a day's travel from the other one. Each one had a name, so if these guys had a trapline on that side and they had to go through to get to their dinner camp on your line. They had the right to go through and eat there you know. And go back this way because it better traveling to avoid a mountain or a swamp. So the dinner camp belongs to them, you can't use it. And you do the same thing, you got your dinner camp on their territory because it is easier to go around to your line. So that's the way they worked it eh.

MICHAEL: Would these carvings only be at the meeting place camps?

NICK: Yeah, just at the meeting places.

MICHAEL: They would actually meet there as families?

NICK: Yeah it depends, there might be two lakes close together, one lake down on their trapline. Another family might be one day's travel apart. When they are finished hunting over there, they might get together and spend two or three days socializing. Before they head for home. They share stories and they know how much each other has got, and what they left. Especially they talk about what they left, they did not go out and kill everything they see. Like they say in one place the family say 'geez we saw some moose, three or four moose feeding in that swamp or lake.' They will kill one only. And they say we left that there.

MICHAEL: So they take pride in what they left rather than what they took?

NICK: Yeah, because they were more conservationist. They were the true conservationists. Today I do not know what the hell is going on. [This is an excellent comparison between the First Nations' meaning of conservation and the Western notion of regulating how many animals are killed.]

MICHAEL: So would they pick any tree or just one near the camp?

NICK: They give the tree a name and that's the name of that camp. Each dinner camp or any camp that you go to has a name. You know I can name all the camps between here and Mcleod Lake. There must be thirty or forty of them. I know each camp. I used to know each camp.

MICHAEL: What would be a name of a meeting place camp that you know of?

NICK: Well there is which means the 'water runs right through the pines,' that's one camp that they use in the winter, that's a winter camp. Or 'where the trail splits,' one families goes there together, there is a camp there. Okay, the family is one day's travel from here. They go there in a wagon. They go there with a team of horses and that's where it ends, they start packing. That's why it means 'it splits.' You see, names like that is very important. You know because of if you were here and I am going out to check my lines eh, you know I will tell you, tomorrow I will be in 'Ba' nal yeh,' that's a camp a day and a half travel from here. That's where I will be tomorrow. The next day you will know where I am, and every day that I am gone you will know where I am. So if somebody comes along and they say we got to see him, they got to see that person. Because maybe his mother or father died or something. Where do I find him. You know where he is, exactly.

MICHAEL: When they name that tree, is that like naming someone at a potlatch?

NICK: No, they just put a name to it, they think of a name, especially the Elders. They will look around and see what the country is like.

MICHAEL: Is there a ceremony giving the tree a name?

NICK: No, they just carve. They just carve it, that is all they do. Unless they plant another tree beside it you know.

MICHAEL: Why would they do that?

NICK: Second generation. You see if I find one of those trees now, on the traplines that I have been on, on the river. You know if there is another tree beside, which is fully grown, thirty or forty years old, I would plant another tree beside it. The camp will still be there ninety years from now.

MICHAEL: If that tree fell down, would they recarve it again on another tree?

NICK: No they, what they do then, they just cut it off, dig a hole and stick it in the ground. They leave it there until that one rots before they, it has to be close by, they pick a tree where there is another tree close by you see. If that tree goes down they just carve it on the next one.

MICHAEL: Do they have trained carvers?

NICK: No, not really, they, most of the carvings done around here in that time, in them days, were just rough. They were not artists like the Northwest Coast people, it was just rough carvings that they did. They used to have carvings on their little grave house. Even their smokehouses used to have a carving on it, to bring luck. To keep bad luck away, and stuff like that, any animal, a beaver or a crow. They put it up there to ward off bad luck.

When you go these camps, you look around, you'll find carcass. I don't know if you can find them now, there have been so many years since the practice has been abandoned, I think. You know you'll find carcass of otters and wolverines and different things. And you will notice that each carcass is pointed towards that tree. It don't matter which direction the carcass is. They either put it on the branches or on the ground eh, and they point it toward the tree. They believe by doing so, the spirits of their animals is going to come to you or your camp eh.

MICHAEL: Why would they carve a human face?

NICK: I think it is more or less it was meant to know it was done by their own people. I don't know if it had any significance, except to use it as a marker. Sometimes they will put a name in syllabics on it you know, what camp it is. There is a lot of things that is dying out today.

MICHAEL: With lynx, my great aunt told me the Gitxsan would carve a face on the tree to attract the lynx to the area.

NICK: Yeah, well I don't know. The story about the lynx is different in different areas, you know we have the same thing. But in our stories, people would put a face on the tree in respect to the lynx, 'wasi' they call it, they carve, you know like a caricature of a face you know, it would mean that a lynx was caught there eh. You know they are apologizing to the lynx by carving a face on that tree where it was caught. When the next lynx come along it sees these people they apologize for what they done. They say a lynx is just like a human being, you know he memorize everything he sees. If a lynx was caught right there in that trap, the lynx would know that and he looks around, see that little face on the tree where it was caught, and he says 'they apologize, I have no grudge against them.' That's their beliefs you know. That's what we have in the Carrier stories. I don't know about the Gitxsan people, it might be different.

MICHAEL: So a lynx gets trapped there and they carve a face there to apologize. Was the belief that the lynx spirit would come back into another lynx and then that spirit would see that they had apologized?

NICK: Yeah, it is the continuation.

MICHAEL: Like a reincarnation?

NICK: *Yeah, their belief is that you never actually kill the lynx, the spirit is there*, that's where the face, the spirit is in the face eh, an apology to the lynx. There is quite a lot of things that is interesting. It wasn't till I was about forty years old that I started thinking about these things. A lot of things are going to die out unless you start writing [emphasis added].

MICHAEL: The lynx was a powerful spirit?

NICK: Yeah, he was a helper to E'stas, he is the Creator, in our stories

and that lynx, Wasi, he help him put people together. So he knows everything about people hey. They say he even knows who's gone nuts, people go like this [he points his finger, and laughs].

MICHAEL: I have never seen a lynx in the wild, or a wolverine.

NICK: You know my dad he caught a few of them in his trap, but some of them he caught in his traps eh, but some of them he caught in his snares he let loose, the ones in his traps he had to kill. The ones he caught in the snares there was no damage to them, it was around the neck. But there was something he had about his animal, that I can never understand. I never really understood what it was. You know, I used to trap, just a little kid you know, on the old telegraph trail they call it near Fort Fraser. We used to set snares for coyote and fox. Sometimes we caught a lynx you know, the lynx was still alive. But there was something I could not understand how he did it. He talked to the lynx and the lynx would lie down there while he loosened the wire around his neck and the lynx he would not move. I still don't know what he does because I tried and the lynx would scare the hell out of me, the claws would come right out. He would talk to it and walk right up to it, and turn it loose.

MICHAEL: Would they trap lynx on purpose or were they caught just by accident?

NICK: Well, lots of people trap it you know because it is part of their kill. My dad you know was one of them guys that never trapped lynx and never trapped wolf. Wolf was a spirit brother to my grandfather and lynx was his own spirit brother you know. They tried not to harm the animals. I never killed a wolf. I caught a lynx in my snares you know but I turned it loose after a struggle.

Nick's commentary is rich with meaning: as a verbal artist, historian, and storyteller he connects the spiritual and physical landscapes. Although he did not know the meaning of the Hallett Lake tree carving, he adds to the possible intended meanings for Carrier tree art. He gave three possible meanings:

- They are burial markers inscribed with a syllabic message.
- They mark a "meeting place" camp which marks the invisible boundary between two families' "Khe yoh" or countries.
- They are small carvings of faces that are apologies to the lynx spirit.

Eliade (1963, 1) alludes to the ambiguity of the boundary separating the sacred and profane worlds: "as soon as you start to fix limits to the notion of the sacred you come upon difficulties." Nick attributes multiple meanings to the tree bearing the carving. The tree and associated carving acted as a locus of spiritual power, and as the guardian of the invisible boundary. Carcasses of animals, like otter and wolverine, were placed around

the camp, on the ground, or in the branches of trees,[8] facing the tree carving so that their spirits would "come to [the] camp" and go into the tree, and thereby ensure good luck in hunting and trapping. The tree was the spiritual centre of the camp, and it acted as the *axis mundi* for the animal spirits to return to the spirit world. The Carrier regenerated the tree guardian function over hundreds of years by continually planting a seedling beside the tree bearing the carving, to make ready for the time when that tree returned to nature and a new carving would have to be created. Carrier trappers and hunters always used the same spot as a camp, and thus it was necessary to keep regenerating the art form – by regenerating the forest around the camp.

Nick described how Elders gave the tree carving and camp a name, such as "water runs through the pines," which reflected the physical landscape surrounding the meeting place camp. Carrier place-names, as with most First Nations, reflect the landscape and its history, and this is one reason why First Nation languages help define the nation's connection to their land. The chiefs who testified in the Delgamuukw land claims case, as well as John Adams (1986, 2), suggest an association between the Gitxsan totem pole and the "trapline" (territory is sometimes translated as trapline) because the oral history represented by the pole reaffirms a house's claim to a trapline or territory. The meeting place tree carving acts in a similar way for the Carrier. The meeting place tree reaffirms the boundary between territories or traplines called "Khe yoh."[9] Language and art connect the people to their land.

The lynx is again linked to the practice of tree art. The carvings which apologized to the lynx acted in a similar way to the meeting place's *axis mundi* tree. The spirit of the physically dead lynx entered the tree and traveled back to the spirit world, ready to be reincarnated. The next lynx would see this carving and, because they have such good memories and they know humans so well, would realize that the Carrier had apologized. Consequently, the lynx would forgive the person. Without the carving, the lynx would make the person very unlucky as a trapper. Because the lynx is a recurring figure in the study of tree art, I provide a survey, in the following section, of First Nations lynx spiritual beliefs.

THE LYNX

The lynx, or wild cat, is a mysterious and powerful being. It hunts the hare at night in coniferous forests throughout British Columbia and in boreal forests throughout Canada. The bobcat and cougar are close relatives of the lynx. The adult lynx can weigh between fifteen and thirty pounds and it has relatively long legs (Nelson 1986, 225). Partially webbed paws help it run on the snow. It has a fine grey-brown fur and long ear tufts which amplify the sounds of its prey (The Wildcats 1995, 44, 48).

A Gitxsan transformer oral history tells how Lynx was given the tufts on his ears after he helped We-gyet (Big Man) free himself from a rock that had wrapped around his legs.

We-gyet was giving up all hope of escaping from the rock when Lynx, who was always curious, came along. We-gyet knew that Lynx owned a tongue like a rasp. The Big Man decided to bribe the creature to use that rasp-like tongue to free him from the rocky trap.

'Help me, Great Lynx,' he begged. 'I will reward you with whatever gift you choose.'

Lynx could see that if he succeeded in freeing We-gyet it would happen only after hours and hours of tedious work. Therefore Lynx decided to ask for a payment that We-gyet might not want to give.

'I will try to set you free if you will give me the longest hairs on your body but not those of your head,' said Lynx.

We-gyet hesitated. Freedom, however painful was essential. We-gyet agreed to Lynx's price.

Patient Lynx began to lick the rock with his rough tongue. He worked day after day. Finally one of We-gyet's legs was free. Then the other leg. Then an arm. Then the other arm. Much, much later We-gyet's whole body could move out of the rock. Only his head was anchored. At last Lynx loosened it and We-gyet was free to travel again.

The delighted We-gyet kept his promise. He pulled his body hairs and stuck them jauntily on the ears of Lynx.

To this day Lynx walks with the hair standing out on his ears, a payment of gratitude from the Big Man of long ago (We-gyett 1977, 46).

Claude Lévi-Strauss (1995) dedicated an entire book to defining the lynx within First Nations cosmology. He summarized one of his mythical perceptions of the lynx:

Considered as a whole, the mythical field [of lynx] seems to be the locus of a double pendulum swing. One oscillation pertains to the sweat lodge – at times a supernatural mediator with a place in the pantheon, at others a hygienic practice whose legendary origin is narrated in one version. The other oscillation pertains to Lynx's character, which has varying connotations ranging from the negative mode (when

he causes famine through fog, making it impossible to hunt, or when he impris-
ons all the animals, which amounts to the same thing) to the positive mode (as a
creator of a new humankind and the arts of civilization) (15).

Lévi-Strauss' work, although relatively comprehensive, does not include ref-
erences to Haida, Tsimshian, and Gitxsan lynx beliefs. Additionally there is
no mention of the lynx in Boas's *Tsimshian Mythology* or in Barbeau's
manuscripts. Consequently, Lévi-Strauss concentrated on Athapaskan, Nez
Perce, and Salish beliefs. I surmise that the lynx did not play as important
a role in Tsimshian oral histories as in those of the Carrier or Nez Perce.
Lévi-Strauss interpreted the lynx in Nez Perce legends as follows:

... Lynx appears as the master of the fog: he can bring it on and lift it at will. And
it is yet another kind of fog, one that is beneficial rather than harmful, warm
rather than cold – namely steam – that heals Lynx and gives him youth and hand-
someness. To these paired elements the second version adds the earth oven, dug
into the ground and heated with hot stones (like the warm water bath, thus replac-
ing the sweat lodge also mentioned in this version). Fog, sweat lodge and the earth
oven thus form a triangle in which fog, in the realm of nature, corresponds to the
sweat lodge and the earth oven in the realm of culture (6).

In Western terms the lynx has both positive and negative powers (First
Nations people do not judge power relationships using this dichotomy).
Lynx can create bad luck and heal the sick. These powers are similar to
those of the Iroquois faces in the trees and the Dakota tree dweller spirits.
 The Athapaskan and Salish cultures also have high regard for the lynx's
spiritual power. For instance, Richard K. Nelson (1983, 140) explains that
the Athapaskan Koyukon people consider the lynx to be second only to
the wolverine in spiritual power.[10] The Koyukon people treat the lynx with
the utmost respect because "[t]his animal can afflict a person with a more
complete and lasting alienation than any other," which can result in sick-
ness, or they will "permanently lose their luck in catching this animal"
(156). Nelson includes a pre-contact oral history about the lynx and bear.

*In the Distant Time, the bear and lynx were talking. The bear said that
when humans began hunting him they would have to treat him right. If
he was mistreated by someone, that person would get no bears until he
had gray hairs on his head. But the lynx said that people who mistreat-
ed him would never get a lynx again in their lives ... (156).*

Father Morice (1893, 108–10) translated a Carrier pre-contact oral his-
tory about the lynx to illustrate his point about how the Carrier respect-
ed the lynx's power. He tells of Carrier men lowering the carcass of a lynx

through the smoke hole of the lodge. The lynx was only touched and eaten by men. The story begins as follows:

A young couple of Indians was living in the woods. One morning, as the husband was absent chasing large animals, a stranger of surprising beauty and was apparently endowed with superhuman powers came upon the young woman. "Follow me: you shall be my wife," he said to her. But as she was very much attached to her husband, she strove hard not to harken [to] him. Yet such were the stranger's charms and hidden powers that her mind was as if paralyzed in his presence. As she pretended that she had no provisions for the journey, he told her that the distance was short, and that he had plenty in his own place. Whereupon he seized her and she had to follow him. Now the stranger was no other than the lynx.

They arrived at the lynx's lodge, and the husband followed by tracking the trail of grouse feathers left by his wife. The husband and wife strategized over how they would trick the lynx rather than fight him because he was so powerful. The wife told the lynx she was having her menses, and he was afraid of her because he feared "you will throw a spell on my arms." The lynx lost interest in the wife and the couple killed him while he slept (109–10). Morice mentions that the lynx had two Carrier names, "washi" and "sunte" or "my first cousin" (94). Remember that Nick Prince told me the Carrier respected "wasi" because "he was a helper to E'stas, he is the Creator, in our stories and that lynx, Wasi, he help him put people together. So he knows everything about people hey. They say he even knows who's gone nuts." The Carrier also believe that if you hear a loud bang in the forest it is the sound of hundreds of lynx coming to the forest from the sky world.

The Nez Perce story called "How Bobcat Found a Wife" is very similar to the Carrier story translated by Morice. The Nez Perce version tells of how Bobcat impregnated a girl called Pine Squirrel. He urinated on the same spot as she, and that is how she became pregnant. There was a great mystery in the camp about who the father was. The people discovered that Bobcat was the father and they became angry and killed him. His wife stayed after the people moved and resurrected Bobcat by placing his bones under her pillow and healing him in a sweatbath. A magpie told the people that Bobcat had "come back" and the people "went to see and apologize. They sort of repented him ... They had happy days from then on" (Aoki and Walker 1989, 541–2).

The Tena pre-contact oral history about the lynx is also similar in theme to that of the Carrier and Nez Perce. Sullivan (1942, 97–9) retells a Tena story about lynx, which begins:

*Once the lynx [who was a man at first] had two wives, and he stayed
alone with them on a mountain. For many years they stayed there. He
was trapping every day in the winter and the two women stayed at
home. One time he went out again. Usually he would be out only dur-
ing the day and come back at night. But this time he did not come back
at night. When he returned the next day, his wife asked him, "What was
the reason you stayed out?" "Oh, I was tired," he answered, "and I
couldn't come back so I stayed out ... After two or three days he went
out to hunt again. That night he didn't come back, nor the next ...
(1942, 97–9).*

Eventually the man leaves his two wives and boys for good. They try to
follow him but he has left no trail. Eventually a bird tells them, "Your
husband has two wives back in the mountain." The first wife finds the
husband's new home in a valley, and she tricks his new wives and kills
them. She also tricks her husband into holding a hot rock, and his hands
and feet shrivel, and then his face: "He did it – and then he turned into a
lynx and went outside. And after that the three boys were turned into
lynx, young ones, and the two women turned into lynx too. That's all"
(Sullivan 1942, 99). Sullivan relates this story to the Tena practice of plac-
ing carved dolls on either side of a lynx snare (99). The Tena also observed
taboos similar to the Carrier and Gitxsan. For instance, women are not
allowed to mention the lynx's proper name, "otherwise its *yega* [spirit
power] would prevent any more lynx being caught by the men in the
household," and unmarried girls were not allowed to eat its meat. Sulli-
van emphasizes that the lynx was an important food source and "they
cautiously avoid doing anything that would make its capture more diffi-
cult or deprive them of it entirely" (99).

The Carrier, Nez Perce, and Tena stories suggest that Lynx and Bobcat
will try to impregnate women, and the people must apologize to Lynx or
Bobcat, otherwise he could use his power to create bad luck. The lynx has
a good memory and will remember if someone has tried to harm him.[11]
Consequently, the hunter would be unable to feed and support his family:
the family's very survival is at stake. Nelson (1983, 26) suggests that a
hunter's good luck is based on the support or blessing of something or
someone who "created the world." Luck is not a fitting term, however,
because it is not a random turn of fate that a hunter has good luck, but
rather it is with the spiritual support of the lynx that the hunter can sup-
port his community. Spiritual support results from the hunter's respect for
his environment. Many Gitxsan stories demonstrate the fate of those who
do not respect the salmon people, or goats, for example. The punishment
is severe. Barbeau (1973, 198) warns in his second Gitxsan precept, pre-
sented previously, that "[t]heir lives are not unlike yours. Their spirit-

selves, unless propitiated, stand over them in readiness for the deed of retaliation."

The lynx were trapped for their fur and as a source of food long before the arrival of the white man (Blackwater 1995). Alexander Mackenzie (1970, 368) observed a patient being covered with a lynx robe, and he showed records of 6,000 lynx skins being shipped to Britain in the autumn of 1798 (1970, 82). Father Morice (1893, 97) describes the Carrier use of a deadfall trap to catch lynx. The trap design is often specific to an animal. Figure 33 reproduces Morice's figure 81 of the lynx deadfall trap. This design is very similar to the Gitxsan trap design for lynx described to me by the Gitxsan trapper Walter Blackwater.

Nelson (1986, 226–7) describes the trapper's landscape and how it is interpreted when deciding where to set traps. For example, he points out that "[t]rap sites are usually associated with some geographic peculiarity that tends to funnel lynx through a certain place, such as a narrow isthmus of forest between open areas, or at the end of a forested point jutting out into a lake or meadow." Nelson also suggests that the presence of a trail in combination with a natural feature of the landscape creates an important "crossroad" for the lynx's routes of travel. The lynx, its power, and routes of travel are all important clues to the placement of some of the Carrier, Koyukon, and Gitxsan tree art.

Figure 33. Morice's drawing of a Carrier deadfall trap for lynx (1893, 96). The log (d) is meant to drop on the lynx's neck.

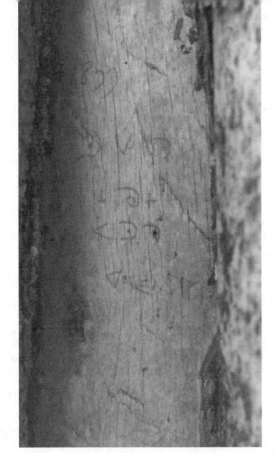

Figure 34. Carrier syllabics on Klez lake pine tree.

KLEZ LAKE

Klez Lake is about eight kilometres south of Fraser Lake, B.C., and south of Dry William Lake. Highway 16 west passes by Dry William Lake. The Klez Lake arboroscript tree is shown in figure 34 (Borden number: Ga Se-11). The tree was found by a forestry crew surveying pest damage in 1994, and the archaeological site report says that the tree is on a spur trail of the Cheslatta Indian trail. There are syllabic characters written in pencil on the blaze of the tree, as shown in figure 34. Dr Bill Poser, Nick Prince, and Ed Kettle each deciphered the message. Bill Poser's translation is "Corpse there is, Pierre, Hello I am saying this, Antoine." Nick Prince's translation is "Body there is, at house, Hello I am saying this, Antoine." Ed Kettle's translation is "Trail there is, house, Hello I am saying this, Antoine." The message was prefaced with the characters "1877," which appears to be the year. The site report says "[Father] Morice according to current info. did not introduce syllabics until 1885. Poser says that they are definitely Morice's syllabics and not earlier 1847 Cree syllabics" (Suttill 1994, 4). Suttill infers this may be a message regarding a death, rather than a burial marker.

I have encountered a similar, more recent, example of a message about a death written on a tree. This arboroscript tree was at the Deep Canoe site. Neil Sterritt interpreted the message.

NEIL: You know what this is, it's almost a message to get their stuff. May the 27th, he died on May 27th, he must have been trapping there. Somebody walked in there and on June 4th they told them to get their stuff and come to town. You read that. Chief Aleast died on May 27th, they sent a runner right away to tell them to come in. Grab your stuff and come to town.

MICHAEL: Oh, somebody from his house was out there trapping and they told them to come in.

NICK: That's what that message is, that is exactly what it is. Now what is this age 5 yrs? Maybe 75 years, doesn't matter, that is what it is. They got there on June 4th, grab your stuff, that's all you have to say. You know that if you have been in the bush. You know you don't have to say much. That is what it is. Now, why the cat, there is a reason for the cat? 'Oh no he I still alive chasing squirrels and girls.' Did it look fresh to you?

MICHAEL: Pretty recent.

NICK: They are making a joke about it, Chief Aleast is still alive. They would have taken a horse in four days. That's my view of it.

A possible intended meaning of the Klez Lake arboroscript is a message to a hunter or trapper about the death of Pierre. Neil suggests it was common to leave written messages on trees, for trappers, for instance. This tree gives some insight to the life of a trapper and how connections to the village were maintained regarding important events.

The Fraser Lake portion of our journey is now complete, and now we travel to Tumbler Ridge in northeastern British Columbia.

TUMBLER RIDGE

While researching the provincial archaeological records, I found a site report for a tree carving near Tumbler Ridge, B.C. (Borden number: Gg Rg–1). Tumbler Ridge, a coal mining town, lies at the foot of the Rocky Mountains, about 170 kilometres east of Chetwynd, B.C. The site report was filed in 1976, just prior to the establishment of Tumbler Ridge. The site report included photographs of a face carved on a tree (figures 35, 36), and of the specific and general site. There was also a map showing its location. I traveled to the site on three different occasions to look for the tree carving, and looked in every possible location, but finally resigned myself to the fact that the tree had been removed. The Tumbler Ridge

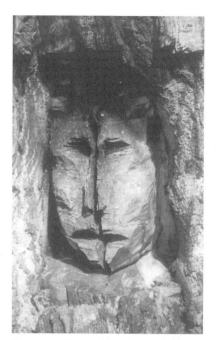

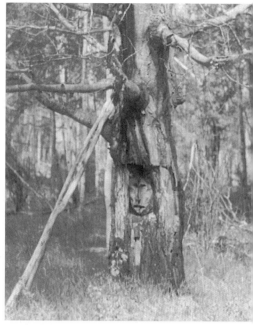

Figure 35. Dunne-Za tree carving at Tumbler Ridge (Gg Rg-1).

Figure 36. Dunne-Za tree carving at Tumbler Ridge (Gg Rg-1) shown in context.

municipal campsite is located in the spot where the tree was reported. Unfortunately, the report designating the tree as an archaeological site was filed after the campsite was established.

I followed up with a phone call to W. Warn, who was one of the original informants, and a resident in Dawson Creek. His first visit to the area was in 1937, and he saw the tree carving, two graves, and Indian buildings on the east side of Flatbed Creek. They were all about fifty to one hundred metres from the steep hill along the creek, and the carving was on a poplar about ten to fifteen metres from the creek bank.

The Flatbed Creek area is in the traditional territory of the Dunne-Za people from Moberly Lake.[12] The photographs show a beautiful and well-carved piece, which challenges the popular belief that only the Northwest Coast people had mastered the art of carving. This carving has the aesthetic power and quality of Northwest Coast art but it was created over 800 kilometres into the interior. The carving seems to be looking downward, and it was beside the two graves. During my exhaustive search I did find a very roughly carved face on a snag along the creek shore, about a hundred metres west of the reported location. This carving may be a rough replacement for the original.

In my discussion with Chief George Desjarlais, of the Dunne-Za people of West Moberly First Nation, he confirmed that they had a tradition of carving the image of a deceased's guardian spirit on living trees: "if the tree lived it was a sign that the spirit [of the deceased] is alive" (1996). Some of the reasons for carving on a tree include recording visions and marking graves. The image on a grave marker could be of the deceased's spiritual guide, seen in youth during a vision quest, who had guided him on his journey through life.

It is unfortunate that the Tumbler Ridge tree was removed or destroyed. Its demise represents to me how these wondrous art forms have all too often, and probably unwittingly, been destroyed. This sad history is the second journey of meaning for the Gg Rg-1 arboroglyph. British Columbians' ignorance of their rich history has resulted in some cases in its destruction. A similar story will unfold regarding the Blanshard River tree carving at our next stop in the Yukon.

YUKON

KOHKLUX TREE CARVINGS

I found myself in the Yukon with my friend Joey Himmelspach after following up on leads from Mike Murtha in Prince George, and Sarah Gaunt in Whitehorse. Sarah had suggested that I talk to Ron Chambers, the deputy chief councillor of the Champagne and Aishihik First Nation. Ron lives in Haines Junction just a few hours west of Whitehorse, and this is the next stop on our journey. He is a First Nations artist, and a retired Kluane Park Warden. He is knowledgeable of the arts and the land, and he has taken a special interest in tree art. In our interview, he discussed two carvings (see figures 37, 38, 39, and 40):

MICHAEL: Maybe I will just get you to explain what tree carvings are for.

RON: What I kind of thought they were for, and my understanding of it, they are trail markers, and they are usually about a distance either from a major crossing or a travel distance from each other of a day. I would think they would come to these certain markers, they already knew ahead of time what each one is. They get to a certain place and they see that marker and they knew something about it, and they go on to the next place and they see another marker with a design on it. They also again knew there was a certain kind of fish there, or it a good camp spot. Or they might be a day or so from another village. Or they also indicated the ownership of the trail. Chief Kohklux or Shartrich, from Klukwon, did most of the trading in the 1800s. It may be some of his symbols, clan symbols. These are definitely Tlingit trail

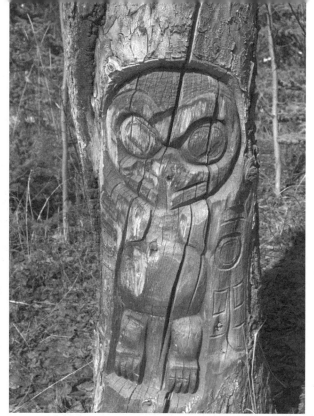

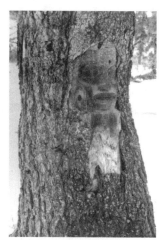

Figure 38. Tlingit tree carving at Blanshard River in 1944. (Photograph by Conrad Hug, from the Della Murray Banks Collection. Courtesy of Janet R. Klein.)

Figure 37. Tlingit tree carving, shown after it was cut from the tree near Frederick Lake, Yukon (courtesy of Sarah Gaunt per the Champagne and Aishihik First Nation).

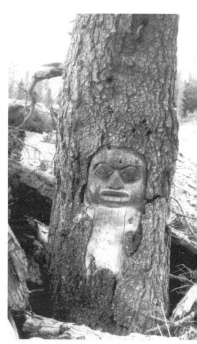

Figure 39. Tlingit tree carving in the intended viewing context at Blanshard River in 1944. (Photograph by Conrad Hug, from the Della Murray Banks Collection. Courtesy of Janet R. Klein.)

Figure 40. Blanshard River tree carving in 1950s, in a modified viewing context (courtesy of MCC/CMC, photograph no. 98086).

markers. I think if the information gathered on them, the type of carvings for example, there would be some explanation of the symbols. Like I was saying, the two carvings, the one on the tree at Blanshard (figures 38, 39, 40), and the one at Frederick Lake (figure 37), the one at the parks office. The carvings, the style and the eyes is about similar. I would expect they were done by the same carver. The time is the same, on either one of those trees. They are not rotten trees, they are old trees. So the carver probably did it about the same time. I don't know how far back in history they do them. Once the fur trade came along it created a bigger spark between the interior. So it maybe started with the fur trade. While they pushed the routes even stronger. In the past they had contact, they might have had contact, but a bits and pieces type of thing. Because they did not have to, other than moose hides and that type of thing. But once the fur trade started it was very important to mark your turf. That was done by the Tahltans as well.

MICHAEL: The people that they were trading with in the interior, what were they called?

RON: The southern Tutchone. The people down Tatensheni, there is a real mix of names there, Tatensheni-Alsek, they are called Gonenough, they traded with the Yakatak, but also with the Klukwon. There is a three-way meeting place area there. So this is going towards Klukwon, Chilkat. The Yakatak did not go very far in the interior. The Chilkat Tlingits went all the way to Fort Selkirk. They sent Robert Campbell packing down the river. Did you hear that story?

MICHAEL: No.

RON: He was a Hudson's Bay trader, he established a trading post down on the Yukon River. While again you see how important it was to the Tlingit. That's about, gee I don't know what it is in distance, but I guess it is about 250 miles from the coast, they went all the way up, burnt the place down, put him in a boat, and sent him down the river. Now that's what I call taking care of your turf, am I right?

MICHAEL: Yeah.

RON: It's a hell of a long ways to go, and you ain't going for nothing. So that's how important it was. They did, they sent him down the river, that's Robert Campbell. There's a Campbell River now, and a Campbell Bridge across the street in Whitehorse, a Campbell this and a Campbell that. That's the same guy, but this Shartrich is the guy that sent him down the river. A Tlingit chief.

MICHAEL: Your feeling is when you find these trees is to leave them there eh?

RON: Yeah, I'd say leave them there, record everything you can, the area, photograph the whole dog-gone works. And if there is a problem with the tree surviving, then that's the next question but up till

then document them real well. Also we need to put them in a reference you know. Photos only do one thing, they show you it was there. It's something to see something in reality. If you have to move them, then have a place to put them. Like that one over at the parks, it's an information, but it does not have any background or nothing. It's just a carving. What's poor about that, people come look at and say 'oh that's neat' and walk off. It's more than neat! There is a whole lifestyle to that.

Shartrich is Wolf, that's important to note because it might affect what the designs are. That's important to what you do there. If you go back to Hazelton, and you got those twenty-some [carvings]. Find out who were the chiefs at the time, who were the leaders at the time and what were their clan symbols. Now with him being Wolf, I would almost wonder about that design, the raven or owl. I can't remember what moiety the Owl is under, make a note to yourself, do you know what I mean. If it doesn't fit in, I mean again I am just speculating. If he is Wolf and it has wolf indicator things in it, then he may not have a raven on the tree. If that's him. And if he definitely has a raven, then you say how comes that. But if this is an owl and the owl is tied in to that moiety, then it could still tie back to Shartrich. A bit of detective work.

MICHAEL: What do you guys believe about a tree, do you believe that a tree has a living spirit?

RON: Well, I don't know for sure how powerful that would be. I could not tell. That's one of those things, I would not want to speculate of something, if I was not sure. That's the thing that does get me, some people would say 'oh yeah it does that,' you know, when they are not sure.

MICHAEL: The raven [or owl] one was found ten years ago at Frederick Lake (figure 37), and Paul Berkel was the chief that cut it down.

RON: Yeah, if it was a raven.

MICHAEL: What would be the most important piece of advice for me when researching these trees?

RON: Well, the thing is to nail down more of why they were made, what the reasons are. If you learn the reasons. And the other part is to nail the common part of it. I mean that these two were so close together, if you did a study on these carvings you may find that they belonged to the same artist, the same carver. That's important to get continuity. Rather than a tree carving is just a tree carving, while it's not, there is more to it. So that and uh, the date. Because it is very important. We are theorizing that these were done by and for Shartrich, Kohklux. While if they are not, that puts another light on it again. I suspect though it has his influence on it though. That would also indicate the differences in styles from place to place. Because he would have his

carvers doing his signs, right. My sign, my carver. You go down the coast and you will find somebody in the Tahltan's did the same type of thing. They have another carver, different style, different chief and clan symbols would show up. And right on down the coast, because these thing do have a common meaning, same as these rock carvings you know. You go right down the coast and they have similar themes. The style changes a bit from part of the country to part of the country. They have a lot in common in that aspect, the Northwest Coast. The style all the way up to Washington state and California even. You will find similarities, big change, but similarities. There is differences, but a good idea is a good idea, you know what I mean. So trail marker, maybe there is some in California for all we know. Totally different kind of carving, but the same principles behind it.

MICHAEL: Yeah, that's why I came up here to talk to you, because we need as many clues as we can get. As an artist what do you think of these, as an art form?

RON: Well this guy, I mean that's a carver there. You know and the tools back then, he probably had some good tools with him. For him to carry, to come up on a packing trail with the big loads they carried, coming and going, they traded. You take stuff in, you take stuff out. This guy is like bringing a photographer along on a mountain climb. I think he had to carry a smaller load than the next guy, because he had a purpose. That's important. The quality and the style and the ability. This is harder wood to carve than cedar. The tree is more dense. It's a spruce. These interior spruce is harder wood to carve, he had to have had good tools. They are not going to wait forever for him to carve. So the guy had to have a really good carving ability. I mean I would not even want to take that on in a few days. I mean if you give me enough time I could do a design like that. I can't do that in two days, this guy could, more than likely. That tells me a lot, it tells me that there is a lot of thought behind what those are for. They didn't just bring anybody to hack away. They brought somebody in who was an intelligent carver who did that design. You don't do all that detail for nothing. You want to blaze a trail, you blaze a trail, you know. Three chops of the axe tells you something too. There is more to that, it's establishing a trail.

And the next step, here for example, they call it the Dalton Trail. Dalton came in with a pack train and everything else. This tells you they were here before Dalton, well everyone knows that, it's history. The thing is, if you go through this amount of trouble to show you are using the trail, it sure as hell is not a fly-by-night trail. So when they come along and put a name like Dalton's name over it, arbitrarily like, because he brought some horses over it. He used the same damn

trail, to me I say you got your priorities backward. This guy went to a hell of a lot more trouble than Dalton ever did to think about the trail. Dalton did not ever carve a totem pole design on the tree. Okay, then I say let's put the importance of the trail back to where it belongs. And if you find it that this is Kohklux's symbol and design, you can call it the Kohklux trail, the trading trail, the Tlingit trail, the Tutchone trail. There is some concern about the Tutchone, and calling it that. There was some animosity between them and the Tlingit. But if that's what it was, that's what it was, it's history. The Tlingit were notorious traders. You had to count your change after they left, you know. But that's their business, that's what they did. But the people up here they more or less lived off the land. They did not spend their time trying to squeeze the extra dollar out of you. They traded for what they thought was fair enough. Tlingits were pretty fast and powerful. But they did have respect for the people up here, they protected them. It was very important to maintain contacts here. By and large they treated the people up here not too bad. They had battles down south and made slaves of them. I don't know of any slaves from here. They valued their trading contacts.

Ron's insightful commentary began with a discussion of tree art functioning as trail markers. He said the markers are about a day's travel apart, and located at major junctions or water crossings. The traveller associated knowledge of the landscape, or hunting and fishing prospects with each marker. For instance, the fishing may be very good at a particular marker, or it may be a good river-crossing site. Ron suggested tree carvings could also indicate trail ownership. The Tlingit Chief Kohklux, also known as Shartrich, from Klukwon, Alaska, was a powerful chief, similar to the southern Tsimshian Chief Legaix. Ron believes that the Blanshard River and Frederick Lake carvings were of Tlingit origin, based on the style. The geopolitical consequences of the European fur trade strengthened the practice of creating trail markers to "mark your turf." Evidently Chief Kohklux knew his territory very well because he drew a detailed map of it in 1869 for a visiting astronomer named George Davidson. "When asked by George Davidson, visiting scientist, about his travels, Kohklux and his two wives were able to draw a map for him, although they had never used paper or pencils. It is the earliest known map of the southern Yukon and the first known map to be committed to paper by a First Nations person in this part of the world ... [and it] is a tangible symbol of the cultural links among the Tlingit of the coast, and the Tagish and Tutchone people of the interior" (Yukon Historical & Museums Ass'n 1995, 1).

Ron told a story about the ousting of the Hudson's Bay trader Robert

Campbell by Chief Kohklux, who traveled 250 miles inland to Campbell's post to assert his claim over the trading rights with the interior peoples like the Tutchone: "The Chilkat guarded the few mountain passes that gave access to the interior. The people of the Yukon were not allowed to come to the coast except under very special circumstances ... Similarly, traders on the coast were not allowed access to the interior where they could trade directly for furs, thus bypassing the Chilkat" (8).

As Ron stressed, "It's a hell of a long ways to go, and you ain't going for nothing." This story shows how important it was to lay claim over trading rights, and that it is conceivable Kohklux would mark his interior trading trail. Ron pointed to the high quality in style of the carvings, combined with the difficulty of carving spruce wood, as reasons to believe that the carvings had an important purpose: "That tells me a lot, it tells me that there is a lot of thought behind what those are for ... You want to blaze a trail, you blaze a trail, you know. Three chops of the axe tells you something too. There is more to that, it's establishing a trail."

Ron had suggested researching the Wolf clan's crest to see if the owl was a crest design associated with Kohklux: George Emmonds (1991, 117, 441) says that Shartrich was chief of the Wolf of Klukwan and the owl is a crest of the Wolf clan. This association of the owl crest with Kohklux reinforces the link between Kohklux and the carvings.

Chief Legaix commissioned one of his artists to mark his trading route as shown in figure 41. Barbeau and Benyon recorded a pre-contact oral history about the Legaix pictograph in 1952 from John Tate of Gispaxloats:

Suddenly a thought occurred to him [Legaix], and he called out his chief spokesman, 'Kawela, come here! I want to discuss with you something which I think very important. In Order to show to all my people and all the other Tsimshian that I control not only the Skeena River, but also the Nass, I am going to paint my picture on the sides of the cliff at Ktsiyamxl, now known as Ten Mile Point. This will show that I control this River, as well as knowing that I control the Nass.' ... When they got to the place where he had chosen to be the place to paint his picture, he and his men climbed to the top of the cliff, and getting a very strong wicker-like basket, they lowered the man down in the basket. When he was at the right spot, he began his paintings of a face which was to symbolize Legaix and the twelve copper shields, each of which had a name and were very valuable ... Then he spoke [at a later feast]. 'Chiefs, chiefs, and princes and chief women, and all the great spokesmen for the chiefs, and tribesmen of the chiefs! I have acquired greater power, now that my face is painted on the walls of the cliff which you will see as you go past (and he pointed to the cliff). This is to signify that I control these waters. Even though there are those among my own tribe who are

trying to overcome me and belittle me, I can still overcome them. This place will be known from now as 'The picture place of Legaix.' It also shows my wealth ... It is the name of this place to this day. Thus it was that Legaix overcame his enemies and put them to great shame (Barbeau and Benyon 1987, 64–5).

Marsden and Galois (1995, 172) mapped out Legaix's trading route prerogatives in the period of 1787–1830. He was a successful trader because "he controlled three of the four main routes by which interior furs reached the coast." They also say Chief Shakes controlled the fourth route, the Stikine River. Chief Kohklux controlled the area north of Chief Shakes' territory. Ron told me of how Chief Shakes scared Robert Campbell away after he fled from Kohklux at Fort Selkirk. These three chiefs controlled fur trading with the European traders by restricting European access from the coast and the eastern overland routes, and by establishing trade protocols with the interior peoples regarding their access to the European traders along the coast. The oral history story tells of a feast that Legaix held to settle the internal and external strife. He asked the chiefs to come and witness the rock painting and thereby agree to the control Legaix was asserting through the creation of the painting.

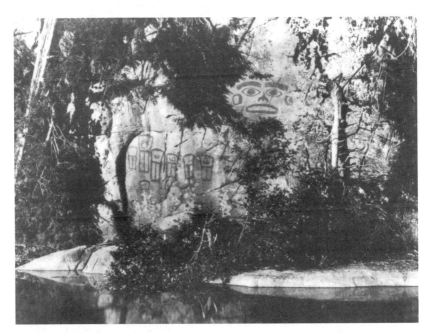

Figure 41. Tsimshian Chief Legaix's rock painting (courtesy of MCC/CMC, photograph no. 64381).

This story also supports Ron's theory that Kohklux was asserting his control of trails by carving trail markers on trees.

I know of a Gitxsan story, recorded by Barbeau and Benyon (1959a, n.p.), which exemplifies the creation of carvings to signify access and control. However, the access was restricted for more spiritual purposes.

Over towards the bridge [Kiskgas] at the other end, Meluleq had a carving of the Mawdzeks [eagle-like bird, sometimes called hawk], which he used as a charm. He, at that time, was a great halaeit [healer]. He made it a ruling that no woman was to go across the bridge when she was in her monthlies. And this was observed by all women ... At one time, a woman named Qaspegwilarhaitu, the Wolf-howls-about-at-random, forgot this rule and stepped across. Meluleq heard the voice of his Mawdzeks [charm] warning him. It was not possible for the others to hear it, but only for him. The one [Mawdzeks] on the opposite side also spoke to him, saying 'There is a woman in her monthlies going over the bridge.' He found out who was that woman, and they summoned her to his house ... There seems to have been two Mawdzeks carvings, one at each end of the suspension bridge.

It is not clear whether the guardian carvings were carved on a tree or on the bridge. However, this example is a good reminder of the spiritual nature of First Nations art. Legaix's and Kohklux's carvings may also be spiritual guardians of the trade routes, but there is no evidence that this is the case.

The Frederick Lake tree carving now resides in the Kluane National Park Interpretation Centre in Haines Junction. It was cut out of the tree around 1985. Ron stresses that people don't appreciate the carving in its current context: "What's poor about that, people come and look at, and say 'oh that's neat' and walk off. It's more that neat!" He believes tree art should be left in its intended context because "[i]t's something to see something in reality." I felt saddened by the sight of the Frederick Lake tree carving squeezed in between other displays at the centre. It was invisible because it didn't look like a *tree* carving – it was treated as a wooden artifact. Tree art is better understand in its intended viewing context, which, in this case, Ron provided through his verbal artistry.

The Blanshard River carving does not exist today. Ron feels it was removed or damaged when a bridge was built at the site in the 1950s. The first photographs that I saw of this carving (see figures 38 and 39) were in a set of photographs sent to me by Janet R. Klein. Frederica de Laguna (1995) remembered seeing a copy of Janet's photographs and gave me Janet's address. Janet kindly gave me permission to use the photographs from the Della Banks collection. Janet estimates that the photographs

were taken in 1944. The next photograph I discovered was taken about ten years later (see figure 40) in Julie Cruikshank's book entitled *Reading Voices* (1991, 97). These two sets of photographs provide a poignant look into the history of this arboroglyph. They show the intended viewing context (1944) and then the disturbed viewing context at the bridge site (circa 1954), just before the tree was removed or destroyed. The original image of the carved person looking across the snow-covered river through the old trees sparks images of the old ways, and of Kohklux passing by, as he heads up to Fort Selkirk to oust Robert Campbell. The second photograph instills a sense of nostalgic sorrow in me. We are lucky to be able to piece together the story of this carving; it deserves a respected place in First Nations history.

OTHER IMAGES OF THE YUKON

I was able to visit the sites of other tree carvings, or gain access to photographs of tree carvings because of the generous help of Mike McFadden, Willie Smarch, Larry Fault, and Sarah Gaunt. I know very little about these carvings, but an example in figure 42 is shared for your enjoyment. This image concludes our visit to the Yukon, and leads into our final destination, Manitoba.

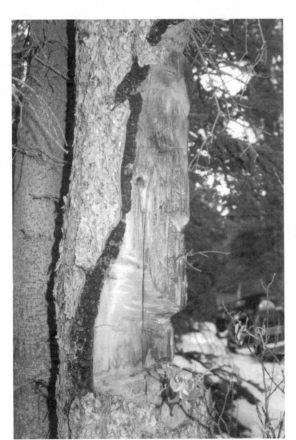

Figure 42. Tree carving in the Yukon (courtesy of Sarah Gaunt, per the Champagne and Aishihik First Nation).

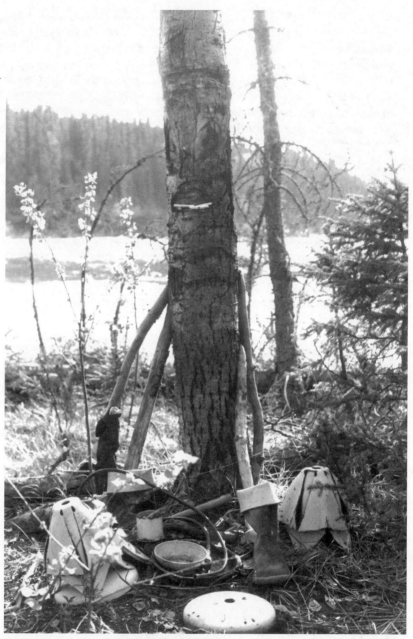

Figure 43. Tree carving offering site along the Churchill River, Manitoba
(courtesy of David Riddle, Manitoba Historic Resources Branch).

MANITOBA KAPUCHIHAGAN

This last stop is at Early Morning Rapids on the Churchill River, Manitoba. I want to complete our journey with an emphasis on the sacred nature of tree art. A face has been carved on a tree along the river's edge upstream of the rapids (see figure 43). David Riddle, an archaeologist with the Manitoba Historic Resources Branch, introduced me to this site (Borden number: Gj Lq-1) and forwarded a photograph and his explanation of the carving. "The reassessment of the site at Early Morning Rapids (Gj Lq-1) confirmed the presence of a Kapuchihagan, or 'Fart-Person,' being used by members of the Nelson House community. Here, near the head of the east side of the rapids, a zoomorphic figure has been carved into a tree. Such figures are votive objects, where gifts are placed to ensure safe passage past a dangerous rapid. Several hundred offerings, ranging from cigarettes to sparkplugs to coins, have been placed on and at the foot of the tree below the figure by travellers from Nelson House First Nation" (Riddle 1994, 9).

David also had the following comments: "In case it is hard to see [the photograph], the cigarettes are in his mouth with the eyes and nose cut into the poplar above the mouth. There is a deep band cut into the tree above the eyes. As you can see much of the stuff surrounding the base of the tree is junk. However, money, nails and other things are also present. From what Felix Spence, aged about 38, from Nelson House First Nation told me it's more the giving of a gift than its value that is important" (1995). Alexander Mackenzie observed painted figures on a rock in close vicinity to the Early Morning Rapids tree carving in the late 1700s. Offerings were also left at this site along the Churchill River: "At some distance from the silent rapid, is a narrow strait, where the Indians have painted red figures on the face of a rock, and where it was their custom formerly to make an offering of some of the articles which they had with them, on their way to and from Churchill" (Mackenzie 1970, 122).

The practice of making offerings to ensure safe passage at a site such as an arboroglyph or pictograph is a common practice for many First Nations. The Tsimshian made offerings of mountain goat fat by spreading it on the turbulent waters of rapids and whirlpools.

There were many abodes of monsters from the mouth of the Nass River right to the head, and the most feared was Skacol, which seemed to be angry at all times. When anybody approached, the water would seem to boil and the current was very treacherous and although the people always put much mountain goat fat upon these waters to appease the constant anger of this monster, many people would perish. Now there were other monster's abodes all along the Nass River, but these were not angry ones and they never caused any harm to the people and

were always pacified when given offerings of mountain goat kidney fat (Benyon 1987, 22, 66).

Weisel's 1951 account, recounted earlier in chapter 2, of the Flathead people's practice of making offerings at a medicine tree called the Ram's Horn tree is a similar example.

David Riddle (2001) shared another example of a Kapuchihagan located on Southern Indian Lake, Manitoba. The Manitoba Rock Cree carved faces in the trees along trails, at the farthest extent they wanted their children to wander from the camp or village. The parents would tell "scary" stories associated with thses carvings. These examples of offering sites show that they are common to many First Nations, and suggest that tree art may function as sacred offering sites. The Early Morning site is a good example of the practice, and it adds to the possible intended meanings of tree art. It also reinforces the importance of the intended viewing context, in this case one of the strongest rapids along the Churchill River, in order to interpret the intended meaning.

Alexander Mackenzie observed the practice of leaving offerings at a pictograph site in the 1700s, and today offerings are being left at the Early Morning site. This site demonstrates the continuity of practice to the present, the sacred nature of tree art, and its relationship to the First Nations landscape. And now we retire to the campfire to reflect on the experiences of the journey and the teachings of the Elders. The campfire has been a central focus for storytelling for endless generations. The flames twist and turn, dim and flare, and court the mind's eye to open the doors to many dimensions. The smoke curls and swirls from this world, through the smoke hole, to the world of the ancestors. What better place to reflect on the journey than the campfire?

Campfire Reflections on the Journey

As I gaze into the flickering flames of the campfire, I remember a Tsimshian pre-contact oral history about a man who carved a wooden image of his lost child. Boas gives the Tsimshian equivalent for a wooden image: "g·a'dEm ga'ng·ê"; his literal translation is the "person of wood." Note that this is very similar to the modern Git<u>x</u>san "Gyetim Gan." Boas recorded the story told by Moses and it begins when a young boy is taken by a star. The boy's father cried and sought help from a woman shaman. She told him the star had taken his son and tied him to the edge of the star's smoke hole; the son was consequently being burned by the sparks. A person gave the father the following advice:

'Carve a piece of wood so that it will look just like your child.' He gave to this person tobacco, red paint, and sling-stones in return for his advice. Then the person was very glad. The man made a figure of spruce, one of hemlock, one of balsam fir, and one of red cedar, and one of yellow cedar, all as large as his boy. Then he made a great fire. He built a pyre of slender trees, which he placed crosswise, and placed fire underneath. He hung his wooden images to a tree over the fire. He poked the fire, so that the sparks burned the body of the wooden figure. Then the latter cried aloud, but after a short time it stopped. Then he took it off, and took another one. It did the same. The figure stopped crying after a short time. He took it down. Then he tied the red cedar to the tree and poked the fire. There were very many sparks. The figure cried for a long time, and then stopped. He took it down and hung up the yellow cedar. It did not stop. Then he took the image of yellow cedar.

He went on, and came to a place where he heard a man splitting firewood with his wedge and hammer. His name was G·ix·sats'ä'ntx·. When he came near, he asked him, 'Where is the house?' At the same time he

gave him tobacco. Then G·ix·sats'ä'ntx· began to swell when he tasted
the tobacco. (the people of olden times called it 'being troubled.') He
also gave him red paint and sling-stones. Then G·ix·sats'ä'ntx· told him
where the child was. He said,'Wait in the woods until they are all asleep,
then go up to the roof of the house.' The man went, and when he came
nearer, he heard the voice of his boy, who was crying; but as soon as the
boy stopped, the chief ordered his men to poke the fire until many
sparks flew up. When all the people were asleep, the man went to the
roof of the house where the child was. The child recognized his father
and cried; but his father rebuked him, saying, 'Don't cry, don't cry!
They might hear you in the house.' The boy stopped and the man took
him off. In his place he tied the wooden image to the smoke hole. Then
he went down. Early in the morning the chief ordered his people to
poke the fire. The wooden image cried while the man and his son were
making their escape. But the wooden image did not cry long. Then it
stopped. The chief became suspicious, and sent a man to the roof. He
went up, and, behold, there was a stick. The boy was lost, and the
wooden image was on the roof. The chief said, 'Pursue them!' The peo-
ple did so. The man heard them approaching. When they were close
behind him, he threw tobacco, red paint, and sling-stones in their way.
The paint was red; the sling-stones were blue (1902, 86–93).

The story reminds us of the audience and sacred purpose of First
Nations art. The audience for the wooden image was the stars. The
father's purpose was to establish a sacred connection by carving an image
of his son so that he could ask the spirits for help in locating his son. Boas
(1970, 161–6) recorded a similar Tsimshian origin story about how a
chief instructs his six sons to find his lost daughter; she was taken by the
snail people. The sixth and youngest brother carved a spiritually power-
ful eagle with "a body of red cedar; the head, and also the tail, of white
pine; the legs and beak of yellow cedar; and the claws of mountain goat
horn." The brother put on the eagle form and flew down to the snail vil-
lage to get his sister. These stories also set the context for our reflections
on tree art, as we address questions such as what are the purposes of tree
art? Who is the audience? Why has tree art been so invisible to the colo-
nizer? How can tree art be protected? And why were faces a common
image carved in trees? I offer my reflections as a guide, as a forester, and
as an artist. As your guide I consider the insightful commentary given by
the Elders at the tree art sites, which added to the realm of tree art's pos-
sible intended meanings. Next, as a means to answering why tree art has
been hidden for so long, I discuss the concept of the First Nations land-
scape. I then ponder how a renewed appreciation of tree art and a desire
to protect it will change the path of the second journey of meaning for

tree art. As a forester I propose two principles of forest management from a First Nations perspective on ecology. Finally, as an artist, I reflect on tree art as a uniquely beautiful and meaningful art form.

REFLECTIONS ON THE ELDERS' COMMENTARY

The Elders, in sharing their knowledge regarding tree art and the First Nations landscape, have guided our appreciation and interpretation of tree art along a wise path. George, the hop pole carving, and Frank Malloway, the Stó:lö Elder, revealed the concept of the second journey of meaning, in which George inspires Elders to reflect on the hop picking era and to pass this history on to the next generation. The Stó:lö believe there is a living spirit in all belongings, materials, and tools made from trees. George Yutslick, who carved George, saw a living spirit in the knot of the hop pole: the pole was "living." This perspective expands the scientific notion of a "living" tree. For example, there is a story about "stump" who tricks We-gyet the trickster and eats all his food (*We-gyet* 1977, 58). George is a living marker recently blessed with a name. Frank introduced the concept of a marker as an informant or witness to the past.

While George has *become* a living marker, Art Wilson's carving was *created* to be a marker or memorial to the Sam Greene blockade. Doreen Jensen (1992, 17) calls this type of art "historical memory." Art Wilson hopes people will see his carving and ask questions about it and why it was created. The art form will help future generations access their history through the visual and verbal art forms. As an artist, he recommended finding clues to the meaning of tree art by carefully observing the creation, because "it will tell you something." Art's advice helped me to understand the Deep Canoe Creek carving with the feather, and the Kuldo carving with the cross.

Walter Blackwater, like Ron Chambers, was careful in his explanation of Gyetim Gan because he wanted to tell me only what he knew. He teaches, through his own cautious approach, the need to avoid speculation as much as possible because it may muddy the waters for the next generation – hence my emphasis on presenting the realm of possible meanings, and on differentiating between the intended meaning and the second journey of meaning. The realm of possible meanings is constructed recognizing the amorphous nature of visual art and Foucault's suggestion that text describing art has grey meaning. I prefer to add grey tones, or new possible meanings, because I want to promote discourse on tree art. Additionally, I want to avoid relying on textual taxonomic classification of tree art because this would create a false sense of clarity. Walter is careful to say that some carvings may have stories and are similar to crest poles while others may have just been carved by a trapper at a camp to pass time.

Walter knows and respects Sophia Mowatt's knowledge, but he had not witnessed the practice of carving faces in trees to attract the lynx as Sophia had. However, he had seen doll's heads carved and placed in a trap at the base of a tree to attract the lynx. Sophia is about twenty years older than Walter, and I believe the practice she describes probably pre-dates Walter's experience, as she is keenly aware of the transitional practices that emerged as a result of early European contact. We also saw that the Koyukon trappers also created images on trees to attract the lynx.

Both Walter and Neil Sterritt confirmed that Gyetim Gan could be found throughout Gitxsan territory. They are particularly abundant along what is now called the Telegraph Trail. The style of Gyetim Gan, as Walter points out, was consistent as well. Walter, Sophia, and Neil all independently referred to human faces carved in trees as Gyetim Gan (person in tree or wood). Neil Sterritt told us how his son Gordon carved a new face beside an old Gyetim Gan; the practice continues. Gordon carved his image while on a trip sponsored by the Gitxsan nation to retrace an important trail, and thus his Gyetim Gan is a historical marker for their trip. Art Wilson's carving contributes to Gitxsan historical memory by marking a successful blockade. The Gitxsan still create Gyetim Gan, although the reasons for the contemporary markers are varied and reflect the Gitxsan culture of today.

Nick Prince, with his vast experience as a Carrier trapper and historian, tied together numerous concepts. He offered a path of care and respect for the journey with his "the long way round is closer to home" story, while his story of the dugout canoe introduced the importance of perspective and how it influences the interpretation of meaning. He brought the canoe alive a second time by telling the story from the canoe's perspective as a living spirit, rather than from the perspective of the young boy making the canoe; the canoe inspired the verbal art. Next, Nick expanded the realm of possible intended meanings of tree art with three important possibilities: 1) a burial marker; 2) a meeting place camp marker and *axis mundi*; and 3) an apology to the lynx.[1] When the tree at a meeting place fell, the image was recarved on a nearby tree. The Carrier would even plant a tree beside the carved tree in anticipation of its eventual replacement, thereby ensuring that the art form was regenerated and the spirit lived on. This regenerative notion to art is foreign to Western culture: Western curators would never dream of repainting the Mona Lisa on new canvas. Here, the spirit of the art is more important than the manifestation. Nick was careful to limit his commentary to the Carrier, because he knew that others may have different interpretations. Thus, a link between the research and the First Nation of origin is established. Nick's commentary also reinforces the point that many First Nations created tree art, and this practice predates European contact.

Nick Prince and Walter Blackwater, as verbal artists, create vivid images of the First Nations landscape. Both of these men have traveled across their territory, its meeting place, dinner, and lunch camps since birth. The camps have been in the same spot for generations, so that trappers could avoid leaving their sign for the animals to discover. They both describe distances traveled in days rather than miles or kilometres. They know the names, in their own language, of the mountains, rivers, lakes, creeks, and of other families' territories. They know the oral history of the migration of their ancestors across the landscape.

Ron Chambers used his verbal artistic skills to create a rich sense of landscape. He eloquently led us across this landscape by describing it as trails that weave the villages together. The Tlingit marked their association with important trading trails to the interior. Ron described the political economy of the Tlingit and Tutchone people, and how the political connections were marked with tree carvings to reaffirm economic access for both trading parties to the exclusion of European traders, especially during the early phases of the fur trade. Tsimshian Chief Legaix marked his connections through pictographs in the same period. As an artist, Ron paints a picture of the role of the Tlingit artist as one of marking the landscape to communicate power and trading relationships. Ron had given a lot of thought to the meaning of the two tree carvings discussed. He knows the landscape, history, and art form, and yet he points out that his theory is only learned speculation in the end. After all, the artist, from another era, cannot explain the intended meaning of the carvings to us. I am, however, impressed with Ron's theory as an addition to the realm of possible intended meanings of tree art. Ron appreciated the art form and admired the artist. And, in the end, appreciating the beauty of tree art may be the most important experience of the journey.

What is a living tree? Frank Malloway, the Stó:lō Elder, told us the answer. It does not matter whether the tree is living in a biological sense. George was carved on a pole cut from a cedar tree, but the Stó:lō believe that George is alive. They consider him a living member of their community and have given him his name in a recent ceremony. Frank helped us think about the concept of living from a spiritual point of view rather than a scientific one. In Nick Prince's story of the dugout canoe, the Carrier canoe builders fed the cut log water and respected its spirit. The Gitxsan also feed a tree when it is cut to make a crest pole before they bring it to the village. The photograph of a watchmen pole, shown in figure 16, looks similar to a tree carving, but it is not carved in a living tree. Naturally, the question whether tree carvings are totem poles arises. The Gitxsan name for a tree carving is Gyetim Gan, and as Walter Blackwater points out there are similarities and differences between the Gyetim Gan and crest poles; both have a metonymic purpose. A question for further

research is whether there is a clear distinction between crest poles and tree carvings. I suspect they may be viewed as quite similar. Tree carvings created by the Dunne-Za and Carrier (see figures 32 and 35) could be considered a type of crest pole or totem pole. If this supposition were found to be true, through further study, it would dispel the common notion that "totem poles" were only created by the Northwest Coast First Nations (see Stewart [1990, 25–7] for a description of where each type of pole is typically found).

Nick told us how trappers would place animal carcasses facing the meeting place tree, and the spirits of these animals would go into the tree. The spirits in the meeting place tree were regenerated over time since the carving was recarved after the tree decayed. Nick also suggested that a trapper would carve a small face in a tree as an apology. The living spirit of the small face in the tree would communicate the trapper's regret for killing a lynx to other lynx. The Gitxsan pre-contact oral history of Mawdzek is another example of a living spirit in the form of a carving that communicated, this time with a human, when a taboo associated with crossing the bridge was violated. Chief George Desjarlais told us that the Dunne-Za people knew that the spirit of a deceased person was alive if the tree survived the effects of carving the deceased's guardian spirit in the tree. The Nisga'a refer to a "living tree" as a tree which has the living spirit of a man carved on it. One chief commissioned a carving of his face in a tree to enable his spirit to watch over his territory after he had died. The concept of a spirit entering a tree is related to the central question of Gitxsan reincarnation beliefs – what is the next incarnation of the living spirit after it leaves the dead body? Elders hold the answer to this question close to their heart.

Each Elder has his or her own reasons for sharing information on tree art. I asked Mary Thomas, a Secwepemc Elder who says she is "crowding eighty," why she shares her information. Here is her eloquent reply:

I guess it goes quite a ways back. For many years I guess I was kind of a lost person. I lost my identity when I was in the Kamloops residential school. For many years I walk with a low self-esteem, full of anger and hate and all the negative things of life. Somewhere along the way, having always hated my identity because that's all I knew, to be Indian was something to be ashamed of, you learned that you were not allowed to practice anything your Elders taught you. I know I wanted to be a white person. I was ashamed of my mother to walk up town with her. She was wearing her moccasins, I would walk way behind her or walk way up ahead and pretend I am not with this little old Indian with moccasins. I feel so bad about that. I even told my mother, and she said "I knew it, I knew it." And I would apologize, and feel so bad … We're stereotyped as being dirty and lazy. That's what I believed. Well it seems the more I studied, the more I wanted, like a hunger. All

of a sudden I was being fed and I was not getting enough. It changed me from a spiteful person. I hate my spirituality, God, I condemn him. Why did you create Indians, if we are that bad? Why did you? But when I really found the beauty of our culture, the strength, and I learned how to pray and use the spiritual strength to help me. It changed my whole life, and it started to change my family. Bonnie, my youngest, was just starting school, when my husband got himself killed with alcohol. You know my children just started like they were waking up. It was the culture that changed us around as a family. I tell my family, nobody owes us anything, we owe to ourselves. Let's get together as a family and go for it. I guess it is just a brief thing that brought me back to my culture. Today I have so much self-confidence. I am so concerned for the future of the young people, that I commit myself anywhere. Through the Okanagan university college, I do lectures. I work with some of the professors. Anywhere, when the forestry need me, yes I will come.

Yes, the Elders did come when I asked for their help; I respect it dearly. Their commentary and advice is invaluable because it marries the verbal art form with the visual, to create meaning and provide a First Nations perspective – a perspective that, within the context of tree art, evolved into the broader concept of the First Nations landscape.

A CURIOUS QUESTION

The concept of a First Nations landscape includes having new eyes for appreciating the viewing context for tree art, acknowledging the coexistence of the sacred and profane landscapes, and recognizing the effects of colonialism on First Nations people and their land. The discussion in this section addresses my deep curiosity regarding why so little is known about tree art, particularly in the colonial consciousness of British Columbia. I am drawn to the concept of the First Nations landscape over and over, regardless of my path of approach, because fundamentally, tree art is connected to the landscape, and it is simultaneously a profound expression of the physical and spiritual landscape. Tree art is a First Nations landscape marker and it symbolizes the relationship between people and the land.

When Rena Bolton, a Stó:lō Elder, advises younger generations to "go back into the history of your people to where your ancestors traveled on the River, and in the mountains" (Daly 1993, xv), she is suggesting travel across the First Nations landscape in order to understand the history of a people. The trees and forest, rocks and mountains, are part of the physical landscape, and oral history, Elder's teachings, crest poles, and tree art are forms of the verbal and visual arts that demonstrate that the physical landscape is sacred landscape. The sacred landscape can be the sky world or underground world, the salmon people's world or world of the squirrel

people. The sacred and profane landscapes combine, coexist, exist as one, and at other times are worlds apart. To have a First Nations perspective one should be familiar with the existence of both worlds; a shaman is one who has mastered travel between the two landscapes. The *axis mundi*, a ladder between the sacred and profane, can take many forms, including tree art, a hole in the sky, or a centre pole of a Sun Dance ground.

Eliade (1963, 30) noted the sacred often manifests itself in profane forms such as rocks and trees, yet the dichotomy or division into sacred and profane are part of Eliade's European perspective, not that of the First Nations viewer. Nothing is as it seems on the First Nations landscape. Barbeau's (1973, 198) second precept of the Gitxsan, as passed down to the Gitxsan from the Chief-of-the-Skies says: "The man who never seeks restraint shall never know endurance and fortitude; he shall never have visions of the spirit worlds, never grasp the dictates of unseen wisdom." In other words, those who do not prepare themselves spiritually will not see the "unseen wisdom." The First Nations landscape and tree art will not come into complete focus unless one has a First Nations perspective. D.W. Meinig (1979, 3), a geographer, says landscape is defined by our vision and interpreted by our mind. The interpretation of landscape is based on the viewer's cultural perspective, even as that cultural perspective changes: "Today's past is an accumulation of mankind's memories, seen through our own generation's particular perspectives. What we know of history differs from what actually happened not merely because evidence of past events has been lost or tampered with, or because the task of sifting through it is unending, but also because the changing present continually requires new interpretations of what has taken place" (Lowenthal 1979, 103).

Western definitions of cultural landscape stem from geographers such as Carl Sauer: "The works of man express themselves in cultural landscape. There may be a succession of these landscapes of cultures. They are derived in each case from natural landscape, man expressing his place in nature as a distinct agent of modification" (1963, 333). Elspeth Young (1992) developed Sauer's concept of a succession, or linear replacement of landscapes, into a concept of "layers" of landscapes. She (1992, 264–6) gives an excellent example of how a sand painting of a Yurnipirli waterhole, in Australia's Northern Territory, is interpreted as a Dreaming track, and then she overlays it upon a Western territorial map, showing how the Dreaming compares to the Western perception of the land. The sand painting shows significant trees, a camp, a waterhole, and animal and human tracks. Young's approach recognizes that no era of history subsumes the previous era: "The landscape also consists of 'layers,' reflecting historical processes which have resulted in its continuous transformation, and which stem from changing economic, political, cultural, and demo-

graphic factors affecting a particular society. Visible evidence for the exis-
tence of these factors may almost be non-existent, and hence people tend
to ignore their presence in the landscape" (255). The Western landscape
is layered upon the First Nations landscape, and both are defined by cul-
tural perspectives and vision. Young hints that the Australian Aboriginal
landscape is ignored and therefore remains unseen. In contrasting the
Aboriginal spiritual perspective with the Western economic perspective,
she concludes that "[a] major cosmological contrast concerns the per-
ceived relationship of people and land" (256). The First Nations land-
scape has become submerged below the capitalist landscape because the
colonizer's economic and political power has redefined the relationship
between people and the land.[2]

An example of how colonizers have redefined the First Nations land-
scape is Ron Chambers' story of how the name "Dalton Trail" came to
be: Dalton brought his horses over Chief Kohklux's trading trail; conse-
quently the trail was named the Dalton Trail. Ron is frustrated with this,
because he thinks that Kohklux went through "a hell of a lot more trou-
ble [than Dalton]" to establish and mark the trail with tree carvings. The
"Telegraph Trail" in Gitxsan territory and the Nuxalk-Carrier grease
trail, now named the Alexander Mackenzie Grease Trail, are further
examples of First Nations trails being renamed. First Nations people are
concerned that more recognition is being given to white explorers rather
than to First Nations history (Birchwater 1993, 2), and that First Nations
history is being erased from the maps and minds of subsequent users.

First Nations place names help define First Nations peoples' relation-
ship to the land.[3] James Henderson (1995, 202) refers to naming the land
in the indigenous language as *langscape*: " ... it reveals human attitudes
and perceptions in language or *paysage interieur* (the langscape of the
mind)." For example, place names such as "where the rivers meet," "lake
of many beavers," "where the ancestors tied the canoe to the mountain in
the flood," or "Painted Goat Mountain" were created to reflect the phys-
ical and sacred landscape: "Often, place names were not just labels but
descriptions of features that would enable travellers to orient themselves.
The mountain now known as the Three Guardsmen is called Nanda
duiyakhache in Tlingit – 'facing North the wind is to your back'" (Yukon
Historical and Museums Association 1995, 25).[4] *Tribal Boundaries in the
Nass Watershed* (Sterritt et al. 1998, 295) provides some good examples
of Gitanyow and Gitxsan place names.[5]

Anda'gansgotsinak: like an anthill or clitoris
Anxhorn: where eat/salmon
Anxts'imilixnaagets: where eaten/ beaver/ wolverine
Gwinganik: where /jack pine [*Pinus contorta*] pitch mountain
T'amansingekw: where get swans

T'amgwinsqox: lake/ place/ where fording
Sga'nisimgohl: mountain of flint
Sgan'nisimluulak: mountain of ghosts
Adami<u>x</u>w: where to mark seasons mountain [e.g. when the last snow
 leaves a certain peak]
Galdoo'o (village of Kuldoe): out of the way place
Gitanmaaxs (village of Hazelton): people/ where use/ torch lights
 [to fish]
Maxhlabiluustmaaxws: up over where like / stars/ on snow [sparkle]
T'amganaxdigwawaxw: lake of bloodsuckers
Xsa'anxt'imi'it: water/ where get/ kinnikinnik berry

Early explorers relied on the First Nations people as guides in a foreign land.[6] A passage in Alexander Mackenzie's journal describes a meeting with a Native person near Alexandria who drew a map showing a route to the ocean. "I now proceeded to request the native, whom I had particularly selected, to commence his information, by drawing a sketch of the country upon a large piece of bark, and he immediately entered on the work, frequently appealing to, and sometimes asking the advice of, those around him ... These people describe the distance across the country as very short to the Western Ocean ... It occupied them, they said, no more than six nights, to go to where they meet the people who barter iron, brass, copper, beads, &c. with them, for dressed leather, and beaver, bear, lynx, fox, and marten skins" (Mackenzie 1970, 319–20). Yi-Fu Tuan (1991, 688), a cultural geographer, shows how European explorers presumed the right to name geographical features in lands they "discovered," thereby obscuring First Nations place names. The imported colonial language was projected onto the "alien" aboriginal landscape which was, in Henderson's words, "a way for the colonial mind to create a comforting reality" (1995, 204). Tuan refers to naming geographical features as a creative power to impart a certain character to the landscape. Present-day British Columbian topographical maps hardly refer to First Nations place names or trails, and consequently the First Nations landscape is submerged below the colonial landscape.[7] The Inuit in Nunavut are reclaiming their traditional place names, sanctioned by the territorial government.

Until recently, as cultural geographer Philip Wagner (1994, 5) points out, archaeologists and anthropologists have neglected the cultural landscape aspect of their study sites.[8] Consequently, there is a paucity of knowledge regarding the First Nations landscape, as exemplified by the invisibility of tree art in archaeological and anthropological discourse. These fields have historically had a "McKenna-McBride" resolution or perspective of the landscape. The McKenna-McBride Royal Commission traveled throughout British Columbia from 1913 to 1916, redetermining the number and size of the Indian reserves (Duff 1980, 68).[9] My perception of their process

is that they drew small boxes on a map around the location where they found Indians, regardless of whether they were at their summer, winter, fishing, trapping, or hunting camp. These small boxes, called reserves, reduced the First Nations landscape. The commissioners did not understand the extent to which First Nations people traveled through and modified the landscape. More importantly, they had no concept of the sacred landscape. Anthropologists and archaeologists have unconsciously adopted this narrow perspective of the First Nations landscape as centred on the reserve or village site, and thus they have had little exposure to the broader First Nations landscape, and have rarely encountered tree art.

It was a revelation for me to discover how extensive are the signs of First Nations travel and use in the forest, as I learned to interpret the First Nations landscape while searching for tree art. A "land without history" came into focus as a landscape rich in history: I began to notice the deeply trodden trails and the trees scarred from bark harvesting, camps, deadfall traps, and tree art. I learned to look and see the "unseen." I learned that First Nations travelers followed ridge tops, hogsbacks, and trails that linked lakes and paralleled watercourses. Trails may also go to spiritual sites on mountaintops where vision quests occur and medicine plants were gathered. Ernest Hyzims, a Gitxsan Elder, describes the trailscape as an ancient connection, marked with blazes, between the village and the land: "We follow the trail, blazes notched out on the trees by our grandfathers and follow the trails to our trapping grounds, hunting grounds, berry patches. As a rule, if someone got lost on the trail, they would break twigs to show which way they went, they didn't notch out trees as not to scare away the animals" (1983, 13). Trailscape, then, is the system of trails that connects camps, villages, traplines, and trading partners, including the associated camps, markers, traps, food gathering sites, and water crossings. MacDonald and Cove (1987, xii-xvii), Sage Birchwater (1993, 3, 13), and *The Kohklux Map* (Yukon Historical and Museums Association 1995, 15) all describe Tsimshian/Gitxsan, Carrier/Nuxalk, and Tlingit/Tsoshone trail systems. Birchwater (1993, 24) quotes a Carrier Elder as saying, "Them old people had trails all over the place ... People lived all over."

Richard Nelson, one of the few anthropologists to study the First Nations landscape, describes how the Alaskan Kutchin peoples mark their trailscape.

Trails are often very easy to follow because they are clearly defined corridors through dense vegetation. In some areas, however, it is hard to find a trail in untracked snow without some kind of markers. In open spruce forests, for example, the trees are blazed at frequent intervals by chopping a narrow strip of bark from a tree trunk, leaving a white mark which is easily seen. Markers are very important at places where a trail opens onto a River, Lake, slough, or meadow,

where travellers may have difficulty finding the trail's opening when they reach the other side. Large blazes are used here if there are big trees at the trail's edge, but the margins of Lakes and meadows are often fringed with scrub, so instead of making blazes the Indians often hang something like a tin can or shred of cloth in the brush (1986, 183).

Ernest Hyzims stated that if lost, a traveller would break twigs to show the direction of travel along a trail. Alexander Mackenzie observed route markers called "lopsticks" in northern Canada. The highest tree along a stream or lake would be cleared of branches until only a tuft remained. The lower branches were lopped off, sometimes leaving only one or two to mark directions at turns in the trail. The trunk may also have had a name inscribed of the person who made it (Calverley n.d.[b], 4–5). Mackenzie observed a "number of trees branched to the top in several places," to direct travelers near winter quarters near the Mackenzie River delta (Mackenzie 1970, 198, 205). "Lopstick" trees may have also been used as convenient message trees.

Dorthea Calverley (n.d.[a], 4) observed that "[t]oday many of these old [Indian] trails are the routes of our railways, highways, and forestry roads." Road engineers doubtless found the First Nations trails convenient routes across the landscape. Tree art symbolizes a lack of awareness by the dominant culture of the First Nations landscape which still exists, pocketed by clearcuts, roads, and utility corridors. Tree art marks the remnants of the trailscape, reminding us of another layer of history and perception. The signs are still there to be interpreted by younger generations. Elders who have lived on the First Nations landscape are still keenly aware of the physical and spiritual places and the associated histories.

There are two reasons, then, discovered thus far as to why tree art has remained relatively invisible. First, the process of colonialization has submerged the First Nations landscape below the Western capitalist landscape. Additionally, the Western perception of the First Nations landscape is that of narrow parcels of land. Second, to see the unseen, one must be willing to see the First Nations perspective, which can bring the First Nations landscape into focus as the intended viewing context for tree art.

The colonial landscape, layered upon the First Nations landscape and langscape, has transformed and submerged the intended viewing context into a viewing context for the second journey of meaning for tree art.

THE SECOND JOURNEY

We return once again to the medicine cross described by Hugh Brody (1988). Joseph Patsah's father established a medicine cross on a tree to seek spiritual support for the family's new-found territory. Brody tells of

his pilgrimage many years later to see the medicine cross: "The importance of the cross permeated everything that he and others had been trying to explain about their feelings for and use of the land ... In fact, the cross had rotted at its base and fallen back to lean, precarious and dilapidated, into the pines that surrounded it ... It would be quite easy to pass the cross, unnoticing, so nearly did it merge with the woodland around ... Once noticed, however, its presence could be felt" (107–8). He knew that a logging road was scheduled to be built, and "[i]t would probably follow the trail that led us from the camp to the cross." Moreover, because the cross was so inconspicuous, it "would all too easily be bulldozed into the ragged brush piles that lie alongside new roads on the frontier." As they left, one of the Beaver members in the party remarked "Sometime we better put up a new cross. That one's getting old now."

We have also witnessed the Kuldo Gyetim Gan looking across the road at the new clearcut only metres away (figures 28 and 30), and the destruction of the Tumbler Ridge tree carving (figures 35 and 36). Doubtless many examples of tree art have ended up in brush piles, or the sawmill. Even recently the Golden Spruce, a tree sacred to the Haida Nation and the residents of the Queen Charlottes, was cut down with a chainsaw by a transient. The sitka spruce tree was over 300 years old and it produced golden, rather than green, needles because of a rare genetic mutation. According to Haida oral history the tree is a boy named K'iid K'iyaas who took root as a tree when he disobeyed his grandfather's warning not to look behind him as he fled a violent snowstorm. A Haida Elder referred to the felling of the tree by saying "It was the killing of a person" (Gram 1997, A1, 6). A similarly tragic crime occurred in 1964 when a doctoral student named Donald Currey cut down a 4,950-year-old bristlecone pine which was named "Prometheus." Prometheus lived on Wheeler Peak near Nevada's border with Utah. Altman (1994, 186–7) tells a story of how the arrival of St Joseph to Glastonbury England was commemorated by planting two oak trees which came to be known as Gog and Magog. These sacred trees were the last remaining trees in an ancient Druidic grove, and they were both cut down in 1906. The smaller of the trees, Magog, was over 2,000 years old. These blatant examples of disrespect, in addition to the ones we encountered on our journey, saddens me greatly. Should tree art be protected? And, if so, how should it be protected? Cultural geographer David Lowenthal offers some interesting discussion relevant to these questions.

Lowenthal's protection paradox says that "[t]o realize that something stems from the past is actively to alter it" (1979, 109). He recognizes the need for "reminders of our heritage in our memory, our literature, and our landscapes" (125), although efforts to preserve artifacts and landscapes will affect the nature of the past by altering its meaning (124). Thus the

preservation and appreciation of tree art, which results in its modification, is the second journey of meaning. Preservation includes three types of activity: 1) recognition and celebration, 2) maintenance and preservation, and 3) enrichment and enhancement (109). Tree art must be protected, but it cannot be protected without altering its intended meaning.

1) Recognition and Celebration

Tree art should be recognized and celebrated. Tree art can teach us about its intended viewing context – the First Nations landscape – and its meaning. I debated whether or not I should publicize the existence of tree art because I was afraid of what may happen to the remaining examples once people became more aware of it. However, awareness of tree art should be increased for two reasons. First, the younger generations of First Nations people should have access to the knowledge the Elders shared with me about tree art. Ron Chambers commented on this point:[10] "Oh somebody will come along and see [tree art] and say 'Oh that's that,' 'Oh is that right,' you know all of a sudden they knew but didn't know to say. And there it is now you know. That's the other part of why you need that [information] out, because people can say, 'Oh yeah,' somebody will know, but nobody asked. You didn't know that they know, so you did not ask, it goes on like that" (Chambers 1995). Awareness of tree art may motivate younger generations to ask their Elders if they know of any other examples and their meaning. Consequently, this generation may be able to save the old examples of tree art and continue its practice if they so desire.

Second, sharing this information may increase the awareness of archaeologists, anthropologists, and forestry workers. These people are responsible for conducting and managing cultural and heritage site inventory. Consequently, they must be aware of tree art in order to identify it and protect it from logging. First Nations people should be responsible for locating tree art by interviewing their Elders, especially those Elders who know the landscape and trailscape well, such as trappers, hunters, and gatherers of medicine, berries, and other forest foods. Additionally, the concept of a "Culturally Modified Tree" should be expanded to the more general one of "Trees of Aboriginal Interest," since some sacred and medicinal trees are not modified – for example, the Haida Nation's Golden Spruce.

2) Protection and Maintenance

Tree art can be found throughout British Columbia, the Yukon, and Manitoba. Tree art may be found in other places in British Columbia than have been described in this book, such as near Mount Currie, Usk (near Terrrace), the Monkman Pass (Rocky Mountains), and Lillooet. For instance, Philip Drucker apparently photographed a rudimentary face carved in a

tree located on an island in the Quaal River near Hartley Bay. Tree art can be difficult to see because the tree scar may partially or entirely cover the image. Neverthelss, archaeologists and professional foresters have an ethical responsibility to become aware of tree art and its prevalence. Additionally, in British Columbia they have a legal responsibility under the Heritage Conservation Act and the Forest Practices Code of British Columbia Act to identify and protect tree art from logging or other forms of destructive development. I encourage these professionals to learn about tree art and the First Nations landscape.

The date when a tree carving was created can be established by using tree ring dating (dendrochronology). These methods were not used in this study because I had not secured permission from the appropriate First Nations. (I hope to determine the date of tree carvings in the Gitxsan territory.) Hicks (1976, 3) describes the tree ring dating procedure from an archaeological perspective: "Dendrochronology, in most archaeological areas where it is practiced, involves the construction of tree-ring chronologies through crossdating. Crossdating hinges on the presence of relatively small rings, compared to their neighbours, resulting from water deprivation to the tree in a given year. These patterns in a series of rings, constitutes a distinctive 'signature' that can then be matched to the other like patterns in older wood. The process allows wood that has no reference to a cutting date to be dated by the cutting date of other trees." Study of cut stumps, removal of "cookie" wedges, or, preferably, collecting increment core samples are the main methods of collecting tree ring samples (Stryd 1997, 99–107). Toolmarks evident on the tree can also indicate the approximate period of the modification. A blunt, curved cut, as compared to a straight, sharp, and deep cut in the wood may indicate the use of a stone axe rather than a metal tool. Stone, bone, and shell tools were commonly used until the mid to late nineteenth century on the coast of British Columbia, for instance (Stryd 1997, 11). Section 6(2)(d) and (g) of the Heritage Conservation Act automatically protects trees that were culturally modified prior to 1846. This arbitrary date is used because it was the year that Britain and the United States signed the Oregon Boundary Treaty establishing Vancouver Island and land north of the forty-ninth parallel as British territory. A culturally modified tree, defined by the act, is a tree which shows evidence of traditional First Nations use such as bark stripping for baskets and plank removal for houses. Stryd (1997, 113) points out that "[i]n addition to comprising an archaeological resource, a CMT may constitute evidence regarding the practise of an aboriginal right."[11] If a post-1846 CMT is removed during a development activity it may preclude the continuance of modern cultural practice or, even more seriously, remove evidence of past practice. CMT's have cultural and legal significance regardless of the date they are created. Boundary

or burial marker CMT's have particular significance for researching, proving, or asserting aboriginal title, as defined by the Supreme Court of Canada's 1997 Delgamuukw decision. Yet protection appropriate to the special nature of tree art does not exist in the legislation of British Columbia.

Ron Chambers adamantly says tree art should be left *in situ*, where it's created. It should not be cut from the tree and put on exhibit. I agree with Ron because the intended viewing context is so important to the intended meaning of tree art. Gordon Grimwade (1992, 78) discusses a method to create latex moulds of the carved image using liquid latex. Three coats of latex are applied, and then a final coat of fiberglass. Castings are made back in the workshop. No damage is done to the tree and the viewing context is preserved.

By preserving the tree art, the site's full meaning and significance is preserved. The Carrier preserved the significance of meeting places over a long period of time by regenerating the site's marker, a tree carving. They planned for the eventual decay of a tree carving: Nick Prince said that the Carrier would plant a new tree beside the meeting place tree carving in anticipation of the tree rotting and falling. We also observed a tree carving at Deep Canoe Creek that was recarved after the scar grew over the original carving. Some First Nations people, such as the Carrier, have regenerated trees to replace the decaying meeting place tree carving, for instance, and therefore it seems appropriate to continue the practice for future generations.

The Forest Practices Code of British Columbia Act and Heritage Conservation Act together have provisions for the preservation of cultural heritage resources such as tree art. A requirement of the Forest Practices Code is that a forest company must do an archaeological assessment to determine if there are any cultural heritage resources, as defined in the Heritage Conservation Act, that could be detrimentally affected by a proposed logging plan. Section 51 of the Code also protects cultural heritage resources even after a logging plan is approved. If a person who carries out a forest practice, such as harvesting, finds an unidentified resource such as an arboroglyph, for example, they must modify or stop that practice in the immediate vicinity and promptly advise the Ministry of Forests. The effectiveness of this provision, however, relies on the ability of the logger to recognize an archaeological site. Tree art requires more protection than is provided for under these acts because of its cultural importance and its rarity.

Additional protection of tree art and its intended viewing context could be accomplished by designating a cultural reserve around tree art sites, which can be done through a number of mechanisms. For instance, the Ministry of Forests can recommend that ecological reserves be designated under the Land Act around unique or rare forest ecosystems. The Min-

istry of Forests forest district manager could similarly designate the area around a culturally significant site as a "sensitive area" under section 5 of the Code because the argument can be made that the area should be treated differently from adjacent lands. Another protective measure is available under section 6 of the Code whereby the chief forester could designate the site as an "interpretive forest site." A ten-hectare area surrounding the tree art would be the minimum size necessary to protect the art and the important forest viewing context. Trail corridor reserves (250 metres wide) would also be appropriate, since tree art usually exists along trails and at camp sites.

3) Enhancement and Enrichment
I would advise against the enhancement or enrichment of tree art sites into tourist attractions. In fact many First Nations believe that some sacred sites, such as burial grounds, are dangerous for the visitor. Bad luck or death may fall upon the intruder. The forest context should be left untouched and low impact trails and signage should be used. Great care should be taken to preserve the intended viewing context. Awareness of tree art could be enhanced through other means such as publications or multimedia presentations, which are less intrusive to the site.

A FORESTER'S REFLECTIONS

What have I learned, as a professional forester, from the faces in the forest? While I was studying to be a forester at university, I learned that a forest is a community of ecosystems. This interconnected web of life is complex and dynamic. Forest ecosystem types are classified by identifying segments of the landscape that have relatively uniform climate, soil, vegetation, animals, and microorganisms. The ecosystem can be a small grove of trees or a large watershed, depending on the life forms of interest. Components of the ecosystem are categorized into biotic (e.g. trees, animals, and insects) and abiotic (e.g. rocks, soil, and atmosphere). Forestry professionals are gradually coming to understand how the forest relates to the landscape and neighbouring ecosystems. Changes in light, water quality and quantity, and soil fertility affect forest communities. University training, however, did not educate me to maintain balance and harmony in the sacred forest, or to integrate Traditional Ecological Knowledge (TEK) into current forest management practices. Consequently, I propose a planning framework for forest management based on two practical forest management principles and derived from First Nations epistemology, for integration into forestry curriculum and practices. Together the planning framework and the principles they incorporate form a First Nations sustainable survival plan.[12] The planning framework is comprised of three

types of units. The first two are introduced in the discussion of *principle one: respect and restraint,* and the third is described, along with TEK, in *principle two: balance and harmony.* The units are summarized below from the highest to lowest level of planning scope, under the principle they support.

PRINCIPLE ONE: RESPECT AND RESTRAINT

1) Forest Management Zones establish the primary management objective for the forest land base, and they are rooted in the sustainability interests of the public and First Nations;
2) Sustainable Management Planning Units are relatively small harvest planning units designated within the Forest Management Zones, which conform to the Traditional Ecological Landscape (TEL), local socio-economic objectives, and to the environmental landscape; and

PRINCIPLE TWO: BALANCE AND HARMONY

3) Forest Land Flow Categories are categories of forest land used to analyse the net flow of land within a Sustainable Management Planning Unit, and these categories include old growth, medicinal plant reserves, sensitive watersheds, riparian areas (around or on a river bank), barren cutover areas, and plantations. By establishing these categories the chief forester could measure whether balance is being achieved within a Sustainable Management Planning Unit.

PRINCIPLE ONE: RESPECT AND RESTRAINT

Respect all life forms by not wasting their gifts. The Chief-of-the-Skies (Sun) handed down this first principle that the Gitxsan should live by. The Chief-of-the-Skies says, according to Barbeau (1928, 198–9): "The Sun is your father and the Sky his abode. Life is his seed and growth his daily concern. Beware lest you spoil his work and mar the beauty of his creation. Never laugh tauntingly to his face, for you owe respect to him. Else you court your own doom; else, you conjure the downfall of your tribe and its final dispersion in the wastes of the wilderness." All life forms have lives not unlike our own. Human beings must seek restraint in their use of the planet and its resources by seriously embracing principles such as sustainable consumption. The Independent Commission on Populations and Quality of Life recommended sustainable consumption when the world's population reached the 6 billion mark. We must use goods and services in moderation to improve our quality of life, minimize the use of natural resources, and reduce toxic emissions as recommended by Maria Pintasilgo et al. (1996, 51). Chief Manuel Louie of the Syilx (Okanagan) nation spoke in the 1940s to provincial government officials; they had gathered to reconcile broken promises of providing irrigation water for his people.

He is reported, by Jack Thorp (1995, 17), to have described what was happening to the land as follows: "Before white man came to our land, our land was like a woman who had given birth to a child. First, Americans came along and drained one of her breasts. Then the English came along and drained the other breast. We Indians are her child. Our Mother Earth has nothing left for us. You have taken it all away."

We are over-harvesting the forests in British Columbia, and in many other places in the world.[13] Smith and Lee (2000, 54) state that British Columbia is exceeding long-term sustainable harvest levels by 11 million cubic metres per year, or 18.5 per cent. Drushka (2000, 47) suggests that a 30 per cent reduction in current harvest levels may be needed in British Columbia to ensure a long-term sustainable level of harvest. Unfortunately, problems associated with an excessive rate of harvest overshadow some of British Columbia's successful forest practices, such as aggressive reforestation, detailed ecosystem classification, and the protection of wildlife trees. Tragically, the concern about over-harvesting our forests is not new. The poet Wilfred Campbell warned Canadians about deforestation in the early twentieth century:

It must be admitted that we, as a people, have not been as true as we should have been to the vast and priceless trust which fate and nature have given into our hands, as the possessors of so much natural wealth. We, in common with all inhabitants of new countries, have been sadly wasteful of our forests, which as a people, we were unfit not only to possess but to control. It would have been well for Canada if, fifty years ago, someone had warned the people of the terrible destruction of timber all over the country, and we had had statesmen to make laws to restrict this destruction (1907, 9–10).

We have about forty years of experience in modern forestry in this vast and varied province; since it takes an average eighty to one hundred years to re-establish a forest, we still have a lot to learn. The practice of forestry, as opposed to forest harvesting, started in British Columbia during the 1960s when reforestation started in a significant way. Harvesting and fire suppression were the main practices prior to 1960. The chief forester in British Columbia manages the level of timber harvested by determining the Allowable Annual Cut (AAC) in cubic metres per year.[14] Setting the AAC is a judgment call, not a calculation. Computer models forecast hundreds of years into the future. The chief forester uses these results along with an assessment of the intangible social needs of other resource users (e.g. recreational) to determine the AAC. The current process is based on the assumption that we are confident in the efficacy of our management interventions and that we can predict their results a century into the future. However, recent forest research is revealing

interconnected relationships in the forest soil that may call into doubt some current management practices.

J.P. Kimmins (n.d., 10), a highly respected Canadian ecologist, says, "One of the greatest lacks in the training of foresters (and ecologists) is in the area of soil science. Serious damage has been done, and is still being done to forests' soils around the world ... Although this is by no means true everywhere, the number of examples of damage to the physical, chemical, and biological characteristics of the basic forest resource, the soil, is shamefully high." For example, doubts have been expressed about our understanding of how chemicals and nutrients are exchanged within an ecosystem and the trees themselves. Our lack of understanding may be contributing to the mortality of planted trees (Kronzucker et al. 1997, 59). Trevor Goward and André Arsenault (2000) discovered a connection between *Populus*, conifers, and cyanolichens. Conifer bark is enriched by the rainwater that drips off the leaves of the *Populus* species from the canopy above. The bark enrichment process creates a substrate on the conifer bark for the cyanolichen to grow. Cyanolichen, which are nitrogen fixers, then indirectly enrich the soil. Rainwater is the intermediary for this connection. Goward and Arsenault say this inter-relationship "can be expected to have significant [biodiversity and productivity] implications for silvicultural practices in many forest ecosystems" (36). Connections between trees of different species, created by the common mycelium of soil mycorrhizal fungi, were discovered by Simard et al. (1997) who found a "tightly linked plant-fungus-soil system," which prompted forest managers to change their impression of paper birch (*Betula papyrifera*), once thought of as a "weed" species. Douglas fir seedlings are in a reciprocal relationship with paper birch since there is a net positive transfer of nutrients between each other through the soil mycorrhizal fungi network (Simard et al. 1997, 581). The network allows water to transport the nutrients across species gradients. These emerging studies on how boreal and temperate forest ecosystems function, and on complex climate change issues, suggest that we should place more constraints on deforestation (Pintasilgo et al. 1996, 36).

We cannot, therefore, place high confidence on our assumptions about the effect of our interventions until we have gone through at least one rotation of growing a forest. British Columbia is responsible for about 6.5 per cent of the world's harvest of timber (Bartlett 1996, 112). The AAC in British Columbia is currently set at about 72 million cubic metres per year, although the actual volume cut can vary from the target by as much as 10 per cent per year. This volume is equivalent to about 1.9 million truckloads of logs or 196,000 hectares of harvested forest land.[15] The harvest level in Canada ranges between 800,000 and 1,000,000 hectares a year. About 2.1 million hectares (10 per cent) of available forest land is

harvested each decade in British Columbia (Bartlett 1996, 10). I recall flying over the forests surrounding Mackenzie, a community in northern B.C., and seeing the large continuous cutover areas which stretched to the horizon; my gut feeling, at that moment, was "this rate of harvest cannot be sustainable."

Forest Management Zones

I propose the first and highest level planning unit on the forest landscape be the Forest Management Zone (FMZ), which is intended to reflect the primary land management objective. These objectives are a reflection of my attempt to integrate aboriginal values with those of the dominant society. There would be three FMZ's: 1) water reserve zones; 2) silviculture zones; and 3) arboriculture zones. Sustainable management planning units, the second type of planning unit, which are discussed later, would be established within these zones. The forest landscape in which FMZ's are created is defined here as publicly owned forest land (or working forest) that is not protected in parks or ecological reserves. As I discuss each zone, I incorporate the valuable insight into the sacred and profane relationships in a forest ecosystem from the First Nations.

Water Reserve Zone The primary objective of the water reserve zone is to protect water and soil quality. Water, not timber, is the primary product. Water "symbolizes the whole of potentiality; it is *fons et origio*, the source of all possible existence ... water symbolizes the primal substance from which all forms come and to which they will return either by their own regression or in cataclysm. It existed at the beginning and returns at the end of every cosmic or historic cycle; it will always exist, though never alone, for water is always germinative, containing the potentiality of all forms in their unbroken unity" (Eliade 1963, 188). Many First Nations creation oral history cycles begin when there was just water on earth – it is the primal substance.[16] For instance, Syilx Elder Harry Robinson (1989, 31) says: "God made the sun ... Then after that and he could see. All Water. Nothing but water. No trees. No nothing but sun way up high in the sky." Coyote created earth by diving into the water to get a grain of dirt, which expanded into earth as we know it today. The Gitxsan creation oral tradition speaks of the flood, which describes how a people were brought by flood to live in their traditional territory. For instance, there is a mountain top, in Geel's house territory, named "where the canoe landed during the flood." On the other hand, the legendary world of Hopi origins lay deep below the surface of earth.[17]

The Hopi Indians of northeastern Arizona are an epitome of human endurance: they are farmers without water. According to their genesis narrative, the Hopi

emerged from a layer under the earth into this, the fourth, world by climbing up inside a reed. On their arrival, they met a deity, Maasaw, who presented them with a philosophy of life based on three elements: maize seeds, a planting stick and a gourd full of water ... Wikoro, the gourd filled with water, represented the environment – the land and all its life forms – as well as the sign of the creator's blessing (Whiteley and Masayesva 1998, 10).

Water is the element from which all else came, and it is therefore the primary substance within the interconnected web of life; it is the centre of the web, rather than being a component among equals. Elders Mary Thomas and Mary Louie both stress the importance of water in the interview transcripts below.

MARY LOUIE (Syilx): Water is the biggest part of all our lives, without it we'd never survive. So when you go to the water and you talk to that water, that water helps you. But you have to come from the heart with it, with your words. If you go to the water early in the morning and get into it before anybody's up or around, that water will strengthen you because your spirit cries for that water, not just your shower or your tub water, it's tired of the hot water, it wants cold water (Louie 2000).[18]

MARY THOMAS (Secwepemc): You can't live without water, your body is over two-thirds fluid. And how can you survive without water – everything needs water. That's the biggest belief that our people had. Water is something they really wanted to protect because that's where they get their food, their daily living like the fish, all kinds of fish ... Without the water we can't survive. And I can remember our Elders talking about it. Therefore when we're weighted down with a lot of grief, your life is becoming unmanageable, or you're going through a lot of pain, the first thing our grandmother and my aunt and my mother would say, "Go to the water." Water is powerful and yet it can be so gentle. You can see that when there's a big washout, the water can bring down boulders and big huge trees. It can move anything – a whole mountainside. And yet if you sit by a little brook, which I often did when I had a home up at Mabel Lake, I can feel that – I experience all what my Elders taught me – I personally experience it. And you think of that water, you wonder where is it coming from – will it ever empty? Where is it going – will it ever fill up? The wonders of Mother Nature's gifts. And while I'm sitting there, I'm thinking, meditating and I pray. What has gotten me down so bad? And then I think I could hear my grandmother's voice saying go to the water. Water is powerful. You couldn't go in that little creek, it was so small, just a little brook, gurgling along. I'd sit at the edge of it and

just put my hands in it and I could hear the little birds singing around me, the same tune they've sang forever since Creator put them on this earth. The little squirrels chirping, they're all wondering what am I doing here? It makes me feel that I was connected to them. The pure life they were living, and why am I feeling the way I am. I wash my hands in the brook and then I sponge bath in it. That was something that our grandparents, our parents taught us. You wash and then you take a big drink, drink, drink, drink a lot of it. I'll be honest when I come away, turn around to come home from there, I feel as if I've left a ton of weight back there. I feel better, I feel light, and that's the same thing with a sweat lodge (Thomas 2000).

I witnessed, in the most dramatic way, a Nlaka'pamux Elder's concern over water and what is happening to Mother Earth. At the age of eighty-six, Mildred (Millie) Michell agreed to my request for an interview on the importance of water to our lives. She was a highly respected and knowledgeable Elder in her nation. I arrived with my colleagues Joyce Sam, Art Sam, and Rhonda McAllister, at Millie's home, house #1 (Siska Indian Reserve #3, British Columbia), on 2 October 2000. We introduced ourselves, made our tea, and then Millie began to speak to me, through Art Sam, the interpreter, in her own language about the importance of water. His dialogue summary, shown below, is included here in its entirety out of respect for Millie's knowledge and as a record of her last words.

Millie began to talk about the 1935 snowfall, wherein there was no traffic or train movement for three weeks due to the abundance of snow from the mountaintop to the river bottom. Millie lost one of her relatives during the snowfall, while trying to remove the snow, on his third attempt, along the highway. Millie said the snow was so abundant, that there were no landform distinctions, such as the highway or railway lines. Millie also talked about the last flood in B.C. during 1948. Bridges, roads were washed away, again, crippling traffic and railway lines. Millie pointed to the mountain, she said that everything from the top of the mountain, and down to the river bottom relied on "water," including people. Every life form, from the tiniest bug to the fish that lived in the water. When animals get sick, they require water, when people take medicine, they require water.

Millie grew up with knowing and using her traditional teachings about respecting water. She was taught, by her grandparents and parents, to respect everything, which we do not teach our children today. In her childhood, they had to pack water for bathing, drinking, cooking, and making tea. When Art told Millie that you [the author] were going to write about water, Millie glanced over to you and Rhonda, and she asked, "Are they going to fix it?" She meant that, as you children, were you going to fix what is happening to the earth? Millie continued talking about respecting the water, in the form of cleansing yourself. Everyday she

prayed to the water, rocks, air, and trees. When people went hunting, water was used for praying and cleansing one's mind, body, and spirit. People used to talk to the deer just before shooting, to let the deer know why you were taking him and to thank him for being taken. Every part of the animal was used, nothing was wasted. Nowadays we just shop at the supermarket. Millie also talked how people used to go out to get their own clothing in the mountains, such as gathering bark, roots, and mosses. All the clothing, right down to your feet were gathered or hunted for. Today we have different material, and don't practice this anymore – people don't know how. Millie also talked about water in seasons.

- Springtime brought lots of water; it was also a time for new birth. In May, were the first thunders of the year. A time that was important for the deer and other animals. It indicated to the people that it was close to giving new birth for the deer and animals depended on the water.
- Summertime made things grow. Water flowed, but also evaporated. Water went underground or filtered down into the earth and came out at a creek, earth has its own filtering system, which was in place before our time.
- Fall was the season of fog. Warm air and cool air are circulating. This was the storage season. Putting away our garden in cellars.
- Wintertime was the season to sit down. The earth is sleeping. This is the time to fix your clothing, patchwork or making buckskin clothing.

Millie talked about pollution. Diesel disturbs the earth. Fumes that come from the machines: where does it settle? Where do these bugs come from that are killing the trees? Millie also talked about the land. There are too many gates, with no-trespassing signs. A long time ago, people used trees as markers or boundaries. Everyone knew where these boundaries were. Each place had a name. Everyone knew where these places were. Today they call it "Crownland."

Throughout, Millie questioned the weather pattern. She was very concerned about the weather change around the world. Examples were too little snow, what's going to happen? Thunder used to be in May, and now it thunders in December as well. Millie also talked about how artesian water or underground water was so important to villages.

Logging in the watershed [Millie pointed behind Siska, to the coast range mountains, which tower above her house], has caused streams to disappear; when trees are removed water disappears underground or dries up. At this point, Millie said, *"My heart is sad, why do they do this to us?"*

At that moment her body began to shake, and she fell back into her chair. She had suffered a massive stroke and she died four hours later in the Lytton hospital. Her sons told us that Millie's deceased husband and son had visited her in her dreams several times, calling her to join them. On the night before our visit, they both came to her, all dressed up, and that was the first time on their visits that they came in that form. She said, "Not now; her mission on earth was not complete until she met with us." After

my shock and sadness, I wondered what was the lesson I should learn.

Water was very important to Millie; it was important to her that children were taught to respect water. She was very concerned about the water drying up, about pollution, and about the changes in the weather's annual cycle. Millie, Mary Louie, and Mary Thomas all emphasized the importance of groundwater. They believe that trees and vegetation act as water pumps; the trees pump water from the ground and store it in the forest. Mary Thomas spoke earlier about her experiment with collecting sap from the birch tree and her amazement at how many gallons of sap went up the tree each day. Continuing with her discussion of sap, she shares her view below of why creeks dry up, as it relates to spacing (removing competing commercial tree species) and brushing (removing competing "weed" species) tree plantations.

So we pulled the spigot out [of the tree], we mudpacked it to stop it from dripping, to let it heal itself. You know what ... I just kept thinking where on earth did my people a long time ago know this? When that sap comes down, it goes in the ground and other plants feed from it. There is so much sap there, [in a place with lots of brush], no wonder the creeks were filled up. There was a certain amount of fluid going into the creeks, it had to come out somewhere and build up our creeks. So when they [loggers] cut everything out, and what got me started on that was when Gary and them were tree spacing I'd go up there with them up towards ... I can't remember that place they were tree spacing ... they were cutting everything out! Everything! Just the little trees that were planted [were left]. And that's what got me started thinking, why are they doing that? I could hear my Elders speaking about how much sap there is in those trees they're cutting. And why are our creeks drying up?

David Schindler (1998, 157–60) discusses the negative effects of global warming on boreal forests; some of these effects include declining water levels in the boreal wetlands (e.g. marsh, bog, or muskeg), reduced streamflow of headwater streams, and increased residence time of water in lakes resulting in increased concentrations of chemicals. The Elders believe logging can impair or disable the ability of a forest to pump, store, and enrich groundwater.[19] Mother Earth filters the water as it is pumped. On wet (hygric) sites, the water table may rise after harvesting because the water is no longer stored in trees, and instead it pools on the already saturated soil.[20] On dry (xeric/mesic) sites, the water table may fall after harvesting since the trees can no longer pump and store the scarce water, and the evaporation rate may also increase because of higher soil temperatures. As the Elders say, "the water goes back down – it dries up."[21] Millie was very conscious and respectful of groundwater movement, the annual hydrologic cycle, and the importance of water to all life forms. Millie had

a spiritual connection to the land; additionally, Millie's life, her physical being, was also directly connected to the water and mountains overlooking her house. When harvesting occurred there it affected her; her physical health was affected by the health of the ecosystem.

A healthy ecosystem is one in which water of sufficient quality and quantity is delivered in a functional rhythm. Water is essential for the existence of life, and "[a]lmost every plant process is affected directly or indirectly by the water supply," more than any other single environmental factor (Kramer 1983, 1–2). In some cases the ecological health of a forest watershed can only be maintained by minimizing significant human interventions such as harvesting.[22] Ecosystem integrity is defined by the *Vision for Water and Nature* project "as the range of interactions between the water cycle, individual species and biophysical, chemical and ecological processes that support the organization of an ecosystem." They suggest that the ecological health or integrity of freshwater ecosystems can be preserved by maintaining "the hydrological characteristics of catchments, including the natural flow regime, the connection between upstream and downstream sections (including coastal and marine zones), the linkages between groundwater and surface waters, and the close coupling between the rivers and floodplains" (World Conservation Union 2000, 50). Ecosystems such as upper catchment cloud forests, springs, and certain wetlands directly provide us with clean water, and help regulate flooding and basic ecosystem functions. These types of ecosystems would be included in the water reserve zone to protect the integrity of the ecosystems; remember, Elders believe water is the heart of the ecological web and that this "life blood" should flow uninterrupted throughout the strands of the web.

Forest land already designated as community drinking water basins would be included in this zone. However, the objective is to also protect the soil and water for non-human water needs, such as for fish and wildlife. Timber would be harvested in the water reserve zone only to reduce the incidence of pest and disease or to raise capital to invest in the rehabilitation of the watershed.[23] The forest inventory in the water reserve zones should not be included in the AAC determination. Botanical forest products such as mushrooms, berries, and medicinal plants could be harvested. Livestock grazing would not be permitted because their waste can contaminate the water supply. Recreation would be limited to low impact uses such as hiking.

Silviculture Zone The production of high quality wood for value-added products, high grade building materials, and secondary products such as botanical forest products would be the primary objective in silviculture zones. This type of zone would cover the highest proportion of the forest landscape. The ecological objective in the silviculture zone would be to

maintain or restore the forest ecosystem function and structure to a perpetual and self-sufficient dynamic equilibrium, including maintaining or restoring the functional rhythm of water (adapted from "Le specie forestali" 1981, 497–9). The goal of the forest manager should be to return a harvested site to its pre-disturbance ecological condition (Kimmins 1987, 480). Silviculture would integrate TEK into the practice of forestry. For example, clean water is a crucial component of the ecosystem for aboriginal people. They place great importance on preserving riparian and wetland (e.g. streamside and still-water pond) ecosystems.[24] Thus the no-harvesting buffers on riparian and wetland ecosystems should be increased (probably to a minimum of 100 metres) in silviculture zones. Springs are also of great importance since they provide very pure water for medicinal plants, are used for making medicinal tinctures, and are a source of great spiritual power (Louie 2000). Mary Thomas (2000) explains, below, the importance of springs for small mammals.

According to the Elders a long time ago, they looked after the environment. They always said that we should keep the springs the way they are because that is the home of our little creatures. There are porcupines, slow-moving creatures that cannot go all the way down to the river or the lake, and go all the way back to their feeding ground. They always said that Mother Nature is so good that she looked after her own. And that's why these little springs erupted where little animals that are slow-moving would have their share of the water. That was their understanding between Mother Nature's creation, not every animal could make it all the way down to the river and the lake, cause they're slow-moving. Maybe a deer can do that, a bear can do that, but you take little porcupines and the small creatures which are just as important to the environment and to the living of our people, that they respected them. That's why these little springs were put there for these little creatures to use as their drinking hole. That's what my understanding the old people used to talk about. I can remember when the little Dry Lake up there ... started drying up and we used to take mom up there. She was up in her seventies, she'd stand there with her cane and really look and she would say, Ohhhhh, what's happening, is that water ever going to come back again like it used to be?

Springs were also important water sources for sweat lodges and villages. There is an ancient St'at'imc pithouse village, for instance, located northwest of Lillooet, high above the Fraser River; it is located right beside a series of spring-fed pools which probably supplied the village with drinking water. Springs should be protected by 100-metre buffers because of their ecological and cultural importance.[25] The net harvestable landbase would therefore decrease, and the area of forest affected by logging would be reduced in this zone. First Nations Elders are also concerned about the effects of cattle grazing on soil quality and on their medicinal plants.

Grazing would be limited in silviculture zones to reduce soil compaction in sensitive ecosystems, and livestock would be closely monitored to ensure their fecal matter does not contaminate the water in streams, lakes, and wetlands. Recreation use would be the most intense in this zone.

Aboriculture Zone The primary objective of the arboriculture zone is to produce wood fibre as fast as possible to address wood supply objectives within economic and ecological constraints. Arboricultural products could include pulp, chips, and lower grade building materials such as studs. The rate of harvest in this zone would be higher than that in the silviculture zone. The government could set aside a small percentage of the productive forest land base for this primary use. It could also provide incentives for private landowners to convert marginal agricultural land into arboricultural land. Faster-growing exotic tree species could be planted. Recreation, range, and botanical forest product uses would be considered only if they did not affect the wood fibre productivity.

The combined effect of creating these three zones would be to lower by at least 30 per cent the current AAC to a long-term sustainable level, and to significantly reduce the forest area impacted by logging. The public, as owners of the forest land, would also have a clear understanding of the land management objectives. Additionally, this model incorporates First Nations input, lacking in the current public input process, into the creation of the zones and their ongoing management. Using this model we could maintain our quality of life and minimize the negative effects on the ecosystem. There must be a practical balance between establishing fast-growing species to address future wood supply problems and maintaining harmony and balance. A lower rate of harvesting in silviculture zones would help alleviate First Nations fear that their territory is going to be destroyed by logging.

 Terry Glavin (1996, 146) discusses the First Nations concern over the rate of logging in their territory. He tells of how the Chilcotin Elders linked unexplained tragic deaths of their people to the deteriorating health of the land, and "they'd point out from time to time that in the Chilcotin, you couldn't just change the way things had always been done without there being some consequences. For many things, if something wasn't done just the right way, death could result." Chief Roger Jimmy of the Klùskus band said he could tally the number of Indians who would die a violent death that year by adding up the miles of new logging roads into the country. Glavin counted more than 200 fully loaded logging trucks rumbling past Chilcotin Indian reserves every day. And yet unemployment rates on these reserves often exceeded 80 per cent.

 Before introducing the second sustainable planning unit type, I would

like to share Elder Mary Thomas's advice, which helped me with its design. I asked Mary how we could manage our forests in the future.

MICHAEL: What would you tell people working in the forest to do in the future?

MARY THOMAS: [She laughs] I would strangle them first. [She laughs and remembers a story about the time Bob, a Forest Service employee, cut her birch trees down]. I really believe we are too late. Why ask us now? There has to be a lot of understanding taken from our Elders who are disappearing too fast. Once we are gone, forget it. Like they were chopping down all our natural foods. It was not only us who takes of that food. The little birds and chipmunks, who cannot speak for themselves. Why are the bears and cougars coming into the cities? They are not looking after our forests, they are destroying; destroying for the sake of the almighty dollar. Whoever has the most money will be the so-called winners, but in the end they will have to come down to our level. The only thing I can say is let's create an understanding about survival between our people. And I talk to my family like that. Be concerned about each other as aboriginal people and study what little Mother Nature has left. Take it from there and try to survive. They should clamp down on the big corporations. Aboriginal people and not only them, but also everyday people must come to some kind of a happy medium in order to look after what we have left. At the rate I see logging trucks, day and night, day and night, I don't know where they are taking them. There used to be logs on those trucks, but now they have little logs. What do you call it, Frank? [Her husband laughs and says, "They call them pecker-poles." We all had a good laugh.]

Survival is Mary's goal for the future: "How do you survive? Especially now in this dog-eat-dog world, you have to believe in something." Mary thanks the Great Spirit every morning for allowing her to survive a new day. Or maybe the answer is written on the stone sitting amongst Mary's baskets, shawls, and carvings in her living room: "never, never, give up."

Sustainable Management Planning Units
In light of Mary's advice, I propose the second step towards determining a sustainable AAC, which is to reduce the size of the harvesting planning units. In British Columbia, for example, the target harvesting level is set for very large harvest planning units called Timber Supply Areas (TSA) and Tree Farm Licenses. There are seventy of these units, each representing, on average, about 160 square kilometres (100 square miles). Their boundaries are administrative rather than ecological or social in nature. The

Forest Service completed its most recent review of the AAC in 1996, and it resulted in a paltry 0.5 per cent decrease in the AAC for the province. The AAC should be set for smaller Sustainable Management Planning Units (SMPU) because there are risks of overcutting small watersheds and of severe overuse in local forests within the larger units. The overcutting risk is present because the awareness of over-harvesting in local watersheds, within the larger harvest-planning analysis units, is watered down statistically. Thus, the analysis should narrow in scope into small sustainable management planning units, rather than focusing on large economic units such as a TSA. Once the beaver leave a valley or the medicine plants dry up it is very hard to restore them to the local watershed, even if a long-run supply of timber is maintained in the larger TSA. Local ecosystem and social needs, including the needs of First Nations, can be sustained more effectively on smaller ecologically based planning units; TSA boundaries do not take such needs into account. The ultimate long-term environmental goal for these units should be to protect the quality and quantity of water and soil.

PRINCIPLE TWO: BALANCE AND HARMONY

Achieving harmony and balance through respect and giving back is the second principle of this planning framework for forest management. A Gitxsan chief has the responsibility of protecting the First Nations landscape for future generations by controlling the nox nox spirits represented by greed and pride so they do not disrupt the balance and harmony. We must show respect to the spirit-selves of the animals and trees if we want to achieve harmony with the spirit world.[26] Otherwise the spirit world will retaliate. Carrier First Nation Elders warn of prophecies that say we have only one more chance to show respect to our world; the spirit powers will not fix this world again. Mary Louie (2000) suggests that offerings to water are a sign of respect: "It bothers me because our water is going down; it's disappearing because it's not being respected. People won't offer gifts to the water anymore you know, they don't take food to it, or tobacco. All they're used to, is just taking and taking and taking, they don't know how to give back. They've never learned to balance things."

Forestry professionals must realize their responsibility to achieve harmony and balance as they care for this world. The advice and council of First Nations leaders can be invaluable. The distrust between forest managers and Elders must be overcome to produce viable cooperative management: forestry professionals need to recognize that they can benefit from listening to the wisdom of the Elders and from integrating First Nations knowledge, epistemology, and values into current practices. Witnesses of the past, such as tree art, can also aid forestry professionals in seeing the forest with new eyes, and a sacred gaze.

The growing concern by peoples the world over about the lack of harmony and balance in our land management has resulted in a convergence of thinking. The concepts rooted in Traditional Ecological Knowledge (TEK), the Deep Ecology movement, and the Gaia hypothesis all share a common desire to focus on achieving harmony with the sacred aspects of the earth. Additionally, the goal of sustainable development and consumption is to try to achieve a balanced use of Mother Earth's gifts.

TEK represents *a particular First Nations cumulative and evolving body of knowledge, attained over long periods of time, of the sacred and secular relationships between living beings in a variety of ecosystem types* (adapted from Doubleday [1993, 41], Berkes [1999, 8], and Kimmins [1987, 25–7]). All cultures have their own distinctive body of traditional ecological knowledge since they each live in a unique community of ecosystems. The degree of similarities and differences to their neighbour's body of knowledge depends on cultural and ecological factors. A Syilx (Okanagan) Elder, Herb Manuel (1999), shares an example below of his TEK. He described to me how the collection of cambium from the lodgepole pine (*Pinus contorta*) (eight to twelve inches in diameter) varied throughout the season. It was collected from April to late June for food and medicinal purposes. The selection of candidate trees was based on the relationship between the sun and the tree: the tree required a certain amount of heat from the sun before the sap could start flowing. So, cambium would be collected in the early spring in the valley bottoms on the southeast side of the tree. The cambium collectors would follow the receding snow up into the mountains to collect the fresh cambium as spring progressed. As spring turned into summer, the valley bottom cambium had hardened from the sun, so the collectors would look for trees in the depth of higher elevation forests and collect the cambium on the tree's north sides. The cambium had to be of a certain quality so the collectors went to different areas and collected on different parts of the trees depending on the time of year. Herb also explained he preferred the cambium from lodgepole pine trees that grew alongside aspen.[27]

The epistemology of TEK involves two interlocking ways of knowing. First, there is the intimate experiential knowledge of the relationships between humans and all components of the environment, including water, plants, animals, birds, fish, rocks and minerals, the cosmos, and other spirits such as the ones in the upper and lower worlds.[28] This knowledge includes where and when life forms can be located on the landscape; how they can provide sustenance, medicines, and technology, and fulfill spiritual needs for humans; how non-human life forms relate with each other; how to take only what is needed; what to give back as thanks; and the origin stories of life forms such as coyote or raven. For example, "The Widow and Her Daughter" story mentioned at the end of chapter 2 is

an origin story that reveals the traditional ecological knowledge of the devil's club. Henderson (1995, 219) eloquently summarizes aboriginal spatial relations to the land: "The sharing of space, then, is the meaning for all of Aboriginal life. The relations contained in those spaces shape both choice and placement and ultimately group life. Aboriginal people do not speak of living "there"; rather, each family or person "belongs" to the space. Belonging, then, is directly tied both linguistically and experimentally to a space as well as to shared knowledge of a series of common places. Belonging to a space is more than just living in a place or using its resources; it is attendant with benefits and obligations. Belonging is viewed as a special responsibility."

Second, there is the intimate experiential knowledge of the temporal changes in the relationships between humans and all forms of life. Aboriginal space is never at rest, yet it adapts to flux and is refined by eternal ceremony (Henderson 1995, 219). The Tsimshian calendar, for instance, describes each month of the year in terms of what significant events are occurring, such as the arrival of the first spring salmon.[29] This seasonal round illustrates the cycle of time for collecting plants, fishing, or hunting in appropriate locations. Coincidentally, Teit (1900, 239) reports, along with the Indian names for lunar months, that "[t]he Indians could tell the solstices to within a day by the position of the sun in relation to certain trees or other marks on the mountains. There were trees in certain places, with stones to sit on near them, to which they frequently repaired to observe the sun when they believed it to be near the solstice." There are several bow-forked or twisted trees in the St'at'imc area. The bow-forked trees are reported to be either solstice markers or directional markers for the trails (figure 44a). The bow could have been created by girdling the trunk and then twisting the forks back towards the centre by tying willow or rope to them (Serack 2000). The bow created by the fork in the tree acts like a gun sight or compass sight. The Haisla people (near Kitamat, B.C.) marked summer and winter solstice with a "prominent tree. The distance separating these two points was divided according to the season when certain foods could be obtained" (Robinson 1961, 45).

Much longer time scales are involved with human relations relating to water, rocks, minerals, and the elements of the cosmos such as the moon. There are cycles of life with different time scales for each relationship in the community. The seasonal round is based on the TEK of where and when a particular need can be fulfilled. There are a few defining distinctions between TEK and Western science's notion of the ecosystem:

- TEK is based on the lived experience and teachings of ancestors who relied on reciprocal relationships with all beings to survive, and who learned by doing for many generations. Western science relies on facts

7 m

Trail

Top: Figure 44a. St'at'imc trail marker north of Lillooet, B.C.

Bottom: Figure 44b. St'at'imc knotted tree trail marker northwest of Lillooet, B.C.

1 m

derived from a reductionist process; TEK focuses on maintaining harmonious relationships, whereas science focuses on the cause of the effect.

- There is no dichotomy in TEK between biota and abiota; there are no non-living elements to the community – all are living – as our earlier lesson with George showed us. For instance Elders like Mary Thomas and Mary Louie believe that water is alive – a component of the biota, and the heart of the web of life or ecosystem. As Mary Thomas (2000) explains: "How can you separate it? It's just like the human being, you can't live without water, and you can't live without food. It's all like a circle; everything depends on each other. And if you're talking about trees, you definitely have to have water. You can't depend on the mountain to survive if you take everything [trees] out of there because there will be no water left to speak of to rejuvenate the mountain, it's impossible. If they cannot understand it, my god, let's get rid of the universities and get little old ladies like me!" However, Western science's definition of an ecosystem does not explicitly include water: "In the geographical context, a forest ecosystem is a segment of landscape that is relatively uniform climate, soil, plants, animals, and micro-organisms … The biotic community of a site is composed of a combination of plants (vegetation), animals, and microorganisms, each of which forms its own community" (Klinka et al. 1989, 4). It seems that ecologists do not include water in the definition of livings things. They assume that pure water is abiotic, a component of the physical world. Berkes (1999, 9) suggests that "there is no separation between native and culture … nature is imbued with sacredness."

- TEK is directly linked to a specific land base; it has spatial boundaries that are multidimensional. Earth, the skyworld, and underworlds form the ecological landscape. The experiences on the ecological landscape are directly encoded in the indigenous language and symbolic literacy (Henderson 1995, 225).

Thus, the concept of Traditional Ecological Landscape (TEL) is introduced and defined here as *a multidimensional (spatial and temporal) landscape and langscape in which the indigenous culture holds a body of TEK, based on the lived experience of previous generations, about the interrelationships between humans and the local water, animals, plants, rocks, and cosmos.*[30] This ecological space creates our consciousness: "Aboriginal consciousness is more an emotional response to a place that acknowledges the ability of the forces in a space to move the soul. A consciousness that honours processes and relationships rather than fixed rules, leads to an understanding and acceptance of the inter-related relationships and expressive energies and experiences. This generative order is the source of Aboriginal Law" (Henderson 1995, 196, 221). A rock in the TEL may in fact be the transformation of a powerful medicine man, rather than an

inert lifeless fixture of the geological substrate. A raven may be the transformation of a powerful spirit from the skyworld, rather than an avian species of the animal community. The distinction between *Homo sapiens*, other animals, and spirits is blurred on the TEL; the cloak of the spirit changes. The health of the spiritual relationship between the human and animal spirits will affect the function of the TEL. The TEL is complex, with more spatial and temporal dimensions than in the purely physical Western-defined ecosystem. First Nations have names, in their own languages, for every mountain, river, lake, and meeting place on the TEL. They also have names for each lunar month and life form. And, as discussed earlier, the names usually reflect a key characteristic of the mountain (e.g. "where the canoe landed in the great flood"), plant (e.g. trembling aspen [*Populus tremuloides*] is known as "howling leaf" in some First Nations languages), or month (e.g. "arrival of the spring salmon month"). Thus TEL also includes the concept of traditional ecological langscape. The indigenous languages have place names, plant names, and calendar names that give tone and texture to the TEL. Language ties First Nations culture to their land.

First Nations need to be able to document and map their Elder's TEK and TEL using their indigenous language.[31] Cooperative research with governments and third party interest groups can improve non-First Nations awareness of the TEL, and improved awareness can lead to cooperative management engagement. However, First Nations are usually afraid of allowing access to sacred knowledge because of past experiences with unscrupulous researchers and government representatives. First Nations prefer to control how the information is collected and accessed. As Chief Robert Wavey (1993, 16), of Fox Lake First Nation in Manitoba, warns, "There is no question that increased access to traditional ecological knowledge will allow non-indigenous managers a means of refining and focusing environmental regulation and management. However I am concerned that science-based management approaches will use the improved ecological database not to focus on development-related ecological impacts, but to impose additional regulations and restrictions on the resource uses of indigenous peoples." The goal of cooperative management should be to share information and ideas for the benefit of all, and ultimately to ensure harmony and balance.

Traditional ecological knowledge is similar to the Deep Ecology movement that has its roots in First Nations cosmology. Both movements enshrine the principle that all life on earth is interconnected and humans must learn how to be in tune with its rhythms.

"Gaia" is the Greek word for Earth, and it also symbolizes another philosophical movement that began in the 1960s. James Lovelock's book *Gaia, A New Look at Life on Earth* reintroduced the sacred nature of the

scientific study of earth. He postulated that Earth is a self-regulating liv-
ing entity, not a lump of rock, which consciously regulates its biosphere.
His hypothesis has matured since the 1960s into a theory "that views the
evolution of the biota and of their material environment as a single tight-
coupled process, with self regulation of climate and chemistry as an emer-
gent property ... In no way do organisms 'adapt' to a dead world deter-
mined by physics and chemistry alone. They live with a world that is the
breath and bones of their ancestors ..." (1991, 30). Forest managers can
learn from such perspectives as a means towards achieving balance.

One way of achieving balance is by *giving back* to the land. For instance,
Carrier Elders leave tobacco when they harvest medicines from the forest.
Interior Salish people leave grains for the mouse in exchange for the "Indian
potatoes" (western springbeauty or *Claytonia lancelota*) the mouse has col-
lected.[32] The Carrier definition of conservation is demonstrated in Nick's
story of how their hunters would talk only about the animals they left
during the hunt, not about those they killed. Hunters were taught how to
maintain a sustainable moose population for future generations.

Our Common Future (1987), the report of the World Commission on
Environment and Development, introduced the concept of sustainable
development.[33] The report raised concerns about global issues such as deser-
tification, deforestation at the approximate rate of 10 million hectares a
year, the deterioration of air quality, and overpopulation (Kimmins n.d., 9).
Forests represent 27 per cent of the global land area, and thus the health
of the forests has a great impact on the health of our environment (Bartlett
1996, 103). David Runnals (1990, 4) provides clarity around the concept
of sustainable development, which has now become a cliché, by suggesting
that the merging of economic and environmental decision-making is the
most important principle. Runnals uses the analogy of a bank account to
explain: "This merging of environment and economics requires that we
treat the world's renewable resources as capital and that we attempt to live
off the interest of that capital, rather than constantly running down the
principal as statistics tell us we are now doing. This recent principle of sus-
tainability will require accounting of ecological capital in a country's bal-
ance sheet." This model shifts the focus away from accounting for what we
take from the forest to maintaining the ecological balance over the long
term. The status and health of the forest land base is described, rather than
simply the amount of timber harvested.

Practically this means we must accurately monitor the ecological and
spiritual health of our forests. Indicators are needed that help the public
understand the outcome of our actions (Pintasilgo et al. 1996, 87). A bal-
ance sheet could be created for each ecosystem, with categories such as
old growth; second growth; medicinal plant reserves; recreational sites;
plantations; newly logged and barren cut-over areas; riparian areas around

lakes and streams; and community watersheds. We can measure the balance for each Forest Land Flow Category (FLFC) by comparing the reduction of area and quality to the additions in area and improvements in ecosystem's quality. Jeanette Armstrong, a Syilx philosopher, defines balance as "a way of describing how change, which is the natural outcome of any creative process, can be brought about by humans in a deliberate mutually beneficial pattern as an enrichment process rather than one which is competitive and therefore as a destructive force" (Cardinal and Armstrong 1991, 18).

Statistics, such as that 253 million tree seedlings were planted in British Columbia during 1994, are meaningful only if presented in the context of how they affect the balance. There should be no net difference over a ten-year period in important categories such as old-growth forests and community watersheds. Hopefully there is a positive balance in categories such as recreational sites. An illustration of this method would be that if we planted trees on a recent clearcut, it would reduce the amount of area in the barren cutover category, and increase the area in the plantation category. But we should then account for any reductions in plantation area due to mortality caused by pests, for example. Eventually the plantations will grow, thereby increasing the area in the second-growth category. Likewise, the second-growth forest will eventually take on old-growth characteristics. We should only harvest the old-growth at a rate less than or equal to the rate at which the second-growth forest takes on old-growth characteristics. The net change in area for each category is the primary indicator of balance.

To further illustrate this flow concept, imagine a paper cup filled with water: the water represents the forest land area in the second-growth forest category. Now a small hole is punched in the bottom of the cup and water starts to leak out. The leak represents the rate at which second-growth forest is harvested, alienated for other purposes, or destroyed by fire and pests. Water can be added at the same rate it is leaking out, to achieve a sustained level. In this case balance would be achieved by adding more land to the second-growth category by increasing the rate of growth in the young plantations through thinning and fertilization, and allowing them to grow into second-growth forests faster. The land flow method focuses on monitoring the net flow of land from each forest land type so the public can easily understand what is happening on the forest land base, and to ensure that balance and harmony are being achieved. Various categories could be used to analyse net flows in each SMPU to monitor the balance.[34] The chief forester could be mandated to monitor the net flows, and to suggest adjustments in practices, including harvesting, which would restore balance – to ensure we give back as much as we take. Monitoring provides a feedback loop to assess the success of forest management.

The AAC determination would evolve into determining targets for net changes in forest land categories, which are regularly refined as monitoring provides information on forest management results. For instance, harvesting would be balanced with reforestation, second-growth forest growth rates with old-growth harvesting, and alienation of forest land with rehabilitation.

RENEWING COMMITMENT

Our current planning framework needs to incorporate First Nations land ethic principles such as respect for the land, taking only what we need, giving back, and seeking to maintain balance and harmony. Some of the practical concepts suggested here, to manage within these principles, exist in current planning processes. However, a renewed commitment to these principles by forestry practitioners is required. I suspect that most foresters initially chose forestry as a career in part because of a spiritual connection to the forest. This connection needs to be continually renewed and celebrated; First Nations can help re-establish this connection to the sacred forest.[35] Mary Louie emphasizes the importance of a "giving back" ceremony: we should give back in thanks for the water's gifts to us, for instance. She feels the water is becoming angry with humans because they do not recognize its gifts. Mary says a gift of food, tobacco, or coins, along with a simple thank you, can help renew our commitment to showing respect to the water and Mother Earth (Louie 2000).

Commitment can also be renewed through reverence, which means in part the ability to appreciate or see the familiar with new eyes. It means taking time out from the busy day to get away from seeing the forest only as work. The forestry practitioner's spiritual connection to the forest can be refreshed by *regular* strolls through moss-carpeted, old-growth forests or bluebird grassland habitat; return visits to healthy plantations; listening to Elders such as Mary Thomas on ethnobotany and spirituality; "giving back"; or perhaps through field trips with artists to learn about their perceptions of the forest.

AN ARTIST'S REFLECTIONS

What have I learned, as an artist, from the faces in the forest? Something stirred in me the moment I saw my first Gyetim Gan. I learned that the forest context enhances the aesthetic beauty and spiritual power of tree art. The carved face in the forest is so anonymous and humble (see figures 24 and 35), so distant from gallery walls, and so hidden from the view of the colonizer. The tree connects the carved face to Mother Earth in a profound way, similar to how the sand connects the their Dreamings of the Australian Aborigines to the desert they walk upon, or how Navajo artists

connect, through their paintings on the desert sand, with supernatural healing powers. Tree art connects us to Mother Earth through its roots, to the sacred world as an *axis mundi*, and to the past through stories. The Gyetim Gan have witnessed tremendous change since artists unfolded their spirit in the trees. They were created for many purposes, such as acting as guardians of territory, trails, or burials; recording or witnessing vision quests; communicating apologies to the lynx; attracting the lynx; acting as an *axis mundi* for returning spirits at the meeting place camp; or acting as an witness or historical marker. The second journey of meaning for all tree art, as introduced by George, regardless of the intended meaning, is to act as an historical marker. Tree art, like crest poles, evokes stories and provides visual cues for oral tradition or adaawk.

What is the link between art and culture? Joan Vastokas (1992, 17) emphasizes the importance of the art-making process. She pioneered the concept of considering the First Nations art-making process as a performance. For example, when roots are harvested from cedar trees to lace birch bark baskets, there is a link between the resulting culturally modified trees, cedar and birch trees in this case, and the art-making process. Tree art, paintings and carvings on trees, is an obvious "art" form, but if art includes the art-making process, then CMT's are evidence of the performance. This performance helps to define culture. Vastokas urges a shift in our perception of art as a cultural artifact to art as performance in a specific socio-economic setting. To further enlighten this point, a First Nations artist usually leaves an offering to a tree when he or she collects bark or roots. This performance ritual is part of the art-making process; the phenomenological experience, or lived experience, is a means to "make explicit the truth of primary experience of the social world" (Bourdieu 1977, 3). First Nations artists' performances help keep the culture vibrant, and thus they must have continued access to the forest. Explorations below further pursue the link between art and culture.

Who are these artists? Some may be master carvers, employed by great chiefs to communicate ownership of important trails or territory. Some may be trappers, apologizing to the lynx or trying to attract a lynx to their trap. Some may be mourners of a lost relative who create a memorial on a tree. Others, like Art Wilson, create a memorial of an important event in history. Finally, some may be like George Yutslick, who saw the spirit of the tree and was inspired to share his vision. The artists were many and so were their motivations for creating tree art, yet all felt the living spirit of the tree. The role of the artist in many cases was to facilitate the reincarnation of a living spirit into a tree, as in the case of the Dunne-Za burial markers, the Carrier trapper's apology to the lynx, the Carrier meeting place marker, and the Nisga'a chief's territory maker. The First Nations artist was commissioned to help perpetuate the cycle of life.

The artist's role in the evolution and performance of culture includes regenerating ceremony and connection to the land, but also to sound the alarm – "walking upright earth beings" are becoming an asynchronous presence in their environment.[36] Contemporary artworks such as 'Wii Muk'willixw's (Art Wilson's) book *Heartbeat of the Earth* (1996), David Neel's *Oil Spill* mask, and Lawrence Paul Yuxweluptun's painting *Clayoquot Sound Environmental Terrorist* are examples of works by First Nations artists that "like eyeglasses, show us initially shocking images of reality that were there all along, including the self-image we see in the mirror " (Sainte-Marie 1996, 13).[37] In contrast, my art could be characterized as firmly rooted in the Northwest Coast art tradition and at first glance does not appear to be social commentary. Initially I painted as a way to explore my Gitxsan heritage. I taught myself by spending countless hours viewing the Royal British Columbia Museum's Native art collection. I wanted to be true to the old ways. Oral history is my main source of inspiration. Now I try to enhance oral history with my artwork by synthesizing and sharing its teachings, especially about how we should show respect to our environment. For instance, my print entitled *One Horned Goat* is based on a story about how the people of Temlaham, near Hazelton, B.C., failed to show respect to the mountain goats who lived above their village. The goats retaliated and caused an avalanche, which buried the village. All were killed except for a young boy who was saved by the one-horned goat because the boy had rescued kid goats from the taunting village children. Many of my artworks are based on similar stories. My "traditional" art is primarily a regeneration of culture through my form and style lens, but it is also an indirect social commentary. I am worried that humans are not living in harmony and balance with the land. I seek harmony in my art through flowing formlines, which connect to each other like the arteries in the body; balance is sought through symmetry. Harmony and balance in my art are metaphors for ecological harmony and balance.

I have begun to create, however, more direct social commentary, a change is inspired by Art Wilson's visual and textual discourse. For instance, in collaboration with naturalist thinker and artist Annerose Georgeson, I painted *Bluebirds in the Ozone Hole*. As with Art's works, it is initially pleasing to the eye but soon the message comes into unpleasant focus – have the bluebirds disappeared into the ozone hole? When linked with social purpose, art – ever expressive of the culture it derives from – becomes more powerful (Ames 1993, v). Since culture is not static, First Nations art evolves. Tree art is an old and traditional form of symbolic expression, but the meaning it represents will evolve with the culture. Future artists may choose to create tree art, for instance, as direct social commentary, or to regenerate traditional ritual. The artist, able to

see and communicate with both the sacred and profane worlds, has an important role as a social commentator. In this way, the artist's insight on the sacred forest can assist the forester to monitor and maintain harmony and balance in the physical forest.

How is the power and beauty of art created? Is the power and beauty of art created by the artist? Maybe powerful art, that which inspires the soul, is created by the synergy between artistic vision and technical ability. I struggled with an answer until I met Philip Janze, a Gitxsan master carver. We had many discussions about art philosophy while he was teaching me the basic skills of wood carving. Philip believes the power in art is created through the artist; the artist obeys and becomes a tool for art creation (Janze 1999). Making art is a meditative process whereby the artist seeks a nirvana-like place to allow their god or guiding spirit to create through them. I have occasionally experienced the nirvana space while creating art, but I think Philip exists there. Art is *being* in this space, rather than the product being created; it is not necessarily meant for human consumption. In this space, even bodily functions are ignored or unnoticed. The artist will emerge, bladder bursting, fingers aching, and say, "wow, did I do that?" Philip would answer, "I did not do that, I was just obeying. We do it because we are asked." My inquisitive reply was, "Well, who asked?" In part, the carver is obeying the rules of the Northwest Coast art tradition. At first the artist's creativity is constrained by the tradition's rules, such as the use of ovoids, symmetry, and form, but after a while, in Philip's words, "the artist bursts through a pinhole, where the possibilities are endless."[38] Philip has also obeyed master carvers who lived over 200 years ago, while he recreates or regenerates their decaying crest pole. His hands and eyes just obey the wishes of a carver of long ago.

On a practical side, the apprentice carver may also be obeying the wishes of a master carver. Gitxsan artists also traditionally fulfilled practical needs of the community by making bowls, spoons, masks, and crest poles. Such items continue to be made for the use of the community, while those and others including silver and gold jewelry are also made for sale.[39] Navajo artists create silver and turquoise jewelry to sell to non-Indians, and Witherspoon (1977, 150) notes that "traditionally they put their works of art to practical use in their daily activities. Now it is more practical to sell them for money and buy stainless steel pots and other more durable but less artistic things. This practice offends the purist's view of aesthetics, but it is in fact, not a depreciation of aesthetic value at all. It is simply based on the idea that beauty is a dynamic experience in conception and expression, not a static quality of things to be perceived and preserved." Philip enjoys carving more for the sake of carving than for receiving recognition for the end product. He enjoys carving a spoon

because of its elegant simplicity, and he is carving to enjoy the process of carving, nothing more. When I was afraid of making a mistake in my carvings, Phil would say: "It is just a piece of wood, just throw it out if you make a mistake." Bill Reid (Holm and Reid 1975, 35–6) comments that monumentality and a tremendous, compressed power and tension define good Northwest Coast art. He hints these characteristics are achieved by the artist's courage; the artist's eye continues beyond what the mind says is logical.

Art-making is analogous to the mythical transformation described in the adaawk, as in We-gyet transforming from man to raven. The spirit uses a tool, the artist, to transform its vision into a creation. Olive Dickason (1998, 23–4) correctly describes art as "an active agent" with an "intermediary role between spiritual and material worlds." Unfortunately, she fears, contemporary art no longer has this role: "In today's market-driven society, art has undergone a profound change of purpose: instead of being a facilitator of cosmic relationships, it now defines humans in a human world" (27). Art is an active agent, but so is the artist an agent of his or her own spirit, and in this sense contemporary art can still be an agent of cosmic relations. The spirit or "god" instills the power of the art. The artist's reward is being in the space, and enjoying the process. The beauty in art exists equally in the creative process, or performance, and the resulting art.

The tree is also an assisting spirit in the art-making process; it moulds the artist's initial creation. The tree's scar gradually heals and conceals the art – embracing it as its own. Tree growth adds an additional dynamic to tree sculpture. For example, Albert Joseph, from the Bridge River First Nation (near Lillooet), created a twisted tree sculpture, shown in figure 45, when he was a boy of five years. He tied a hemp gunnysack to the stem of the young ponderosa pine tree, and then twisted the sack, and thereby the stem, with a stick. He then tied off the assembly with string which later rotted away, and the tree trunk grew into the beautiful curved shape.

Witherspoon (1977, 151) explored the Navajo concept of beauty in art. He says that: "[f]or the Navajo, beauty is not so much in the eye of the beholder as it is in the mind of its creator and in the creator's relationship to the created (that is, the transformed or the organized). The Navajo does not look for the beauty; he generates it within himself and projects it onto the universe. The Navajo says *shil hozho* 'with me there is beauty' ... Beauty is not 'out there' in things ... "

He goes on to note that the Western observer of art is bewildered and frustrated when the Navajo "destroy" an intricate and beautiful sand painting when its purpose has been served (152). The Western observer wants to take a photograph to preserve the image, but to the Navajo, the artistic or aesthetic value of the sand painting is found in its creation, not

in its preservation. Witherspoon's conclusion is that Navajo society is one of art creators, whereas Western society is predominantly one of art consumers.

Suppose, for the purpose of epistemological exploration, that Philip's belief that he obeys the spirit in the art-making process is extended to mean that the artist is the *axis mundi*. In our exploration of the supernatural tree as *axis mundi* we learned that this role occurs for some trees, some of the time. The artist can be chosen, perhaps because of technical skill, devotion, passion, patience, and spiritual awareness, for a particular work of art. The art has a better chance of achieving its purpose, the more technically perfect its creation (Dickason 1998, 24). Or the artist may be chosen based on the intensity of their connection to the sacred, which is developed through the Elders' teachings, the guidance of their ancestors, and their experiences on the land. At other times the artist may be obeying his or her own spirit while carving a simple feast spoon. So, what spirit chooses the artist, the context, and the tree for the performance of carving a burial marker? Vastokas considers the rendering of guardian spirits on rock art a sacred and powerful activity since a precondition for this image-making is the blessing, through a vision experience, from a spirit to the artist (Vastokas 1992, 43). Australian Aboriginal ground mosaics are sanctioned by ancestors, they represent journeys across the landscape, linking the people to specific geographical sites and their associated sustenance plants and water sources. The sand paintings are "tangible representations of legendary events, relating to mythological beings who are seen as both distantly ancestral and yet also ever-present in quiescent, invisible form" (Kimber 1992, 47).

The meaning of intended viewing context has just expanded to include the spirit's intended context, assuming the artist and/or tree can act as the *axis mundi*. Unfortunately, many of the tree artworks have been destroyed, or cut and removed from their context and displayed in museums. How important is the viewing context of First Nations art? Native art is often relegated to museums of anthropology or to "special" events in public and private art galleries (Vastokas 1992, 15; Young Man 1998, 25). Both Young Man and Vastokas view this correctly as hegemony of the colonizing culture, and call for Native art to be displayed alongside Western works of art. This would serve the purpose of social justice, but would it do justice to the Native works of art? Hilde Hein (1994, 1–2) contends that since the eighteenth century, the role of the art museum has been to canonize works of art for the dominant society.[40] Once canonized, the work embarks on its second journey of meaning; it becomes an official purveyor of culture. On the other hand, museums of anthropology and ethnography "identify objects, taken as non-art, that are produced by 'other' cultures, which may be aesthetically appealing, but are chiefly inter-

esting because they illuminate those cultures" (2). The modern art museum or gallery is described by Hein: "White windowless walls and unadorned rectangular spaces are designed to impede local interpretation and thus to authenticate a universal experience. The art alone is meant to speak, and it speaks only for itself, and to a disembodied perceiver (an Eye). Lifted out of their usual context and reference, visitors to the museum are supposed to enter a Platonic realm of pure, timeless being. The museum as canon forger is removed from the 'warm foothills of humanity'"(4).

Vastokas (1992, 16) reveals that art is perceived by the Western observer as a static material object which is self-referential and meant largely to be looked at from a single perspective. For example, the picture frame metaphorically signifies the separation of the painting from the context in which it was created. Young Man (1998, 32) disapproves of the separation of the art behind glass because it creates a schism between the artist and the work. So why is the barren environment of the art museum so desirable, apart from the pleasure of receiving the ratifier's official blessing, for an art form such as tree art that is so richly connected to the land and culture? If tree art is displayed in an art museum, it is out of its intended viewing context; the intended viewing experience is lost, as is the case for the tree carving that was cut down and displayed at Haines Junction information centre. Scott (1975, 50–1) provides examples of how incorrect interpretations of First Nations art can be made in the absence of the intended viewing context: "This was obvious when one [Nuxalk] elderly woman informant explained to me that one mask which we were discussing might be a particular character, *the one who calls the dancers*, but she couldn't be sure, because if it was it had to have a carved staff with it. Similarly she thought that another mask might be carpenter, *Musmusalanik*, but couldn't say so definitely. Carpenter [wood carver] masks always appeared traditionally in quartets, and one in isolation was difficult to recognize." First Nations people could lead a renaissance for the art world, rather than joining the present day one, by creating context-rich art celebration and preservation institutions. For instance, tree art could be placed in a forest-like context.

Verbal artists can enhance the viewing experience in this proposed context-rich art gallery by adding song, story, or adaawk. As I have emphasized throughout this study, developing this metonymic relationship between visual and verbal art is a vital means of communicating and reaffirming culture.

Northwest Coast art is known, in particular, for the consistent application, over time and place, of design rules. Tree art is created by many First Nations, and it is not specific to the Northwest Coast people. Moreover, exquisite examples, such as the Tumbler Ridge carving, are found deep in the interior, contrary to the popular assumption that the interior people

were not artists. Spiritual inspiration knows no boundaries. The consistency of practice ensures that meaning can be communicated across tribes and to many generations. The image of a face on a living tree is a consistent thread to the meaning of tree art.

Who is the intended audience for the faces of the forest? The Tsimshian pre-contact oral history in which the father carved a wooden image of his son for the star reminds me that art is not always created for the human audience. More so, Elder Mary Louie (2000) explains that there are rock paintings near Christina Lake, B.C., created by the Little People, that humans cannot see: "it's their own little histories. The stories of their lives."[41] I am fascinated by the humble essence of tree art; it wasn't intended to be viewed by the masses, nor was it important for the artist to affix his or her name to the creation. This private quality makes the art very powerful. Yet, is tree art really isolated in the forest, or is the audience the spirits of the forest? It is crucial to remember that, in some cases, the artist created the art for sacred audiences such as the spirit of the lynx.

I hope people can appreciate tree art for its aesthetic and spiritual power. But more importantly, I hope they appreciate its message. My own message is essentially this: we need to see with new eyes the sacred audience in the forest and to pay it more respect. The artists of long ago, and a few contemporary First Nations artists, have created these markers as witnesses to events such as vision quests, burials, trapping practices, trading, or the establishment or exchange of territory. Eliade (1963, 2) defines a sacred historical event experienced by humans as a hierophany; tree art created as an *aide-memoire* documents a hierophany. Since their creation, the remaining examples of tree art have witnessed many changes due to colonization and industrial development. Now their second journey of meaning is to cause us to reflect on our perception of the forest and on our lack of respect for the spirits of the forest. Faces in the forest live as shadows of history, in our midst to guide our destiny. Their sacred gaze is intended for audiences of the human and spirit worlds. We as humans must return to the forest with respect if we are to survive the new millennium. The adaawk about the spiritual training of the great Squirrel shaman teaches: "Then the great master of the squirrels was glad, because his tribe had come to life again. Then the prince sang, "Ia heiaha a, heia'aya negwa iaha!' I become accustomed to this side; I become accustomed to the other side" (Boas 1902, 211–16). We as humans must become accustomed to this world and to the spiritual world if we are to live in harmony and balance. Artists can play an important role by being able to see the unseen dictates of the spirit world and warn of impending disruption in harmony. The artist can create a witness to today and a window to the past for tomorrow.

Figure 45. Twisted tree (ponderosa pine) created by Albert Joseph when he was five years old.

I don't believe that Northwest Coast art is simply the duplication of one artifact after another. Each generation saw with new eyes, while living on the breaths of their grandfathers. Each generation developed individuals who maintained the continuum of the past through ceremonial practice, from dance to song, to object, while imprinting their own experience and vision. Each generation sought to express its own relationship to the present and future, in reference to our philosophy of achieving balance and harmony. And of course, the trickster was always there to throw a few curves" (Jensen 1999, 6).[42]

Why are most of the carvings of human faces? Art Wilson's reason for carving a face is a possible answer to my question: "I chose a face because when people see a face it just naturally draws their attention." Eliade (1963, 300) in his review of world religions found that some people believe that "[t]he tree or bush is held to be the mythical ancestor of the tribe." Many First Nations associate birth and death with the power of the sacred tree. Eliade refers to this as the "mystical relations between trees and men" (300). Is the face our reflection? Is the tree a mirror of our own spirits? Yes, the face *naturally* draws our attention. There is a self-reflective quality to the faces in the forest, similar to Velazquez's reflection in his painting *Las Meninas*. Jung believes we have a "bush soul." The Gitxsan word for spirit or soul is ootsxen, which also means a shadow. Our oral history talks about encounters in the forest with "shades of our ancestors." A Kwakwaka'wakw Elder once said, "Souls have no bones in

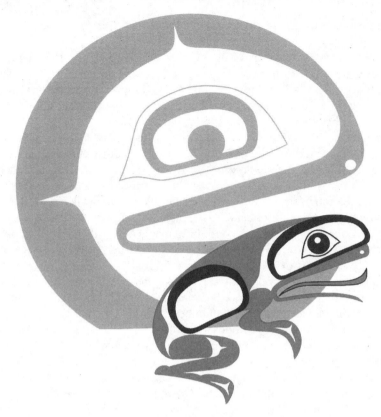

Figure 46. *Watch Over Me* limited edition silkscreen print
by Michael Blackstock.

their bodies, and they have no blood, for the souls are just like smoke or
shadows" (Boas 1913, 727–8). Our bush soul is our shadow.

Who guided me to Gyetim Gan? During a camping trip in Yukon, my
friend Joe and I had a profound conversation about our spirit or shadow.
We agreed that our shadow is like an Elder who watches over us; I creat-
ed the silkscreen print *Watch Over Me* (figure 46) to represent this con-
cept. Our shadow will only teach us or give us information when we are
ready for it – when we have matured enough to deal with that informa-
tion. Jung (1964, 17–55) says we have premonitions about coming events
because our unconscious, symbolized by the shadow, is leaking informa-
tion to our consciousness. Our shadow can see the unseen; our shadow is
an absentee presence. Ancestors guide me through life, as they guided me
to the tree carvings. Maybe our shadow is casting a shadow of what is to
come – foreshadowing. Our shadow is giving us a hint. It is about to give
us an important message.

Tree art is unimagined by most people. Why have the spirits of the for-
est chosen this time to reveal tree art to the post-colonial consciousness of

British Columbia? Have they come out of hiding to signify their disappointment over the disrespect being shown by industrial society to the forest and its spirit? There is hope for our forests because First Nations people can help to bring the industrial society into a balanced state with nature and her spirits.[43]

Each generation needs to understand the shadow cast by previous generations to forestall the deterioration of our environment. Previous generations are passing the shadow on to my generation. Survival, as Elder Mary Thomas advises, is a root motivation for spirituality. It helps us through the tough times. We have a saying: "Walk on, walk on, walk on the breath of our grandfathers." Doreen Jensen explains: "These words proclaim our strong sense of continuity, our belief in the constant reincarnation of thought, deed and man, our knowledge of the presence of yesterday in today, of today in tomorrow" (1999, 1). It means we carry our ancestors' breath and shadow with us when we inherit their world. They are our guides to survival. Sustainable survival with dignity, rather than sustainable development, should be our goal as we pass our shadow on to our grandchildren. The book *Only One Earth: The Care and Maintenance of a Small Planet* (Ward and Dubos 1972), which was commissioned by the United Nations, was the first attempt to examine global environmental issues and was the predecessor to *Our Common Future*. In the final section, the authors discuss a vision of unity, where all humans share an inescapable fact – that the planet is a "totally continuous and interdependent system of air, land, and water." They hope that with this shared global vision "we may find that, beyond all our inevitable pluralisms, we can achieve just enough unity of purpose to build a human world." Their concluding paragraph emphasizes survival rather than development: "Alone in space, alone in its life-supporting systems, powered by inconceivable energies, mediating them to us through the most delicate adjustments, wayward, unlikely, unpredictable, but nourishing, enlivening, and enriching in the largest degree – is this not a precious home for all of us earthlings? Is it not worth our love? Does it not deserve all the inventiveness, courage and generosity of which we are capable to preserve it from degradation and, by doing so, to secure our own survival?" (218–220).

My duties as your guide are now fulfilled. Inspired by tree art and the Elders' commentary, I reflected on my own perspective, worldview, and values, as I hope you, my fellow traveler, have. At my journey's end I was able to answer the question "Why did I feel that I was meant to find tree art?" While presenting my research to the Gitxsan community, the Elders reassured me that the Gitxsan spirit within me guides me; I had been earmarked for this task by the spirit world. I share this gift with you in hope of change. *Ia heiaha a, heia'aya negwa iaha.* That is all.

Appendix:
Comparison of Art History and Anthropological Research Methods

AUTHOR & RESEARCH SCOPE	CATEGORIES OF MEANING
Hatcher (1985) General	1) Subject or content; 2) Icons (arbitrary symbol); 3) Interpretation; 4) Metaphors; 5) Ambiguity; and 6) Restricted and Multiple codes.
Morphy (1991) Yolngu tribe in Australia	1) Denotative meanings: • iconographic collective meanings that are part of the ancestral reality (Morphy 1991, 118). • ireflectional; Dynamic meaning referential to the context of meaning (Morphy 1991, 122). 2) Connotative: • thematic: "denotative iconographic meaning becomes the raw material for the creation of a metaphor or analogy that is appropriate to the performance of a particular ritual event" (Morphy 1991, 125). • particularistic "meanings that are created through the association of a painting with a particular event such as the burial of a relative" (Morphy 1991, 131). 3) Sociological: • A social designation of ancestral connection. 'Paintings function in ceremonies to provide a locus of *wangarr*[1] power. They have the advantage of flexibility and durability; they may be painted directly onto an individual's body and so bring the person into direct contact with the *mali*[2] (shade) of the wangarr beings, or they may be painted on objects and in this form last beyond the duration of the ceremony. The fact they encode the relationship between place and the actions of wangarr beings enables them to be integrated within the structure of ceremonies as a whole and to act as a suitable medium for symbolically transmitting wangarr power through space and time' (Morphy 1991, 138).
Jonaitis (1989) Tlingit	1) Secular 2) Shamanic
Labadic (1992) Prehistoric pictographs in the Lower Pecos region	1) Intrinsic 2) Extrinsic • A question is established for the mode and qualified by a certain aspect of the art such as style, and by a focus such as technique.
Vastokas (1986, 1992) General	1) Function of the object; 2) Iconography, or explicit meaning; 3) Implicit or general meaning; and 4) Performance.

1 Wangarr Ancestral being, world creative force, time of world creation (311)
2 Mali: shade, reflection, shadow

OBJECTIVE	KEY QUESTIONS FOR INQUIRY
Study of art in the Cultural context	• What are the cognitive and emotional qualities of the art? • Whether there are subjects and form qualities that have similar universal meanings? • Which one have only very specific meanings, unique to each culture?
Explain art form in relation to use. Explain how art is a meaning creation system and can be a loci of power.	• What is the historical context of the art? • How are meanings encoded? • What are the conditions for interpretation? • What is the social position of the interpreter? • How important is theme and context in creating meaning?
Explanation of art in relation to the source of power	What is the visual system of symbols that corresponds to social order and the perception of the supernatural?
To employ art-historical methods to understand prehistoric pictographs.	• Who painted the pictograph? • Why are they painted? • What did they mean to those who produced them?
Understanding art through the concepts of performance and experience Reconstruct the art history	• What is the chronology of the art? • What is the personal experience of art for the observer?

Notes

PREFACE

1 "Elder" is capitalized as a symbol of my respect for their knowledge. The Royal Commission on Aboriginal Peoples uses this convention in their reports.

2 Paul Rabinow (1977, 157) observed that Moroccan informants who were "situated between two communities" helped him make transitions between cultures.

3 Ong (1982, 177) compares chirographic cultures with oral cultures. He highlights the fact that written text appears at first glance to be a one-way information street where the writer's audience is not present. Speech, on the other hand, is a performance-oriented communication where the "hearer" is present.

4 Each interview was conducted using a standard set of interview questions. While the informant chose the path of the conversation, I checked that each question had been addressed before the interview was concluded.

5 The Supreme Court of Canada, in 1997, reversed McEachern's ruling by saying that oral history can be introduced as evidence.

6 Internal tests include identifying themes; assessing the logic; allowing for embellishment; reconciling divergent accounts; and assessing whether it is a first-, second- or third-hand account. External tests include seeking corroboration from material culture, known cultural tradition, and printed records (Allen and Montell, 71–85).

7 As in other cultures the world over, wry and satirical humour is a vital part of Gitxsan culture. It reminds us not to take life too seriously and it can also teach. To this end, I have included in the endnotes brief selections from Thomas King's *Green Grass, Running Water* (1994).

 "I don't know," said Norma. "The green's nice too. Don't want to make a mistake, you know." She ran her hand over the carpet, "you make a mistake with carpet, and you got to live with it for a long time."
 "Everybody makes mistakes, auntie."
 "Best not make one with carpet" (King 1994, 8).

8 'I got back as soon as I could,' says Coyote. 'I was busy being a hero.' 'Thats

unlikely,' I says.

'No, no,' says Coyote. 'Its the truth.'

'There are no truths, Coyote,' I says. 'Only stories' (King 1994, 391).

9 Is there an association between primarily oral cultures and their emphasis on sacred cosmology? Likewise do primarily secular cultures prefer written expression?

CHAPTER ONE

1 "'We would have gotten here sooner,' said the Lone Ranger, 'but Coyote knew a short cut'" (King 1994, 382).

2 "Alberta's father was a great believer in dreams ... 'It's all forest right up until you get to the mountains ...'

'What do you do, Dad?'

'Why, hell, you walk. That's half the doing, the walking'" (King 1994, 255).

3 An interesting aside for me is that the book is catalogued as a work of fiction. I lean towards labeling it non-fiction.

4 "'And here at this restaurant that you own,' she said, raising her voice a notch, 'you serve dog?'

'That's correct ... It's a treaty right,' Latisha explained. 'There's nothing wrong with it. It's one of our traditional foods'" (King 1994, 132).

5 The number four is significant to many First Nations because it takes four times to get it right. In other words, it takes four stages to achieve a spiritual understanding.

6 I endnote examples of the Australian Aboriginal art forms in the fourth preparation and subsequent sections because they bear important spiritual similarities to tree art. As well as creating art on trees, Aboriginals paint masterful mosaics of their physical and spiritual landscapes (Dreamings) on the sand – another poignant medium – to express their attachment to the land.

7 My journey included a few wild goose chases and frustrating dead end leads. I remember a long windy canoe trip with my father on the Nation Lake searching the shores for a tree carving that was seen over thirty years ago. I also spent a scary few hours saying "Don't worry, I think I know where we are" to my friend Joe in the unfamiliar Yukon forest. Charlene, my wife, and I spent two days searching the shores of Discovery Channel. The search was playfully observed by fifty dolphins. My "city" sister even accompanied us on one fruitless trip to south Pender Island.

8 Coy (1999) also refers to mudglyphs.

CHAPTER TWO

1 The forest is a place of spiritual attachment for many cultures whether it be expressed in fantasy, cosmology, or art.

2 There is a tree in the parking lot entrance to the Vancouver train-bus station which has a burl growth on the side which looks like a face. The face is looking

towards the entrance door of the station. It can be seen easily from the window along the coffee bar of the McDonalds resturant.

3 Many First Nations languages, such as Tlingit, Blackfoot, and Nahuatl, do not have specific words for art. Hatcher (1985, 8) points out that one cannot assume there is no concept of art in a society because there is no directly translatable word for art. More importantly, some First Nations languages do not distinguish between the English words for writing and image making. The Tlingit word *sinaaki* means 'write/draw/make images' (Frantz et al 1989, 243), the Blackfoot word *ka-shi-xeet* means to 'use a pen, pencil or paintbrush' (Story et al. 1973. 251), and the Nahuatl word *tlacuiloliztli* means both 'to write' and 'to paint' (Boone 1994, 3).

4 Said interprets Foucault's definition of "discourse" as a body of text which creates an academic tradition. Said describes the power and influence of text, or "the bookish tradition," in society as follows: " ... texts can *create* not only knowledge but also the very reality they appear to describe. In time such knowledge and reality produce a tradition, or what Michel Foucault calls a discourse" (1978, 94).

5 All cultures have a notion of magical geography. For instance, J.R.R. Tolkien created a magical geography in his books.

6 "YOU AWAKE?" Norma put out a hand and pushed at Lionel's ribs. "Maybe it's time for me to drive."
 "I'm awake. I was just thinking."
 "Thinking with your eyes shut tight like that will land us in the ditch" (King 1993, 55).

7 Tree art also exists in Northeastern Queensland (Grimwade 1992).

8 The Kamilaroi word "Boor" means the belt of manhood.

9 Daramulan is a spirit who lives beyond the sky. This belief is held by the Yuin branch of the Coast Murring people (Etheridge 1918, 75)

10 The expedition was directed by Franz Boas and funded by Morris K. Jessup, president of the American Museum. They collected information on archaeology, linguistics, and anthropology (Suttles and Jonaitis 1990, 76). Teit married an Interior Salish woman and thus became a member of the Nlaka'pamux Nation.

11 Statl'imx dip net frames were made from young Douglas firs (*Pseudotsuga menziesii*) which were tied in a loop and left to grow for three to five seasons. The trees were chosen before there was a "red core, or heartwood formed in the young tree." The resulting loop was much stronger and it had fewer knots (Serack 1999).

12 "The Map. Bursom loved the sound of it. There was a majesty to the name. He stepped back from the screens and looked at his creation. It was stupendous. It was more powerful than he thought. It was like having the universe there on one wall ... " (King 1994, 128).

13 The Australian Aborigines express their spiritual attachment to the Earth in a beautiful and fundamental fashion through their sand paintings. The Earth is

their medium. Geoffrey Bardon's 1992 book entitled *Modern Art – Ancient Icon: A Gallery of Dreamings from Aboriginal Australia* displays the sand paintings within the context of the Aborigines' spiritual beliefs. He describes their tie to the land: "The association with the land is basic to Aboriginal spiritual belief, and his recall and heritage explains poetically his understanding of the land and nature" (8).

14 First Nations do not have a "heaven and hell" concept in their cosmology, rather it is Earth and the spirit worlds.

15 "Pardon me, says that Tree, maybe you would like something to eat.
That would be nice, says First Woman, and all sorts of good things to eat fall out of that Tree. Apples fall out. Melons fall out. Bananas fall out. Hot dogs. Fry bread, corn, potatoes. Pizza. Extra-crispy fried chicken.
Thank You, says First Woman, and she picks up all that food and brings it back to Ahdamn.
Talking trees! Talking trees! says GOD. What kind of a world is this?" (King 1994, 40–1).

16 Trees were cut down with stone adzes in the "old days," prior to the introduction of the metal axe. The Koyukon people used the "beaver style" method to fell a tree (Nelson 1986, 35). John Brown (1959, 775), a Tsimshian Elder, recalled in 1927 that "In the old days, the trees were cut down with stone axes, and the carvings were done with sharp bones, the leg bones of the bear or the caribou. As for the finishing touches, the carver would use beaver incisors tied together very tight, from beaver teeth lashed on a handle."

This passage from an oral history provides important clues to how trees were cut and carved, and is reminiscent of Walens' description of the close relationship between human beings and beavers as the only beings that cut down trees.

17 The excellent website at http://www.umd.umich.edu/cgi-bin/herb/ is an online database which can be used to search for ethnobotanical references by plant name. The website is hosted by the department of Anthropology of the University of Michigan-Dearborn.

18 The Interior Salish also placed the bodies of deceased babies in a birch or cedar basket and hung the basket on a tree.

19 Mallery (1972, 409) shows an Australian native's grave surrounded by carved trees.

20 Morphy (1991, 119–20, 130, 138) describes another Australian Aboriginal belief: the djuwany post in the Australian Yolngu molk (initiation) ceremonial ground as a locus for the transmission of ancestral power through time and place. The ceremony reenacts the creation of a river, at the location the ancestors chopped down a stringybark tree. When the tree fell it split into many pieces which became djuwany posts, and it also spread honey and bees across the land.

21 "That Sky world has all sorts of things. Sky things. They got Sky Moose. They got Sky Bear. They got Sky Elk. Sky Buffalo."
"And Sky Coyotes?" says Coyote (King 1994, 38).

22 "Is that a chicken hanging out of your mouth? says that GOD.
No, no, says Old Coyote. It must be my tongue. Sometimes it looks like a
chicken" (King, 1994 69).

CHAPTER THREE

1 The paintings of Kihn, Emily Carr, A.Y. Jackson, Edwin Holgate, and Annie
Savage were used as illustrations in Barbeau's *Downfall of Temlaham*. These
artists all visited the Gitxsan territory to paint village life and the landscape.

2 A shopping mall was built on the Hulbert hop farm property.

3 Site DIRx - 009, a human face recently carved on a tree stump near the mouth of
the Vancouver River, is registered in the British Columbia Provincial Heritage
Register. The Borden number is a unique identification number assigned by the
British Columbia Archaeology Branch for each recorded archaeological site.

4 It is possible that the blood may be – a query for further study – menstrual
blood, which could symbolize the matriarchal transfer of territory.

5 I have also heard that the Nlha7kapmx people marked the change of ownership
of resources with tree or rock art. See Millie Michel's interview in chapter 4.

6 The Gitxsan name for Wiiminoosik Lake is T'amuumxswt. It gets its name not
from the Gitxsan name for devil's club (as most people assume), but from a
plentiful grub or larvae in the lake.

7 Source: British Columbia Provincial Heritage Register (as of 4 May 2000).

8 Sullivan (1942, 102–3) reports that if the Tena killed a wolverine they would
prop the carcass up in their cabin or camp and make offerings of food to it.

9 The British Columbia government implemented a trapline registration system in
1925. The system is patrilineal and it created a lot of confusion in First Nations
communities because the definition of a trapline was not consistent with that of
a house territory or family hunting *and* trapping area. "Trapline" and "house
territory" are not synonymous, but they are associated.

10 Nelson (1983, 140) states that "[t]he most spiritually powerful of the predators
is the wolverine, and it is followed by the wolf, lynx, and otter. Taken collective-
ly, these animals are a greater locus of power than any other group of animals."
Mills (1996b) suggests that Nelson may be using the Western notion of a hierar-
chy of power, something she learned was not part of the Beaver Indian view of
spiritual power relationships.

11 Elder Margaret Gagnon (1995) told me a story about the wolverine. She said if
you tease or shoot the wolverine he will get back at you. She knew of a trapper
that teased a wolverine; up until then he had been very lucky in trapping beaver,
but thereafter he did not get any. The wolverine sprang the beaver traps, pulled
them up, and pooped on them. It is common for wolverine to urinate and defe-
cate on traps. Margaret described a remedy for this situation which involved
washing the traps and hanging them in balsam smoke. She ended her story by
saying, "If you tease one wolverine, other wolverines will know, like all the
family and they will all get mad at you."

12 The Sekani people are to the west of the West Moberly people. I have photo-
 graphs of an arboroglyph in their territory, courtesy of John Bedell. There are a
 group of lodgepole pines just south of Gataga Lake that have faces carved on
 them. I have not been able to confirm whether they were created by the local
 First Nation. However, the lake is very isolated and I suspect they are of First
 Nations origin.

CHAPTER FOUR

1 "Apologize for what?" says Coyote.
 "In case we hurt anyone's feelings," said Hawkeye.
 "Oh, okay," says Coyote. "I'm sorry."
 "That didn't sound very sorry, Coyote," said the Lone Ranger. "Remember what
 happened the last time you rushed through a story and didn't apologize?" ...
 "Sorry, sorry, sorry, sorry," says Coyote.
 "Okay," said the Lone Ranger. "We believe you."
 "Hee-hee," says Coyote. "Hee-hee" (King 1994, 430).
2 "In a democracy, everyone gets a turn," says Coyote.
 "Nonsense," I says. "In a democracy, only people who can afford it get a turn."
 "How about half a turn?" says Coyote. (King 1994, 327).
3 There is a good Canadian internet website that catalogues the origin of place
 names: http://www.atlas.gc.ca. The National Atlas website is hosted by National
 Resources Canada.
4 "My name is Glimmerglass, says that Lake. What's yours?
 I'm Old Woman, says Old woman. And I am floating.
 It's a nice day for that, says that Lake" (King 1994, 391).
5 Here is a game that can be used to demonstrate how language influences our
 orientation on a landscape using descriptive place names.
 • Form groups of two people: a hider and a seeker;
 • The hider places a red card (which has their group number written on it)
 in the building or outdoors in a place where it is visible from about two
 metres away and at least a four-to-five minute walk away from the seeker;
 • The hider returns to where the seeker is waiting and describes the route to the
 location where the card is placed (e.g.: I went out the door, past the place
 where coffee is served, then to where the hall forks, and then towards where
 we met early this morning etc.) but under the following restrictions:
 • The hider cannot use numbers, the words "left, right, up, down, north, south,
 east, or west," or compass bearings.
 • The seeker must listen to the description of the route, clarify, and then find
 the card within the time limit (ten to fifteen minutes). The seeker can come
 back for clarification.
6 Alexander Mackenzie clearly alludes to his reliance on the Carrier-Chilcotin
 guides in his journal. "As for attempting the woods, without a [Indian] guide, to
 introduce us to the first inhabitants, such a determination would be little short

of absolute madness" (Mackenzie 1970, 337).

7 "It doesn't look like an Indian dam," said Hawkeye. "It doesn't look like an Indian Lake." "Perhaps it's a Coyote dam," says Coyote. "Perhaps it's a Coyote Lake" (King 1994, 409).

8 James A. McDonald (1983, 27) has written one of the few descriptions of Tsimshian landscape and place names.

9 Reserves were created in 1876–78 by the Joint Reserve Commission, in 1878–80 by the Indian Reserve Commissioner Gilbert M. Sproat, and in 1880–1910 by commissioners O'Reilly and Vowell.

10 "Silly Coyote," I says. "There are good points and there are bad points, but there are never all good points or all bad points" (King 1994, 324).

11 First Nations people do not make a distinction between whether a tree of aboriginal interest is an archaeological resource or an indicator of aboriginal rights and title. The tree is culturally important regardless of how the provincial or federal governments define it in their legislation.

12 Sustainability is defined here as ensuring the survival, with dignity, of human beings without threatening the survival of ecological communities. Currently, it seems the focus is still on *development;* however, as water, in particular, becomes scarce, the focus will inevitably shift to survival.

13 Over-harvesting is defined as exceeding the sustainable long-term harvest level which takes into account the economic, environmental, and social interests of the public and aboriginal peoples.

14 The public does not relate to the unit of measure *cubic metres/year* of wood harvested. It is easier to relate to *hectares per year* of harvested area.

15 This figure is based on a twelve-year average of crown land harvested from 1983–95. The values ranged from 160,000 to 239,000 hectares (Bartlett 1996, 9).

16 All right.
In the beginning there was nothing. Just the water. Everywhere you looked, that's where the water was. It was pretty water too.
"Was it that wonderful, misty water in California," says Coyote, "with all those friendly bubbles and interesting stuff that falls to the bottom of your glass?"
"No," I says, "This water is clear" (King 1994, 104).
Readers interested in a more comprehensive analysis of water as the primary element of the ecosystem from a First Nations point of view can find my paper "Water: A First Nations Spiritual and Ecological Perspective," published in the June 2001 edition of the online *Journal of Ecosystems and Management* (www.siferp.org/jem).

17 Anthony Aveni (2000, 35) postulates reasons for the creation of the Nasca lines, geoglyphs created by the people of ancient Nasca, which cover over 400 square miles in the Peruvian desert. He concludes that the lines were pathways: "I have no doubt that some sort of ritual on the ray centers and trapezoids, wherein people assembled for reasons connected to the acquisition of water, was involved. The patterns of lines speak of relations among people who maintained

them, and possibly of astronomy via the connection between sunrise/sunset positions and the date of arrival of water in the valleys adjacent to the pampa."

18 Mary Louie believes the water is a living spirit, just as George is on the hop pole.

19 Waring and Schlesinger (1985, 79) report that "[i]n conifers, particularly those of large stature, sapwood storage may approach 300 t/ha of water, equivalent to the amount transpired by a forest over a period of 5–10 days." They define the movement of water in the soil, through the vertical plane, as capillary rise: "Water can move upward in response to potential gradients within the soil from a water table some meters below the surface. This is called capillary rise, which can be very important in saturated coarse-textured soils where water may be supplied from a depth of 1 m at rates approaching 1mm/day" (115).

20 Black Cottonwood (*Populus tricocarpa*) has a tremendous ability to pump and store water.

21 Hetherington (1987, 192) explains the effects of harvesting on summer low flow: "Under some circumstances, low flows might be reduced in small streams following logging or fire. After initial increases, flows in west coast or eastern Canadian streams could eventually be diminished below predisturbance levels by the vigorous transpiration of new streamside deciduous vegetation or reduced fog interception. Even if flows are not reduced, build-up of gravel in streambeds, such as might occur after logging, could result in flow being entirely subsurface. This change in the channel would impair its use by fish. In general, however, the evidence indicates that low flows in most of Canada are more likely to increase rather than decrease after removal of the forest cover." Springs and creeks may appear to dry up when they are disturbed by road building or site preparation and their course is altered or caused to pool.

22 Naiman et al. (1992, 129) define ecologically healthy ecosystems as "... functions affecting biodiversity, productivity, biogeochemical cycles, and evolutionary processes that are adapted to the climatic and geologic conditions in the region ... Some tangible measurements of ecologically healthy watersheds include water quality and yield, community composition, forest structure, smolt production, wildlife use, and genetic diversity."

23 There is a debate over whether "decadent" old-growth forests should be harvested to protect water quality.

24 "The heart of an ecologically healthy watershed is the riparian forest ... This strongly suggests that maintenance of riparian forests in their historic abundance and in healthy ecological condition is of fundamental importance for long-term ecological and socioeconomic vitality of watersheds in the Pacific Northwest coastal ecoregion" (Naiman et al. 1992, 173).

25 Paahu, 'natural water' or 'spring,' is absolutely central in Hopi social and environmental thought. Indeed, the term itself points to the significance springs hold: they are the prototypical water sources (Whiteley and Masayesva 1998, 13). The spring can act as *axis mundi* between the underworld and earth. Waters (1963,

200) describes the sacred relationship between the spruce tree and a spring: "The sacred spruce is all important ... For spruce has the magnetic power to bring in the clouds and moisture. Some day, it is said, the white man will find out that the spruce has the most powerful magnetic forces of all trees." Clouds rest upon the spruce branches and the tree also has the ability to draw water up through a spring (49–51).

26 The concept of "good luck epistemology" as it relates to hunters showing respect to their prey animal spirits, to ensure they can provide for their family, was discussed earlier in the review of oral traditions and examples of tree art.

27 Black bears (*Ursus americanus* Pallas.) commonly feed on the cambium of several conifer tree species. Observations from Salmon Arm Forest District, of south-central B.C., indicate that lodgepole pine (*Pinus contorta* Dougl.) is the favoured species in the Interior Cedar-Hemlock biogeoclimatic zone. Rapidly growing, vigorous trees in moderately to lightly stocked young stands are preferred. Bears begin to utilize this food source once the trees exceed 10 cm in diameter, which occurs locally at age ten to fifteen years. Cambial feeding occurs in late May. While bears may feed annually in the same stands for several years, they rarely feed on the same trees more than once (Wright 2000).

28 Barbeau (1944, 109) describes the Nahannie concept of the Milky Way: "the luminous trail which departed souls followed into the upper world."

29 The time between October and November is "Falling leaf month"; November and December is "Taboo Month," symbolized by the devil's club; December and January is the "Intervening Month"; January to February is "Spring Salmon Month"; February and March is "Month when Olachen is Eaten" (Olachen is similar to herring); March and April is "Month when Olachen is Cooked": May and June is "Egg Month"; June and July is "Salmon Month"; July and August is "Humpback Salmon Month"; and September to October is "Spinning Top Month" (Boas, 1970, 398–9). Barbeau (1944) refers to lunar months such as the Moon of Snow, Moon of Ducklings, and Moon of Grizzlies. Each First Nation probably had a lunar calendar, which usually reflected the activities of the seasonal round.

30 See Henderson (1995, 225–36) for an excellent discussion on the Mikmaw concept of ecology, sacred order and relations, and responsibilities within this ecological order.

31 Bardon (1992, 8) explains how Australian Aboriginal sand mosaics "concern ceremonies held at a particular location, or place. Each painting possibly can be described as a map or location of a particular corroboree site, layout or group; but more often, as with the Pintupi, they are maps of journeys, and travels over hundreds of kilometres from very distant places called 'My Country,' as an endearment of their aesthetic and moral values."

32 Indian celery is cow parsnip (*Heracleum lanatum*) and Indian carrot is water parsnip (*Sium suave*).

33 This was by no means the first global call to action. In 1972 an unofficial report

entitled *Only One Earth* (Ward and Dubos, 1972) was commissioned and published by the Secretary-General of the United Nations.

34 A FLFC is not a designation of a piece of land, rather it is an analytic category which measures the flow of land from one category to another.

35 André Arsenault's comments and review of my manuscript inspired me to write this call to reconnect spiritually with the forest.

36 The Syilx name for humans is "walking upright earth beings" (Cardinal and Armstrong 1991, 14).

37 "Yuxweluptun is a voice literally and figuratively crying in the wilderness – the wilderness of Canadian politics – daring to bring issues and concerns of contemporary Indian people in the public forum in a way which has never before been attempted. Art is one of those areas where politics are shunned, but Yuxweluptun has thus far been able to overcome that barrier recognizing that art and culture are intertwined and inseparable" (Young Man 1998, 42).

38 Bill Reid (Holm and Reid 1975, 142) made a similar comment when he was discussing the design on a particular bent box: "What intrigues me, more than anything else, is that it shows the unlimited imagination of an artist pitted against the convention he's forced to work within. It also shows that he didn't let reality interfere with his design or aesthetics."

39 There is a debate in many First Nations communities about which artworks are sacred and therefore should not be sold, especially those related to shamanistic ritual.

40 "As John Guillory has noted, canonization is not possible in the absence of preservative institutions. The concept of canonicity derived from ecclesiastical law refers to the selections of certain scriptural texts as not in conflict with Christian doctrine and hence as acceptable for inclusion in the orthodox Bible. Ecclesiastical canonization also affirms conditions of beatitude for the elevation of persons to saintliness and confers that exclusive status upon them. Here the church or its official persona is the ratifying institution" (Hein 1994, 1).

41 The "Little People," Mary Louie explained, are her advisers; to me they are an enigma. I have heard other Elders in my community, and Mary Thomas, speak of them.

42 Bill Reid has referred to some of his artworks as "arti-fakes" in which they set out to be nothing more than a representation of artworks created in the past by other artists (Holm and Reid 1975, 134). Was Bill Reid merely an arti-faker? I believe not, but an exploration of Bill Reid's art is needed to clarify his art philosophy.

43 "It's a lot of work fixing up this world, you know," said the Lone Ranger. "Yes," said Ishmael. "And we can use all the help we can get." "The last time you fooled around like this," said Robinson Crusoe, "the world got very wet." ... "I didn't do anything," says Coyote. "I just sang a little ... I just danced a little, too ... But I was helpful, too" (King 1994, 416).

References

Adams, John. 1986. Gitksan Totem Poles: Notes on a Complex, Paleolithic Notation System. In *Fourth International Conference on Hunting and Gathering Societies. September 1986, Pre-Circulated Papers*. Hamilton: McMaster University

Allen, Barbara, and William Lynwood Montell. 1981. *From Memory to History: Using Oral Sources in Local Historical Research*. Nashville, Tennessee: The American Association for State and Local History

Allen, Paula Gunn. 1992. *The Sacred Hoop: Recovering The Feminine in American Indian Traditions*. Boston: Beacon Press

Altman, Nathaniel. 1994. *Sacred Trees*. San Francisco: Sierra Club Books

Ames, Michael M. 1993 (reprint). Foreword to *Robes of Power: Totem Poles on Cloth* by Doreen Jensen and Polly Sargent, v-vii. Vancouver: UBC Press.

–1991. *Court of Appeal* CA013770 *of Appellants Factum between Delgamuukw and Her Majesty the Queen*. Volume 1 of 3, Tab 4B

Aoki, Harou, and Deward E. Walker Jr. 1989. *Nez Perce Oral Narratives*. Berkeley and Los Angeles: University of California Press

Arnett, Chris. 1993. The Archaeology of Dreams: Rock Art and Rock Art Research in the Stein River Valley. In *They Write Their Dreams on the Rock Forever: Rock Writings in the Stein River Valley of British Columbia* by Annie York, Richard Daly, and Chris Arnett. Vancouver: Talon Books

Assu, Harry, with Joy Inglis. 1989. *Assu of Cape Mudge: Recollections of a Coastal Indian Chief*. Vanouver: UBC Press

Aveni, Anthony F. 2000. Solving the Mystery of the Nasca Lines. *Archaeology*. (May/June) 26–35

Barbeau, Marius. 1928 (2nd ed. 1973). *The Downfall of Temlaham*. Toronto: Macmillan

–1944. *Mountain Cloud*. Toronto: Macmillan

–1950. *Totem Poles*. Bulletin 119. Ottawa: National Museum of Canada

–1958. *Pathfinders of the North Pacific*. Caldwell, Idaho: Caxton Printers Ltd

Barbeau, Marius, and William Benyon. 1959a. *The Gwenhoot of Alaska: In Search of A Bounteous Land*. Manuscript. Ottawa: National Museum of Canada

–1959b. *Wolf-Clan Invaders from the Northern Plateaux among the Tsimsyans*. Ottawa: National Museum of Canada

–1987. *Trade and Warfare: Tsimshian Narratives* 2. George F. MacDonald and John J. Cove, eds. Ottawa: Directorate, Canadian Museum of Civilization

Bardon, Geoffrey. 1992. *Modern Art – Ancient Icon: A Gallery of Dreamings from Aboriginal Australia*. Alice Springs: The Aboriginal Gallery of Dreamings

Bartlett, Kim. 1996. *Just the Facts: A Review of Silviculture and Other Forestry Statistics*. Government of Canada and the Province of British Columbia

Basso, Keith H. 1983. Talking with Stories: Names, Places and Moral Narratives Among the Western Apache. In *Text, Play, and Story: The Construction and Reconstruction of Self and Society*, Stuart Platner, ed. 19–55. Washington, D.C.: American Ethnological Society

Battiste, Marie. 1985. Micmac Literacy and Cognitive Assimilation. In *Promoting Native Writing Systems in Canada*, Barbara Burnaby, ed., 7–16. Toronto: OISE Press

Benson, Richard. n.d. *Affidavit In The Supreme Court of British Columbia Between Delgamuukw and Her Majesty the Queen*. No. 0843 Smithers Registry

Benyon, William. 1987. Nass River Monsters Angry with One Another. In *Tricksters, Shamans and Heroes Tsimshian Narratives I*, John J. Cove and George F. MacDonald, eds. Ottawa: Directorate, Canadian Museum of Civilization

Berkes, Fikret. 1999. *Sacred Ecology: Traditional Ecological Knowledge and Resource Management*. Philadelphia: Taylor & Francis

Birchwater, Sage. 1993. *Ulkatcho Stories of the Grease Trail*. Anahim Lake

Blackwater, Walter (Gitxsan). 1995. Interview by author, tape recording, July 27.

Blocker, H. Gene. 1991. Is Primitive Art Art? *Journal of Aesthetic Education* 25, no. 4

Boas, Franz. 1902. *Tsimshian Texts*. Washington: Government Printing Office

–1913. Ethnology of the Kwakiutl: Based on Data Collected by George Hunt in the *Thirty-fifth Annual Report of the Bureau of American Ethnology* (1913–14)

–1955. *Primitive Art*. New York: Dover Publications

–1970. *Tsimshian Mythology*. United States: Johnson Reprint Corporation

Boone, Elizabeth Hill. 1994. Introduction: Writing and Recording Knowledge. In *Writing Without Words*, Elizabeth Boone and Walter D. Mignole, eds., 3–26. Durham: Duke University Press

Bopp, Judy et al. 1985. *The Sacred Tree: Reflections on Native American Spirituality*. Lethbridge: Four Worlds Development Press

Bourdieu, Pierre. 1977. *Outline of a Theory of Practice*. Trans. Richard Nice. Cambridge: Cambridge University Press

Bowers, Faubion. 1987. Arts, Crafts and Religion. In *The Encyclopedia of Religion*. Mircea Eliade, chief ed. Vol 1. New York: Macmillan

Brody, Hugh. 1988. *Maps and Dreams*. Vancouver: Douglas & McIntyre

Brown, John. 1959. The Crest of Tsananuq (#97). In *Temlarh'am, The Land of Plenty on the North Pacific Coast*, Marius Barbeau and William Benyon, eds. Manuscript. Ottawa: National Museum of Canada

Calverley, Dorthea H. n.d. (a) Prehistoric Trails. In *History is Where You Stand*. Unpublished, compiled under the direction of Dorthea H. Calverley. Dawson Creek: School District 59. Book 1, chapter 2, section 17. Dawson Creek Public Library, Calverley Collection

–n.d. (b) Indian War Trails (Footpaths). In *Transportation, Waterways, Carts, and Craft*. Unpublished. Compiled under the direction of Dorthea H. Calverley, Dawson Creek, School District 59. Book 3, chapter 1, section 2. Dawson Creek Public Library, Calverley Collection

Campbell, Wilfred. 1907. *Canada*. London: A&C Black

Cardinal, Douglas, and Jeanette Armstrong. 1991. *The Native Creative Process*. Penticton: Theytus Books

Cardinal-Schubert, Joan. 1992. Looking and Seeing. *This Country Canada* 1, no. 1: 18–20

Chambers, Ron (Champagne and Aishihik First Nation). 1995. Interview by author, tape recording, 12 September.

Coe, Michael D. 1993. *Breaking the Maya Code*. New York: Thames and Hudson Inc

Colden. 1866. *History of the Five Nations*. New York

Coy, Fred E., Jr. 1999. *Dendroglyphs*. Draft paper prepared for the International Rock Art Congress

Crapanzano, Vincent. 1980. *Tuhami: Portrait of a Moroccan*. Chicago: University of Chicago Press

Cruikshank, Julie. 1991. *Reading Voices: Dan Dha Ts'edenintth'e*. Vancouver: Douglas & McIntyre

–1994. Notes and Comments: Oral Tradition and Oral History: Reviewing Some Issues. *Canadian Historical Review* 75, no. 3. (Sept 1994): 403–19

–1998. *The Social Life of Stories: Narrative and Knowledge in the Yukon Territory*. Vancouver: UBC Press

Daly, Richard. 1993. Writing on the Landscape: Protoliteracy and Psychic Travel in Oral Cultures. In *They Write Their Dreams on the Rock Forever: Rock Writings in the Stein River Valley of British Columbia*, by Annie York, Richard Daly, and Chris Arnett. Vancouver: Talon Books

Dawson, George M., D.S., F.G.S. 1887. Customs and Arts of the Kwakiool (Abridged from a paper entitled *Notes and Observations on the Kwakiool People of Vancouver Island*, presented to the Royal Society of Canada, 25 May 1887)

–1891. *Notes on the Shuswap people of British Columbia* section II. Trans. Royal

Society of Canada

de Laguna, Frederica. 1995. Letter to author, 7 June.

De Schweinitz, Edmund. 1870. *The Life and Times of David Zeisberger: The Western Pioneer and Apostle of The Indians*. Philadelphia: J.B. Lippincott & Co

Delgamuukw *vs.* the Queen. 1987. *Opening statement of the Gitxsan and Wet'sewet'en Hereditary Chiefs to Chief Justice McEachern of the Supreme Court of British Columbia*. 11 May 1988

Dene Wodih Society. 1990. *Wolverine Myths and Visions: Dene Traditions From Northern Alberta*. Patrick Moore and Angela Wheelock, eds., Edmonton: University of Alberta Press

Desjarlais, Chief George (West Moberly First Nation). 1996. Letter to author, 12 December.

Dickason, Olive Patricia. 1998. Art and Amerindian Worldviews. In *Earth, Water, Air and Fire: Studies in Canadian Ethnohistory*, David T. McNab, ed., 21–31. Waterloo: Wilfrid Laurier University Press

Doubleday, Nancy C. 1993. Finding Common Ground: Natural Law and Collective Wisdom. In *Traditional Ecological Knowledge: Concepts and Cases*, Julian T. Inglis, ed., 41–54. Ottawa: IDRC

Drushka, Ken. 2000. Guest Column. *Truck Logger* Spring 2000: 47–9

Duff, Wilson. 1959. *Histories, Territories and Laws of the Kitwancool: Anthropology in B.C.* Memoir No. 4. Victoria: British Columbia Provincial Museum

–1980. *The Indian History of British Columbia: The Impact of the White Man*. Victoria: British Columbia Provincial Museum

Dwyer, Kevin. 1982. *Moroccan Dialogues: Anthropology in Question*. Baltimore: Johns Hopkins University Press

Eliade, Mircea. 1963. *Patterns in Comparative Religion*. Cleveland: World Publishing Company

Eldridge, Anne. 1982. *Cambium Resources of the Pacific Northwest: An Ethnographic and Archaeological Study*. Unpublished report. Simon Fraser University, Dept of Archaeology

Eldridge, Morley. 1991. Kispiox Pictograph Tree. *The Midden*, 23, no. 1: 6–8

Emmonds, George Thornton. 1991. *The Tlingit Indians*. Edited with additions by Frederica de Laguna. Seattle: University of Washington Press

Etheridge, Robert, Jr. 1918. *The Dendroglyphs, or "Carved Trees" of New South Wales*. Memoirs of the Geological Survey of New South Wales. Ethnological Series, No. 3

Fenton, William N. 1987. *The False Faces of the Iroquois*. Norman: University of Oklahoma Press

Franck, Ian. 1997. Letter to author, 29 December.

Frantz, D.G. et al. 1989. *Blackfoot Dictionary of Stems, Roots and Affixes*. Toronto: University of Toronto Press



Fraser, Simon. 1960. *The Letters and Journals of Simon Fraser 1806–1808*. W. Kaye Lamb, ed. Toronto: Macmillan

Gagnon, Margaret (Carrier). 1997. Class presentation, 28 November

Garland, Hamlin. 1899. *The Trail of the Goldseekers: A Record of Travel in Prose and Verse*. New York: Macmillan

Glavin, Terry. 1996. *This Ragged Place: Travels Across the Landscape*. Vancouver: New Star Books

Goldman, I. 1940. The Alkatcho Carrier of British Columbia. In *Acculturation in Seven American Tribes*, R. Linton, ed. New York: Appelton Century

Goward, Trevor, and André Arsenault. 2000. Cyanolichen distribution in young unmanaged forests: A dripzone effect? *The Bryologist* 103, no. 1: 28–37

Gram, Karen. 1997. *Legendary Tree's Loss Sickens Residents*. Vancouver *Sun*. 25 January. A1–6

Grimwade, Gordon. 1992. Aboriginal Tree Carvings of Northeast Queensland, Australia. In *The Proceedings of the Environment and Archaeology: New World Conference on Rescue Archaeology*. December 1992, San Juan, Puerto Rico. Agamemnon Gus Pantel et al., eds. 74–81.

Gupta, Sen. 1980. *Sacred Trees Across Cultures & Nations*. Calcutta: Indian Publications

Hankin, Arthur. 1923. Indian Signals in the Interior. In *Raven Clan Outlaws on the North Pacific Coast*, 1951, Marius Barbeau, ed. (unpublished manuscript). Ottawa: National Museum of Canada.

Hatcher, Evelyn Payne. 1985. *Art as Culture: An Introduction to the Anthropology of Art*. New York: University Press of America

Haudenosaunee Confederacy Announces Policy on False Face Masks. 1995. *Akwesasne Notes* 1, no. 1: 39

Hausman, Gerald. 1993. *The Gift of the Gila Monster: Navajo Ceremonial Tales*. New York: Simon and Schuster

Hein, Hilde. 1994. Institutional Blessing: The Museum as Canon-maker. In *Artifacts, Representations and Social Practice*, Carol C. Gould and Robert S. Cohen, eds., 1-20. Netherlands: Kluwer Academic Publishers.

Henderson, James sákéj. 1995. Mikmaw tenure in Atlantic Canada. *Dalhousie Law Journal* 18, no. 2. 202–225

Hetherington, E.D. 1987. The Importance of Forest in the Hydrological Regime. In *Canadian Aquatic Resources*, M.C. Healey and R.R. Wallace, eds., 179–211. Ottawa: Department of Fisheries and Oceans

Hicks, Russell. 1976. *Culturally Inflicted Injuries to the Western Red Cedars of the Northwest Coast*. Unpublished non-permit report. Simon Fraser University, Dept of Archaeology

Holm, Bill. 1985. *Northwest Coast Indian Art: An Analysis of Form*. Vancouver: Douglas & McIntyre

–1990. Art. In *Handbook of North American Indians: Volume 7, Northwest Coast*. Wayne Suttles, ed. 602–32. Washington, D.C.: Smithsonian Institution

Holm, Bill, and William Reid. 1975. *A Dialogue on Northwest Coast Form and Freedom Indian Art*. Houston: Institute for the Arts, Rice University

Howard, James H. 1955. *The Tree Dweller Cults of the Dakota*. Journal of American Folklore 68, no. 268: 169–74

Hyzims, Ernest. 1983. *Gitksan Carrier Tribal Council Land Claims Fish Management Study Summary Sheet*. Hazelton: LCO, Gitksan Carrier Tribal Council. 13 January. 18p. (p 12, 13): 2 cassette tapes. Recorded by Harry Daniels.

Ignace, Marianne, Jeff Bailey, and Marie Antoine. 1995. *Maiden Creek Watershed Sustenance Study: Traditional Secwepemc Land Use*. Unpublished report

Janze, Philip. 1999. Conversation with author, September.

Jenness, Diamond. 1937. *The Sekani Indians of British Columbia*. Bulletin no. 84, Anthropological Series no. 20. Ottawa: Dept of Mines and Resources, Mines and Geology Branch, National Museum of Canada

–1943. *The Carrier Indians of the Bulkley River: Their Social and Religous Life*. Anthropological papers, no. 25. Smithsonian Institution. Bureau of American Ethnology. Bulletin 133.

–1986. *The Faith of a Coast Salish Indian*. In Province of British Columbia publication. Wilson Duff, ed. Victoria

Jensen, Doreen. 1992. Art History. In *Give Back: First Nations Perspectives on Cultural Practice*. 15–26. North Vancouver: Gallerie Publications

–1999. *Frederick Alexcee: Tsimshian Artist*. Unpublished speech presented at Otsego Institute, Cooperstown, New York, 7 August 1999.

Johnson, Mary. n.d. Testimony. *In the Supreme Court of British Columbia Proceedings as Trial Between Delgamuukw and Her Majesty the Queen*. Vols 13, 14. Vancouver: United Reporting Services

–1981. *Gitxsan Carrier Tribal Council Land Claims Cultural Research Summary Sheet*. Hazelton: LCO, Gitxsan Carrier Tribal Council. 21 May. 9p. (p 6–9): 2 cassette tapes. Recorded by Violet Smith.

Jonaitis, Aldona. 1986. *Art of the Northern Tlingit*. Vancouver: Douglas & McIntyre

Jorgensen, Joseph G. 1974. *The Sun Dance Religion: Power for the Powerless*. Chicago: University of Chicago Press

Jung, Carl G. 1964. *Man and His Symbols*. New York: Laurel

Kehoe, Thomas F. 1965. *Indian Boulder Effigies*. Regina: Saskatchewan Museum of Natural History

Kihn, W. Langdon. 1926. The Gitksan on the Skeena. *Scribner Magazine* February 1926: 169–76

Kimber, Richard G. 1992. Mosaics You Can Move. In *Modern Art – Ancient Icon: A Gallery of Dreamings from Aboriginal Australia*. Ed. Geoffrey Bardon. Alice Springs: The Aboriginal Gallery of Dreamings. 45–53

Kimmins, J.P. (Hammish). n.d. *Clearcutting: Responsible Forest Management or Environmentally-destructive Forest Exploitation*. Unpublished paper.

University of British Columbia

–1987. *Forest Ecology*. New York: Macmillan

King, Michael. 1990. *A Land Apart: The Chatham Islands of New Zealand*. Auckland: Random Century New Zealand Ltd

King, Thomas. 1994. *Green Grass, Running Water*. Toronto: HarperPerennial

Klein, Janet. 1995. Letter to author, 27 June.

Klinka, K, V.J. Krajina, et al. 1989. *Indicator Plants of Coastal British Columbia*. Vancouver: University of British Columbia Press

Kloos, Peter. 1990. Reality and Its Representations. In *True Fiction: Artistic and Scientific Representations of Reality*, Peter Kloos, ed., 1–6. Amsterdam. VU University Press.

Knudtson, Peter, and David Suzuki. 1992. *Wisdom of the Elders*. Don Mills, Ontario: Stoddart Publishing Co.

Kramer, Paul J. 1983. *Water Relation of Plants*. Toronto: Academic Press Inc.

Kronzucker, Herbert J., M. Yaeesh Siddiqi, and Anthony D.M. Glass. 1997. Conifer root discrimination against soil nitrate and the ecology of forest succession. *Nature* 385, no. 6661 (January): 59–60

Labadic, John Antoine. 1992. An Art-Historical Paradigm for Investigating Native American Pictographs of the Lower Pecos Region, Texas. *Explorations in Ethnic Studies* 15, no. 1 (January): 5–11

Layton, Robert. 1991. *The Anthropology of Art*. New York: Cambridge University Press

Lepofsky, Dana. 1988. *Stein Valley Archaeology Assessment*. Unpublished. Nl'akapxm Nation Development Corporation

Lévi-Strauss, Claude. 1995. *The Story of Lynx*. Trans. by Catherine Tihanyi. Chicago: University of Chicago Press

Loskiel, George Henry. 1794. *History of the Mission of the United Brethren Among the Indians in North America*. London

Louie, Mary (Syilx). 2000. Interview by author, tape recording, 6 September.

Lovelock, James. 1991. Gaia: A Planetary Emergent Phenomenon. In *Gaia 2 Emergence: The New Science of Becoming*, William Irwin Thompson, ed., 30–49. Hudson, NY: Lindisfarne Press

Lowenthal, David. 1979. Age and Artefact: Dilemmas of Appreciation. In *The Interpretation of Ordinary Landscapes: Geographical Essays*, D.W. Meinig, 103–25. New York: Oxford University Press

McClellan, Catherine. 1975. *My Old People Say: An Ethnographical Survey of Southern Yukon Territory*. Ottawa: National Museum of Man

MacDonald, George F. 1993. The Epic of Nekt. In *The Tsimshian: Images of the Past; Views from the Present*, Margaret Seguin, ed., 65–81. Vancouver: UBC Press

–1995. Telephone interview with author, 27 March

MacDonald, George, and John J. Cove. 1987. Introduction to *Trade and Warfare: Tsimshian Narratives 2*. George F. MacDonald and John J. Cove, eds. Ottawa:

Canadian Museum of Civilization

McDonald, James A. 1983. An Historic Event in the Political Economy of the Tsimshian: Information on the Ownership of the Zimacord District. *BC Studies* no. 57: 24–37

–1985. Images of the Nineteenth-Century Economy of the Tsimshian. In *The Tsimshian: Images of the Past; Views from the Present*, Margaret Seguin, ed., 40–54. Vancouver: UBC Press

McEachern, Chief Justice Allan. 1991. *Reasons for Judgement: Delgamuukw vs. Her Majesty the Queen*. Supreme Court of British Columbia. No. 0843 Smithers Registry

Mack, Charlie. 1977. Coyote and His Son. In *Lillooet Stories*, vol. VI, no. 1, Randy Bouchard and Dorothy I.D. Kennedy, eds. Victoria: Aural History.

Mackenzie, Alexander. 1970. Journal of a Voyage From Fort Chipewyan to the Pacific Ocean in 1793. In *Journals and Letters of Sir Alexander Mackenzie*. W. Kaye Lamb, ed. New York: The Syndics of the Cambridge University Press

Mackenzie, Mary. *In the Supreme Court of British Columbia Proceedings as Trial Between Delgamuukw and Her Majesty the Queen*. Vol 4. Vancouver: United Reporting Services

McMurdo, John. 1975. *Archaeological Resources and Culture History in the Kitwanga – Meziadin Highway Corridor*. Unpublished report: Permit no. 1975-10

Mallery, Garrick. 1972. *Picture Writing of the American Indians*. Vol 1. New York: Dover Publications

Malloway, Frank (Stólö). 1995. Interview by author, tape recording, 15 May.

Manuel, Herb (Syilx). 1999. Letter to author, 27 October.

Marsden, Susan. 1987. *Historical and Cultural Overview of the Gitksan*. Vol 2. Unpublished paper

Marsden, Susan, and Robert Galois. 1995. The Tsimshian, The Hudson's Bay Company, and the Geopolitics of the Northwest Coast Fur Trade, 1787-1840. *The Canadian Geographer* 39, no. 2: 169–83

Maud, Ralph. 1993. *The Porcupine Hunter and Other Stories: The Original Tsimshian Text of Henry Tate*. Vancouver: Talon Books

Meares, John. 1790. *Voyages made in Years 1788 and 1789 from China to the North West Coast of America*. London

Meinig, D.W. 1979. *The Interpretation of Ordinary Landscapes: Geographical Essays*. New York: Oxford University Press

Menisk, Chief, and Benyon, William. 1987. Person of the Trees. In *Tricksters, Shamans and Heroes: Tsimshian Narratives I*, John J. Cove and George F. MacDonald, eds. Ottawa: Directorate, Canadian Museum of Civilization

Mills, Antonia. 1988. A Preliminary Investigation of Cases of Reincarnation Among The Beaver and Gitksan Indians. *Anthropologica* XXX, 23–59

–1996a. Conversation with author (unrecorded), 6 February.

–1996b. Conversation with author (unrecorded), 3 May.

–1996c. Conversation with author (unrecorded), 8 August.

–1994. Rebirth and Identity: Three Gitksan Cases of Pierced-Ear Birthmarks. In *Amerindian Rebirth: Reincarnation Belief Among North American Indians and Inuit*, Antonia Mills and Richard Slobodin, eds. Toronto: University of Toronto Press

Morice, Rev. Father. 1893. *Notes Archealogical, Industrial, and Sociological, on the Western Denes with an Ethnographical Sketch of the Same*. Transactions of the Canadian Institute Session 1892–93

Morice, A.G. 1896. *Three Carrier Myths: With Notes and Comments*. Transactions of the Canadian Institute. Toronto

Morphy, Howard. 1991. *Ancestral Connections: Art and an Aboriginal System of Knowledge*. Chicago: University of Chicago Press

Mowatt, Sophia (Gitxsan). 1995. Interview by author, tape recording, 24 July. Translated by Norma Mowatt.

Mulwain, Olive. 1982a. *Gitksan Carrier Tribal Council Land Claims Historical Research Tape Summary Sheet*. Hazelton: LCO, Gitksan Carrier Tribal Council, 28 January. 16 p. (p 1–2): 1 cassette tape. Recorded by Violet Smith.

–1982b. *Gitksan Carrier Tribal Council Land Claims Historical Research Tape Summary Sheet*. Hazelton: LCO, Gitksan Carrier Tribal Council, 10 February, 1982. 7 p. (p 1): 1 cassette tape. Recorded by Violet Smith.

Naiman, Robert J. et al. 1992. Fundamental Elements of Ecologically Healthy Watershed in the Pacific Northwest Coastal Ecoregion. In *Watershed Management: Balancing Sustainability and Environmental Change*, Robert J. Naiman, ed., 127–88. New York: Springer-Verlag

National Museum of New Zealand. 2000. Te Papa Onscreen. Visitor onscreen database.

Nelson, Richard K. 1983. *Make Prayers to the Raven: A Koyukon View of the Northern Forest*. Chicago: University of Chicago Press

–1986. *Hunters of the Northern Forest: Designs for Survival among the Alaskan Kutchin*. Chicago: University of Chicago Press

Olson, Wallace, and Ramon Vitt. 1969. Tree Paintings Near Tok, Alaska. *Anthropological Papers of the University of Alaska*, 14, no. 2: 77–83

Ong, Walter J. 1982. *Orality and Literacy: The Technologizing of the Word*. New York: Methuen

Parker, Arthur C. 1923. *Seneca Myths and Folk Tales*. Buffalo, New York: Buffalo Historical Society

Penney, David W. 1981. The Nootka "Wild Man" Masquerade and the Forest Spirit Tradition of the Southern Northwest Coast. *Res.* 1, (spring 1981): 95–109

Pierce, Rev. William Henry. 1933. *From … Potlatch to Pulpit*. Vancouver: Vancouver Bindery Company

Pintasilgo, Maria de Lourdes et al. 1996. *Caring for the Future: Making the Next Decades Provide a Life Worth Living*. New York: Oxford University Press

Powell, Addison M. 1909. *Trailing & Camping in Alaska*. New York: A. Wessels

Prince, Nicholas. n.d. *How I Became a Dugout Canoe*. Unpublished

Prince, Nick (Carrier), 1995. Interview with author, tape recording, 6 November.

Rabinow, Paul. 1977. *Reflections on Fieldwork in Morocco*. Berkeley: University of California Press

Riddle, David K. 1994. *A Report Detailing the Results of Archaeological Surveys Undertaken Along the Churchill River Between Leaf Rapids and Opachuanau Lake, The Rat and Burntwood Rivers From Wapisu Lake to Wuskwatim Lake with Specific Reference to Burial Recoveries*. Unpublished report. Manitoba Historic Resources Branch

–1995. Telephone interview, 27 January.

–2001. Telephone interview, 26 March.

Robinson, Frances M.P. 1976. Introduction. In *Visitors Who Never Left: The Origin of the People of Damelahamid*, by Chief Kenneth B. Harris and Frances M.P. Robinson. Vancouver: University of British Columbia Press

Robinson, Gordon. 1961. *Tales of the Kitamaat*. Kitamat: Northern Sentinel Press

Robinson, Harry. 1989. *Write it on Your Heart: The Epic World of An Okanagan Storyteller*. Wendy Wickwire, ed. Vancouver: Talon Books/Theytus

Robinson, Will, and Walter Wright. 1962. *Medeek*. Terrace: Sentinel Press

Runnals, David. 1990. *Keynote Address to the 1990 Forest Sector Conference*. Unpublished paper. Institute for Research on Public Policy

Ruoff, A. LaVonne Brown. 1990. *American Indian Literature: An Introduction, Bibliographic Review, and Selected Bibliography*. New York: Modern Language Association of America

Rush, S., P. Grant, L. Mandell, M. Jackson, M. Adams, and S. Guenther, 1990. *Summary of Argument of Gitksan Wet'Suwet'en Hereditary Chiefs. Delgamuukw and Her Majesty the Queen*. No 0843 Smithers Registry

Ryan, J. n.d. *Testimony in the Supreme Court of British Columbia Proceedings as Trial Betweeen Delgamuukw and Her Majesty the Queen*. Vol 80. Vancouver: United Reporting Services

Ryan, Olive n.d. *Testimony in the Supreme Court of British Columbia Proceedings as Trial Betweeen Delgamuukw and Her Majesty the Queen*. Vol 17. Vancouver: United Reporting Services

Said, Edward. 1978. *Orientalism*. New York: Vintage Books

Sainte-Marie, Buffy. 1996. Foreword to *Heartbeat of the Earth* by Art Wilson. Gabriola Island: New Society Publishers.

Sampson, Geoffrey. 1985. *Writing Systems: A Linguistic Introduction*. Stanford: Stanford University Press

Sarris, Greg. 1994. *Mabel Mckay: Weaving the Dream*. Berkeley: University of California Press

Sauer, Carl O. 1963. The Morphology of Landscape. In *Land and Life: A Selection from the Writings of Carl Ortwin Sauer*, John Leighly, ed. Berkeley: University of California Press

Schindler, D.W. 1998. A Dim Future for Boreal Waters and Landscapes. *Bioscience* 48, issue 3: 157–65

Scott, Margaret A. 1975. *Bella Coola Ceremony and Art*. Ottawa: National Museum of Canada

Serack, Marjorie. 1999. E-mail to author, 10 November.

–2000. E-mail to author, 13 January.

Shiner, Larry. 1994. 'Primitive Fakes,' 'Tourist Art,' and the Ideology of Authenticity. *The Journal of Aesthetics and Art Criticism* 52, no 2: 225–34

Simard, Suzanne W., David A. Perry, Melanie D. Jones, David D. Myrold, Daniel M. Durall, and Randy Molina. 1997. Net transfer of carbon between ectomycorrhizal tree species in the field. *Nature* 388, (7 August): 579–82

Smith, Wynet, and Peter Lee. 2000. *Canada's Forests at a Crossroads: An Assessment in the year 2000*. Canada: World Resources Institute

Le specie forestali estotiche nella selvicultura italiana. 1981–82. *Annali dell'Instituto sperimentale per la selvicoltura*. Vol. XII e XIII: 693–702, Arezzo

Sterritt, Neil, Jr. (Gitxsan). 1995. Interview by author, tape recording, 21 July.

–1996. *Tribal Boundaries in the Nass Watershed*. Unpublished report

Sterritt, Neil J., Susan Marsden, Robert Galois, Peter R. Grant, and Richard Overstall. 1998. *Tribal Boundaries in the Nass Watershed*. Vancouver: UBC Press

Stewart, Hilary. 1984. *Cedar: Tree of Life to the Northwest Coast Indians*. Vancouver: Douglas & McIntyre

–1990. *Totem Poles*. Vancouver: Douglas & McIntyre.

Stó:lö Sitel Curriculum Committee. 1983. *Upper Stó:lö Interaction: A Story About Cedar Bark*. Sardis: Stó:lö Sitel Curriculum

Storm, Hyemeyohsts. 1972. *Seven Arrows*. New York: Ballantine Books

Story, Gillian et al. 1973. *Tlingit Verb Dictionary*. Fairbanks: Summer Institute of Linguistics Inc

Street, Eloise. 1974. *The Songs of Y-Ail-Mihth*. Chilliwack: Sepass Trust

Stryd, Arnoud H. 1997. *Culturally Modified Trees of British Columbia: A Handbook for the Identification and Recording of Culturally Modified Trees*. Ministry of Forests, British Columbia

Sullivan, Robert J. 1942. *The Tena Food Quest*. Dissertation. Washington, D.C.: The Catholic University of America Press

Suttill, David. 1994. Letter to Ministry of Forests re: *Klez Lake Message Tree*. March 16.

Suttles, Wayne, and Aldona Jonaitis. 1990. History of Research in Ethnology. In *Handbook of North American Indians: Northwest Coast*. Vol 7, Wayne Suttles, ed., 73–87. Washington: Smithsonian Institution

Tate, Agnes Carne. 1973. *Tales from the Longhouse by Indian Children of British Columbia*. Sidney, B.C.: Grays Publishing Ltd

Teit, James Alexander. 1900 (reprint 1997). *The Jessup North Pacific Expedition, Edited by Franz Boas; Memoir of the American Museum of Natural History*

New York, Vol 1 Part IV – The Thompson Indians of British Columbia, Franz
Boas, ed. New York. Reprinted with permission from a volume originally
owned and annotated by James Alexander Teit, now on display in the James
Teit Gallery, Nicola Valley Museum Archives, Merritt, B.C.

–1906. Part V – The Lillooet Indians. In *The Jessup North Pacific Expedition:
Memoir of the American Museum of Natural History,* Franz Boas, ed. New
York: G.E. Stechert

–1909. Part VII – The Shuswap. Reprint from Vol II of *The Jessup North Pacific
Expedition: Memoir of the American Museum of Natural History,* Franz Boas,
ed. Leiden: E.J. Brill Ltd

Teit, J.A. 1956. Field Notes on the Tahltan and Kaska Indians: 1912–15.
Anthropologica Vol 3

Teit, James A., and Franz Boas. 1973. *The Salishan Tribes of the Western Plateau:
An Extract from 45th B.A.E.* Annual Report 1927–28. Seattle: Shorey
Publications

Tens, Issac, and Marius Barbeau. 1952. The Kanawdzenerh or Shadows (#61). In
Wolf Clan Invaders, Marius Barbeau, ed. Manuscript. Ottawa: National
Museum of Canada

Thomas, Mary (Secwepemc). 1997. Interview by author, tape recording, 8
February.

–2000. Interview by author, tape recording, 13 October.

Thomas, Sophie (Carrier). 1995. Class Presentation, 17 October.

Thompson, Stith. 1967. *Tales of the North American Indians.* Bloomington:
Indiana University Press

Thorp, Jack. 1995. Chief Louie. In *Oliver Area: Secrets and Surprises,* Jacquie
Bicknell and Vicky White, eds. Oliver: South Okanagan Writers & Publishers

Torgovnick, Marianna. 1989. Making Primitive Art High Art. *Poetics Today* 10,
no. 2: 299–328

Tuan, Yi-Fu. 1991. Language and the Making of Place: A Narrative-Descriptive
Approach. *Annals of the Association of American Geographers* 81, no. 4:
684–96

Turner, Nancy. 1979. *Plants in British Columbia Indian Technology.* Handbook
no. 38. Victoria: British Columbia Provincial Museum

Valdes, Mario J. 1992. *Worldmaking: The Literary Truth-claim and the
Interpretation of Text.* Toronto: University of Toronto Press

Vastokas, Joan M. 1986. Native Art as Art History: Meaning and Time from
Unwritten Sources. *Journal of Canadian Studies* 21, no. 4: 7–36

–1992. *Beyond The Artifiact: Native Art Performance.* North York: Robarts
Centre for Canadian Studies

Wagner, Philip L. 1994. Foreword: Culture and Geography: Thirty Years of
Advance. In *Re-Reading Cultural Geography,* Kenneth E. Foote et al., eds.
Austin: University of Texas

Walens, Stanley. 1981. *Feasting with Cannibals: An Essay on Kwakiutl*

Cosmology. Princeton: Princeton University Press

Wallace, Paul A. W. 1952. *Historic Indian Paths of Pennsylvania*. Reprinted from the *Pennsylvanian Magazine of History and Biography* 76, no. 4: 18–19

Ward, Barbara, and René Dubos. 1972. *Only One Earth: The Care and Maintenance of a Small Planet*. New York: W. W. Norton and Company Inc

Waring, Richard H., and William H. Schlesinger. 1985. *Forest Ecosystems: Concepts and Management*. Toronto: Academic Press Inc.

Warn, W. (Dawson Creek). 1995. Telephone interview with author, 16 September.

Waters, Frank. 1963. *Book of the Hopi*. New York: Viking

Wavey, Chief Robert. 1993. International Workshop on Indigenous Knowledge and Community Based Resource Management: Keynote Address. In *Traditional Ecological Knowledge: Concepts and Cases*, Julian T. Inglis, ed., 11–16. Ottawa: IDRC

We-gyet Wanders On: Legends of the Northwest. 1977. Saanichton: Hancock House Publishers Ltd

Weisel, George F., Jr. 1951. The Ram's Horn Tree and Other Medicine Trees of the Flathead Indians. *The Montana Magazine of History* 1, no. 3: 5–13

Whiteley, Peter, and Vernon Masayesva. 1998. The Use and Abuse of Aquifers: Can the Hopi Indians Survive Multinational Mining? In *Water, Culture, and Power: Local Struggles in a Global Context*, John M. Donahue and Barbara Rose Johnston, eds. Washington D.C.: Island Press

The Wildcats. 1995. *Beautiful British Columbia Magazine*. Special Edition Number Two

Williams, Jimmy. 1952. Conquest Story of Gutkwinurhs (#76). In *Wolf Clan Invaders*, Marius Barbeau, ed. Manuscript. Ottawa: National Museum of Canada

Williams, Stanley. 1983. *Gitksan Carrier Tribal Council Land Claims Fish Management Study Summary Sheet*. Hazelton: LCO, Gitksan Carrier Tribal Council. 10 March. 7p.: 1 cassette tape. Recorded by R. Sterrit.

Wilson, Art (Gitxsan). 1995. Interview by author, tape recording, 16 July.

–1996. *Heartbeat of the Earth*. Gabriola Island: New Society Press

Witherspoon, Gary. 1977. *Language and Art in the Navajo Universe*. Ann Arbor: University of Michigan Press

Wong, Hertha D. 1989. Pictographs as Autobiography: Plains Indian Sketchbooks. *American Literary History* 1, no. 2: 295–314

World Conservation Union. 2000 *Vision For Water and Nature: A World Strategy for Conservation and Sustainable Management of Water Resources in the 21st Century*. IUCN – The World Conservation Union

Wright, Jim (RPF). 2000. E-mail to author, 28 September.

Young, Elspeth. 1992. Hunter-Gatherer Concepts of Land and its Ownership in Remote Australia and North America. In *Inventing Places: Studies in Cultural Geography*, Kay Anderson and Fay Gale, eds., 255–72. Melbourne: Longman Cheshire

Young, Jane. 1988. *Signs from the Ancestors: Zuni Cultural Symbolism and Perceptions of Rock Art*. Albuquerque: University of New Mexico Press

Young Man, Alfred. 1998. *North American Indian Art: It's a Question of Integrity*. Kamloops: Kamloops Art Gallery

Yukon Historical and Museums Association. 1995. *The Kohklux Map*. Whitehorse.

Index

108–10; Wilson, Art, 86–90
trees of aboriginal interest (TAI), 51,
 156
twisted tree, 28: as sculpture, 184

Vastokas, Joan: art-making, 14, 181;
 art history, 13; research approach,
 xxiii, 192–3
verbal art, 7: connection to visual art,
 xxvii, 78
visual communication system, 15–19;
 artist as encoder and decoder, 16;
 between hunters, 30

Walens, Stanley, 46, 53–4
warming tree, 48
watchmen pole, 37
water: annual cycle of, 166; drying
 up, 167; filtering, 167; fons et ori-
gio, 163; First Nations perspective
on, 201; as heart of ecosystem,
168; Hopi, 163; human needs, 164;
and livestock, 168; management
interventions, 169; Nasca lines,
201; scarcity of, 201; trees as
pumps of, 167; water reserve
zones, 163
white: significance of colour, 58
wilp (house), 36, 64, 107–8
wolverine, 199
writing systems: crest pole, 15; chrio-
graphic cultures, 195; definition of,
16; origins of, xxvii; semasiograph-
ic, 17. *See also* visual communica-
tion system

xmass (bark is off) ceremony, 36. *See*
also crest pole